"The Christian doctrine of the [...] 'y
countless believers and scholar: [...] n
a new book bring? Doctor Spe [...] l-
ments advocate for the use of imperfect imagery for better understanding of
God and for effective evangelism. While the book will benefit anyone who
wants to know more about the mysterious God they worship, the author as a
renowned theologian and a lifelong urban minister intends it for thousands
of his urban-campus seminary students who are bivocational ministers in
practical ministries. It speaks volumes about using images and illustrations as
legitimate and profitable ways to reveal the nature of God to profound effect."

—Lance Pan,
Investment Research Professional,
Gordon-Conwell Theological Seminary

"William David Spencer treats us to a cultural linguistic medley on the identity
of the Trinity in his book *Three in One: Analogies for the Trinity*. He brings
to bear on the topic his energies as theologian, biblical scholar, novelist, and
cultural critic. Spencer's goal is through language to ask whether the Bible
really teaches that God is a Trinity, whether it is even legitimate to express the
inexpressible in language. Jesus' example offers such permission. This sanc-
tion is followed by a cross-cultural analysis from early Christian exegesis into
the present. The chapter that asks about an analogy to that of a family raises
such questions as whether God has a wife, is gendered, or is best thought of as
community. Spencer's answer to these and other questions takes us on a journey
from the ancient Near East to the contemporary world through the eyes of 'one-
third world' scholars but also through those of students and theologians from
Asia, Africa, Latin America, and other cultures. Throughout, Spencer stays
centered on the role of language, its capabilities and limits, while emphasizing
the personal identity of the triune God in dynamic, analogical thinking."

—Rev. Rodney L. Petersen, PhD
Visiting Scholar, Duke Divinity School

"Bill Spencer has a penchant for going after the tough questions, and in *Three
in One* he takes us on an important journey through the history, theology,
and morphology of explaining the nature of the unexplainable. Concerned
that we use illustrating images correctly in talking about the nature of the
triune God, Spencer urges caution in our use of one-dimensional images for
our multidimensional God. But he also reminds us of the profoundly effective
ways in which Jesus' parables helped his listeners grasp truths about God."

—Alice Mathews, PhD
Lois W. Bennett Distinguished Professor Emerita,
Gordon-Conwell Theological Seminary

"At a time when many continue to revisit and reexamine the gains and losses of the so-called twentieth century Barthian and Rahnerian trinitarian 'revival', 'renaissance', or better put 'reengagement', here comes globally-minded churchman and biblical theologian Dr. William David Spencer's particular contribution to the growing literature: *Three in One*. While focusing on questions and issues attending to language, Spencer's *Three in One* is both a testament to his high view of Scripture as well as his expertise in the theological retrieval of the Christian tradition. What is unique to *Three in One* among many recently published treatises in trinitarian theology, is Spencer's evident trajectory as a life-long urban pastor-scholar and his urgent call to once again consider the practical implications of images for the Trinity."

—David A. Escobar Arcay ThM, PhD
Associate Professor of Theology and Director Hispanic Ministry Program
Western Theological Seminary

THREE
IN
ONE

Analogies for the Trinity

WILLIAM DAVID SPENCER

Three in One: Analogies for the Trinity
© 2022 by William David Spencer

Published by Kregel Academic, an imprint of Kregel Publications, 2450 Oak Industrial Dr. NE, Grand Rapids, MI 49505-6020.

All rights reserved. No part of this book may be reproduced, stored in a retrieval system, or transmitted in any form or by any means—electronic, mechanical, photocopy, recording, or otherwise—without written permission of the publisher, except for brief quotations in printed reviews.

Unless otherwise noted, the English translations of the original Greek or Hebrew texts are the author's own, except where the Greek text of early Christian theologians is not available.

Scripture quotations marked RSV are from the Revised Standard Version of the Bible, copyright © 1946, 1952, and 1971 by the National Council of the Churches of Christ in the U.S.A. Used by permission. All rights reserved.

ISBN 978-0-8254-4606-1

Printed in the United States of America

22 23 24 25 26 / 5 4 3 2 1

To my dear wife,
the Rev. Dr. Aída Besançon Spencer,
whose profound gifts of wisdom and
organization enhanced this book.

HEAVEN'S TERMS FOR PEACE

I

CREATOR/ CONQUEROR/COMFORTER

II

One God—when no one else—sufficient.
One Love creating us, proficient.
Our wills, returning love, deficient.
One Sacrifice applied, efficient.

III

The Voice spoke to conceive
not a replica or a reflection
but the Ray from the Sun of affection
to image the source of election: the only Fountainhead.
Thus, the Word came to reprieve,
with an amnesty with proviso,
the news on its combat radio:
fleshing in our own barrio is heaven's bold beachhead.
The Nurse heals to relieve
the wounds of warring wills of lovers
to unify sisters and brothers, equally,
loving God and others: peace terms of the Godhead.

William David Spencer, August 17, 2011[1] / May 23, 2022

1. An earlier version of the poem appeared in *Priscilla Papers* 25, no. 4 (2011): 30.

OTHER BOOKS BY THE SAME AUTHOR

THEOLOGY AND THE ARTS

God through the Looking Glass: Glimpses from the Arts (ed. with A. B. Spencer)
Mysterium and Mystery: The Clerical Crime Novel (Edgar Award nominee by the Mystery Writers of America)
Redeeming the Screens: Living Stories of Media "Ministers" Bringing the Message of Jesus Christ to the Entertainment Industry (ed. with J. C. DeFazio)

THEOLOGY, APOLOGETICS, AND CULTURE

Chanting Down Babylon: The Rastafari Reader (ed. with N. S. Murrell, A. A. McFarlane)
Dread Jesus: A Christian Response to Rastafarian Views of Jesus
The Goddess Revival: A Biblical Response to God(dess) Spirituality (with A. B. Spencer, C. C. Kroeger, D. F. G. Hailson) (a *Christianity Today* Book of the Year)

THEOLOGICAL AND BIBLICAL STUDIES

The Global God: Multicultural Evangelical Views of God (ed. with A. B. Spencer)
Joy Through the Night: Biblical Resources on Suffering (with A. B. Spencer)
The Prayer Life of Jesus: Shout of Agony, Revelation of Love: A Commentary (with A. B. Spencer)
Reaching for the New Jerusalem: A Biblical and Theological Framework for the City (ed. with A. B. Spencer, S. H. Park)
Second Corinthians: A Commentary (with A. B. Spencer)

CHRISTIAN LIVING AND MINISTRY

Christian Egalitarian Leadership: Empowering the Whole Church according to the Scriptures (ed. with A. B. Spencer)
Empowering English Language Learners: Successful Strategies of Christian Educators (ed. with J. C. DeFazio)

Global Voices on Biblical Equality: Women and Men Serving Together in the Church (ed. with A. B. Spencer, M. Haddad)

Marriage at the Crossroads: Couples in Conversation about Discipleship, Gender Roles, Decision Making and Intimacy (with A. B. Spencer, S. R. Tracy, C. G. Tracy)

NOVELS

Cave of Little Faces: A Novel (with A. B. Spencer)

Name in the Papers (Golden Halo Award for Outstanding Contribution to Literature by the Southern California Motion Picture Council)

CONTENTS

ACKNOWLEDGMENTS

I thank the triune God, without whom this book would not have been written.

I thank my wife, Rev. Dr. Aída Besançon Spencer, who looks out for everyone, especially for her family. In this case she initially read and critiqued each chapter as it appeared, and at the end she rallied around, double-checking the references and inputting the corrections. She is also my Bible-answer woman to whom I bring any sticky translation issues; it's so nice to have a world-renowned senior professor of New Testament in the house! I also want to highlight the exemplary work of Dr. Robert Boenig, a lifelong friend and consummate scholar whose example encouraged me to explain each technical term for my readers, as he does in his masterpiece *C. S. Lewis and the Middle Ages*. Reading his insightful pages in which he carefully explains every technical term he uses so that readers would understand, I realized that neglecting to do this was a failing in my own discipline, as I note we theologians often use terms without adequate explanation that not even our students can follow. So, applying his model, I tried to explain every term so that lay readers can follow my discussion too. I also intentionally used both popular and accessible books, like a college Latin dictionary and the Langenscheidt Hebrew and Barclay Newman Greek lexicons, so that students could see them in use, as well as the scholarly staples like Brown, Driver, Briggs; Liddell and Scott; and BDAG resources. On resources I owe a great debt to our former Gordon-Conwell Theological Seminary librarian James Darlack, who graciously helped me retrieve the 110 passages of the *Thesaurus Linguae Graecae* that I slowly studied over ten months while I taught in our Gordon-Conwell Boston Campus Center for Urban Ministerial Education. I was assisted by Anastasios Markoulidakis and Josh Reno, and for the final key entry, I compared my translation with that of Dr. Catherine Kroeger, our school's treasured classical scholar. She was blessed, as is Dr. Boenig, with a photographic memory. I am also continually grateful to David Shorey and Adam Davis who run our copy services as a ministry, and the gracious Robert McFadden, who helped me

find many of the rare books I consulted for this study. There are so many other library staff members without whom no thorough research project could ever be done. The library staff is the lifeline for all professors, as well as for students, just as the truly excellent staff members at Hamilton-Wenham Public Library keep us connected to the world of thought. Between the two libraries I found everything I needed to hunt down, technical and popular. The internet is truly an exciting jungle of opinions, and often illuminating, but books are profound, being the product of sustained thought. On this note, I thank my colleague Dr. John Jefferson Davis, who graciously critiqued my manuscript and helped me refine some key points. At Kregel, I first owe my thanks to Dr. Herbert Bateman, who initially championed this project; Laura Bartlett, then editorial director, who encouraged it; Kevin McKissick, who supported it; my editors Dr. Robert Hand, Shawn Vander Lugt, Carl Simmons, and all the skilled staff at Kregel, who did so much to make this a trim, concise, offering.

And, of course, this book was greatly enriched by all my students since 1992, when I began teaching the required systematic theology courses on our Boston campus. As we wrestled in class with the Trinity imagery that they used in their own evangelizing, teaching, and preaching, all of us, students and professor, were deepened in our understanding of the revelation of the God who loves us.

ABBREVIATIONS

ACW Ancient Christian Writers

ANF *Ante-Nicene Fathers*

BDAG Danker, Frederick W., Walter Bauer, William F. Arndt, and F. Wilbur Gingrich. *Greek-English Lexicon of the New Testament and Other Early Christian Literature.* 3rd ed. Chicago: University of Chicago Press, 2000.

BDB Brown, Francis, S. R. Driver, and Charles A. Briggs. *A Hebrew and English Lexicon of the Old Testament.* Oxford: Oxford University Press, 1907.

BDF Blass, F., and A. Debrunner. *A Greek Grammar of the New Testament and Other Early Christian Literature.* Translated and edited by Robert W. Funk. 10th ed. Chicago: University of Chicago Press, 1961.

BN Newman, Barclay M., Jr. *A Concise Greek-English Dictionary of the New Testament.* Stuttgart, Germany: Deutsche Bibelgesellschaft/ United Bible Societies, 1993.

FC The Fathers of the Church

HPA House of Prisca and Aquila Series

ICC International Critical Commentary

IDB *The Interpreter's Dictionary of the Bible.* Edited by George Arthur Buttrick. 5 vols. Nashville: Abingdon, 1962.

LCC Schaff, Philip, and Henry Wace, eds. *The Nicene and Post-Nicene Fathers.* Library of Christian Classics. Grand Rapids: Eerdmans, 1969.

LCL The Loeb Classical Library

LSJ Liddell, Henry George, Robert Scott, Henry Stuart Jones. *A Greek-English Lexicon.* 9th ed. With revised supplement 1968. Oxford: Clarendon, 1940.

LXX *The Septuagint Version of the Old Testament and Apocrypha.* London: Samuel Bagster, n.d.

MT Masoretic Text of the Hebrew Bible
NICNT New International Commentary on the New Testament
NIGTC New International Greek Testament Commentary
NT New Testament
OCD Hammond, N. G. L., and H. H. Scullard, eds. *The Oxford Classical Dictionary*. Oxford: Oxford University Press, 1970.
ODCC Cross, F. L., and E. A. Livingstone, eds. *The Oxford Dictionary of the Christian Church*. 2nd ed. Oxford: Oxford University Press, 1983.
OT Old Testament
Thayer Thayer, Joseph Henry. *Thayer's Greek-English Lexicon of the New Testament*. Marshallton, DE: National Foundation for Christian Education, 1889.
TLG Thesaurus Linguae Graecae

CHAPTER 1

INTRODUCTION

This book is about a variety of attempts Christians use to explain the triune God using illustrations and images of the Trinity and the theologies—good, bad, and confusing—that these illustrations convey. The approach is to analyze a number of these images, highlight what is good about them, warn about what might be misleading in them, and then suggest how they may be used best to teach about God's nature.

This is not an easy task. Why is that? Because God, who is at the center of the message we find revealed in the Bible, is completely other than humans. In our world, and indeed our universe, where everything we see or experience is breaking down or beginning, we have no point of reference by which we could have created the concept of an eternal and almighty Being who is forever unified and diverse, three in one—not three as in the case of three parts, but a triunity beyond our experience, yet graciously self-revealed by God to humanity. That this information was even given to us by our Creator is a great gift of love. It identifies the first Cause that brought ourselves and everything around us into being, since adequate cause reasoning tells us the material in which we exist has no eternal dimension and could not have created itself out of nothing. Is such information hard to fathom? Of course it is! Why would it not be? So, this revelation by the one we call "God" is a precious treasure of love we want to share with everyone.

GOALS OF THIS BOOK

Why Have I Written This Book?

Before setting out on any journey where one is not just wandering about but has a destination in mind, the wise traveler programs the GPS, downloads the directions, and checks the map. The wise chef consults the recipe. The wise student reviews the syllabus. The wise assembler who does not want to end up with a handful of odd bolts and a rattling machine studies the manufacturer's instructional pamphlet. That is what this introduction is. It is an orientation so you can get the most out of this book. I start with why I wrote it, who it is for, what it's not about and what it is about, where its focus lies, and what it is assuming. If you read it and the next chapter, you will be equipped with tools you need for theological interpretation.

Theology is the central part of a three-part scholarly endeavor to understand God's revelation. The first stage of inquiry is exegesis (from *ek* = "out" and *ago* = "I lead," meaning to derive the truth out of God's self-revelation in the Bible). The second is theology: ordering and interpreting that revelation. The third stage is application: learning to apply what we have learned through preaching, teaching, counseling, church administration, and so on. Doing this three-stage preparation (what was called "rightly dividing the Word of Truth" from the King James Bible's rendering of 2 Timothy 2:15, beloved in the church in which I was born and reared) helps us to become selective with all the opinions about what the Bible means that constantly bombard us as we gather information that we hope will help us in our understanding and our ministries. In this book, our focus will be all these images and interpretations about God's nature and actions among us that we will encounter.

Also, on a personal note, I love God, and I love theology. I find learning about God nourishing and exhilarating. If this book helps you draw nearer to God and fills you with gratitude and praise to the incomprehensible One who, having no necessity to do so, still determined to communicate with us, animated dust, and that realization results in your greater desire to know God through God's self-revelation and to explain the content of that communication more and more accurately to those you serve, then I will be blessed. If it helps you commit yourself to making every effort to understand what we limited humans can about the great, mysterious God we worship and to present the revelation of God's nature in the Bible as accurately as you can in your discourse and the illustrative images you choose to use, then I will be doubly blessed.

Who Is My Audience?

As an author, I have learned that to reach everybody, we have to reach somebody specifically. Explaining what one means to people one knows is the first step in communicating to someone one has not yet met.[1] So, for this topic, the particular audience I have in mind is a group of friends interested in this topic who are very dear to me: the more than 3,600 seminarians to whom I have had the privilege to teach theology for more than forty years in a variety of courses throughout the great range of systematic theology.

Their fields before, during, and after graduation have varied widely. And one feature I have built into this book is to include their contributions, particularly answers to a brief survey, where these scholars from many different cultures have graciously told me what images they use when they describe the Trinity. I also made this survey anonymous to dispel any fears among students who disagree with my views—that they can speak plainly without worrying that, when I inevitably disagree with them in print, I will do so by name (which no responsible teacher should ever do with trusting students still formulating their viewpoints). Understandably, I am indebted to my students for graciously providing so many of these illustrations from their own ministries, gathered over these many decades.

Most of these former students I had the privilege to teach at Gordon-Conwell Theological Seminary, and the overwhelming majority of them at its multicultural Boston Campus for Urban Ministerial Education (CUME). As a result, they ensure my approach in this book is both global and melded with my own heritage. My parents came from diverse backgrounds (my mother being a second-generation child of Greek and Czech immigrants; while my father descended from Leni Lenape First Nations heritage, mixed down the years with Pennsylvania Dutch [Deutsch], French, and Irish ancestors, with an English surname picked up somewhere along the way). I was reared in urban New Jersey, the "two-thirds world state" of the US (as I like to call it for its vast ethnic diversity), with a conscious understanding of my Native American heritage. My father was a Renaissance man who dabbled in everything, but he focused in my earliest years on collecting artifacts and pursuing incessant research in First Nations history. So, my perspective was already budding multiculturally when I married into Latino culture and today reside for a portion of each year in the Dominican Republic. Add to these factors fifty-five

1. Les Stobbe develops the value of Luke writing to Theophilus, "Earning the Right to Be Published," *Africanus Journal* 10, no. 2 (2018): 4–11.

years now of urban ministry, and together all of these sources account for most of the interesting illustrations this book contains.

My varied, globally oriented student body initially came to me, of course, as individuals, sensing a calling from God and having a variety of preparation levels. But the challenge for all of them, as well as for their professor, was the same as it is for any informed lay leader, elder, deacon, Sunday school teacher, pastor, or chaplain (or those aspiring to fill one or more of these callings): How does one explain the inexplicable Trinity to ourselves, our children, and those with whom we have the opportunity to share the good news that Jesus Christ brought us about: that the God who created us loves us and sent the only Son to redeem us?

I decided to share my intentions with all readers so that you will understand why I care so much about this topic and why I want to communicate as accurately as I am able who God is to a wandering world, and why my desire is to help each of you do the same.

What This Book Is *Not* About

A book's introduction is where authors are supposed to tell readers not only what they are up to but also what they are not attempting to do. Often that second part of the task is skipped over by readers who see the so-called delimitations statement as at best boring, and at worst depressing, since it convinces some they have not gotten their money's worth. I can also assure you, since I have been an editor for two journals, that bad habit is even worse for the well-being of authors when it's done by reviewers who enjoy carping on what writers admit they are not including. I've had to send back reviews to some reviewers who have let that aspect dominate their reviews with the warning to let it go, with a passing mention and focus the review on what the book does have. Clearly, with books, it's essential for readers to know the point of it all in order to stay on track. That is how a delimitation statement operates: like positive and negative images in art, if you see what is being shadowed, it may help highlight for you what is actually the focus.

So, here is what I am *not* trying to do in this book, so that you won't expect it and be disappointed when you don't find it. This is not an introduction to a survey course on theology covering everything from creation to the end times. I am not writing yet one more history of theological thought on the Trinity. My library is full of them. Gordon-Conwell's Goddard Library has many more. And every new catalogue I receive from my fellow scholars and their publishers provides us even more. Do I value these books? Of

course! And I consult them constantly. And you'll find this book replete with references and even analyses that touch past and current perspectives on the Trinity. But the present book you are holding is trying a different approach to this sacred and cardinal topic than a history would. Therefore, I am not able to load up the text or the footnotes with references to every single wonderful book on the Trinity I have managed to get in my hands, as these are countless. I know that I will disappoint so many fellow scholars who have done fine work in the field and who themselves will automatically flip to the index looking for a reference to their work and find nothing.

In addition, it's always a temptation to any academic writer to demonstrate to peers (and particularly to those who are book reviewers) that she or he knows the field and, therefore, should be taken seriously, respected, and heeded. Well, that's an irresponsible way to write a book. Space is precious, and as good writing demands, I am confining mine to references that move my analysis forward. This is not to say that I have dismissed the worth of all the other books and articles and manuscripts and recorded talks that I reviewed but didn't make the final cut of this book. It just means I did not feel a particular argument being covered was the best place to interact with a specific and, unarguably, thoroughly worthwhile piece of scholarship. So, readers, if you don't see a particular book on the Trinity listed in the bibliography, it doesn't mean it's not a present or future classic. Go ahead and read it anyway. You're bound to learn something worthwhile, whether you agree or disagree with it.

At the same time, I am not annotating a picture book of depictions of the Trinity over the ages or throughout a variety of cultures, as delightful and valuable as such books are—and again, I have also gathered up many of these over the years, enjoy them immensely, and often draw from them in talks and lectures I have given.

While I am listing this set of denials, I also realize a book like this could never be exhaustive. New images for the Trinity are being created constantly. For example, while I was working on this chapter, an announcement arrived of Andrew Farley's challenge to Kenneth Copeland whether his "fleet of private jets" was "a biblical thing." Dr. Farley's promoter, Grant Soderberg, gave this email a clever title: "The Holy Trinity: Three Gulfstream Jets or the Father, Son, and Spirit?"[2] When we arrive at our chapter on static images that are not human

2. Grant Soderberg, "The Holy Trinity: Three Gulfstream Jets or the Father, Son, and Spirit?," email advertising Dr. Andrew Farley, *Twisted Scripture: Untangling 45 Lies Christians Have Been Told* (Washington, DC: Salem, 2019).

to illustrate the Trinity under the section of three-parts images, we'll review the strength (distinctness) and the weakness (division) of these. In other words, new images are being invented constantly, but we cannot fit in every illustration everybody has used over the centuries. So we will deal with representative ones in the hope you can use what you learn in each analysis to interpret and make a judgment on the usefulness of any new ones you encounter.

As for the illustrations I have selected to discuss, each is intended to be instructive, fitting the book's goal to show images in use that can illuminate or obscure the revealed nature of God, depending on how they are being presented. I am not writing as a historian, artist, or art historian but primarily as a biblically oriented theologian with an interest in the arts and history.

What This Book Is About: An Overview

So, what is this book about? It is an introduction to doing theology and the importance of forging a biblical understanding of the Trinity in correspondence with the Scriptures and primal creeds of the Church such as the Old Roman Creed (c. AD 100s); its elaboration, the Apostles' Creed; and the Creed of Nicea (AD 325). A creed is a reaffirmation of the central tenets of the Christian faith, useful for when biblical orthodoxy is threatened. New creeds are functional. Like the Nicean Creed announcing that the Arian redefinition of the Godhead was a pernicious error, or the Barmen Declaration of 1934 proclaiming to the Nazi party there was only one leader that the church could follow, Jesus Christ, creeds have re-confessed the bedrock doctrines of our faith generation after generation. A few years ago, when arguments opposing relational equality in the Trinity by promoting subordination of the Son and the Holy Spirit were tightening their grip into a stranglehold on current evangelicalism, I was asked to create a creed under the title "An Evangelical Statement on the Trinity." Realizing that wisdom is found in the counsel of the wise, I recruited a sounding-board team of experts in Bible in its original languages, church history, classics, and theology. I drafted a creed along with a theological defense for it, which I sent back and forth until everyone in my smaller and larger circles could sign. Since then, this reaffirmation has served as a confession of faith for all those who have signed it. And it articulates my statement of belief for this book as well as for all my writing and teaching:

> We believe that the sole living God who created and rules over all and who is described in the Bible is one Triune God in three co-eternal, co-equal Persons, each Person being presented as distinct yet equal, not as three separate gods, but

one Godhead, sharing equally in honor, glory, worship, power, authority, rule, and rank, such that no Person has eternal primacy over the others.[3]

As a result, I hold what I call an Eternal Trinity Position. What I mean by that is I believe the monotheistic, immutable God, while eternally being one God, is also eternally triune, forever existing in three persons.

Did the term *person* mean the same to the early church theologians that it does to us today? To answer that question, we need to ask who inserted it into theology and what it meant for its initiator. Church historians trace the source to Tertullian, the incisive, controversial Christian lawyer and apologist who used it to distinguish the eternal Father God from the eternal person of the Godhead who incarnated on earth as the divine and human Son of God: Jesus Christ.

Tertullian's choice of *persona* (in Latin), translated as *prosōpon* (in Greek), seems a good initial choice to recognize complete unity and still observe distinctions between the Father, Son, and Holy Spirit of the Godhead.[4] Scriptural

3. See www.trinitystatement.com for "An Evangelical Statement on the Trinity" in several languages with both a biblical and theological exposition and a place for readers who wish to do so to affirm the statement. My theological version first appeared in *Priscilla Papers* 25, no. 4 (Autumn 2011): 15–19, and reprinted in Dennis W. Jowers and H. Wayne House, *The New Evangelical Subordinationism? Perspectives on the Equality of God the Father and God the Son* (Eugene, OR: Pickwick, 2012), 213. The creed and its explanation is on 213–22. Stanley Gundry later added a Bible verse–oriented creed with the same title on the website.

4. What those distinctions are is contested among contemporary theologians. Much of this controversy, I note, is centered on the contributions of the Cappadocian theologians born immediately after the Nicean Creed was signed (AD 325), among the most prominent being Gregory of Nazianzus (born c. AD 326–330), Basil of Caesarea (born c. 330), and Gregory of Nyssa (born c. 330–335). Lucian Turcescu in his book-length study *Gregory of Nyssa and the Concept of Divine Persons* (New York: Oxford University Press, 2005), considers him "a great theologian, philosopher, and mystic" (4), who "conceives of a person as a unique collection of properties that in themselves are not unique. Each such collection has causal relationship and finds itself in communion [*koinōnia*] with other similar collections. These relationships are what make the collections persons" (5) as opposed to the modern "understanding of person as a center of consciousness" (4). Catherine Mowry LaCugna in *God for Us: The Trinity and Christian Life* (New York: HarperCollins, 1991) explains, "Largely due to the influence of the introspective psychology of Augustine and his heirs, we in the West today think of a person as a 'self' who may be further defined as an individual center of consciousness, a free, intentional subject, one who knows and is known, loves and is loved, an individual identity, a unique personality endowed with certain rights, a moral agent, someone who experiences, weighs, decides, and acts. This fits well with the idea that God is personal, but not at all with the idea that God is three persons. Three persons defined in this way would amount to three gods, three beings who act independently, three conscious individuals" (250). Gregory of Nyssa himself, in "On Not Three Gods," argues, "Although we acknowledge the nature is undifferentiated,

background for such use might be seen in 2 Corinthians 4:4–6, where the face (*prosōpon*) of Jesus Christ displays or reveals (*phōtizō*; think of the English word *photograph*) "the knowledge of the glory of God." An example might be Jesus' face revealing glory in the transfiguration (Matt. 17:2; Luke 9:29; "face" is also used to represent the presence of God in passages like Rev. 20:11).

Tertullian was driven to come up with a term describing permanent distinctions in the three-in-one Godhead in his battle against Praxeas (c. AD 200), an ancient "Oneness" teacher who claimed the Father became the Son in the incarnation. This modalistic, dynamic Monarchian view, dubbed "patripassianism" (the suffering of the Father), saw the one God appearing as the Father in the Old Testament, the Son in the New Testament, and finally the Holy Spirit after Christ's ascension (and still continuing in that mode today). As a result, Tertullian charged Praxeas with two tasks of the devil: he set the

we do not deny a distinction with respect to causality. That is the only way by which we distinguish one Person from the other, by believing, that is, that one is the cause and the other depends on the cause. . . . Thus the attribute of being only-begotten without doubt remains with the Son, and we do not question that the Spirit is derived from the Father. For the mediation of the Son, while it guards his prerogative of being only-begotten, does not exclude the relation which the Spirit has by nature to the Father" (266) (Gregory of Nyssa, "On Not Three Gods," ed. and trans. Cyril C. Richardson, in *Christology of the Later Fathers*, eds. Edward Rochie Hardy and Cyril C. Richardson [Philadelphia: Westminster, 1950]). Gregory illustrates this view in his defense *Against Eunomius* by depicting the Father as the sun and the Son as a sunbeam (3.7). These views could be seen as reflected in humanity in Genesis 1:26–27's description of the creation of man and woman as sharing jointly the image of God. They are able to relate not only to each other but to God, who of course is already in an eternal love relationship in the Trinity. We, of course, need to keep in mind that reflecting humans are material and God is not, so that they are two individuals, united as humans, but God is a spirit and not material and is not individuated in the same sense. An image is not necessarily a point-by-point allegory. It is a limited reflection or depiction of a truth. I also think, however, that because the ancients seemed to think collectively about persons, being influenced by the Platonic and Aristotelian systems, the traditionally received orienting thought patterns of their day, such an influence of pagan philosophy, so evident in their views, does not by itself make these views necessarily biblical. The Bible is the revelation of God and not a product of pagan philosophizing. So I think that seeing the persons of the Godhead as centers of consciousness could still be admissible if one banished the word "individual" from one's definition and stressed the unity of the One monotheistic God with three centers of consciousness with one will. This understanding would resonate with the Gospel reports of the presence of Jesus among us, who underscored doing the will of the Father (e.g., John 10:25–38) as he modeled being the second Adam. But he was still revealed as possessing the full deity of the One God (Col. 1:19), not a part or a third of it, as one of three gods would have, but as possessing equally with the Father and the Holy Spirit one divine will. The perfect triune God might then be understood as One monotheistic God, distinguished with three distinct centers of divine consciousness perfectly related, encapsulating the knowledge, glory, substance, will, and nature of the triune Godhead: the monotheistic triunity of the one God.

"Holy Spirit to flight" (*paracletum fugit*) and "crucified the Father" (*et patrem crucifixit*).[5]

Tertullian (c. AD 160–c. 240), the son of a centurion at Carthage, North Africa, applied the term *persona*, meaning "mask, part, character" or "person"[6] (rather than the *vultus* or *voltus*, "face," "features," "appearance").[7] The Greek apologists of the next century translated his term into Greek's *prosōpon*, the word for "mask," "dramatic part as in a drama," "character," "person," "legal personality," "face," "countenance," sculptural "bust," "portrait," "front," or "façade."[8] But, as the discussion continued heating up, by the 300s orthodoxy's defenders widened the discussion to include other terms, such as *hupostasis*, a word in classical times meaning initially "that which settles at the bottom, sediment." It had come to mean what endures through time; a "substructure" or "foundation" supporting a building; a firm resolution undergirding a belief or argument; something with "substance," "actual existence," "reality," "real nature," "essence."[9] What they were trying to express is that the monotheistic God has three enduring centers of consciousness in the one divine nature. These are distinct, yet share the same nature, substance, eternal duration, and consciousness perfectly as one, yet they are distinct. As we can see, much of this language is as metaphorical in both Latin and Greek as it is imaging God.

One fascinating image introduced today by John Jefferson Davis, the Andrew Mutch Professor of Theology at Gordon-Conwell, seeks to capture these meanings in an image from jazz, depicting what he names "The Reciprocally Nested Hypostasis Model: A Jazz Trio Analogy." He pictures "a trio of jazz musicians—a pianist, a drummer, and a bass player playing together." These are "personal, conscious human beings in communication and cooperation with one another, enjoying their common experience."[10] The positive contribution of this image is that these are three distinct persons who share a common humanity and experience. The analogy ceases to hold beyond that,

5. Q. Septimii Florentis Tertulliani, *Adversus Praxean Liber* (*Tertullian's Treatise against Praxeas*), ed. Ernest Evans (London: SPCK, 1948), 1.33.

6. John C. Traupman, *The New College Latin and English Dictionary* (New York: Bantom, 1966), 224.

7. Traupman, *The New College Latin and English Dictionary*, 335.

8. LSJ, 1533.

9. LSJ, 1895.

10. See the much fuller explanation of this fascinating analogy and the light it sheds on the nature of the triune God, in John Jefferson Davis, "A New Metaphysical Model for the Social Trinity: Father, Son, and Holy Spirit as *Reciprocally Nested Hypostases*," an enrichment paper composed for the faculty of Gordon-Conwell Theological Seminary, Hamilton, Massachusetts, October 2018, 11–12.

for the active divine Trinity has singularity. The Trinity shares the exact same substance with a perfectly reciprocal state of consciousness, which is eternally experienced simultaneously, distinct but without separation, by the three persons of the one God.

On the basis of this foundational set of beliefs, we examine illustrations we use to explain God's triune nature. Consequently, in this book I am concentrating on evaluating the meanings inherent in both the images and also the explanations of these images that are used regularly by Christians who teach about God all over the world. After this introduction orienting you to the important issues underlying our topic, we will consider the Bible's answer to the challenge of whether our whole task is legitimate or not, before we explore images that are kinetic (moving), then those that are static (without movement), and then nonhuman and human. And we will try to draw conclusions all along the way.

Before we can do that, of course, I have to establish that the Bible, the written revelation about God's nature, really does assume that the Godhead is triune (along with being monotheistic). As we will see, this is not a given among every one of our neighbors, nor among everyone who claims to be Christian, but my authority here will be the Bible itself, God's inspired written record of God's revelation about God's own nature. I will also address objections to our entire task and summon up a defense for why I believe our task is legitimate.

Then, I will proceed to examine a variety of images being used to explain God's nature and—most importantly for our task—assess their value and potential danger and posit guidelines we should keep in mind when we use such illustrations. Also, since we are all living in visually oriented global societies, we will analyze the impact of our figurative language on the way we perceive God's revealed nature and convey that perception to others.

So, the goal of this book is to help us all use illustrating images correctly and with appropriate qualifications. Through them, we can convey truth about God while attempting to avoid the historical errors that have clouded and misrepresented God's nature and misled unwary seekers through the centuries.

OUR FOCUS IS LANGUAGE

To accomplish my goal, I am trying to write this book as plainly and as engagingly as possible so as not to frustrate multilanguage learners (like many of my students) who find so many textbooks on the Trinity confusing and

laden with an excess of technical language.[11] Terms like *perichōrēsis* (which initially might sound like some sort of exotic flower from the South Seas) or *aseity* (what is that, a health condition inflicted on those who don't drink enough water?) may be essential to enlightening discussions on the Trinity, but they are incomprehensible without clear definitions. The same problem goes for terms like *economic Trinity* (which suggests to contemporary readers that God is on some sort of strict budget).

However, when we discover, for example, that *perichōrēsis* is a Greek term from the word *peri* (meaning "round about")[12] and notice that it appears to be similar to several forms related to *korennumi* (meaning "satiate, fill one with a thing"),[13] we begin to understand that the word is being used to mean that all three persons in the Trinity surround and indwell one another completely. Yet each has a distinct identity, so that one person of the Trinity can incarnate as Jesus Christ, suffer, and die for us without the entire Trinity dying and the universe God sustains imploding or exploding in chaos.

Further, we can read the explanation of the renowned Cuban-born theologian Justo González, who informs us that "since *perichōrēsis* is very similar, though not the same, as a word that could be used for a choreographic dance, sometimes the image is used of the Trinity as a choreography in which all three Persons act together, yet distinctly, each as it were dancing around the other two." Also, when we notice that *perichōrēsis* is often substituted by *circumincession* (a term derived from the Latin meaning "interpenetration of the three divine Persons of the Trinity"),[14] then we are no longer lost. Our understanding expands, and the word becomes useful. Distinct as they are, the three persons are really one harmonious God, not three gods working in harmony.

11. Please see Jeanne C. DeFazio and William David Spencer, eds., *Empowering English Language Learners: Successful Strategies of Christian Educators* (Eugene, OR: Wipf and Stock, 2018) for helpful advice on teaching in our global world to students whose first language is not English. My chapter, "Intentional Teaching," lays out my own theory of education and includes appendices of teaching aids in theology I've developed to assist multicultural students for whom English is a second or third language.
12. BDAG, 797.
13. LSJ, 980.
14. Justo L González, *Essential Theological Terms* (Louisville: Westminster John Knox, 2005), 36. Van A. Harvey also explains *perichoresis* as "mutual interpenetration of the *persons* of the godhead, so that although each person is distinct in relation to the others, nevertheless, each participates fully in the *being* of the others. The being of the godhead is thus one and indivisible" (Van A. Harvey, *A Handbook of Theological Terms* [New York: Macmillan, 1964], 181).

Aseity (a term from the Latin *ā sē*, "from oneself") simply means "existence originating from and having no source other than itself."[15] In this context, to me the term is describing the Father, Son, and Spirit as self-originating, having no other first causes, which is what the Athanasian Creed states: "In this Trinity none is before or after one; none is greater or less than another; but the whole three persons are coeternal together, and coequal."[16]

Perichōrēsis from the Greek and *aseity* from the Latin are words that have entered English language theology as adaptations, somewhat similar to cognates (borrowed and adapted words from other languages) like "baptize," which is itself an attempt to shape the Greek word *baptizō* into something comprehensible in English and other languages. When non-Greek or non-Latin readers first see such words, they seem odd. But when used constantly in theological discussions, as with "baptize," such use gives readers and hearers ownership of the word. Well, this is the case with words like *perichōrēsis* and *aseity*. They have become so much the grammar of theological discourse that they are now commonplace in the field and are indispensable tools for those who want to go deeper in exploring the discussions about the nature of the God we worship.

Another benefit in using such terms is that they connect us with the original languages, where the issues of the Trinity's nature were first debated and their meanings hammered out. This keeps us aware that what we are discussing has been revealed in a language other than our own (unless you happen to be Greek or began reading Latin at an age so early it is now part of your nature). For most of us who learned these languages along the way (or are yet to learn them), we must be very careful how we read. Some of us, of course, might understandably want to leave the jury out on unnecessarily confusing terms like "economic Trinity." But this is how the seascape of theological studies looks these days, so those who want to navigate it safely should learn the terms, and I will try to explain key ones as they arise.

I single out "economic Trinity" from the other two terms not just because it is confusing but it has become an increasingly popular term these days. In the past, Justo González warned, this specific term was "commonly rejected by orthodox theologians," since "the term 'economic' is understood in its etymological sense as 'management' or 'administration,' and what is meant

15. "Aseity," *Random House Webster's Unabridged Dictionary* (New York: Random House, 2001), 121.
16. "The Athanasian Creed," in *The Book of Concord: The Confessions of the Lutheran Church*, http://bookofconcord.org/creeds.php.

by an 'economic Trinity' is that the Trinity is a matter of God's outward management of creation, and not of God's very essence."[17] In other words, this approach claims we know God as God acts, not God as God is.

Given this definition that who God actually is in nature may not be reflected by who God appears to be in action, why would anyone wishing to be historically orthodox want to embrace such a term with such a doctrine? If what God reveals to us is not actually who God is, then we really know nothing concrete about our God's nature except that God has completely hidden it from us. Such an interpretation of the term would certainly undercut our doctrine of the Trinity; God would appear to be triune when interacting with humans but in reality would be unitarian in nature. Thus this take on the term's meaning might preserve the doctrine that God is monotheistic but would not be an acceptable orthodox *trinitarian* Christian position (*ortho* = "straight or right"; *doxia* from "belief or doctrine").

However, some conservative theologians I am encountering these days seem to be selecting the latter option: to redefine it. They have opted to embrace a slogan invented by the innovative Roman Catholic theologian Karl Rahner that has become popular in liberal and conservative scholarly circles: "The immanent Trinity is the economic Trinity and vice versa."[18] "Immanent" means "remaining within, indwelling, inherent."[19] In evangelical circles, this adopted equation seems to me both an attempt to evangelize liberal theological lingo by reinterpreting one of its popular phrases, and thereby to salvage the term for orthodoxy, while at the same time demonstrating that conservative scholars are well-schooled in liberal discussions

17. González, *Essential Theological Terms*, 50. ODCC notes in "Antiochene Theology": "The doctrine of the Trinity prevalent in this school of thought was what F[riedrich] Loofs [1858–1928] calls the 'Economic-Trinitarian' (from the word *oikonomia*, i.e. 'Divine plan of salvation'), in which the Three Persons are distinguished only by their modes of operation." The entry adds, "In such teaching on the Godhead there is an obvious similarity to Sabellianism." Though it observes "the Antiochenes hotly rejected the identification of the two views" (65–66, 835).
18. See Robert W. Jenson, "God," in Alister E. McGrath, ed., *The Blackwell Encyclopedia of Modern Christian Thought* (Cambridge, MA: Blackwell, 1993), 245. David F. Ford and Rachel Muers also emphasize differences in their definitions for "Trinity," when, after giving an orthodox definition, they add: "The immanent Trinity is the Trinity considered in itself in the interrelationship of the three persons. A social doctrine of the Trinity conceives the Trinity in interpersonal terms as a society of three." David F. Ford and Rachel Muers, eds., *The Modern Theologians: An Introduction to Christian Theology since 1918*, 3rd ed. (Malden, MA: Blackwell, 2005), 792. A "society of three" is a much more vague and ambiguous, though practical, concept. We will be reviewing Karl Rahner's perspective in the context of his own thoughts later in the book.
19. *Random House Webster's Unabridged Dictionary*, 956.

and deserve a place in the academy as well. Either way, "economic Trinity" has become a popular part of the verbal currency of exchange in current discussions of the Trinity.

The perceptive Fred Keefe, one of my professors, used to tell us students that scholars write books to one another, and problems happen when laypeople listen in. One might think a term means the same thing to academicians that it does to everybody else in the larger culture, when in reality it may mean something entirely different to each particular camp in the small theological subset of scholarly thinkers. But readers who are made aware of these nuances and the attempts to reinterpret traditional or, in this case, new theological terms will be better able to decipher their meanings more astutely when encountering them in texts. The key for proper interpretation is to realize that what a term may mean for one, it may not mean for the other. Therefore, if you can figure out what the term means for an author or a specific theological stance, you will understand what either of them is trying to make you believe. Perhaps this is the most important point I am trying to share in this introduction.

When we explore the various images we use to describe the Trinity, you will notice that on some of the key ones, I have included extended discussions of some competing viewpoints of what these images convey about who God is. The theology of each teacher or preacher freights the image or illustration with a meaning that may not be immediately clear to the hearer or reader. The mode of presentation colors readers' receptions so that readers' opinions may change without them being aware that their view of God may be altering. Since this is such a key concept to grasp—really an essential warning to stay aware of what is driving what we are receiving—in a moment I will give you an extended example to caution you to read not only the variety of viewpoints to follow with caution but to take such caution critically into every lecture, sermon, book, and podcast that you hear. Keep testing every view presented to you as an authoritative interpretation against the only final authoritative interpretation that we have: the Scriptures of the Bible.

On this note, here at the outset I should explain that when we use the term "liberal" in a theological sense, it has more to do with one's Christology (one's view of Jesus Christ) and of the authority of Scripture than with sociology (and, in that sense, it differs from the way the terms "liberal" and "conservative" are mostly used in secular society). The astute Nancey Murphy observes in her insightful book *Beyond Liberalism and Fundamentalism*, "While it is certainly possible for fundamentalists to 'slide down the slippery slope' to

evangelicalism, it is not equally possible to slide from evangelicalism to liberalism. There is an invisible wall in between; a 'paradigm shift' is required."[20]

We can use the attempt to reinterpret a term like "economic Trinity" to illustrate what she means. When a term is taken from one theological position and adapted to another, we wonder: Can it actually survive the paradigm shift necessary for taking out its liberal meaning and reinfusing a historically orthodox one into it? Or conversely, can a traditional term shed its historic meaning and "upgrade" (as some see it) into liberal vocabulary? Or will it simply shatter into meaninglessness? This question, as we see, works in both directions, whether shifting terms by reinterpretation from conservative to liberal or liberal to conservative understandings. That is to say: what can be lost in one direction, of course, can easily be lost in the other.

Here now is an example from my own experience. I asked a similar question years ago when, as a student, I was assigned Gordon Kaufman's *Systematic Theology: A Historicist Perspective* as the required textbook for my first systematic theology course at the local seminary, where I had transferred after the new Gordon-Conwell closed its Philadelphia branch. I read Prof. Kaufman's explanation: "If we recognize that the phrase, 'resurrection of Jesus,' does not refer to an experienced event but to a hypothetical one, we are in a position to evaluate more adequately the traditional Christian view."

"What was that exactly?" I exclaimed as I reread these words. Kaufman's book explained, "These alleged appearances were in fact a series of hallucinations produced by the wishful thinking of Jesus' former disciples who had so strongly hoped and believed 'that he was the one to redeem Israel' (Luke 24:21)."[21] Young as I was, I recognized the significance of the argument Kaufman was proffering from Gregory A. Kimble and Norman Garmezy's *Principles of General Psychology* textbook I was still toting around from college. What I heard Kaufman saying is that the disciples of Jesus were experiencing "cognitive dissonance" wherein "bits of knowledge which fail to fit or harmonize produce a strong negative motive."[22] In other words, the disciples wanted so much to have Jesus back with them they hallucinated his

20. Nancey Murphy, *Beyond Liberalism and Fundamentalism: How Modern and Postmodern Philosophy Set the Theological Agenda* (Harrisburg, PA: Trinity, 1996), ix. That paradigm shift moves from recognizing Jesus as God to viewing Jesus as simply a human being in whom God meets us uniquely.
21. Gordon Kaufman, *Systematic Theology: A Historicist Perspective* (New York: Scribner's, 1968), 422.
22. Gregory A. Kimble and Norman Garmezy, *Principles of General Psychology,* 2nd ed. (New York: Ronald, 1963), 623.

presence, and with that delusion as motivation they began to proclaim he had come back to life. Jesus, presumably, having been only a human being—a simple carpenter preaching a love in which God was meeting humanity uniquely (or so his followers thought)—had come to a bad end they could not accept. He had been torn from them and executed by crucifixion, completely ending his life. So, his impact lived on in these followers who loved him and had invested their hopes in him in the self-deluding dreams with which they medicated themselves by the anesthesia of their longing. That was what this book was claiming.

If Kaufman were right, then there is no Trinity, because the so-called second person of the Trinity is dead and dust now. So this theory cast doubt on whether God exists simply as a single, undifferentiated being, or perhaps it questioned whether God exists at all. And, if God does not exist, or God is not triune, then there is certainly no point in me having bothered to go to seminary for further training.

All defenders of our faith, which should include all of us workers who study so that we won't be ashamed when we are called upon to defend God's truthful Word correctly (cf. 2 Tim. 2:15), should realize these days we need to handle challenges to the Trinity on two levels: whether the Trinity is real and, if so, whether what is being claimed about the Trinity is biblical.

Essentially, today, in our skeptical, technological, postmodern age, we cannot simply assume that all, whether outside or even inside the church, actually believe there is a Trinity. If they do, we cannot assume they believe the historic position on this doctrine as we recognize it in the Bible and in the creeds.[23]

What I was being introduced to as a callow seminarian was a paradigm shift, such as Nancey Murphy describes. The term *resurrection* was being transferred into something entirely different than its meaning in historically orthodox theology, which views Jesus as both fully God and fully human (the trinitarian view) and experiencing resuscitating spiritual triumph over death. Through modernist speculation applied through a hermeneutic (that is, an

23. When we first attended the presbytery of our local area, the moderator, a professor at a prestigious university, greeted us with the casual announcement that he didn't believe the resurrection of Jesus took place. That belief in the historic doctrines was essential to holding office in the church did not seem to trouble this lay leader. Many helpful books are available explaining the usefulness of the creeds in explaining the key doctrines of the Christian faith. An excellent resource is Donald Fairbairn and Ryan M. Reeves, *The Story of Creeds and Confessions: Tracing the Development of the Christian Faith* (Grand Rapids: Baker, 2019) and well worth reading.

interpretation) of denial, *resurrection* was now describing a psychological reaction to a dead messiah whose impact echoed so vibrantly on in memory that his followers became mentally unbalanced, creating an alternate reality where he continued to live despite no earthly proof to support such a conclusion.

Implied in such a radical transmogrification of the term *resurrection*, as this word passed through a theological black hole into another universe of thought, is this dilemma: Has "resurrection" actually taken on a new, significant meaning for theology, or has it lost all significance? Has it become meaningless now, since it only describes the sick wanderings of grieving minds that are more in need of grief counseling than pulpits?[24]

As we can see, underlying our assessment of such an explanation is this foundational issue: what we are talking about is language and its ability to convey meaning. The function for stressing this fact as a part of our present book's orientation is that it illustrates at its root what this book is about and, more important, what our task is about when we examine our use of illustrative language to try to capture a revelation about God's very being. We need to ask continually: Are we making sense? Have we captured God's revelation correctly in each of our illustrations? Or have we left our hearers more confused and distanced from God than if we had just refrained from saying anything at all?

Simeon, the son of Gamaliel, the apostle Paul's teacher (Acts 22:3), once said, "All my days have I grown up among the Sages and I have found naught better for a man than silence; and not the expounding [of the Law] is the chief thing but the doing [of it]; and he that multiplies words occasions sin."[25] What this present book is attempting to do is keep us all from simply multiplying words and bringing about the sin of causing our hearers to stumble into wrong understandings of who God has revealed Godself to be.

And this is a key problem with discussing the Trinity in illustrations. The point of all this advice is to warn each reader about the shifting sand of language. We need to keep alert as we examine each image so we can extract the bedrock of truth from its use to protect those who follow our lead. We need to search in every theology for how terms are being used and clarify

24. Those who wish to read my response to Gordon Kaufman and others of why I believe the resurrection was an authentic, "experienced" event on this earth in real time, see William David Spencer, "Is He Risen Indeed? Challenges to Jesus' Resurrection from the Sanhedrin to the *Jesus Family Tomb*," *Africanus Journal* 3, no. 1 (April 2011): 27–54.
25. Aboth (The Fathers) 1:17, in *The Mishnah*. An excellent discussion on silence can be found in Aída Besançon Spencer, *Beyond the Curse: Women Called to Ministry* (Grand Rapids: Baker, 1985), 77.

when we speak or write how we are using our terms. This becomes even more sophisticated a task when one is working with analogies. And we must stay aware that educating the church, advancing the reign of God, and defending the faith are always the point of every Christian endeavor. We are not working in an academic vacuum. There is a mission involved in this and every area of Christian scholarship. So as we use these illustrations and observe and create new ones, we must stay aware that, what we may think we are saying through employing a particular image, our audience may not be hearing. Each audience member may be envisioning something entirely different.

DOES THE BIBLE REALLY TEACH GOD IS A TRINITY?

To those of us who recognize the Bible as God's inspired words given to us through human authors, the question of whether God is a triune being seems unnecessary to ask. After all, according to Jesus' words as recorded in Matthew 28:18–20, are we or are we not commanded by the continuing God-given authority of Jesus Christ to go into all the world, preach the gospel, baptize, and teach people to follow his commandments? We certainly are! And that baptism is not required to be given in the name of Jesus Christ only,[26] or God the Father only, or the Holy Spirit only. Rather as the great Greek grammarian A. T. Robertson points out, the construction of Jesus' command presents "the words or phrases it connects as on a par with each other." [27] This fact is

26. Acts 2:38 recounts Peter advising baptism in the name of Jesus, which also evoked the baptism of the Holy Spirit that Jesus at his ascension promised (Acts 1:5; 11:16). Acts 10:48 records Peter ordering the baptizing of Cornelius and his Gentile friends in Jesus Christ's name, and we even find Paul baptizing the Ephesians in the name of Jesus so that they would receive the Holy Spirit in Acts 19:1–6 (cf. Gal. 3:27). Still, given Jesus' own command, the specific explanation of Jesus' anointing by God with the Holy Spirit in the context of Acts 10:31–38, and the reception already of John's baptism at least by the Ephesians in Acts 19:1–6, it appears that these passages solely mentioning Jesus are simply highlighting the inclusion of Jesus' name in baptism and not intentionally dismissing the rest of Jesus' commanded formula for baptizing in God's triune name. Emphasizing Jesus certainly seems to be Paul's concern in 1 Corinthians 1:13–17. Why he does that becomes clearer in Romans 6:3–4 as Paul reveals the symbolism of baptism, which is to display our sharing in the death of Jesus for our sins. John also varies his emphasis in John 1:33, underscoring that Jesus will baptize with the Holy Spirit. Germane to all this is Acts 8:14–17, where Peter and John find that the Samaritans' baptism in the name of the Lord Jesus is not enough to receive the Holy Spirit, and they have to supplement it by laying hands on the Samaritans. The safest way to handle baptism is simply to follow Jesus' command and baptize into the one name of the Father, and the Son, and the Holy Spirit rather than to extrapolate out of these verses a variety of baptisms in the various names of the persons of God.
27. A. T. Robertson, *A Grammar of the Greek New Testament in the Light of Historical Research* (Nashville: Broadman, 1934), 1178.

established grammatically by the way that the term for "and" (*kai*) is employed in "paratactic structure[s]" (brief phrases or clauses) as Jesus does in the Great Commission. Herein, the words connected by "and," of course, are the names "Father, Son, and Holy Spirit," showing that each of these are "on a par with each other," or equal. We cannot get around the fact: it is foundational.

At the same time, each name is given its own specific definite article, all in the same case, number, and gender, so that each noun is distinguished and therefore shown to be distinct from the others. So we have equality with distinction. In other words, there are three distinct names in the Godhead that are shown grammatically to be equal to one another.

Yet, although we see three names presented as equal and distinct, Jesus is not commanding we baptize with three baptisms in these three names, but with one baptism in the three, as in one united name (*to onoma*, which is the Greek word for "name," is singular). God is one God, not a triumvirate of three gods that together make up a Godhead of three separate though equal components. God is one monotheistic God with three equal faces or in three equal persons (*prosōpon*, "face, person"), as the early church described this unique nature.

Such an emphasis on the three-ness in the Godhead to describe what the New Testament presents about God's nature was captured theologically with the term *triados* (or triad, or triune) by Theophilus (c. AD 115–c. 181/188), the overseer of the Christian church at Antioch from AD 168 on.[28] His application of this term to the Godhead occurs interestingly enough for our topic while he is discussing an analogy he is using in his defense of the Christian gospel.[29] Theophilus is trying to explain God's nature by making this creation-based comparison: "For the sun is a type of God, and the moon of man." Here is how he sees the analogy working:

And as the sun far surpasses the moon in power and glory, so far does God surpass man. And as the sun remains ever full, never becoming less, so does God always abide perfect, being full of all power, and understanding, and wisdom, and immortality, and all good. But the moon wanes monthly, and in a manner dies, being a type of man; then it is born again, and is crescent, for a pattern of the future resurrection. In like manner also the three days which were before the

28. See these dates in the "Introductory Note to Theophilus of Antioch," 88.
29. For a brief description of Theophilus and his works, see "Theophilus, St." in *ODCC*, 1364.

luminaries [in the Genesis 1 creation account], are types of the Trinity [*triádos*] of God, and His Word, and His wisdom.[30]

A "type" in theology is a symbol. Often we hear of Christ-types in biblical studies, meaning symbols that prophesy the coming Messiah, such as Moses holding up the snake, presaging Christ being executed to save humanity. The standard definition of "type" includes "a symbol of something in the future, as an Old Testament event serving as a prefiguration of a New Testament event."[31] Theophilus is using the metaphor of light for both life and elucidation when he combines these ideas, assuring his "very good friend"[32] Autolycus, to whom this defense is addressed, that "man [or more accurately humanity] needs light." This relates people to "God, the Word, wisdom," who is the creator of light. In this argument, Theophilus is appealing to the imagery in Hebrews 1:3. As we will see when we arrive at the chapter "The Image of Light in the Book of Hebrews," Theophilus is in good company, for his use of it is just one instance of this biblical image of light becoming foundational in the early church as the body of Christ hammers out its understanding of the three-ness of the one God.

The other point of interest for us in this analogy involves the nearly universal conviction and claim that we read everywhere in the present literature that this is the first instance of the use of the term "Triad" for God's nature.[33] For example, the *Ante-Nicene Fathers'* rendering of Theophilus' second book of his defense includes a provocative note by the editors that seems to address this oft-stated idea that here indeed is the "first" application of the term "Triad" to describe God. "The earliest use of this word 'Trinity' . . . seems to have been used by this writer in his lost works, also; and, as a learned friend suggests, the use he makes of it is familiar. He does not lug it in as something novel: 'types of the Trinity,' he says, illustrating an accepted word, not introducing a new one."[34] This speculation suggests that the term itself (and perhaps its application to God's nature) does not appear here for the first time; this just happens to be the earliest extant usage of it that we have, but the term may have been used by Pastor Theophilus earlier in his preceding apologies for the faith and possibly by others too—including some who preceded him. A few

30. Theophilus, "Theophilus to Autolycus," 2.15.
31. *Random House Webster's Unabridged Dictionary*, 2044.
32. Theophilus, "Theophilus to Autolycus," 2.1.
33. See "Theophilus, St.," in *ODCC*, 1364.
34. Theophilus, "Theophilus to Autolycus," 2.15n2. Eusebius, the church historian from the early 300s, notes Theophilus' *Against the Heresy of Hermogenes* and "an admirable work against Marcion" existing in his day but, sadly, lost in ours. See *Church History* 4.24.

years later, Tertullian (c. 160–c. 225) became "the first to employ the word" *trinitas*, from which we directly derive the term "Trinity."[35] So, very early on, following the time of the writing of the New Testament, theologians drawing on the biblical revelation as their basis came up with these descriptive terms, *triádos* and *trinitas* (or the first we know). They have become the terminology to describe the historic, orthodox confession that God is triune, a Trinity, one God eternally existing in three coeternal, coequal persons.

In the Bible, God manifests that triune nature at the baptism of Jesus, when Jesus is singled out by the Father's spoken approval and the Holy Spirit's descent upon him (Matt. 3:16–17). And, all through the New Testament, we see two or all three of the persons of the Godhead being mentioned together, for example, in the writings of Paul (e.g., 1 Cor. 12:3), the preaching of Peter (e.g., Acts 2:17–22),[36] and the letters of John (e.g., 1 John 2:20–22). Over and over again the equality of the persons who comprise the Godhead is emphasized while also maintaining the connected relationship between these persons of the triune God. So, the Holy Spirit is called the "Holy Spirit of God" or "the Spirit of Christ" in verses like Romans 8:9, where both these phrases are used.[37] And the equality of the Father and the Son is continually emphasized in many passages throughout the New Testament. For example, Philippians 2:6 tells us Jesus shared God's nature (*morphā*), being equal (*isa*) with God. Also, a number of passages refer to Jesus as God, for example, John 1:1 ("the Word was God"); Romans 9:5 (literally: "the one being over-all God," that is, "God over all, praised into the ages"); 2 Peter: 1:1 ("our God and Savior Jesus Christ"); 2 Thessalonians 1:12 (whose final phrase reads literally, "the

35. See J. N. D. Kelly, *Early Christian Doctrines,* 2nd ed. (New York: Harper, 1960), 113. Oxford professor Kelly embeds this acknowledgement in an interesting discussion of the term "persons" that the early church used to describe the triune nature of the One God.
36. Acts 2 represents this kind of highlighting of the triune divine presence: the Holy Spirit descends on the apostles (v. 4); Peter explains that event fulfills God's promise of the Spirit (vv. 17–18); then he centers his explanation on Jesus (v. 32). Also interesting to note is that Acts 3 continues featuring the activity of all the persons of God in the healing of the crippled man, who is "healed in the name of Jesus Christ of Nazareth" (v. 6). As a result, the man praises God in the temple, and, when the Sadducees challenge Peter and John, the Holy Spirit fills Peter (4:8), who eloquently defends the healing and its source: the name of Jesus, who was raised from death by God (vv. 9–10). And this pattern continues throughout the New Testament.
37. All translations of the Hebrew and Greek Scriptures in this book are my own unless otherwise noted. My purpose was to ensure whether figurative language that we do or don't find in translations represents the exact wording in the Hebrew and Greek texts. To ensure this goal, I have rendered a more literal translation for each passage.

grace of our God and Lord Jesus Christ");[38] and Titus 2:13 ("our great God and savior"). Colossians 1:19 and 2:9 explain that all God's fullness (*plērōma*) was indwelling the incarnate Jesus Christ. To describe this revelation, we use the term we discussed earlier: *perichōrēsis.*[39]

But despite these biblical attestations, ever since one of the persons of the Trinity "became flesh" (John 1:14) and experienced birth into our world as Jesus Christ, many have doubted Jesus Christ's divinity and, therefore, that God is a Trinity, from the Pharisees and Sadducees who confronted Jesus with their rejection right on throughout history to the present day.

As a result, even today denial of Jesus as fully God and fully human is proclaimed with such zeal throughout the world that Lifeway Research discovered that 52 percent of present-day North Americans agree "Jesus was a great teacher, but he was not God." Only 36 percent disagree. Among evangelicals 66 percent disagree, but 30 percent of self-identified evangelicals agree that Jesus is not God! At the same time, 42 percent of evangelical responders agree that "God accepts the worship of all religions, including Christianity, Judaism and Islam," with 9 percent unsure, and 49 percent disagreeing with this pluralistic statement.[40]

If one is confused by these numbers, one is thinking correctly. What the statistics are telling us is that many of the same people "strongly agreeing" that God is triune are also affirming that God accepts worship from religions that deny God is triune. How is that for living with a contradiction?

38. This reading is truer to the text than that which we normally encounter. Attempting to follow Paul's formula that we usually see in Paul's greetings—as we do here in 2 Thessalonians 1:2: "Grace to you and peace from Father God" (according to the codex manuscript *Vaticanus*), or "God our Father" (according to the codex *Sinaiticus*) and "Lord Jesus Christ"—Murray J. Harris suggests, "Since in 2 Thessalonians 1:10–12 OT formulas that refer to Yahweh are applied to Christ, it is conceivable that the divine title *theos* is also given to Jesus here." He also states the case for adding the "and" as separating "God" to apply to the Father, not Jesus (*Jesus as God: The New Testament Use of Theos in Reference to Jesus* [Grand Rapids: Baker, 1992], 265–66). But the proof is even stronger as the grammarian A. T. Robertson observes, "Here strict syntax requires, since there is only one article with *theou* and *kuriou* that one person be meant, Jesus Christ, as is certainly true in Titus 1:13, II Peter 1:1." He refers readers to his own authoritative grammar book (*Word Pictures in the New Testament, Volume IV: The Epistles of Paul* [Nashville: Broadman, 1931], 46).
39. Also many passages show an equality in function, e.g., James 1:17 tells us every good gift comes from the Father; 1 Corinthians 12:11 says the Holy Spirit determines who gets the gifts and distributes them; Ephesians 4:8 explains Christ gives the gifts. Others show a cooperative progressive venture: e.g., in Ephesians 1:5, the Father sets the goal; Jesus makes it possible (v. 7); and the Holy Spirit guarantees we reach the goal (v. 14).
40. Ligonier Ministries and Lifeway Research, "The State of Theology: What Do Americans Believe about God, Salvation, Ethics, and the Bible?" (2020), https://thestateoftheology.com.

The Bible, however, is clear that God is both single and plural. One of the most moving passages in the New Testament is the encounter between Jesus and the travelers on the road to Emmaus, when "beginning from Moses and from all the prophets, he explained [or interpreted, *diermēneuō*] in all the Scriptures the ones concerning him" (Luke 24:27).

The first of those accounts can be found in Genesis 1:1–3, when we see the entire triune Godhead in action. The Holy Spirit is hovering over the waters that will generate life, gestating as a mother bird does her eggs. Then the Father (or the entire triune Godhead, since the name for God in use in this passage is in the plural form) speaks, and the living Word that God utters creates. This very same "Word," John tells us, is the one who creates everything (John 1:3), including forming and animating all human beings. And when re-creation needs to be accomplished to salvage humanity, the Word takes on flesh and is born into our world as Yeshua ("Salvation") to unite us back to God (see John 1:14).

Throughout the New Testament, allusions are drawn and highlighted wherein the triune God is involved in that great work of reconciliation (e.g., Titus 3:4–7). This plurality is indicated in the Old Testament, for example, in Isaiah 7:14 and 8:7–10's promise God would come to humanity as the Lord will give a son: "God-with-Us" (*Immanuel*). Matthew 1:22–23 quotes these words of Isaiah literally: "Look, a virgin in the womb will have and give birth to a son, and they will call his name Immanuel."

Luke in his account tells us this prophecy came true when Mary, a virgin (1:27, *parthenos*), is told by a messenger of God that the Lord (singular) is with her (Luke 1:28). The angel explains that the Holy Spirit will do a similar gestation in her that we read about in the Genesis creation account, and the resulting child will be called the "Son of God" (v. 35). Again, the entire triune Godhead is involved. The Holy Spirit does indeed come over or upon Mary (*eperchomai*). A person of the Trinity transfers to her womb and takes on flesh, and that person becomes God-with-Us, Immanuel, identified by God the Father as God's beloved Son (Luke 3:22). The incarnation is a completely cooperative triune action. Worth noting is that God the Father is not being depicted as the pagan God Zeus, personally impregnating Mary (and many human women).[41] Instead, the Holy Spirit continues the creative act of

41. "Zeus was systematically unfaithful to his wife, and thought up thousands of tricks to give himself opportunities to be with his lovers. Transformation was his favourite device: he appeared to Europa as a bull, to Leda as a swan, to Danae as a golden shower of rain, and to Antiope as a satyr. And once, when he fell passionately in love with the boy Ganymede,

Genesis 1, overshadowing (*episkiazō*) Mary. Then the divine Word endures birth, coming forth as a human now: God the Father self-announces kinship with the God-human, the "Immanuel," who is now God-with-Us.

The Son of God's advent among us begins the work of re-creation, accomplished in the sacrifice of Jesus (see Rom. 3:25; 1 Peter 2:24; John 1:29; Heb. 9:12). John in his Gospel quotes Jesus explaining the symbolism in the Numbers 21:4–9 exodus account: "Just as Moses lifted up the snake in the desert, so must be lifted up the Son of humanity [*anthrōpos*] in order that each one believing in him will have eternal life" (John 3:14–15).

In Numbers 21:4–9, we also notice the singular form for God's name is used, reminding us of the great confession God gave Israel, as recounted in Deuteronomy 6:4: "The Lord [singular] your God [plural], the Lord [singular] is one [or united, *'eḥād*]." Here is a similar interplay between the singular and plural aspects of God's nature that we see in the creation of humanity in Genesis 1:26–27: "And God [plural] said, 'Let us make the human [singular] in our image [or likeness], after our resemblance [or image or likeness] and let them rule [plural] over the fish of the sea and over the birds of the heavens and over the beasts [also mammals] and over all the land and over all the creeping things that creep on the land.' And God [plural] created the human [singular] in his [singular] image, in the image of God [plural], he created [singular] him [singular], male and female he created [singular] them [plural]." So this text goes back and forth between describing God as plural but also as singular, and that plural and singular designating of God runs all through the Hebrew Bible.

Some may doubt that this is really chronicling the Trinity in action,[42] but Jesus begins to clarify the plurality in singularity in the Godhead for those

he turned himself into an eagle in order to snatch the lad and bear him off to Olympus." Maria Mavromataki, *Greek Mythology and Religion* (Athens: Haïtali, 1997), 33.

42. According to W. Gesenius et al., *Gesenius' Hebrew Grammar*, 2nd ed. (Oxford: Oxford University Press, 1910), 398–99, the plural use of God is "closely related to the plurals of amplification . . . which are mostly found in poetry. So especially *'elohim* Godhead, God (to be distinguished from the numerical plural *gods*, Ex 12¹², &c.). The supposition that *'elohim* is to be regarded as merely a remnant of earlier polytheistic views (i.e. as originally only a numerical plural) is at least highly improbable, and, moreover, would not explain the analogous plurals. . . . That the language has entirely rejected the idea of numerical plurality in *'elohim* (whenever it denotes *one* God), is proved especially by its being almost invariably joined with a singular attribute." Other words for God, while undoubtedly plural, are regarded as singular as "The Most Holy" and "The Most High" (398–99). Following Jesus' challenge in Matthew 22:41–46, Christian readers find "Godhead," as a translation, working perfectly, the plural and yet unified singular nature of the term denoting the Trinity at work. Other suggestions to explain the plural *'elohim*

who have ears to hear when he explains the cryptic Psalm 110:1 by highlighting its puzzling verse 1: "The Lord [singular, *YHWH*] says to my Lord [*'adōnî*, a singular, including a first person possessive] sit at my right side [or right hand, *līmînî*, rather than the left]." Jesus couches his explanation in a question to the Pharisees. He asks them whose son is the Messiah (Matt. 22:42). They reply, "David's."[43] Then Jesus introduces the Trinity to them in his nuanced reply, "Therefore, how [does] David in the Spirit call him 'Lord'?" (v. 43). Jesus' reply baffles them. Jesus has pointed out the presence of the Holy Spirit as inspiring the Psalms, the Father being called Lord (singular) in Psalm 110:1 and addressing another Lord who is David's Lord. What Jesus is setting is a trinitarian precedent for the interpretation of all the Old Testament passages wherein the Father is explicitly referenced, while the Son is implicitly present (or prophesied), and the Spirit is actively inspiring the prophetic words as the Holy Spirit inspires the entire Scripture. The whole triune Godhead is always present, indwelling one another (*perichōrēsis*). No wonder Jesus had so much to illuminate and interpret about his presence in the Hebrew Bible to the astonished Emmaus travelers.

Even more explicit is the passage Jesus selects to read early in his ministry at Nazareth, Isaiah 61:1–2, which begins, "The Spirit of the Lord God is upon me." Here we have Jesus identifying himself as the object of this familiar passage (Luke 4:21): the one sent in the Spirit of the Lord God to right all wrongs and usher in the time of blessing. His hearers are enthralled, first in amazed delight (Luke 4:22) but soon in murderous fury (Luke 4:29) at Jesus' refusal to do a miracle among them, especially when he explains his reason. Just as God had

have ranged from being a collective singular, like "the We of Majesty," which is similar to "The Most High," to "The Hosts of Heaven" (though why we would suppose God would involve angels in creation when the Godhead at work is all that is identified [or needed!] in Genesis 1 seems more a later gnostic speculation of demiurges doing the grunt work because the high, holy God can't touch evil matter).

43. In his careful exposition of this psalm, the Lutheran biblical scholar Ernst Wilhelm Hengstenberg observes that in Matthew 22:41–46, "Christ takes it for granted that the Psalm relates to the Messiah, nor did it occur to the Pharisees to question this fact, in order to escape from the difficulty in which they found themselves involved, though their interest must have led them to do so, had there been any diversity of opinion on the subject." He confirms that "when the Christians derived from this Psalm one of the strongest proofs of the Deity of the Messiah," then "polemic prejudices" "prevailed" over "tradition," and the early church leaders Justin Martyr, Tertullian, and Chrysostom began to encounter Jewish scholars offering other possible references to this clearly messianic psalm, such as Hezekiah, Zerubbabel, Abraham, and even the Jewish people. "But still the weight of the internal evidence and the authority of tradition induced many of the older Jews to adhere to the Messianic interpretation." E. W. Hengstenberg, *Christology of the Old Testament* (Grand Rapids: Kregel, 1970), 63.

preferred to help a widow of Zarepath over all Israel's widows in Elijah's day (1 Kings 17:7–24) and chose to heal Naaman, an Aramean, over the leprous Israelites of Elisha's day (2 Kings 5:1–27), so God was rejecting Jesus' Nazareth audience. That is why they were seeing no miracles that day. In their faces, Jesus was telling them that God the Father was empowering God the Son by the Holy Spirit to reject them for their doubt (their refusal to accept him for who he had just claimed to be, the Messiah, by calling him Joseph's son, rather than God's in Luke 4:22). Small wonder they wanted to kill him.

So Jesus could turn to many passages besides Isaiah 61:1–2 to show his presence. The Old Testament is full of such passages prophesying the Messiah. Some are obvious, as is Isaiah 61:1–2, and some are more implicit, like Ezekiel 43:2, where, in Ezekiel's vision, "the glory of the God [*ĕlōhē*, plural with a suffix] of Israel" arrives in verse 1, and then verse 4 employs the singular (*YHWH*) to report "the glory of the Lord" went into the house. The Spirit transported Ezekiel to the inner court (v. 5) while a voice spoke from within the temple (v. 6), and a man stood beside Ezekiel, interpreting what was happening. Herein we see two separate sources of the divine glory, God and the Lord, as well as the Spirit and a messenger from God. The nineteenth-century theologian Charles Hodge was convinced that such a messenger was actually Jesus the Christ. As he put it, "He is, however, no less clearly declared to be the Angel of Jehovah, Jehovah, Elohim, Adonai, the Mighty God, exercising all divine prerogatives, and entitled to divine worship from men and angels."[44] Another example might be the visitation with Abraham in Genesis 18, where the Lord [*YHWH*, singular] appears to Abraham. How might Hodge's point be possible? If God dwells above time and all is eternally present to God, then a person of the Trinity could dip into time at any point from the eternal present to the timeline's past, current present, and future. We see that in the post-resurrection appearances in the Gospels, Jesus retained a new kind of body, but it was a recognizable one that had supernatural capabilities, like passing through locked doors (John 20:19, 26).

Wherever an explicit reference is being made to the Father and the Holy Spirit, and an implicit one to the Son, or Father and Son are being referenced by the Holy Spirit's inspired prophesies, Scriptures in the Old Testament are trinitarian: all inspired by the Holy Spirit, focusing on God's parental care for human lives and actions. They foretell the advent of God's Son among us as the Shepherd out of Bethlehem (Micah 5:2, cited in Matt. 2:6) who will be

44. Charles Hodge, *Systematic Theology*, vol. 1 (Grand Rapids: Eerdmans, 1968), 495.

struck down (Zech. 13:7, cited in Matt. 26:31). Though he was slaughtered as a sacrificial lamb (Isa. 53:1–12, as seen in John 1:29; Matt. 8:17; Acts 8:32–33), he brought salvation (Ps. 106:10, in Luke 1:69–71).

While anticipating this sacrifice, being struck down by rocks became a continual threat to Jesus even before the crucifixion not only in Nazareth but elsewhere also. We see this in Jerusalem when Jesus announces he is the "I Am" before Abraham was even born (John 8:58). While the enraged audience is searching around for stones, Jesus slips away (v. 59). Another near miss in the temple occurs when Jesus declares he and the Father are one, and the faithful again snatch up stones because "you, being a human, make yourself God" (John 10:30–33). We notice Jesus doesn't disagree with them. He accepts their charge, thwarting their attack by quoting Asaph's Psalm 82:6, God's appeal to people to act like godly children. Then Jesus stresses his unique status as being set apart and sent into the world, wisely withdrawing as some were no doubt mulling this parry over while others were trying to renew their attack (v. 39).

In the New Testament, we see the Trinity is pervasive. We noted the evidence in the narrative passages, as in the case of the baptism of Jesus, where the Spirit of God descends on Jesus and the Father declares, "This is my beloved Son, in whom I am well pleased [*eudokeō*, or delighted, taking pleasure in]" (Matt. 3:16–17).

We find the Trinity in the sermons, for example, in Acts 20:28–35, where we find Paul charging the Ephesian elders to care for the people to whom the Holy Spirit has given them as shepherds. These comprise "the church of God, which he acquired through his own blood" (v. 28). At first glance, this passage may appear to be yet one more instance where Jesus is called God, but the context four verses earlier in verse 24 suggests it is more likely that Paul is referring to the Son and the Father, and in verse 23 (as well as 28) the Holy Spirit. So what we see here is the church, called the "flock,"[45] belonging to God, who bought it by "his" blood (an obvious reference to Jesus' sacrifice). And the responsibility to continue shepherding is being delegated by the Holy Spirit to the church leaders.

45. I have sometimes heard the term "flock" noised about as a pejorative term, suggesting church people are docile, stupid, all the same, and therefore easily led and "fleeced." A recent study, reported in *Diario Libre*, however, suggests a different conclusion. This study concluded that there are individual differences among sheep according to definitive personalities ("*las abejas pues, tenien personalidades definidas*") that cause the desire or will to do certain actions ("*functiones*"). This would distinguish some among others, and therefore an attitude of cooperation would be a personal choice. See "Las abejas son muy diferentes," *Diario Libre*, February 4, 2020, 30. A gentle nature in animals and humans would not be a sign of weakness, then, but a behavioral choice.

Also worth noting is that the reference to Christ's blood as belonging to the Father would be underscoring God the Father as the ancestor of Christ's "bloodline," though obviously this is metaphorical since the Father, as a spirit, is not corporeal and has no flesh and blood. To confuse the Father as being the one who dies on the cross or as a spirit with actual flesh and blood is to wander out of orthodox thinking into heterodoxy (*hetero* meaning "other," thus a thought other than orthodox or right thinking). To avoid such wrong conclusions, we might compare this passage with Romans 3:24–25, that Jesus Christ is the one "God put forth to be a sacrifice through faith in his blood." God the Father presents the blood of his Son, as we might be seeing here, to bring about human salvation. God the Father has none to give, but the incarnated Son does, and this he came among us to offer.

Once again, what we have observed in this brief section is that all the Bible is inspired by the Holy Spirit. Therefore, the Spirit is endemic (totally pervasive) through the entire Scriptures, both the older and newer covenants. The Father is also everywhere. And the Son is prophesied in the Old Testament and testified to in the New. Thus, one would think that the Lifeway statistics showing such doubt among self-proclaimed evangelical Christians must be wrong. But one drops that wish when one considers how many competing views of God are constantly bombarding us from the media, the internet, cinema, television, radio talk shows, popular music, books, magazines, newspapers, and on and on.

But against all this doubt, we clearly see the Trinity in the Bible's blessings and salutations, as in 2 Corinthians 13:13: "The grace of the Lord Jesus Christ and the love of God and the fellowship of the Holy Spirit be with all of you." Here we note the equality in the triune Godhead as "the Lord Jesus Christ" is listed first, God the Father second, and the Holy Spirit third, underscoring the Athanasian Creed's observation there is no precedence of persons in the Godhead. The equality taught in Philippians 2:6 is essential in the nature of the one monotheistic God with three faces, or in three persons.

We can see this understanding pulsing in Judaism in the continuing aftermath that Justin Martyr, Tertullian, and John Chrysostom observed after Christians began considering Judaism their home base. We notice that many Jews, what we now call Messianic Jews, began to believe in the Trinity right until today.[46] But, at the same time to the present day, others did not and

46. Messianic Jewish organizations like Chosen People and Jews for Jesus are historically Trinitarian, but some Messianic Jewish pastors and scholars like Louis B. Vos Levitz, in

do not believe in Jesus. This denial came later into Islam.[47] Hinduism also does not accept Jesus' uniqueness, as it posits Jesus Christ is either a human prophet or, at best, one of many incarnations of Vishnu.[48] Buddhism, too, denies Jesus was anything more than merely human,[49] and so on. Therefore, obvious confusion exists in what many people believe about God's nature, and doubt of Christ's uniqueness apparently resonates among a surprising number in Christian churches, as the Lifeway survey reveals.

This is why this book's mission examines illustrations that have been used to convey information about God's nature, checking carefully their accuracy in the doctrines that drive them and the impressions they leave with their hearers. There is no telling at the outset what has influenced them. But there

Monotheism and the Messiah in the Light of Messianic Apologetics, deny God is a Trinity. To him, "The origins of the Trinity, as with the other changes that came about, were decidedly anti-Torah and its foundation was firmly entrenched in Babylon." He believes, "The doctrine of the Trinity developed gradually over several centuries and through many controversies. . . . It was not until the fourth century that the distinctness of the three, yet their composite unity, were brought together in a single Christian Orthodox doctrine of one essence and three persons. We have to bear in mind that the need to re-define the person of *Elohim* did not emanate from Jewish sources, but rather from the Greco-Roman world" (Dover: Vos Levitz, 1999), 6–8.

47. The Qur'an is very clear in opposing the doctrine of the Trinity: "People of the Book, do not transgress the bounds of your religion. Speak nothing but the truth about God. The Messiah, Jesus son of Mary, was no more than God's apostle and His Word which He cast to Mary: a spirit from Him. So believe in God and His apostles and do not say: 'Three.' Forebear, and it shall be better for you. God is but one God. God forbid that He should have a son!" (4:171–72), *The Koran*, trans. N. J. Dawood (New York: Penguin, 1997).

48. In the *Bhagavad-Gita* (*The Song of God*), Vishnu, the "omnipresent," manifests so that Arjuna, the seeker, exclaims, "Ah, my God, I see all gods within your body," and cries, "Universal Form, I see you without limit, infinite of arms, eyes, mouths and bellies" (Swami Prabhavananda and Christopher Isherwood, trans., *The Song of God: Bhagavad-Gita* [New York: New American Library, 1951], 92). Ravīndra-Svarūpa Dāsa posits that "the divine descends in various ways. In the Pentateuch, for example, God intrudes into our world mainly through marvelous acts of divine power" but at the same time "remains even then an awesome, elusive presence just beyond the phenomenal veil"; however, "the divine nature becomes embodied in the human person of Jesus Christ, the Son of God . . . because he is surrendered to God without reservation, God becomes manifest to us in him." Thus, "In this way Jesus reveals himself as an eternal servant of God, saying, 'my Father is greater than I.' . . . Therefore the person of Jesus is itself the revelation of God." The swami's point is that "different scriptures report such vastly different divine descents and direct us toward surrender to God under different names—Jahweh, Allah, Jesus, and so on." Ravīndra-Svarūpa Dāsa, "The Descent of God," *Back to Godhead* 20, no. 5 (May 1985): 7–8.

49. For example, Lāma Kazi Dawa-Samdup, who translated *The Tibetan Book of the Dead*, believes, "If Jesus were an historical character, He, being—as the Lāma interpreted the Jesus of the *New Testament* clearly to be—a Bodhisattva (i.e., a Candidate for Buddhahood) was, undoubtedly, well acquainted with Buddhist ethics, and taught them, as in the Sermon on the Mount," cited in W. Y. Evans-Wentz, ed., introduction to *The Tibetan Book of the Dead*, 3rd ed. (New York: Oxford, 1960), 14.

is yet another challenge to our approach: some are convinced that explaining the Trinity in images and illustrations is not only not viable but wrong. In the next chapter, we'll grapple with this challenge as we survey why there are pitfalls we can stumble into when we use illustrations to try to explain the triunity of God.

CHAPTER 2

CAN WE EXPRESS THE INEXPRESSIBLE THROUGH IMAGES?

How does one explain the great mystery of God's identity to those who have never heard? Junipero Serrá was puzzled.

The year was 1769, and Spain was in full conquest mode. A Franciscan, Junipero was deeply concerned for the safety of the First Nations people in what would become California. So, starting at the age of fifty-six, he began to establish a series of missions. Within fifty years, he had twenty thousand "Mission Indians," as they came to be called, living in their "protected" lands. The devotion to Jesus Christ and loyalty to the church of these first Californian Christians subsequently laid down one of the initial planks for today's flourishing indigenous First Nations ministries, and the agricultural communities they nurtured grew into today's California cities: Carmel, San Luis Obispo, San Juan Capistrano, San Francisco, and others. In fact, some of the Serra palms and olive trees this great Christian hero introduced are still flourishing today more than 250 years later.

But right along with social action, being the devout missionary that he was, Junipero Serrá was equally concerned about evangelism and theology, and he realized that teaching these earliest Californians about the Trinity was going to have to be contextualized. But how was he going to do that?

Then an idea came to him. This former professor of philosophy sat down on the ground, took hold of his blanket, and began to explain the Godhead as

he began to fold the blanket evenly: one fold for the Father, one for the Son, and one for the Holy Spirit, yet the blanket was still one. This is what God is like, he explained—one but three, three but one. There are three persons, like these three folds, but one God, like this blanket.[1]

Ingenious? Unquestionably! Impressive? Yes! Innovative? Of course! Accessible? Absolutely! Perfectly accurate? Well, no. The cost of his clarity was to present God in three parts.

Why is it so hard to explain who God is? Because God is so totally other that our Creator is beyond our comprehension. Trying to explain the inexplicable is the great challenge before any teacher, preacher, or evangelist of Christian theology because no point of reference actually exists in our experience to let us comprehend the nature of God. We have nothing in our world that so corresponds to God that it is completely analogical.

Yet at the same time, God incarnated in Jesus Christ, in whom the apostle Paul tells us in Colossians 2:9 "all the fullness of the Deity dwells in bodily form." So we know who the incomprehensible God is by examining the "image of the invisible God," who is Jesus Christ. As Colossians 1:15 puts it, Jesus, who is God-walking-among us, shows us that God is a loving and merciful healer but at the same time just and holy.

But how do we convey to our children, neighbors, and those we pastor, serve, and teach how the invisible God can be one God in three persons, or with three permanent distinctions, and yet remain one with one will? They can look at Jesus and see that God is just and merciful. But they cannot look at the invisible One that Jesus called the heavenly Father (Matt. 6:32) or at the One he called the Holy Spirit (Matt. 28:19).

So, like Junipero Serrá, we thrash around for images that try to capture by illustration how God can be three and at the same time one. In this chapter, we will examine some of the responses to that thrashing about, asking whether other images should or should not be used to explain God's nature.

The dilemma arises as one of the standard traditional demonstrations of God's existence in Christian philosophy indicates, because the Trinity is so other than anything in our world that it must have been revealed from outside

1. See Jessie Van Brunt, *California Missions: Painted and Described* (Los Angeles: Wetzel, 1932), 40. Recently, the Roman Catholic Church canonized Junipero Serrá. Liturgical Press honored this former professor at Palma in Spain who gave up his teaching post to share himself so graciously to a new people in a strange and rugged land with a "Prayer for Blessed Junipero Serrá" by poet Diana Macalintal, noting, "On the occasion of the canonization of Father Junipero Serrá we pray with the Church for courage to follow the call of God."

our realm of understanding. So maybe we should not try to illustrate God. The same argument is offered to explain the concept of the "eternal." Since we have no point of reference for the eternal in anything we see around us, that idea must have come to us through revelation from a source outside our context, in other words, from One who is eternal: the supreme being. No precedent exists in our world or in our galaxy or even in our universe for either of these concepts, the eternal or the Trinity—or, for that matter, much else about our knowledge of God in what we call in philosophical terms our "contingent" world.

GOD IS NECESSARY TO EXIST, BUT WE ARE NOT!

What we mean when we use the term "contingent" to describe ourselves and our world is that we ourselves and everything we see around us—even what we can glimpse of the vast expanse of creation through the Hubble Space Telescope—are not necessary for the universe to have come into existence or to remain in existence. It is a sobering thought. To bring it home to us: whether you and I were ever born is probably not of essential importance to the formation or continuation of the planet Saturn. And Saturn is not all that relevant to the fact that we exist. We ourselves and everything that surrounds us, including all the distant stars and their related moons and planets just mentioned, are composed of limited existences constantly beginning or ending that hardly appear to be missed when we, or they, cease to exist in the colossal realm of things we see.

Further, all that makes up the universe is for the most part completely out of our control. The universe itself is clearly not dependent for its origin or its existence on you or me or anything else in our physical world. Since every part of the universe appears to be either beginning or breaking down, its source of existence cannot be confined within it or limited to be part of it. If it were limited by what it created or dependent on it for continued existence, then that source would be itself temporary, having not existed at some point and heading for nonexistence ever since it came about. The significance of such reasoning becomes clearer when we ask ourselves what the most durable sight is that we can see when we survey what is around us. Is it a stone? Is it a star? Is it a constellation? Is it space itself? None of these things are absolutely static (in other words, eternally permanent and immobile). Each is subject to change.

But the word *eternal* would apply only to something that does not change, that is, an entity that does not begin or break down and end—it must be immutable, not subject to change, something that always was, is, and will be: in a word, "forever."

We humans are in the habit of throwing around the words *eternity* and *forever* as if we understand what they mean. We do not. Our popular songs and blockbuster films tell us protagonists will love each other "forever" with an "everlasting" love. This is nonsense. Even Greek, which the old adage tells us has a word for everything, cannot adequately capture the concept of eternity. The Greek of the New Testament, for example, settles for the phrase "into the ages of the ages." An "age" has a measurement, a beginning and an end. "Eternity," by the very nature of the concept it is attempting to convey, has no measure—no beginning and no end. When we talk about "eternity past," "eternity present," or "eternity future," we are making no sense. A past implies a beginning and suggests an ending. A present implies a past and future. A future implies a starting date. Eternity has none of these. It did not begin—it always is. It will not come—it always is. It is eternal. We have no point of reference to conceive of such a concept. Everything we know, including our very being, has a beginning and an ending. Everything in the universe is breaking down or starting up, aging, exploding, disappearing, dividing, or spiraling off into a black hole. Eternity's only eternal inhabitant is God, who self-identifies as *hyh 'šêr* (*hyh*, "I Am Who I Am," or "I Am Existing That I Am Existing"; the particle *'šêr* can signify either "who" or "that"; Exod. 3:14). Thus, much of what we temporal mortals posit about a God who is eternal will be so much nonsense, because we do not really understand or fathom what we are saying. We cannot imagine anything that exists without beginning or ending.

The great Reformer John Calvin (1509–1564) chose to speak about God's omniscience (that is, God's attribute, characteristic, or quality of being all-knowing) to mean that all things are always present to God's understanding. I find this to be a very helpful concept. This is how he put it:

> When we attribute foreknowledge to God, we mean that all things always were, and perpetually remain, under his eyes, so that to his knowledge there is nothing future or past, but all things are present. And they are present in such a way that he not only conceives them through ideas, as we have before us those things which our minds remember, but he truly looks upon them and discerns them as things placed before him. And this foreknowledge is extended through the universe to every creature.[2]

2. John Calvin, *Institutes of the Christian Religion*, ed. John T. McNeill, trans. Ford Lewis Battles (Philadelphia: Westminster, 1960), 3.21.5.

How everything that is or was or will be in time could be present to the eternal God makes sense if we keep in mind that God dwells in eternity, the eternal present. Eternity has no beginning or ending—it always is. God does not have a past where God originated or a future where God is going, but God dwells in the eternal present. Though God has created time and entered time, which has a past, a present, and a future, God is not limited by time because God's life and God's attributes are eternal. We creatures of God are temporal. We are born at one date in time, and eventually our bodies turn to dust. Our days here are numbered; mortality is built into us, and we know only a limited amount. No matter how much we can augment our knowledge through artificial intelligence, everything about the future remains speculative. For example, we cannot know for certain all outcomes and their effects precipitated by people yet unborn, no matter how painstakingly we factor in what we can know about those past and present.

For God, however, reality is very different. Being eternal and existing beyond time and its limitations would mean that the days of Christ's incarnation, crucifixion, and resurrection are always present to God. God dwells in the present. Past and future belong to time, but God created time, existed before time, and, as its Creator, is above time. So, God is outside of time, dwelling in the eternal present, never having been born, not aging, never dying, but always existing: the "I Am." God enters or exits time at will.

Thus, the founding of the worlds and their endings are already present to God, as Calvin explains: for God is "nothing future or past, but all things are present." God does not age, does not break down, and does not change. God is the constant in a creation that is ever changing. Therefore, God is the only factor necessary for everything that exists to exist and for every contingent thing that exists to continue to exist. So how on earth do we express that overwhelming reality in a way that is comprehensible in our finite languages, based on our limited comprehension, to our hardly comprehending fellow humans?

PUTTING IT INTO WORDS

Years ago, a group of Oxford University philosophers and theologians began to get together casually to discuss whatever any of them thought was interesting. Their attention was soon caught by a new development in philosophy, a reaction by a set of thinkers being called "linguistic analysts," who had decided that the prevalent logical positivism had so limited its view of meaning to only what could be known empirically that they had dismissed theology, ethics, and morality—anything that could not be analyzed, for example,

through a telescope or on a microscope slide. Attracted by the new approach of questioning a statement's logic by verifying, testing, or justifying it, while also considering its use and function, they recognized the freedom of thought implicit in it. Parting company both with idealists, along with these logical positivists—who dismiss any theological statement as empirically unverifiable and, therefore, meaningless—the Oxford philosophers and theologians decided to test out theological statements with the following criteria of sound logic: intended function and worthwhile use.[3] Out of their discussions grew a book titled *Faith and Logic*, which "reintroduced" theology to philosophy in their age by asking practical questions.

In his critical chapter, "The Possibility of Theological Statements," I. M. Crombie struggled with the lure of regarding theological statements as fictional statements "with which we build up a make-believe world."[4] He concedes a certain similarity may be apparent but can only be granted with this provision: that such statements "are intended in plain earnest . . . not as improving fables about the things in this world, but as divinely given images of the truth about a transcendent being." With this understanding, he laid out the following groundwork on which to build his critique:

> If you are to understand theological statements in the sense which their users intend, it is essential to do equal justice to each of three propositions. First that the theist believes in God as a transcendent *being*, and therefore intends what he says about Him to be referred directly to God and not obliquely to this world; second that the theist genuinely believes God to be *transcendent* and therefore beyond our comprehension; and third, that since on the one hand God is a mystery, and since, on the other hand, if a man is to talk at all he must talk intelligibly, therefore he only talks about God in images.

In reasoning toward a means by which to express the inexpressible intelligently, Crombie seized on the vehicle of imagery as the sole means by which such an activity could be successfully (if not barely adequately) done.

However, Crombie immediately followed this guideline with a warning: "The conception of theological statements as images or parables is, therefore, important, but in one respect it can be misleading." How so? He explains,

3. Basil Mitchell, introduction to Basil Mitchell, ed., *Faith and Logic: Oxford Essays in Philosophical Theology* (London: Allen and Unwin, 1957), 5–6.

4. I. M. Crombie, "The Possibility of Theological Statements," in *Faith and Logic*, 73–74.

"One often thinks of an image or parable as a device by which one illuminates, or compendiously expresses, something already comprehensible."

This was not always Jesus' intention, however, as we see in Matthew 13:11–13, Mark 4:11–12, and Luke 8:10, when the point of the parables is to single out God's chosen from those not illumined by God. Only with those with ears to hear was the parable of the sower intelligible. But there was a further complication that Crombie should have found baffling. In his view, an illustration as clearly drawn as the parable of the sower can be "lucid from the start," so "there cannot be much development." In his perspective, it needs little else for understanding it.

Interesting to note, however, is that Jesus' disciples do not understand it. They come whining to their teacher with questions about why he persists on speaking in parables (Matt. 13:10; Mark 4:10; Luke 8:9). The exasperated Jesus challenges his disciples, "You do not know this parable, and how will you understand all of the parables?" Jesus pointedly reminds them that "the mysteries of God's kingdom" have been given to them (Matt. 13:11; Mark 4:11; Luke 8:10). But he goes ahead anyway and explains the parable to his disciples, also making it "lucid" to us who read his explanation, as recorded by all three initial Gospel writers. One thing this does tell us is that illustrations we use should be followed by explanation if we want to make certain our hearers understand what we want to share with them.

Crombie also points out that nobody appears to have understood a symbolic act like Jesus' triumphant entry into Jerusalem. And he is certainly right since the disciples only came to understand it progressively, for, even after the resurrection, they were asking if Jesus was going to return their kingdom on earth to Israel, apparently still viewing the triumphal entry as the heralding of an earthly king (see Acts 1:6). As Prof. Crombie explains, "Christian doctrines are things in whose understanding one advances." That certainly was the case for the disciples. All Jesus' symbolism began making sense after Pentecost.

To the point of our including his speculation in our present book, the puzzling doctrine Crombie chooses as his example is the Trinity: "In the doctrine of the Trinity we are not perhaps expected to understand in any sense the triune nature, nor required to torment our imagination for an image of it, but to use the doctrine as a caution against what the Church holds to be misleading images."

Now, that's an interesting way to approach depicting the inexpressible Trinity. I would refine this conclusion with this proviso: that we describe the

Trinity in illustrations, but qualify each of these illustrations, so they will tell what we want them to tell without leaving our hearers with a message we do not intend or that misrepresents God. This would put theologians in a parallel camp to physicians, who are warned to do no harm. But that is exactly where the largest current controversial disagreement about the use of this Oxford thinkers' conclusion lies: essentially, is the use of images so precarious that we would do better simply to leave them alone?

IS USING NO IMAGES THE BEST POLICY?

Since 1992, I have been starting off the Trinity sessions of my first systematic theology course each year asking students what images and illustrations they use when they teach in their churches or in their homes. Each time a student would introduce an illustration new to me, I would write it into the growing list in my lecture notebook. I became more intentional on taking a sounding of my student views and, as a result, made up a simple, four-question survey:

1. What illustration or image do you tend to use when describing the Trinity?
2. Does this differ if you are talking to a child, an adult, or someone well-schooled in the faith like a seminarian or pastor? If you use different illustrations, what do you prefer in each case?
3. Do you prefer images that move or change (e.g., are fluid), have parts (e.g., are static), or something else?
4. What do you like to emphasize about God's nature in your illustrations? What limitations do your images have?

I also inquired about their ethnic background, and that was it. I was only trying to sample what was reflected in various churches, since my students are multicultural adults, and many are already pastoring or helping pastor ethnic churches when they arrive at Gordon-Conwell's Boston campus. Furthermore, I wanted to include contemporary students' ideas along with scholarly and early church perspectives.

You can imagine my surprise, then, when one of my Brazilian students handed back the survey with one line scrawled on it: "I don't use one. It's a mystery." A Nova Scotian Acadia Divinity College student expanded the reason for rejecting images: "I do not, but I might say something like: A number of people will use various illustrations. However, to my knowledge,

they all lead to heresy if they are pushed at all. If you find one helpful, that is fine. Do not rest your faith on it or think that it accurately pictures the Trinity." This student, who signed his name, was serving as a denominational representative and had obviously been thinking over the dilemma when he added some thoughtful advice: "Then I give ten-second versions of the egg; clover; man, father, husband; source, score, sound; pie." For kids, he recommended two images, "egg and man-father-husband, but with qualification," and for general preference, "I prefer music because it is less physical. I prefer non-physical images (abstractions)" stressing "unity (oneness)." Still his first preference was not to use any images at all. Back in Boston, a Caucasian student who picked "water as solid, liquid, and gas" as the preference did not extend that image to children, deciding to protect them against imagery. That student explained, "I probably wouldn't use an illustration for a child—just describe three persons living together as one, leaving the mystery in place."[5] (Of course, that is itself an image.)

More and more recently, I began noticing a surprising dearth of images and illustrations both in my student survey replies as well as in the majority of recent books, which are often straightforward doctrinal discussions (including those with reader-friendly contractions).

One of our own pastors shared with me his concerns. He felt that analogies don't tell us anything deeply profound about the Trinity because they are balancing two referents with often only a single connection between them. So, one sees the connection but doesn't really learn anything deeper about either referent that is being compared. The connection's information, while interesting, is shallow.

His concern here is clearly distortion, and in theology that means heterodoxy. The theme of avoiding heresy as a reason for discarding the use of images has come up repeatedly as a reason not to use images at all in describing the Trinity. Many students have returned blank surveys, which was a mystery to

5. After three classes of written student surveys (2017–2019), fifty-three were completed from among African Americans (9), Caribbeans or Jamaicans (3), a Haitian (1), Latinos/as (5), Chinese (Asians) (6), Koreans (4), a Native American (1), Caucasians (16), and no race mentioned (8). In this sample, twenty-three (43 percent) preferred images for the Trinity that moved, and fifteen (28 percent) preferred static images. Many images recur in different cultures, such as ones using water; human roles; a triangle; the human as soul, spirit, and body; and music. The three-leaf clover occurred only among Caucasians and one Chinese, and the egg only among Caucasians and those who did not indicate any race. Of course, a larger sample would be needed to make any cultural pronouncements. I also warmly thank the members of my fall 2020 Theology Survey I class, who opted to critique this book and whose suggestions guided my revisions.

me. What I wanted to learn is what they initially brought to class: what they had been taught and what they were themselves teaching.

Some of this mystery began to disappear when several students (and even some colleagues) began pointing me to "St. Patrick's Bad Analogies," Hans Fiene's entertaining, clear, and provocative cartoon that illustrates this point: "The problem with using analogies to explain the Holy Trinity is that you always end up confessing some ancient heresy. Let the patron saint of the Irish show you what I'm talking about." And show us it does, with two rural cartoon rustics confronting the saint with a plea to explain the Trinity, then charging him with one heresy after another for each image he uses.[6]

But that a proclivity toward thinking use of analogy leads to heresy is not the only concern my students shared. Another recurring theme, expressed succinctly by a Korean student, was, "God is a mystery. We cannot understand how one God can be three." In lieu of imagery, this well-read student settled for a rather interesting explanation: "God is multidimensional. To adapt one used by C. S. Lewis, the Father is the One to whom we pray, and the Spirit is the One who extends our prayer from the Son to the Father." Another reason to avoid imagery language suggested to me by several students was that the problem with analogy is that some minds just don't work that way. It's hard to keep all analogy out of one's language, however.

On the whole, what unites the responses is a pronounced emphasis of caution to the point that use of imagery is basically absent in their thinking. I've already noted that such hesitations and objections are not just limited to many of my students. Many contemporary theologians simply expound their doctrinal slants without using any illustrative language at all. But the state of this affair is more than that. When some inventive theologian does introduce imagery, as the highly creative Roderick Leupp does in his refreshing book *The Renewal of Trinitarian Theology*, the reception may be a frosty one. Contextualizing his book in the popular culture of 2008, he wrote:

> Trinitarian metaphors and remembrances can be multiplied almost without end, to the point of edification for some and distraction for others. Some of these are

6. Its own website, https://lutheransatire.org/media/st-patricks-bad-analogies, posted on March 14, 2013, in 2020 boasted 1,354,929 views. A follow-up to it, "Saint Patrick: The Musical" (posted March 17, 2019), already boasts 101,148 hits, while the original has been picked up by Episcopal Church Memes, Catholic Exchange, Massachusetts' Byfield Parish Church, Road to Emmaus Abington, Pennsylvania's Holy Trinity Lutheran Church, and on and on. In short, with well over two million hits and more websites signing on every month, it's safe to say it's gone viral.

by now virtually enshrined in catechetical instruction: the Trinity "proven" by water existing in the three conditions of liquid, solid and gas; an egg's shell, white and yolk bestowing a breakfast homily. It takes no great theological imagination to see oneness flowering into threeness and triplicity converging to unity here, there and everywhere. Would these trinitarian images be convincing or, if not that, at least inviting?

- three trunks growing together to form one tree
- two men walking as one and huddled under a single umbrella
- knife, fork, spoon—all dedicated to the singular quest for food
- three young girls, arms linked, falling over backward in one motion
- three boys, on the porch together, all eating green apples and sharing common talk
- three squirrels frolicking on the same tree branch

To some observers, then, there may be a hidden trinitarian hand in nearly everything. This hiddenness may often rise to conscious view and intelligible articulation. When one of today's leading rock stars, Bono of the group U2, commends the Beatles' "intoxicating mix of melody, harmony and rhythm" and concludes that their mastery of these three dynamics is the greatest balance "that has ever been, before or since," one may revel in yet another demonstration of God's triunity in a most unlikely place. Or maybe not.[7]

For my part, I think his images do show "great theological imagination," and he extends that vivid imagination throughout this well-written book, even when giving his own warning to keep these images in line within orthodoxy, as we see in this mix of caution and conjecture:

> The Christian calling is not to ingenious speculation about how God can be three and yet one, one and yet three, but is rather a firm adherence to the truth of the incarnation, and a glad acceptance of the benefits of the Father's eternal Word appearing in flesh in Jesus Christ and a sturdy resolve to transform the world in the power of the Holy Spirit.

7. Roderick T. Leupp, *The Renewal of Trinitarian Theology: Themes, Patterns and Explorations* (Downers Grove, IL: InterVarsity, 2008), 9.

Yet the singular story of the gospel is played out by three Actors who are themselves the beginning and the ending of salvation history.[8]

For some scholars, however, even expressed caution does not appear to be enough to excuse the use of imagery for God, as we see in the brilliant Indian scholar Peter Phan's response:

Trinitarian theology has arguably, depending on where one stands, benefited or suffered the most from the use of metaphysics and analogies. To begin with analogies, they range from homespun images of the triangle or the shamrock or father, mother, and child to the so-called psychological models devised by Augustine or Dorothy L. Sayers to contemporary scientific models (e.g., particle, wave, and field). Currently there is an excess of creativity in devising analogies for the Trinity, from the so-called *vestigia Trinitatis* [Latin plural of *vestigium*, "footstep, step; footprint, track; trace, vestige; moment, instant," e.g., footprints of the Trinity] so that any triad, however artificial and accidental, is harnessed for an illustration of the Trinity.[9]

Phan asks "whether there are criteria by which to judge the legitimacy and value of the analogies used for God." And he poses a series of insightful questions: "Are analogies derived from humans as *imago Dei* preferable to those taken from the material world? If so, what are the criteria to judge their usefulness and where are they to be found? Are they to be exclusively based on the Bible or to be determined philosophically?" What follows is an interesting discussion of the appropriateness and legitimacy of various philosophical and methodological approaches to the Trinity.

So, this brief representative sample of outspoken opposition tells us not only that caution is essential in using illustrative imagery to explain the Trinity, but perhaps the whole idea is misguided, dangerous, and a doorway to heresy we had better not enter.

Such a message should be taken seriously, but before you cease using imagery to describe the Trinity, it is worthwhile to pause and reflect. What would help us cut a swath through this dense forest and find a path where

8. Leupp, *Renewal of Trinitarian Theology*, 10.
9. Peter C. Phan, "Systematic Issues in Trinitarian Theology," in *The Cambridge Companion to The Trinity*, ed. Peter C. Phan (Cambridge: Cambridge University Press, 2011), 13–14; John C. Traupman, *The New College Latin and English Dictionary* (New York: Bantam, 1966), 330.

we can lead those we serve, teach, or pastor to solid ground? In the old tales, travelers searched for a light, a beacon by which they could discern a way through dismal swamps and find higher ground. Our best road forward is to see what the certain guide to faith and practice, the Bible, tells us Jesus did, since we model on him as the Second Adam who shows us the right way to handle words and works.

In the next several chapters, we will pursue such a light by examining our Lord's approach to the use of imagery in his teaching about God's nature and then consider a pivotal example (light) that illustrates the relationship between Jesus and the Father from the book of Hebrews. This seminal correlation, seized by many in the early church and appropriated by warring groups, today remains a significant part of the discussion of the Trinity.

CHAPTER 3

DID JESUS USE IMAGES
TO TEACH ABOUT GOD?

In the previous chapter, we hacked our way through a thick jungle of objections and defenses on the edifying versus disastrous use of imagery to explain God. As we proceed in this chapter, then, we find ourselves facing a mountain range, looming before us in the form of a compound question: First, did Jesus himself use analogies to teach about himself, his heavenly Father, and the nature of the Trinity? Second, if so, is that style of teaching part of a whole strategy of the mission of Christ that was intended to be unique to him? Third, should we be attempting to imitate Jesus' creative approach to teaching, preaching, and evangelism ourselves? These are the peaks before us we must scale before we can continue our journey.

To scale the first summit, whether Jesus himself used analogies, we first need to set out on a winding path through the Scripture. There we can discern the footprints of the first followers Jesus chose when he set forth on his mission. The first step we take, then, is theirs, and we start with their question, "Why through parables do you speak to them?" The disciples were baffled (Matt. 13:10). Jesus' reply may seem equally puzzling. Citing Isaiah 6:9–10, he explains that a mind that understands spiritual truths, eyes that can recognize God at work, and ears that can hear God's wisdom are gifts from God, given to some and not to others. This is a theme also proclaimed by Moses in Exodus 7:3–4 and in Deuteronomy 29:4. So faithful was Jesus to

this conviction that Matthew tells us, "All these things Jesus spoke in parables to the crowd and without parables nothing did he say to them." Matthew explains Jesus was intentionally fulfilling the words of Asaph, the hymnwriter in Psalm 78:2 (called a "prophet" by Matthew [Matt. 13:35]), that the deep truths would be explained by the Messiah in parables.

Thus, the reason he continually embeds his teaching in illustrations, adopting an artful approach to his mission, is to fulfill the prophecy of Isaiah 6:9: "To you has been given to know the mysteries of the kingdom of God, but to the rest in parables, in order that *seeing they may not see, and hearing they may not comprehend*" (according to Luke 8:9–10, emphasis added; see also Matt. 13:10–23; Mark 4:10–20). Jesus intends that only the ones God calls will understand. For Jesus, the point of story is clearly both to enlighten and obscure. Art draws on what is inside a viewer, what Jesus called the "treasure box" or "storeroom" (*thēsauros*) in Matthew 12:35 and 13:51–53. One's response to art is dependent on one's own perspective. If we are far from God and not resonant with God's Spirit, little of heaven echoes within us, the inner eye is dark, and the inner ear is dull. If we are oriented by God's grace, then God's truth leaps out from Jesus' skillful prying open of our treasury, and his words resonate in us and enrich us spiritually. We behold his truth. Thus, only those illuminated by God are selected to understand, giving his stories a winnowing effect to separate out those chosen by God for the enlightenment that leads them to salvation.

In fact, as every great artist modeled on him since the dawn of time, Jesus can become exasperated when he has to continue to explain his art to the potentially faithful: "And still you are dull [*asunetos*, also, "without understanding, senseless, foolish"]?" he demands of his hapless disciple, when Peter pleads once too often for Jesus to explain a parable (Matt. 15:15–16). This is not just peevishness. Failing to comprehend Jesus' approach is nothing short of failure to appreciate his person, since Christ's technique assumes God's gifting of ears that hear, so those who understand his words have begun to glimpse his nature as the great crafter who created the world itself.

Also frustrating for Jesus is when in Matthew 16:11–12 (and Mark 8:14–21) he warns the disciples to beware of the "yeast" of the Pharisees and Sadducees. Having forgotten to bring bread, they are dismayed they will be going hungry. He reminds them of his miraculous feeding of the four and five thousand to dismiss their worldly preoccupation and then clarifies his exasperation: "How do you *not* perceive that concerning bread I am *not* speaking to you?" They have been thinking at a superficial level, but Jesus has been sharing a deeper

spiritual truth by using a metaphor. "Watch out for the yeast of the Pharisees and Sadducees," he repeats, maintaining his metaphor. But by separating his reference from bread, he drives them to that more profound level so that they understand he is warning them against the teaching of his opponents.

What exactly is a parable in the ancient Greek understanding? Bauer's *Greek-English Lexicon* defines it as "a narrative or saying of varying length, designed to illustrate a truth especially through comparison or simile" (a comparison using "like" or "as," as contrasted with a metaphor, which is a comparison without using "like" or "as"). But we are also told that it is "someth[ing] that serves as a model or example pointing beyond itself for later realization."[1] L. Mowry, in a helpful article, agrees it is "an extended metaphor, or simile frequently becoming a brief narrative" and points out it was employed "for didactic purposes."[2] This teaching methodology uses the comparative tools of analogy to teach a lesson intended to be realized in the lives of those hearers who are gifted by God to intuit the truths embedded in it and empowered to follow its right example(s).

The question before us, then, is: Is the use of the parable (a simile or metaphor that can extend into a narrative story) to explain the nature of God intended to be unique to Jesus, because he is fulfilling prophecies about himself, or is it an example we should be following in our preaching and teaching as well? To take the next step in exploring this question, we now need to understand Jesus' teaching ministry in his own artistic context.

DOES JESUS COMMUNICATE AS AN ARTIST?

Did you ever notice that Jesus comes at questions at an angle? Even point-blank ones he would often pair with a story, epigram, or analogy. This is why Christians today are still echoing the disciples' question: "Why do you speak in parables?"[3] To understand why Jesus used artistic means to convey truth is to glimpse something about the mission and nature of Christ.

John tells us clearly in his Gospel that the person of the Godhead who incarnated as Jesus Christ worked with the Father and Holy Spirit to create the whole world, "all things through him came, and without him came not one thing" (John 1:3). That Jesus created the world is not up to question. Every-one calling herself or himself Christian agrees—or ought to agree—with that

1. BDAG, 759.
2. L. Mowry, "Parable," *IDB*, vol. 3, 649.
3. In this section, I culled these passages from the Gospel parallels in Robert L. Thomas and Stanley N. Gundry, *A Harmony of the Gospels* (Chicago: Moody, 1978), or its revision, as noted.

statement. But, since the word "art" is drawn from the word "artifice," meaning a copy or representation of something that exists, we might conclude that at the beginning, as a coequal, coeternal person of the triune Godhead, the One who took on humanity to become "Jesus" (savior) "Christ" (anointed one) was hardly an "artist" copying what exists. Instead, the entire Godhead was involved in the initial crafting of the universe. God created what now exists and, according to John 1:3, the One who would incarnate in earth's creation to provide the means for humans to be re-created in a spiritual second birth was particularly active in the first birthing of our world. "Art" would only be able to follow that primal crafting of worlds—to reshape matter, or "imitate, represent, portray" (*mimeomai*)[4] already existing matter.

Therefore, asking if Jesus were both Creator *and* an artist at the creation might be irrelevant when we are talking about God, since there was nothing *arti*ficial, no artifice at all about the original creation. Clearly, at the beginning, the One who would be born into our world as Jesus Christ was hardly an artist. This full person of the Trinity was the originator of the material that is shaped into art: the master crafter.

But now, when we come to the next phase of the divine drama, rescuing humanity from its great tragic plight—its fall—we come up with a different answer entirely for Jesus Christ as a human among humans. The originator has now taken on human flesh and has entered our world as one of us: a human (Rom. 1:2–3; 8:3; Heb. 2:14–18). Jesus Christ has become part of God's own creation; God-Among-Us has taken on human flesh, human gender, human limitations. So, our initial question is posed again: Despite being the original creator, does Jesus, once incarnated, now work as an artist, using the material of the world he created, but this time to *re*-create or sub-create a means to reach people with his message?

To answer this, we need to agree on what we mean by "art," since this word can be defined in many different ways, depending on one's perspective and the context of the discussion. In *God through the Looking Glass*, our book on the arts, we define art as "a type of communication through something arranged or created to represent what the artist perceives in the subjunctive (what could, would, or might happen) to be life or truth and that someone presents as art because of its perceived form and beauty."[5]

4. LSJ, 1134.
5. William David Spencer and Aída Besançon Spencer, eds., *God through the Looking Glass: Glimpses from the Arts* (Grand Rapids: Baker, 1998), 17.

Herein, you notice, are the qualities of being arranged, representing, and communicating. For this discussion, I am condensing these elements into a definition of art as *craft that speaks beyond itself*. Was Jesus a maker of craft that speaks beyond itself? Or, another way to put it is: was the master crafter, when he was God-Among-Us, also a sub-crafter, an artist?

Bringing this question to the four Gospels, we discover that it is answered easily: art presages, surrounds, and even flows from Jesus' nature, as we see it herald Jesus' entry into our world, convey his message to our world, and demonstrate his message before our world.

Jesus Is Artfully Introduced

Prehistoric glimpses in John 1 and Colossians 1, in conjunction with John 8, help us glimpse a fuller understanding of Jesus' identity. John 1:3 tells us that Jesus is the master crafter. Verse 10 of John 1 adds: "the world was made through him." Verse 4 tells us that humanity itself is a creation, whom Jesus himself animated. Colossians 1:16 corroborates: "All things through him and in him were created."

Since all the Godhead's productive, creative activity was done through Jesus, appropriately, his advent was greeted creatively. His mother responded to the news that she had been elected to bear him with a burst of poetry, or an actual song, which today we know as "The Magnificat" (Luke 1:46–55), a piece that has inspired composers down through the ages. His earthly relative Zechariah, when his tongue is loosed, also bursts forth in poetic song when Jesus' herald, John the Baptist, is born (Luke 1:67–79).

John the Baptist himself will soon be proclaiming and fulfilling Isaiah 40:3–5's poetic prophecy:

A voice shouting in the wilderness:
"Prepare the way of the Lord,
Make straight his paths.
Every ravine will be filled up,
And every mountain and hill will be leveled;
And the crooked will be straightened,
And the rough [or uneven] into smooth roads;
And all flesh will see the salvation of God."
(Luke 3:4–6; see also Matt. 3:3; Mark 1:2–3)

When John the Baptist introduces Jesus, he turns to rich metaphors drawn from Old Testament sacrificial imagery to depict the uniqueness of Jesus' coming: "Behold, the Lamb of God, the one removing the sin of the world!" (John 1:29, 36). John also describes Jesus as "the bridegroom" and himself as a friend of the wedding party (John 3:29). Jesus will use this same imagery, explaining the contrast between John's fasting disciples and his feasting ones (Matt. 9:14–15; Mark 2:18–20; Luke 5:33–35; cf. 12:35–38). Eventually, Jesus will return the tribute, responding to John the Baptizer's death by comparing him to "a lamp" that illuminated those around him (John 5:35). Jesus himself, the apostle John tells us, is the giver of light who bestows the light of life on every human coming into the world (John 1:4, 9). John the Baptist, of course, was not *that* light, John the apostle hastens to add (1:8), but a witness to that light, perhaps as a searchlight may be contrasted with the sun. Both of them give light. The searchlight can pinpoint and highlight a particular target, as John did in singling out candidates for repentance. But the sun illuminates everything with life and health.

John's preaching certainly shimmers with luminescent, poignant, searing, definitive imagery. He censures his opponents with a metaphor: "You offspring of snakes!" (Matt. 3:7; Luke 3:7), which is effective in silencing them and illustrating his opinion of them to the watching crowds. We wonder at his choice of words. Was that selection really intended to win over his critics with sarcasm? Maybe not. John's mission was announcing the coming of Jesus, who, John proclaims, will baptize with "fire" (Matt. 3:11). In that sense, John was already striking a match to symbolize the conflagration to come with the One whose heavenly parent cuts off those who will not receive Jesus, just as a gardener prunes off dead branches and heaves them into the fire (John 15:1–6). "Therefore, produce the holy fruit of repentance," John the Baptizer warns, "but now the axe is at the root of the trees" (Matt. 3:8–10; Luke 3:9) and the "winnowing shovel is in his hand" (Matt. 3:12; Luke 3:17). And, after that thorough bit of landscaping, God can raise substitute children out of the very stones to replace those branches God destroys (Matt. 3:9; Luke 3:8).

John's graphic depictions of Jesus and the eloquent setting of his preparatory words are actually most appropriate, since even the moment of Jesus' advent was graced with melodic beauty, as none less than the angels of heaven chant when they proclaim Christ's birth (Luke 2:13–14).

Jesus Continues His Ascent on the Wings of Art

From the moment Jesus begins his public ministry, he fulfills the promises of the Old Testament poetry that prophesies his mission. Robert Thomas

and Stanley Gundry point out how many scriptural prophetic composites are fulfilled in each of Jesus' symbolic utterances or actions, for example, his teaching on the end times in Matthew 24:29 and Mark 13:24–25: "the sun will be darkened, and the moon will not give its light, and the stars will fall from the sky [or heaven]." They cite as references Isaiah 13:10 and 34:4.[6] The pageantry of the triumphal entry into Jerusalem (Matt. 21:1–11; Mark 11:1–11; Luke 19:29–44; John 12:12–19) fulfills such prophetic verses as Isaiah 62:11, Zechariah 9:9, and Psalm 118:26–27.[7] Even on the way to his death, the suffering savior Jesus is quoting Hosea 10:8's use of personification: "Say to the mountains, 'Fall upon us!' and to the hills, 'Cover us!'" (Luke 23:30). Jesus is conscious of the role he will contribute to the great passion play of redemption. But his employment of the arts is not simply limited to this role of a lifetime.

His affinity for things artistic runs through all Jesus' interactions. When reproving his contemporaries' lack of godly cooperation with John the Baptist or with himself, Jesus depicts them as children complaining to would-be playmates: "We played the flute to you, and you didn't dance; we sang a dirge, and you did not lament" (Matt. 11:16–17; Luke 7:31–32). He and John are like musicians, a heavenly band playing to an unappreciative audience. "Tough crowd" about sums it up.

The famous account in John 7:53–8:11 first appears in the Greek and Latin fifth-century codex Bezae (a manuscript that gathered up early traditions).[8]

6. Robert L. Thomas and Stanley N. Gundry, *The NIV Harmony of the Gospels: With Explanations and Essays* (New York: HarperCollins, 1988), 190–91. Also see Ezekiel 32:7; Joel 2:10, 31; 3:15, where the imagery more presages Jesus bringing the sword rather than peace (Matt. 10:34). Thomas and Gundry's *A Harmony of the Gospels* first appeared from Moody Press in 1978, using the New American Standard Bible. A decade later, when it was republished by HarperCollins, it had switched to the New International Version.

7. Thomas and Gundry, *NIV Harmony*, 169–72.

8. Bruce M. Metzger and Bart D. Ehrman, *The Text of the New Testament: Its Transmission, Corruption, and Restoration*, 4th ed. (New York: Oxford University Press, 2005), 71. The beloved story of Jesus' mercy to the woman caught in adultery is not found in any papyri or earliest authoritative codices or early translations of the New Testament. Nevertheless, an account of a woman dragged before Jesus was already extant in the second century. Papias (c. 60–130) mentions this account concerned "a woman falsely accused before the Lord of many sins." It was included in the apocryphal Gospel of the Hebrews, which many believe was an Ebionite document (Montague Rhodes James, trans., *The Apocryphal New Testament: Being the Apocryphal Gospels, Acts, Epistles, and Apocalypses* [Oxford: Clarendon, 1924], 2, 4, 8–10). Papias, along with Polycarp, is said to have been a disciple of John, but Papias does not in the fragments we have of his writings attribute the account he mentions to John (Eusebius, *Church History* 3.39). Whether it is a variation of the same account as the woman caught in adultery is unclear. What is clear is that the majority of textual scholars do not think it belongs in John's Gospel. It is not canonical. Bruce Metzger concludes the account is a "piece of oral tradition which circulated in certain

This story tells how Jesus may have turned to pictorial art when rescuing a woman in jeopardy. Dragged before Jesus on her way to execution, the woman trembles as her abusive accusers accost Jesus, attempting to use her to trap him as a scofflaw, should he choose to intervene and take her part. Jesus, however, appears calm, even unperturbed, choosing instead to give a type of mimed performance rather than answer in verbal argument. The report tells us he stooped down to the ground while listening to the charges being brought against this woman caught in adultery. In classical Greek, the noun related to *katagraphō*, the verb employed to describe what Jesus did then (8:6), is used for "drawing, delineation," "drawing of maps," a "diagram, figure," "delineation in profile," "marking out," "engraving of an inscription."[9] By New Testament times, the verb meant to "write" or "draw figures."[10] Was Jesus doodling as he thought it over, or buying time as he prayed for guidance? Was he sketching the angry crowd, so they could see themselves as he saw them, or, as the original silent Jesus film classic *The King of Kings* (1927) depicts, writing in the sandy dirt the sins of each of her accusers?[11] Whatever the function of his drawing was, when he stood up, his answer confounded them. Then he went back to drawing in the dirt. When he stood up a second time, they had slunk away. The audience of accusers was gone.

No one knows if this tradition is suggesting Jesus was a pictorial artist as well, but we do know he was a carpenter. One of the few light scenes in Mel Gibson's heartrending *The Passion of the Christ* (2004) shows Jesus taking delight

parts of the Western church" (*A Textual Commentary on the Greek New Testament*, 2nd ed. [Stuttgart: Deutsche Bibelgesellschaft, 2002], 187–89). At the same time, A. T. Robertson believes, "It is probably a true story for it is like Jesus, but it does not belong to John's Gospel" (*Word Pictures in the New Testament: Vol. 5, The Fourth Gospel, The Epistle to the Hebrews* [Nashville: Broadman, 1932], 135–36). Leon Morris notes, "If we cannot feel that this is part of John's Gospel we can feel that the story is true to the character of Jesus. Throughout the history of the church it has been held that, whoever wrote it, this little story is authentic. It rings true" (*The Gospel According to John* [Grand Rapids: Eerdmans, 1971], 883). And Bruce Metzger agrees, "The story of the woman taken in adultery, for example, has many earmarks of historical veracity; no ascetically minded monk would have invented a narrative that closes with what seems to be only a mild rebuke on Jesus' part" (*The Text of the New Testament*, 319). These commentators, all of notable scholarly stature, agree that this account fits as a true tradition within John's category of recordings of the "many things Jesus did" that, if written down, all the books in the world could not contain them (John 21:25).

9. *katagraphē*, LSJ, 887.
10. BDAG, 516.
11. "Trace, draw" is the translation choice of Max Zerwick and Mary Grosvenor in *A Grammatical Analysis of the Greek New Testament*, 5th ed. (Rome: Editrice Pontificio Istituto Biblico, 1996), 310.

in showing his mother his model for a futuristic-style chair. It underscores his primal identity as the master crafter and his role now as creative artist.

One of the marvelous scenes in the silent *The King of Kings* depicts a group of children requesting that, since Jesus can heal limbs, he fix a broken doll. In response, the divine crafter fashions a dowel to reattach the limb and "heal" the doll to the delight of the children. It is a tender and beautiful depiction of Jesus as creative woodworker.

JESUS THE MASTER ORATOR

What we do know for certain is that Jesus focused his artistic power on his consummate use of the oral arts: he was a master orator, a crafter of the spoken word.

So renowned was Jesus' love of metaphor that when the Syrophoenician woman wanted to appeal to him, she cleverly answers him in metaphor. He states, "It is not good to take the bread of the children and throw it to the house dogs." She answers, "Yes, Lord, and then the dogs eat from the fallen crumbs from the table of their master." Jesus is so pleased at her respectful and artful response, he praises her faith and grants her wish (Matt. 15:22–28; Mark 7:25–30).

Jesus Uses Puns

Like all literary speakers, Jesus employs an entire rhetorical arsenal to fire at his hearers. He delights in puns from the very beginning of his ministry, setting Simon up for the eventual "rock" pun, as he renames him "stone" (Mark 3:16; Luke 6:14; John 1:42). A. T. Robertson, an astute expositor, points out that this Greek word *petros* is usually used for "a smaller detachment of the massive ledge" (Matt. 16:18). So I might read this as Jesus making a word-play, contrasting himself as the ledge and Peter as one of the stones of the ledge on which the church will rest. A. T. Robertson does caution us, however, that "too much must not be made of this point since Jesus probably spoke Aramaic to Peter which draws no such distinction."[12] But, even given that warning, we can see that Jesus is engaged in a high level of playing with words, as, for example, when he intrigues the Samaritan woman at the well with the lure of a "water" that she won't have to draw; he parlays his request for a drink of well water into a contrasting image of the continual, spiritually refreshing draft of good news he can give her (John 4:10–15). These are but two of many

12. A. T. Robertson, *Word Pictures in the New Testament*, vol. 1 (Nashville: Broadman, 1930), 131.

lighter moments in the Bible that escape most of us when we read the text. God is certainly serious about our welfare and the divine plans for the world. But it does not follow that God has no sense of humor or that God does not take delight in this world God has created. That enjoyment is seen clearly before the fall as God creates and then strolls through that creation in the balmy breezes of the late afternoon into the early twilight (Gen. 3:8). God-Among-Us continues that delight, inventing pet nicknames for some of his disciples; he dubs James and John the "sons of thunder" (Mark 3:17) and calls Simon "the Zealot" (Mark 3:18; Luke 6:15).

Jesus Uses Personification

Jesus also enjoyed playing with personification, for example, counseling the crowds not to let their right hands know what their left hands are doing (Matt. 6:3), as if hands could keep secrets from one another. In his word pictures, flowers and grass wear clothing much finer than Solomon's (Matt. 6:28–30). The earth has a heart (Matt. 12:40). A day worries about itself (Matt. 6:34). Jerusalem is a city that has daughters and children, kills the prophets, has its house left desolate, and must bless Jesus' name to see him again (Matt. 23:37–39; Luke 13:34–35).

Jesus Uses Hyperbole

The images Jesus uses are sharp and poignant, and they arrest one's attention and make one pause and think. That is the point of one of Jesus' favorite devices: hyperbole, the extreme statement for shock effect. His sermons are filled with examples. Anger and insults are equivalent to murder, thunders Jesus, and lust equals adultery (Matt. 5:21–22, 27–28). If your right eye or right hand causes you to sin—gouge out and amputate! (Matt. 5:29–30; see also Matt. 18:8–9; Mark 9:43–47). In danger of misleading a child? Best to go drown yourself! (Matt. 18:6; Mark 9:42; Luke 17:2). Do not resist any evil, he recommends; in fact, invite someone who slaps you to hit you again. If they sue the shirt off your back, toss in your coat as well. Did the army draft you into forced servitude? Do double the work! (Matt 5:39–42; Luke 6:29–30). Other instances of hyperbole include Jesus' warning that we overlook sins the size of planks in our own eye (Matt. 7:3–5; Luke 6:41–42) and that giving good teaching to the unworthy is tossing jewels to pigs (Matt. 7:6). Peter becomes "the devil" when he tries to dissuade Jesus from fulfilling his mission to die for humanity's sins (Matt. 16:22–23; Mark 8:32–33). Jesus also employs the exact phrasing that his cousin John the Baptist used toward the

good but self-righteous Pharisees, when he calls them snakes and offspring of snakes (compare Matt. 3:7 and 23:33). Everyone doing sin is a "slave of sin" (John 8:34), child of the devil (John 8:44), whitewashed tomb (Matt. 23:27), or unmarked grave (Luke 11:44). They devour widow's houses (Mark 12:40; Luke 20:47), straining at gnats and swallowing camels (Matt. 23:24). Those who pause to care for their parents rather than follow Jesus are dead people burying dead people (Matt. 8:21–22; Luke 9:59–60). In fact, he orders his followers to call no one on earth "father" or "leaders" (Matt 23:9–10). Rich people trying to enter heaven are like a camel trying to squeeze through the eye of a needle (Matt. 19:24; Mark 10:25; Luke 18:25). His audience responds as did John the Baptist's hostile hearers: they determine to kill him. Artists who deal in truth don't always receive the acclaim their skills merit.

But Jesus' use of hyperbole is not always condemnatory. It can be positive, too, as he assures those destined for heaven that their task is to proclaim that godly message that his still, small voice whispered in their ears in their own loud announcements from the very housetops (Matt. 10:27). Their prayers can toss mountains into the sea (Mark 11:23). And he counsels them they must cry out their praise, or the very stones will do it (Luke 19:40). Their worth to God is far more than that of sparrows (Matt. 10:29–31; Luke 12:6–7).

Such sharp, memorable contrasts have made impressions that still resonate in our age. No wonder the multitudes were amazed and astonished by the potent strength of his richly illustrated lectures (Matt. 7:28–29).

Jesus Uses Synecdoche

Memorable too is his use of synecdoche, letting a part represent the whole, or a whole a part—particularly a part of his mission singled out to represent the whole. Often the most significant spiritual truth is presented by this technique. For example, Jesus foretells his greatest victory when he states, "I am the resurrection and the life" (John 11:25) or "I am the bread of life" (John 6:35–58), with bread being symbolic for nourishment and, therefore, a representative part of all one's necessary daily sustenance (cf. Matt. 6:11, Luke 11:3). A profound truth is symbolized in each of the representative images of these "I am" statements. Jesus is the road to heaven, the truth about heaven, and the life heaven gives (John 14:6). Sometimes he refers to his own presence grandly as "the kingdom of God," which is among them (or "in their midst," *entos*) (Luke 17:21); where the king walks, the kingdom is present. And sometimes he simply calls himself "the Teacher" (Matt. 26:18; Mark 14:14; Luke 22:11). The Holy Spirit too is reduced to one memorable image:

the helper (which can also mean counselor, encourager, exhorter, comforter) (John 14:16; 15:26; 16:7). Of those who follow him, not one hair of their head will perish in the end times, even if they suffer earthly death (Luke 21:18). But they will be gathered "out of the four winds" or "from all directions" and, "from the extreme limit of the heavens until its extreme limit," or one side of the sky to the other (Matt. 24:31; Mark 13:27). Jesus himself is present in the least of his followers, and acts done to them are symbolically done to him (Matt. 25:31–46). The end times themselves he describes by depicting two men in a field or two women grinding grain (one is destroyed, the other left alive) (Matt. 24:40–41).

As the end of his earthly life neared, Jesus' use of synecdoche, as a kind of analogic shorthand, increases. One of the most dramatic incidents is when he takes a piece of bread and a cup of wine and uses them to symbolize his body broken and blood poured out for humanity's redemption (Matt. 26:26–29; Mark 14:22–25; Luke 22:17–20). Drama will figure significantly, as we will see, in his final artistic lessons.

JESUS DRAWS HIS IMAGERY FROM PEOPLE'S REAL LIVES

The original fashioner of the universe, Jesus, now uses the oral techniques we have been describing as a refashioning strategy. By their use, he subtly forces hearers to understand answers only by placing themselves within the worldview he, as God-Among-Us, has set. To understand what he says to them, his hearers have to accept Jesus' analogical worldview. They have to think in God's framework, not their own. His is a model all artists follow, since art poses questions intended to enable illumination in beholders, but really only in those who are willing to adjust to its presuppositions. Those who won't adjust but want art to fit into their own presuppositions simply peer at it from all angles and finally grunt, "I don't get it."

Therefore, as a quintessential artist, Jesus takes the material of life around him and shapes it for his audience, reshaping people's perspectives through using his formidable arsenal of oral techniques. But, as strong as his presentation obviously was, it was matched by the power of his astute selection of imagery that created analogies to their own experiences, taken no doubt from the material of his followers' daily lives but shaped now creatively to illustrate his teaching. The sheer breadth of his references is impressive.

Amid numerous nourishing images of the coming of God's kingdom, Jesus salts in a number of parables portraying himself and his heavenly Father

in a familial relationship of love. While, as a rule, these did not involve the Holy Spirit explicitly, they were enough to introduce his hearers to the idea that Jesus is divine and at one with the heavenly Father, whom they worshiped as God above all. In that way he introduces the plurality in the Godhead. These we find embedded in a rich treasury of images as Jesus adopts his teaching to the experiences and understanding of his hearers.

Carpentry

Jesus was reared among the working class, and appropriate to the nature of the great creating God-Among-Us come humbly to earth, he was trained to design and build things in his stepfather's carpentry trade. Therefore, he was equipped by his experience to draw a wealth of material from construction to illustrate significant spiritual truth.

"House" imagery, for example, becomes a frequent and changing metaphor for him. Familiar is the famous early story of the homeowners who build respectively on the rock or the sand, illustrating the need to act on Jesus' teaching (Matt. 7:24–27; Luke 6:47–49). But "house" also represents the world as Satan's dwelling that Jesus has invaded, overpowering the evil one and plundering it of what it possesses: people's wills (Matt. 12:29; Mark 3:27; see also Luke 11:21–22). People's minds are also depicted as "houses" demons occupy, leave, and return to (Matt. 12:43–45; Luke 11:24–26). Heaven too is like a house with rooms Jesus is building for his followers (John 14:2–3). In fact, when he is about to return, he will be "upon the door" (Matt. 24:33). Meanwhile, Revelation 3:7–20 notes, Jesus opens doors for churches and knocks at their doors. He is engaged in a search to rescue the precious wandering people he is seeking (Luke 15:8–10); he depicts himself like a woman sweeping the floorboards of her house, looking for the coin she has lost.

Jesus also quotes Psalm 118:22–23, presenting himself as a cornerstone, rejected by earthly builders but chosen by God, the master builder (Matt. 21:42; Mark 12:10–11; Luke 20:17). A cornerstone in ancient architecture was the first stone laid on a foundation to guide the laying of all future stones. So, as the cornerstone, he is the chief measuring guide for his followers, but he is also the chief stumbling block for his opposition (Matt. 21:44; Luke 20:18). He can also call others "stumbling blocks" (literally, "a trap," but used metaphorically for tripping someone up morally into sin; see Matt 16:23; 18:7–8; Luke 17:1–2).[13] Before one follows him, one must be like a builder calculating

13. *Skandalon*, BDAG, 926.

the cost of a tower, because following Jesus' design for us is a costly venture. One has to consider whether one has the spiritual resources to undertake it because, once committed, one cannot turn away without being left spiritually bankrupt (Luke 14:28–30). Remodeling St. Augustine's city of humanity into the city of God is daunting, since "the one consists of those who wish to live after the flesh, the other of those who wish to live after the spirit."[14] That is going to take a complete renovation, spiritually speaking.

We see in Genesis 4:9–17 that the first city of humanity was built by the disenfranchised Cain after he had lost all human contact except for his immediate family. He was lost in the land of "wandering" (the meaning of the Hebrew word *nod*) until he settles down and starts a family, and then a settlement to alleviate the communal aspect of his sentence. He names the city for this son, Enoch: the pathos of a prodigal child wanting something better for his own son. Countless eons have replicated cities of Enoch across the world. How can we build within them towers that symbolize the redeeming message of Christ? The inference is clear. We need to calculate whether we are willing to invest everything we have in this venture, just as Jesus did, before we invite his will to be the guiding cornerstone of our lives and our work.

One of the most dramatic of his building metaphors comes when Jesus cleanses the temple, charging his Father's house has been turned into a market (*emporion*, John 2:16) or a hideout (*spēlaion*, Matt. 21:13; Mark 11:17; Luke 19:46) for robbers.[15] Challenged, he switches the metaphor to signify his own body as he cries out, "Destroy this temple and in three days I will raise it up again" (John 2:19; see also Matt. 26:61; 27:40; Mark 14:58; 15:29). He does this by using the verb *egeirō*, which is not primarily employed for restoring a building but for waking someone up or raising them to a standing position.[16]

He tells his would-be disciples to pick up their crosses (that is, take on his difficult and perhaps fatal service) and follow him (Matt. 16:24; Mark 8:34; cf. 10:21; Luke 9:23). This is one wood metaphor that becomes painfully real

14. Augustine, *The City of God* 14.1. For a fuller discussion, please see my chapter, "Rebuilding the City of Enoch with the Blueprints of Christ," in Seong Hyun Park, Aída Besançon Spencer, and William David Spencer, eds., *Reaching for the New Jerusalem: A Biblical and Theological Framework for the City,* Urban Voice Series (Eugene, OR: Wipf and Stock, 2013). I contend "there is a battle of definitions raging around us" regarding the city. As a result, "we have been deluded into trading the center of humanity for the periphery, thereby handing the locus of action over to evil and all its nefarious work to undermine our reliance on each other, destroy community, isolate individuals, and mug them as surely as was the victim in Jesus' parable. Clearly, many of us need to rethink the city" (3).
15. BDAG, 938; cf. Isaiah 56:7; Jeremiah 7:11; Thomas and Gundry, *NIV Harmony,* 174.
16. BDAG, 271.

for him. Finally, in his passion, when he has struggled to carry his own heavy, wooden cross, Jesus reverts to one last wood metaphor, asking those watching his torment, "If in the green tree these things they do, in the dry what will happen?" What he means is: if such a heinous act as the execution of God-Among-Us who came to bring us redemption can happen in peacetime, what are his persecutors capable of at the fall of Jerusalem? (Luke 23:31).

Fishing

When he invites the fishermen to follow him, he uses imagery drawn from fishing. To Peter and Andrew, he calls, "Come, follow me, and I will make you fishers of people [not specifically men only, but the plural form of *anthrōpos* for humans]" (Matt. 4:19; Mark 1:17; Luke 5:10). All of heaven, he explains, will ultimately fish up humanity in his story of the dragnet. The angels will be saving the righteous and discarding the evil, like fishing folk dividing up their catch (Matt. 13:47–50). In Luke 11:11, he observes, a father will not give his child a snake for a fish, and in John 12:32 he uses a nautical term for hauling in a net (*helkō*)[17] when he announces that, when he is lifted up, he will "draw" all people to himself.

Being God-Among-Us, Jesus has the power to demonstrate his teaching in a kind of participatory art—like a living installation—that becomes alive so that the disciples can walk around in it. So he provides the miraculous catch of fish in Luke 5:1–11 to demonstrate he can indeed make these earthly seafarers uniquely successful heavenly fisherfolk. Like his real Father, Jesus can symbolize by using the actual matter of the world. Lest they miss the point of his symbolic miracle, immediately afterward he reiterates to Simon, "Do not fear, from now on people you will be catching [*zōgreō*, capture alive]"[18] (Luke 5:10). He even teaches his followers to obey God the heavenly ruler as well as earthly governments by having Peter catch their tax contribution out of the sea, a lesson the former tax collector Matthew is careful to record for posterity (Matt. 17:27).

After the cataclysmic events of the crucifixion and the resurrection, his followers seek the salve of routine, attempting to pick up their old lives as earthly fishermen again. But Jesus meets them on the shore and cooks a fish breakfast for them (John 21:9–14), demonstrating that he will provide their

17. BDAG, 318.
18. Michael Burer and Jeffrey Miller, *A New Reader's Lexicon of the Greek New Testament* (Grand Rapids: Kregel, 2008), 119.

needs, just as he did at the feeding of the five thousand and the four thousand with multiplying fish and bread.

Farming

Among his followers were farmers, shepherds, and homemakers, and Jesus uses many images from these occupations throughout his teaching. To him, his followers are like oxen exchanging a heavy yoke of sin and the ritual law's burden for his light yoke of repentance and obedience (Matt. 11:28–30). People are also trees who bear good or bad fruit (Matt. 7:16–20; 12:33; Luke 6:43–45), while his opponents are like "the offspring of snakes" a farmer might turn over in a field (Matt. 12:34). Jesus himself is like a mother hen who wants to gather up Jerusalem's citizens like chicks who need protection (Matt. 23:37). He is also like a vine to which his followers must stay attached to flourish (John 15:1–17). In this extended metaphor, God his Father is the vineyard tender, Jesus is the vine, and people the branches—either fruitful or not, depending on their connection to him. This is an illustration of Jesus as humanity's life giver, as John 1:4 explains. But, as John 1:11 laments, he was not welcomed, so he mourns in Matthew 8:20 (Luke 9:58) that he is more homeless among his own people than the temporarily sheltered fox or bird.

His coming death he depicts as a wheat grain dying to enter a new stage of fruitfulness (John 12:24). So, his life-giving ministry is also rendered in farm terms: healing, especially on the sabbath, is paralleled with watering a donkey (Luke 13:15–16) or retrieving an ox or even a child from a pit (Luke 14:5). To Jesus, this should be intelligible to people who, when asked for an egg, would not give their own child a scorpion (Luke 11:12).

As noted, parables are simple analogical stories, extended metaphors and similes, with a strong spiritual or moral point. Jesus' first ones are almost brief sayings—sewing a patch on a garment or pouring wine in a leather flask (Matt. 9:16–17; Mark 2:21–22; Luke 5:36–39)—but they soon become developed illustrations. They are so poignant that many nations' literatures are built on them, for example, "the good Samaritan" (Luke 10:30–37), presented at an angle to correct a lawyer attempting to justify himself (vv. 25, 29); or "the rich fool" (Luke 12:13–21), aimed at every form of greed, precipitated by a brother angling for part of an inheritance. With this anchoring tale, he extends his teaching with a series of complementary illustrations involving farming and nature imagery: birds that do not harvest but eat well (Luke 12:24), or lilies that do not manufacture textiles but are lovelier than the greatest king's finery (vv. 27–28). Jesus also presents the misadventure of "the prodigal son"

(Luke 15:11–32), who envied the food of the pigs he tended, a lesson on God's salvaging sinners. It ends, as in the case of the reluctant prophet Jonah, with a judgmental elder son challenged to forgive (cf. Matt. 12:39–41; 16:4; Luke 11:29–32). He also describes "two praying men" (Luke 18:9–14), a tax collector and a religious leader, and teaches that humility before God is necessary for forgiveness. The "parable of the sower" is one of Jesus' most developed and intriguing illustrations (Matt. 13:3–23; Mark 4:2–20; Luke 8:4–15). The point of this early parable is to help those being saved to understand what is happening to them. In that sense, it is a kind of performatory utterance. Jesus is sowing truth among them. Those being saved understand the seed on good soil represents the faith growing within them that Jesus is planting, while those who are lost do not understand that their shallowness does not support good growth. That is why their spirits wilt and their loyalty to him fades in the face of opposition and worldly concerns.

Still, Jesus' art can be so obscure to the untrained mind that even those being saved are confused, so he must interpret the point of his parables to his disciples. They welcome Jesus' plain speech, but it comes with a warning. If they do not understand this parable, he cautions in Mark 4:13 (see also Mark 4:23–25; Luke 8:18), how will they figure out all the teachings he will be encasing in his parables? Jesus' concern is central, because the point of this present parable, as of so much of his illustrated teaching, is the spread of God's kingdom.

When my wife and I were researching *The Prayer Life of Jesus,* we were amazed at how many references to the kingdom of God appear in Jesus' teaching, some 148 or so that we counted.[19] Particularly, these occurrences are in the parables or presented analogically. For example, Mark 4:26–29 notes God's reign spreads like a seed that springs shoots overnight. Satan tries to stop the good growth, recounts the parable of "the wheat and tares," by sowing weeds in among the wheat, infiltrating the church with predators and hypocrites (Matt. 13:24–30). Though it begins as the smallest seed that the Jewish farm folk used, God's reign eventually overpowers all other growth and becomes a haven of refuge (Matt. 13:31–32; Mark 4:30–32; Luke 13:18–19), an image Jesus also uses for faith (Matt. 17:20; Luke 17:6).

19. William David Spencer and Aída Besançon Spencer, *The Prayer Life of Jesus: Shout of Agony, Revelation of Love, A Commentary* (Lanham, MD: University Press of America, 1990), 19.

Jesus illustrates the work of God's rule as planting and harvesting. Serving Jesus is a lot like plowing (Luke 9:62). Jesus' followers gather for God's kingdom, while others scatter (Luke 11:23). God roots out satanic weeds that the Father did not plant (Matt. 15:13). God is master of a field who hires laborers at God's chosen wage, each recompensed equally with grace (Matt. 20:1–16) to bring sinners in from the fields (Matt. 9:37–38; Luke 10:2). The devil, of course, wants to do his own form of harvesting, seeking, for example, to grind Peter like one sifts wheat (Luke 22:31).

Sinful humanity makes God's harvesting difficult. The tale of the vineyard owner with one son who is initially unresponsive but later repentant, and the other story of an easy-promising slacker (Matt. 21:28–32), teach the importance of keeping one's vows to God. The parable of the unruly tenants at harvest who kill the vineyard owner's own son is a prophetic warning to the temple authorities to reconsider what they are plotting to do to Jesus (Matt. 21:33–41; Mark 12:1–9; Luke 20:9–16). His hearers realize that those who attempt to thwart the spread of God's kingdom deserve to die at God's hands—and the kingdom will spread anyway (Matt. 21:41).

Therefore, not all of God's harvesting will result in salvation. The fig tree that does not yield is in danger of being uprooted (Luke 13:6–9). The more embattled Jesus becomes, the more he seems to rely on metaphors and imagery, and the more ferocious some of these warning illustrations become. He cannot become more graphic than he does when he curses the fig tree, and it withers for being unfruitful (Matt. 21:18–22; Mark 11:12–21). Like the weather image he hands to the Pharisees and Sadducees when they gang up on him and demand a sign (Matt. 16:1–4), the fig tree tells the season, if one knows how to read it (Matt. 24:32–33; Mark 13:28–29; Luke 21:29–31). Jesus can turn even agricultural images into graphic warnings.

Shepherding

Another rich source of imagery for Jesus was sheepherding. The people, he considers, are like "sheep without a shepherd" (Matt. 9:36; 10:6; Mark 6:34). His little flock of followers (Luke 12:32) contrast as sheep struggling against opponents, who are depicted as wolves (Matt. 7:15; 10:16; Luke 10:3). He hopes they will become as wise as serpents while remaining as gentle as doves (Matt. 10:16).

He himself is like a trustworthy shepherd; his sheep will know his call (John 10:25–30). He heals them as a shepherd lifts a sheep from a pit, whether it is the sabbath or not. In fact, he makes a point of healing on the sabbath to

underscore that part of his loving nature (Matt. 12:11–13). He will even leave the ninety-nine to go and find a straying one (Matt. 18:12–14; Luke 15:4–7). Contrasting with the thieves and robbers who came before, Jesus will die for his sheep's safety (John 10:1–18). In fact, he announces the hour of his passion is here by referencing Zechariah 13:7, where the shepherd is struck, and the sheep are scattered (Matt. 26:31; Mark 14:27).

After his resurrection, Jesus' concern appears to be solely for his flock. In one of his final charges to his disciples, Jesus tells Peter three times in succession to "tend [or herd, *boskō*] my lambs," so that the vacillating disciples will take this task to heart (John 21:15–17). Jesus warns he will take the work back over eventually, this time as a herder separates sheep from goats, assigning some to everlasting life and others to eternal death (Matt. 25:31–46).

Cooking

Jesus expands his rich illustrative detail from the farmyard to the courtyard, where sifted grain is prepared and baked into bread. The culinary arts run through his illustrations.

Salt is a recurring image. Sometimes it is negative: the damned are salted with fire (Mark 9:49). At other times it is positive: the good are filled with salt that causes pleasant relations, as salt preserves food and makes eating it pleasant (Mark 9:50). Thus, his followers need to stay pure so they can season the world, not becoming adulterated with sin or completely sidetracked by worldly concerns and commitments and therefore useless to God (Luke 14:34–35).

He speaks of his suffering as drinking a cup (a recurring OT image is God's cup of wrath and punishment: Ps. 75:8; Isa. 51:17, 22; Jer. 25:15–17; 49:12; see Matt. 20:22–23; Mark 10:38–39). As with grain or wine, the Pharisees have been filling up (*plēroō*) the "measure" (*metron*) of guilt (Matt. 23:32), and that adds to this "cup" with which he struggles with his Father over drinking in his Gethsemane prayer (Matt. 26:39, 42; Mark 14:36; Luke 22:42; John 18:11). John notes Jesus must drink that cup of guilt and destruction for humanity, so Jesus announces on the cross: "I am thirsty" (John 19:28). Immediately after he receives that symbolically sour wine, he dies (John 19:30).

Jesus has drained the dregs of punishment for humanity, so he can serve his followers that post-resurrection meal, showing them that God will continue to provide for their needs spiritually and physically (John 21:1–23), just as one day they will drink the wine of salvation with him in God's kingdom (Matt. 26:27–29; Mark 14:25; cf. Luke 22:20; 1 Cor. 11:23–26).

Bread preparation begins with grain and yeast, and Jesus has both a positive and negative take on the imagery of yeast. Leaven spreads throughout a mound of dough, changing its composition. So, for Jesus it can be positive as it depicts the spread of God's reign throughout earth (Matt. 13:33; Luke 13:20–21), or it can be pernicious, as was the false teaching of the Pharisees, which had become so widespread (Matt. 16:5–12; Mark 8:14–21; Luke 12:1).

Bread serves Jesus as a metaphor very early on; he used this basic, physical staple to represent spiritual nourishment (Matt. 6:11; Luke 11:3). When the crowds who have recently eaten his miraculous gift of bread in the wilderness connect it with Moses' feeding Israel with manna in the desert, Jesus picks up their reference and reinterprets it for them in John 6:30–59. First, he explains, "Not Moses . . . but my Father" gives you "the true bread out of heaven" (v. 32). Second, the only bread they get now from God "is that which comes down out of heaven, and gives life to the world" (v. 33). They are excited and beg Jesus, "Lord, always give us this bread" (v. 34), and he replies, "I am the bread of life" (v. 35). That is not what they want to hear, and they grumble, "How is this one able to give us his flesh to eat?" (v. 52).[20] Does Jesus explain his metaphor? No. He just goes on provoking them, extending his analogy, "Truly, truly, I say to you, unless you eat the flesh of the Son of Humanity [anthrōpos] and drink his blood, you do not have life in yourselves" (v. 53).[21]

The end result? A ministry disaster for church-growth experts: "Because of this, many of his disciples left" (v. 66). But Jesus, using his artful approach, is winnowing out those who really do not believe (v. 64) so he could concentrate on the truly called, who would be protected and empowered by God to survive the devil's own pernicious winnowing when hard times come. So Jesus uses a tale about a man begging bread from his neighbor to teach persistence in prayer (Luke 11:5–10).

So great an impression did Jesus make when breaking and blessing bread that, after the resurrection, his breaking of bread was the symbolic moment in which Cleopas and his companion from Emmaus recognized Jesus (Luke 24:30–31). Thus, along with the fish, he feeds his disciples bread at the final

20. The early manuscripts Papyri[66] and the codex Vaticanus include "his," but P[75] in a passage hard to read and codex Sinaiticus omit it. Bread becomes key to Jesus' teaching, as he used this basic physical staple to represent spiritual nourishment (Matt. 6:11; Luke 11:3).

21. The term Jesus uses, anthrōpos, is inclusive, referring to all human beings, not the sex-specific anēr, which would specify male or man. So, "Son [huios, which is sex-specific, since Jesus became a male human on earth] of Humanity" would be a more accurate rendering of what he is communicating: that he is a full human being, even though completely divine, and, as Ezekiel before him, the representative emissary of God (Ezek. 2:3–8).

seaside meal (John 21:13), teaching them one last time that God will provide their nourishment, both physical and spiritual.

Family

Family metaphors figure all throughout Jesus' teaching. In a way, the entire incarnation can be seen as a metaphorical performative utterance, as Jesus, who dwells in eternity as a full person of the Godhead, enters creation by becoming a baby to demonstrate what a perfect child of God should be like (John 3:31–36). Jesus uses this relationship as a teaching tool throughout his ministry (e.g., Luke 10:22; 22:70), and it gets him into terrible conflict with the Pharisees, who realize sonship means a claim of equality with God (John 5:18). They attack his parentage, snidely asserting they know who their fathers were, legitimate Jews, making them officially recognized sons of Abraham. But since everyone knows that Joseph is not Jesus' biological father, they reject Jesus, calling themselves legitimate sons of God and refusing to believe in the Holy Spirit's direct intervention in Jesus' birth (see the battles in John 8:19–59).

But Jesus is not daunted if they doubt and attack the truth about his origin. He still goes right on and uses the information about his holy birth didactically to teach Nicodemus (John 3:16), pointing out what it takes spiritually to be God's child. To the disciples, he explains God gives good gifts to God's children (Matt. 7:9–12; Luke 11:13), so one must be childlike and innocent of sin to please God (Matt. 19:14; Mark 10:13–16; Luke 18:15–18).

Jesus also uses familial metaphors to describe his relationship with humanity. We saw how he employs the Old Testament image of humanity's Son in his New Testament teaching (Matt. 9:6; 20:18, 28; Mark 2:10; 10:33–34; Luke 5:24; 18:31; John 9:35–37; 12:23). He also paradoxically refers to humans as his children, calling the paralytic man who is lowered down to him "child" (*teknon*, Matt. 9:2; Mark 2:5). He notes he does not want his followers to be abandoned orphans (John 14:18), though Judas is a son of destruction (John 17:12), and the Pharisees' father he calls "the devil" (John 8:44). After the resurrection, Jesus calls his disciples "children" (John 21:5, *paidion*), a fact that is literally true since he created them and was returning to his glory as their God. Of course, they were literally young men (as was Jesus when on earth).

Finance

Very powerfully, Jesus uses these metaphors from occupations we have seen so far, but he is not limited to the working population in his data. He

was a keen observer who noticed everything around him, and all of it became material for his marvelous sayings and memorable stories.

To explain the sovereign God to his hearers, he pictured a king forgiving a debt (Matt. 18:21–35). Robert Thomas and Stanley Gundry point out that Jesus spoke in the temple treasury, "that part of the court of women in which thirteen trumpet-shaped collection boxes were located (cf. Mark 12:41, 43; Luke 21:1). This court was a gathering place for both sexes, and teaching was permitted there." They add, "Interestingly, it was quite near the meeting hall of the Sanhedrin, the official council of Judaism that was determined to dispose of Jesus."[22] We have already noted he used the metaphor of a person's nature as one's treasury (Matt. 12:35; 13:52; Luke 6:45).

Therefore he uses financial stories like "the tale of the talents" (Luke 19:11–27) to teach people to use their God-given gifts to work for God's kingdom. And, while teaching his disciples, he also edifies the Pharisees—who, Luke 16:14 tells us, were "loving possessions"—with the clever account of the wasteful manager who makes friends with his master's creditors by "cooking the books" as a backhanded lesson to make friends with God by currying God's favor with acts of generosity (Luke 16:1–15). He hammers that point home with a tale of what happens to a rich man who does not use money kindly and wisely to impress God by caring for the poor sufferer at his gate, and ends up suffering himself in hell (Luke 16:19–31). Pleasing God is banking in heaven (Matt. 6:19–21; Luke 12:32–34). That treasure is unassailable and worth everything one has, like selling all to obtain a treasure found in a field (Matt. 13:44). As a result, true servants make wise spiritual investments in advancing God's reign as they wait patiently for it (Matt. 25:14–30; Luke 19:11–27), no matter how arduous that investing might become (Luke 6:20–23). Some day that generosity will be returned by God just the way an employer pours a full recompense into the lap of an employee being paid and honored for hard work and good service (Luke 6:38). Knowledge itself is an accessible treasure chest, for it has a key (Luke 11:52).

Governing

As a king himself (John 18:36–37), Jesus can speak with familiarity of kings and rulers, despite being reared in humble circumstances. He begins preaching with a governmental metaphor: the kingdom (or reign or rule) of God in Mark 1:15 (or kingdom of heaven in passages like Matt. 4:17). This

22. Thomas and Gundry, *Harmony*, 133, note d.

metaphor extends throughout his preaching (e.g., Matt. 12:28; 16:28; Mark 9:1; Luke 8:1; 9:27; 10:9–11; John 3:3, 5). I call this a metaphor because God is not merely a king—God is God. Kings do not create their subjects or rule from eternity, or make universal decrees that affect all inhabitants of all worlds.

Jesus fills his teaching on the kingdom with rich picture language. His kingdom has keys (Matt. 16:19), and a child illustrates what its citizenship is all about (Matt. 18:1–5; Mark 9:33–37; Luke 9:46–48).

Jesus sees a correspondence between the earthly reign he is setting up spiritually and the heavenly one over which the Godhead presides. What is done in God's earthly kingdom is done in the heavenly one (Matt. 16:19). Eventually, citizens of this realm will feast with Jesus there (Matt. 26:29; Mark 14:25).

Jesus' kingdom is at war with Satan's (Matt. 12:22–29; Mark 3:22–27). Therefore, when choosing to follow him, one must assess, as an earthly king does before waging war, if one has the strength (Luke 14:31–33). Satan's kingdom is entrenched; it has set up battlements behind which are imprisoned the people of this world. Jesus' kingdom is the invading force that smashes into those gates and breaks them down. They cannot resist it (Matt. 16:18).

How important is this message to Jesus? He invests the forty-day, final briefing, post-resurrection period in teaching about the kingdom of God (Acts 1:3). So, it is central to his mission.

Similarly, Jesus is clearly Earth's lord and master, even when he is washing his disciples' feet to teach them to serve one another (John 13:3–17). Therefore, he is comfortable in using many illustrations and employing many demonstrations to depict how he expects his followers to serve him, drawn from the examples of servants and masters they see around them.

For example, he is like a master, and his followers are like servants who await him in the night (Luke 12:35–48). As householder, he locks people out who have not entered in the proper manner or time (Luke 13:24–30), like the wedding guest who shows up in inappropriate clothing (Matt. 22:11–13); foolish maidens insufficiently prepared to persevere until the bridegroom arrives (Matt. 25:1–13); or the disrespectful business tycoon who spurns the summons, kills the messengers, and will be replaced by beggars (Matt. 22:2–10; cf. Luke 14:16–24).

Jesus expects his servers to attend him (Luke 17:7–10) and serve no other master (especially not money) (Matt. 6:24). They need to be watchful, as does the master who must be away and does not know when a thief will strike (Matt. 24:42–44). This analogy is used by Jesus for the sudden coming of the end of the age. The master will arrive, and the servants will be surprised if

they are not watchful (Matt. 24:45–51; Mark 13:34–37). So, despite being persecuted, as was their master, good servants need to be steadfast in love (John 15:9–14). For those who persevere in faithful service, Jesus the master can also elevate faithful servants to the status of friends (John 15:15–17).

An Arsenal of Images

Jesus employs images from carpentry, fishing, farming, shepherding, cooking, family, finance, and governing. But even these do not exhaust the range of Jesus' knowledge. In addition, he draws from many wells of human activity for his illustrations.

He taps into current events, like the recent Galileans killed by Pilate or workers crushed by a toppling tower (Luke 13:1–5). He summons up urban images, representing heaven as entering a narrow city gate (Matt. 7:13–14; Luke 13:24). Hunting images depict the end times that spring on humanity like a trap snapping shut (Luke 21:34). He employs craft metaphors to explain the Pharisees are like pottery: clean on the outside, filthy within (Matt. 23:25–26; Luke 11:39–41).

He employs legal references, counseling his hearers to settle with an opponent before a trial (Matt. 5:25–26; Luke 12:57–59), warning that God's court is stricter than any human court (Matt. 5:20–22). But it is also much more merciful than the court of "the unjust judge" (Luke 18:1–8). So if their corrupt magistrates may be moved by perseverance, the faithful can expect so much more the perfect judge, God, will be moved by persistent prayer.

We have seen Jesus use meteorological images for the end times. He uses one to describe Satan falling like lightning from heaven, when the seventy-two he sent out to preach return (Luke 10:18).

A favorite image for Jesus is light. He is the light of the world (John 8:12; 9:5; 12:35–36, 46), encapsulating his whole mission for Nicodemus by this imagery, explaining God's light—Jesus himself—has come into the world and is revealing the true nature of human actions (John 3:19–21). Jesus' teaching is a lamp that must not be hidden (Mark 4:21–23; Luke 8:16–17). It provides the understanding that is like a light that illuminates one's body (Matt. 6:22–23). And his second coming will be sudden, as the lightning that illuminates the sky (Matt. 24:27; Luke 17:24). The next several chapters will explore the use of this light imagery more thoroughly.

As the divine physician, Jesus draws metaphors from the curing or medical arts, practicing the art of healing (Mark 6:55–56). For him, even the dead are only asleep (Matt. 9:24; Mark 5:39; Luke 8:52; John 11:11), for he is a doctor who can actually give life. Some of his therapeutic actions seem very strange

to contemporary medical practice, as putting fingers in deaf ears and spittle on blind eyes or dumb tongues (Mark 7:33–35; 8:22–26; John 9:1–11). But as the blind are given sight, the hearing-impaired hearing, and the disabled mobility, Jesus is demonstrating through action what his life-giving words are revealing: God's kingdom has come among us (e.g., Matt. 15:31; Mark 7:37). He also uses blindness as a metaphor to contrast himself with the Pharisees' recalcitrance (Matt. 23:17–24; cf. John 9:39–41). He is the exact opposite of the false teachers, who fall blindly with their spiritually sight-impaired students into the pit of ignorant, catastrophic error (Luke 6:39). When the Pharisees complain that Jesus eats with sinners, he employs imagery to portray himself as a doctor treating patients (Matt. 9:12; Mark 2:17). And a medical metaphor of a woman suffering birth pangs describes for him the natural cataclysms of the end times (Matt. 24:8; Mark 13:8).

JESUS ALSO USES ARTFUL TECHNIQUES IN DISCUSSIONS

What makes Jesus' skill as a storyteller so interesting is that he does not simply employ the technique for public discourse but private instruction as well. In addition to his puzzling reference to being lifted up for healing as Moses' wilderness snake so that everyone may have "life eternal" (John 3:14–15), he baffles Nicodemus with two metaphors, one personal (a birth motif to describe enrolling in the coming kingdom of God) and the other natural (the wind for the Spirit of God at work) (vv. 3–8). Nicodemus misunderstands the first (v. 4) as well as the second (v. 9), as will everyone else, including his disciples. All were assuming Jesus as Messiah, rather than insisting on their rebirth into a heavenly kingdom not of this world (John 18:36), had been born to replace Herod and overthrow Rome (Acts 1:6).

Similarly, Jesus mystifies the Samaritan woman, building a spiritual lesson out of asking her for a drink by offering her eternal water. As the baffled Nicodemus objected that he's too grown to fit back in his mother's womb (John 3:4), she too is confused, unable to see how anybody without a bucket could put living water inside her (John 4:11). Then, while the Samaritan woman is rushing back to tell her friends about the man who offered her "living water," Jesus extends the comestible metaphors to his disciples, telling them he does not need further nourishment than the "food" (John 4:31–32) they know nothing about. This prompts them to ask each other if anyone had brought him something to eat (v. 33). What a week! In two chapters he has confused over a dozen people who have conversed with him.

When a prostitute anoints his feet with perfume and tears, Jesus explains her actions to the affronted Pharisees with a tale about a money-lender's two defaulting clients, bringing his host to the realization that those who are forgiven much are filled with great gratitude (Luke 7:36–50). Even at his ascension, at the last utterance Luke records, Jesus is employing a tailoring image, promising his followers will be clothed (*enduō*) with power (Luke 24:49).

So, all these images enrich Jesus' teachings. But he does not stop with words. He takes his presentation a step further. For Jesus, in public or in private, his message of repentance and forgiveness is illustrated in work as well as word. He acts his words out dramatically: Jesus is an actor, and his stage is real life.

Drama

Jesus often illustrated his powerful speeches in action, even recommending symbolic gestures to his followers, such as shaking the dust off their feet as a testimony against their rejectors (Matt. 10:14; Mark 6:11; Luke 9:5; 10:11). From the very first miracles at the wedding of Cana (John 2:1–11), where wine presages communion (1 Cor. 11:25–26), and the feedings of thousands illustrated divine compassion (Mark 8:1–9), Jesus makes his miracles literal events that are symbolic actions as well. Cleansing the temple was also one such symbolic action. "Destroy this temple," he cries, "and in three days I will raise it" (John 2:19).

His greatest drama comes in his passion, when he illustrates in the most graphic way the love of God for humanity: the sacrifice of the sinless paschal lamb for fallen humanity (see John the Baptist's identifying of Jesus as such in John 1:29, 36). He has told people repeatedly they must carry a cross to follow him (e.g., Luke 14:27). What was metaphorical is now actual (John 19:17).

When he dies and is resurrected, the drama envelops the onlookers as the temple veil tears in two, the earth quakes, the sun is darkened, the dead saints are raised,[23] and the wise realize that his symbolism has been actualized in the

23. One eyewitness, the articulate apologist Quadratus, in his defense of the faith to Trajan's successor, Emperor Hadrian (AD 117–138), affirms, "Our Savior's deeds were always there to see, for they were true: those who were cured or those who rose from the dead were seen not only when they were cured or raised but were constantly there to see, not only while the Savior was living among us, but also for some time after his departure. Some of them, in fact, survived right up to our own time" (Eusebius, *Church History* 4.3). No one who wanted to stay alive lied to a Roman emperor, so such a bold and clear statement was undoubtedly true.

natural world (Matt. 27:51–54). What would have remained symbolic for a mere human becomes actual for Jesus. Humans speak of healing; Jesus cures. Humans speak of living again; he raises the dead. Humans speak of expiation; he dies for humanity. And he leaves behind him one great installation to continue his work: the church.

SUMMARY

Was Jesus an artist? Yes, clearly, as the Gospels reveal:

1. Jesus is a crafter of worlds and words.
2. He is introduced with music.
3. He alludes to music and dance. He may have sculpted in wood and may have even drawn. And he could cook.
4. He was clearly a speaker of consummate skill and a storyteller of unforgettable tales.
5. He was a performing artist who amazed the crowds with his symbolic actions, a dramatist who acted dramas out in real life.
6. Did Jesus use his words and works to enlighten his audience about himself, his heavenly Father, and even the Holy Spirit? Yes.

This data illuminates why Jesus did what he did in the way he did it. But is his example also encouraging to Christians today? Should preachers, teachers, evangelists, artists use imagery to depict spiritual truths about the nature of God and do so boldly, with confidence, and dedicated to Jesus as they follow his leading example? Or was such revelation through art limited only to Jesus, the divine revealer of God's truth? Do we have any precedents?

OTHER BIBLICAL PRECEDENTS

In Genesis 4:26, we see humanity apparently being give a name by which to call on God. But, at the same time, in Genesis 16:13–14 we see Hagar, cast off from the house of Abraham, giving a name to God, ʼel ra'i ("God sees me"). Not only does God not rebuke her for such an act, but God promises her a child, albeit one who will be in conflict with others. A well is even christened from the name she gives God at the desert place where she takes refuge (v. 14). Often, as in this case, God is known by describing the action God is doing for God's people, such as God who led or delivered the people out of slavery (commemorated in Moses' naming a child and repeated in his report to his father-in-law, Jethro, and in Jethro's response

in Exodus 18:4, 8–12 [cf. 3:7–10; 6:6–8; 14:13–14],[24] and the name to which Hannah vows in 1 Samuel 1:11: God, the Lord of hosts (*tsaba'*, "army," given both to an earthly troop or heavenly troop).[25] One exemplary, pervasive metaphor that spans the testaments is God as the bridegroom and husband of Israel (Isa. 62:4–5; Jer. 3:14; and the entire book of Hosea), an image Jesus applies to himself in Matthew 9:15, Mark 2:19–20, and Luke 5:34–35.[26]

In the New Testament, John the Baptist heralds the coming of Jesus with agricultural imagery as a thresher with a winnowing fork, clearing his threshing floor, gathering wheat, and burning chaff (Matt. 3:12).

Jesus' stepbrother James fills his book with imagery to describe God's relationship to humans. In James 1:12, God, like an emperor, awards a "crown of life" to faithful winners of the "race" of faith. In her commentary on James' epistle, Aída Besançon Spencer notes a significant difference between the earthly referent and the heavenly symbol: "In an athletic contest, only one winner receives a crown. But from God there is no limit of crowns, and each persevering believer receives one crown."[27] Also in James 1:18, we see God alluded to as a farmer, raising believers as "first fruits" of what God creates. The farmer image continues in 1:21 as God's "word," like a seed of life, is "implanted" (*emphutos*) in those God chooses.[28] Another beautiful image is the "Father of lights," in whom is no "changing shadow" (1:17) as one sees in heavenly bodies, like the stars changing positions.[29] The Father not only gives "every good gift and every perfect [*teleos*, also 'complete and whole'] gift" but

24. People also felt free to indulge in this spirit of naming with each other, as Zipporah did, labeling Moses "a bridegroom of blood" (Exod. 4:25).
25. Herbert F. Stevenson considers this title "one of the most important" and "most frequently used in Scripture" in his helpful compendium *Titles of the Triune God: Studies in Divine Self-Revelation* (Westwood, NJ: Revell, 1956), 51. See also an interesting discussion of God's titles in Aída Besançon Spencer, "The God of the Bible," in *The Global God: Multicultural Evangelical Views of God*, eds. A. Spencer and W. Spencer (Grand Rapids: Baker, 1998), 21–36.
26. Warren W. Wiersbe in his *Index of Biblical Images: Similes, Metaphors, and Symbols in Scripture* (Grand Rapids: Baker, 2000) divides verse references with images into categories, e.g., under "Bridegroom" is listed "Israel," "Rejoicing," "The Sun," and "Christ" (21).
27. Aída Besançon Spencer, *A Commentary on James*, Kregel Exegetical Library (Grand Rapids: Kregel Academic, 2020), 74.
28. Spencer, *Commentary on James*, 87–96.
29. See *Aposkiasma*, BDAG, 120, "a shadow cast by variation (in position of heavenly bodies)." See also *parallagē*, "change, variation," noting James' astronomical application of this word is rare, BDAG, 768, as is James' equally rare use of *tropē* as "darkening that has its basis in change," as in "the 'movements' of heavenly bodies fr[om] one place in the heavens or fr[om] one constellation to another," BDAG, 1016.

also has made Scripture's "royal" law (2:8–11; cf. 4:12). God is the perfect regal Judge whose rule we should all be following.[30]

Similar to James, the author of Hebrews also pictures competing for a prize in a stadium before witnesses when speaking of life's spiritual journey as running (*trechō*)[31] in an "athletic competition" (*agōn*, also "contest, race,"[32] Heb. 12:1–2).

The apostle Paul, directly after he carefully spells out his elaborate allegorical (*allēgoreō*) illustration of Hagar and Sarah representing the old and new covenants to the Galatians (Gal. 4:21–5:1), also turns to the same image of running a race (*trechō*)[33] to urge the Galatians to keep pursuing freedom in Christ from the ritual law (i.e., practicing circumcision) (Gal. 5:2–12). As Paul explained earlier, he himself has been "running" (*trechō* again) his own race of faith (Gal. 2:2, see also Phil. 2:16). In a similar manner, Paul also advises the Corinthians to train and run (also *trechō*) like athletes in a competition to win an eternal crown from God, as he is doing to partner with the gospel (1 Cor. 9:24–27). Each of these illustrations summons up a picture of a race in a stadium, depicting the faithful as athletes seeking to win an eternal crown from God, who is like a rewarding eternal "emperor."

Paul, of course, steeps his letters in metaphorical language, providing a variety of illustrations for God. In another memorable image, Paul depicts God like a victorious general, leading the church in a victory procession in Christ's triumph (2 Cor. 2:14).[34] And particularly heartwarming is his description in Philippians of God as "our Father," not just Jesus' (1:2).[35]

Now, one might argue that this small sampling is all from inspired Scripture, so wouldn't that be parallel to hearing the unique words of Jesus? The source would still be exclusively divine revelation. Can we find any proof that the practice of transferring the use of imagery for God from Scripture was

30. Also see Spencer, *Commentary on James*, for an illuminating exposition on these points (81–87, 230–34).
31. *trechō*, BDAG, 1015.
32. *agōn*, BDAG, 17.
33. Along with imagery like depicting yeast as a bad influence (Gal. 5:9).
34. This image among a variety in 2 Corinthians is explored in Aída Besançon Spencer, *2 Corinthians*, The People's Bible Commentary (Abingdon, UK: Bible Reading Fellowship, 2001), 56–57, but discussion of Paul's images for God is spread throughout the book.
35. While we are considering the linguistic insights of Aída Besançon Spencer, for an interesting summary of Paul's use of metaphorical language and imagery, see her *Paul's Literary Style: A Stylistic and Historical Comparison of II Corinthians 11:16–12:13, Romans 8:9–39, and Philippians 3:2–4:13* (New York: University Press of America, 1998), 132–35, 179–82.

considered valid by the church in noncanonical writings? To address this issue, we do have an ideal example in a letter attributed to a companion of Paul who wrote outside the New Testament canon, thus bridging the realms of Scripture and noncanonical instructive and devotional writing.

In Philippians 4:3, Paul highlights Clement as his coworker (*sunergos*, or "fellow worker") whose name is in the "Book of Life." Eusebius, the early church historian, notes that Dionysius, the overseer of the church at Corinth in the AD 100s, mentions in a letter to Soter, overseer of the church at Rome, that he was accustomed to read Clement's "Letter to the Corinthians" at church: "We read your letter today, the Lord's Day, and shall continue to read it frequently for our admonition, as we do with the earlier letter Clement wrote on your behalf."[36] The Loeb Classical Library edition of the earliest writings of the early church outside the New Testament that includes 1 Clement suggests the letter is written "in the mid-90s during the reign of Domitian": "If this dating is correct, then 1 Clement was produced at about the same time as or even before some of the writings of the New Testament (e.g., 2 Peter, and Revelation). . . . This makes aspects of the letter highly significant for historians interested in the development of the Christian church in the earliest period."[37]

For our study, the significant aspect would be whether Clement uses imagery to discuss the persons of the Trinity. He does. He uses the word *plēroō* for filling a vessel with water, a sail with wind, a body with breath, or a container with food,[38] or even "to flood"[39] when he introduces the Holy Spirit (1 Clem. 2:2). For Jesus, he uses the image of the shepherd and the regal image of the "sceptre" (*skēptron*)[40] of God's "magnificence" (from *megalunō*, "make great by word, extol, magnify")[41] (1 Clem. 16:1–2), and the "radiance" of the master's magnificence (36:2). If ignored, God is like a rapacious lion (*leōn*; the English word is a cognate) from whom no one can be rescued (35:11). Conversely, the most high is also the defender (or "champion," *hupermachos*)[42] and protector

36. Eusebius, *Church History* 4.23.
37. Bart D. Ehrman, "First Letter of Clement to the Corinthians: Introduction," in *The Apostolic Fathers, Vol. 1* (Cambridge, MA: Harvard University Press, 2003), 25. Also see Michael W. Holmes, *The Apostolic Fathers: Greek Texts and English Translations,* 3rd ed. (Grand Rapids: Baker, 2007), 23–36.
38. E.g., "having poured wine into the vessel," LSJ, 1420.
39. Thayer, 517. The Loeb edition translates the phrase "a full outpouring of the Holy Spirit" (1 Clem. 2:2).
40. Also "staff, stick, baton, badge of command," LSJ, 1609.
41. *megalunō,* LSJ, 1088.
42. LSJ, 1866.

(*huperaspistēs*, "one who holds a shield over")[43] (45:7) of those who are obedient; God, our Master (*despotos*, as in the English cognate "despot," 59:4), is our "Heavenly King" (*Basileu tōn aiōnōn*)[44] (61:2). Like a farmer, God will gather them and their children to the grave like harvesting an "all-nourishing" (*pambotos*) "herbage" (*pambotanon*)[45] (i.e., domesticated food plants) and grain, wheat, and barley[46] in due season.[47] Another image is of a harvested "heap"[48] of grain on a "threshing floor" (*halōnia*)[49] (56:14–15). Such maturing is what our master accomplishes through rearing, training, and teaching us (*paideia*)[50] with instruction hallowed by divine law (*osios*)[51] (56:16). Clement stresses that included in salvation will be those who follow the commandments of the triune God (58:2).

Thus, given its modeling by the prophets of the Old Testament, its use by Jesus and the New Testament writers, and its transition to the early church by the seminal writer Clement and those who follow him, the use of metaphorical language to illustrate God's nature and the way God is at work in the world and in our lives, we can safely conclude, is initiated, legitimate, and approved by God.

In the next two chapters, we will sample some of the orthodox and heterodox interpretations that happened in the early church to a favorite, primal, biblical image for the triune relationship of the Father and the Son as a test case for why we need to be careful with the theologies we convey when we use imagery to explain the Trinity's nature.

43. LSJ, 1859.
44. *basileus*, LSJ, 309.
45. LSJ, 1294.
46. *sitos*, LSJ, 1602.
47. *ōprios*, LSJ, 2037.
48. *thēmōn*, LSJ, 798.
49. LSJ, 75.
50. LSJ, 1286.
51. LSJ, 1260.

CHAPTER 4

IMAGES OF LIGHT FOR
THE TRIUNE GOD

The image of the sun and its effects to depict the Trinity has been a favorite among many of my students who believe in using images. Some simply ticked this analogy off as a given, almost like a universally accepted formula. The emphasis here is the sun as source and its properties as distinct but unified with it. Light and sun as biblical images for God have been used through history by orthodox and heterodox proponents alike. In this chapter we will examine the Bible's general use of light imagery and then focus in the next chapter on the analogy of the sun and its radiance in the book of Hebrews.

My students' interpretation of this image was often expressed in a more scientific direction, since these are working adults with occupations sometimes in the sciences: "Rays, gas, energy of the sun, light rays, chemical rays, heat rays—felt but not seen." One also added the "ice, water, and vapor" image as a second entry. We will be examining that one in our upcoming chapter on kinetic, that is to say, moving or mutating images of the Trinity.

The use of images to teach new Christians about the nature of God needs to be unpacked for those we disciple to make certain they know exactly what we mean. The three distinct persons of the Trinity are all indeed one God. To look carefully at how the Bible unpacks the theology of its metaphorical imagery of light is itself enlightening.

LIGHT AS AN IMAGE

Light, of course, is a pervasive image employed for God's presence in the Bible. Fire in a bush that would not be consumed first introduced Moses to God (Exod. 3:2–6). Then, in Deuteronomy 5:4–5, Moses reminds the Israelites that God also spoke to them out of fire when delivering the commandments, defining what they should believe and how they should live. This fire, Jesus announced, he had come to bring to earth (Luke 12:49), and his return would be like lightning, visible to all (Luke 17:24). For "in him was life, and the life was the light of all people" (John 1:4), a light that "in the darkness shines, and the darkness has not overtaken it" (*katalambanō*, or perhaps "put out").[1]

An interesting discussion in the *Dictionary of Biblical Imagery* details the Bible's metaphorical use of light and darkness as a picture of spiritual and moral deliverance versus down-pressing ignorance, with light representing such qualities as goodness, blessing, truth, and the presence of the sacred. Emphasizing the bookend quality of the image of light in the entire sweep of Scripture, it notes:

> The Bible is enveloped by the imagery of light, both literally and figuratively. At the beginning of the biblical narrative, physical light springs forth as the first created thing (Gen 1:3–4). At the end of the story the light of God obliterates all traces of darkness: "And night shall be no more; they need no light of lamp or sun, for the Lord God will be their light" (Rev. 22:5 RSV). Between these two beacons the imagery of light makes nearly two hundred appearances, with light emerging as one of the Bible's major and most complex symbols.[2]

This well-expressed article also stresses the contrast between acknowledging God for creating light by making its physical generators like the sun and other stars, versus delving into the pagan worship of such generators.

I notice that John Calvin, who was not particularly given to interfaith dialogue, put this contrast rather more bluntly: "We know that the Persians worshiped the sun; all the stars they saw in the heavens the stupid pagans also fashioned into gods for themselves."[3] Calvin's statement does not appear in

1. BN, 94.
2. Leland Ryken, James C. Wilhoit, and Tremper Longman III, eds., *Dictionary of Biblical Imagery* (Downers Grove, IL: InterVarsity, 1998), 509. The entire entry is illuminating; see 509–12.
3. John Calvin, *Institutes of the Christian Religion*, LCC 20, ed. John T. McNeill, trans. Ford Lewis Battles (Philadelphia: Westminster, 1960), 1.11.1.

the *Dictionary* article, since these days we usually word our objections more diplomatically, but the sentiment is still the same: we worship the Creator, not what is created.

One example I might suggest of the Old Testament's metaphorical use of light and darkness to depict the conflict between good and evil can be found in Isaiah's words (c. 740–700 BC), when the prophet challenges his contemporaries in troubled Israel: "And when they tell you to inquire of the prophesying spirit of the dead and the soothsayers with familiar spirits who whisper and mutter, should not a people inquire of their God?" (Isa. 8:19).[4] Isaiah warns that advice from the dead yields "no dawn" ("daybreak or early light," *āḥar*) (v. 20), but those trusting in such knowledge will find themselves thrust into "anxiety and darkness [*ḥašēkāh*] and gloom [or 'darkness,' *mā'ûp*] and distress and calamity [or 'darkness,' *'apēlāh*]" (v. 22). I chose this specific passage to cite as representative of so many analogies involving light and darkness in the Old Testament because in these few words of warning, we see at least three different words that can be translated "darkness," emphasizing by such amplification the horror of such a condition of spiritual and moral enslavement by evil.

But Isaiah assures Israel that God promises no more gloom for those in distress, for "the people walking in darkness [*ḥošek*] have seen a great light; those who sit [or 'wait,' or 'dwell'] in the land of darkness [another word for darkness, *ṣalmāwet*, also meaning 'impenetrable gloom,' or 'the shadow of death'], a great light shines upon them" (9:1, v. 9:2 in the LXX).[5] Why is

4. A. Philip Brown II and Bryan W. Smith, eds., *A Reader's Hebrew Bible* (Grand Rapids: Zondervan, 2008), 674. In my translation, I have supplemented its lexical suggestions with data from Karl Feyerabend, *Langenscheidt Pocket Hebrew Dictionary to the Old Testament: Hebrew-English* (New York: McGraw-Hill, 1969).

5. The Greek Septuagint version adds an extra verse 1. I've translated this passage from the *Biblia Hebraica Stuttgartensia*, which is the Masoretic Text (MT) employed in *A Reader's Hebrew Bible*, as listed in the previous footnote. If the Bible you are using adds the extra verse, it is drawing it from the Greek Septuagint. Scholars use both these versions of the Old Testament as supplementary to each other. The Septuagint was translated before the days of Jesus and his apostles because of the Hellenizing of Israel, especially by Roman occupation and rule. Jesus was conversant in many languages. In the synagogue in Nazareth, the scroll Jesus read contained Isaiah 61:1–2, which would have been in Hebrew. Luke's rendering it into Greek starts out being guided by the LXX, but midway through verse 18 begins using other Greek vocabulary in translating the Hebrew passage (Luke 4:17–21). Jesus spoke to the little girl in Aramaic (or a regional dialect of Hebrew) when he raised her from death in Mark 5:41. He was sought out for conversation by Greeks in John 12:20–22 and entreated by a Greek woman born in Syrian Phoenicia (Mark 7:25–30) for healing of her daughter. He conversed with the Roman procurator Pilate (John 18:28–38), with whom he may have spoken Greek or Latin. Latin was added to Aramaic and Greek for the sign placed on the cross over Jesus' head (John 19:20).

this? "Because a child is born to us, a Son given to us, and to him dominion [or 'domination' or 'rule'] is upon his shoulder. And his name will be called marvelous counselor, mighty God, eternal Father [this last is a combined word that is composed of two words, *ăb*, meaning 'father' or 'begetter' or 'ancestor,' and *'ad*, meaning 'duration, perpetuity, or eternity'], Prince [or 'master, chief, commander, ruler'] of Peace" (9:5 [MT] or 6 [LXX]). Isaiah specifies that this specific promise to Israel will bless the area of the tribes of Zebulon and Naphtali and Galilee of the Gentiles, along the Jordan River.

Consequently, Matthew notes in his Gospel that after John the Baptist was imprisoned, Jesus left Nazareth and went to live in Capernaum, by the lake in the region of Zebulon and Naphtali, in order to fulfill what was said through the prophet Isaiah (Matt. 4:12–16). So, here is a clear bridge between the Old Covenant's use of the metaphor of light and the fulfillment of the promise of deliverance from the dungeon of darkness in the death and resurrection of Jesus. In case anybody misses the connection, Matthew highlights Isaiah 9:1 (v. 2 LXX) to explain that the fulfillment of this prophecy was when "the people living in darkness saw a great light," and those languishing in the shadow of death now find a light has dawned on them (Matt. 4:16). That arrival of light was the birth of Christ. The verb for dawning (*anatellō*) that Matthew uses will soon become itself an image not only for the light in Christ but for the relationship between the divine Father and the Son as the New Testament revelation unfolds.

Understandably, then, Jesus sees the image of light as a central theme in his ministry, as he demonstrated just before he healed the man born blind when Jesus affirmed, "I am the light of the world." The withdrawal of that light causes people to stumble in darkness (see John 11:9–10), as Jesus warned his disciples in John 12:35–36 was about to occur, so his disciples must become, "sons of light" if they were not to become lost in the darkness of the horror of his crucifixion and absence to come. He also warned them in the lamp and sound eye imagery to be lights themselves (Luke 11:33–36).[6]

6. To this earth of repeated polarization between people groups, the distinguished Kenyan scholar Dr. Samuel Ngewa points out that in John 1:9, "Literally, the text says that he was 'the light, the true one.' Jesus is the primary light. All other lights are secondary and shine only as they reflect his light." "John," in *Africa Bible Commentary*, ed. Tokunboh Adeyemo et al. (Nairobi, Kenya: Word Alive/Zondervan, 2006), 1253. The perceptive Thomas Hoyt Jr. also applies a sensitive point in his chapter, "Interpreting Biblical Scholarship for the Black Church Tradition," in *Stony the Road We Trod: African American Biblical Interpretation*, ed. Cain Hope Felder (Philadelphia: Fortress, 1991), 36, "Granted, this imagery of light and darkness may be interpreted differently by blacks and whites, but one

All of this Paul captures in his warning to the Corinthians that "the god of this age has blinded the thoughts of those without faith." As a result, they cannot recognize "the shining of the good news of the glory of Christ, who is the image [*eikon*, from which we get 'icon,' or 'representation'] of God." This is the same God who at the creation declared, "Out of darkness, let the light shine." Thus, God has given light in believers' hearts so that those who believe in Christ as the Messiah and God's Son, a person of the triune Godhead who has come to humanity to be its savior, can perceive "the knowledge of the glory of God in the face of Jesus Christ" (2 Cor. 4:4–6).

Therefore, when Jesus' incarnational birth takes place, an angel appears to the shepherds, and "the glory of the Lord appears all around them" (*perilampō*). The whole sky fills with angels who announce Jesus' advent, so that the shepherds will know the "Savior who is Christ (the Messiah) Lord" has come (Luke 2:8–18). Simeon in the temple, upon seeing the child Christ, references Isaiah 42:6 and 49:6 that this baby is "a light into revelation to the Gentiles and the glory of your people Israel" (Luke 2:32). Such references remind us of the *shekinah* glory that filled the tabernacle when God was present (Exod. 40:34–35). Similar is what we read about in John 1:14, when God chose to settle (*katoikeō*, also "live" or "inhabit") in Jesus (Col. 1:19) as one person of the triune Godhead "became flesh and pitched his tent among us" (*skēnoō*, meaning metaphorically the tent of his body). People saw "his glory as the only-begotten from the Father," filled with God's two categorical attributes revealed to Moses in Exodus 34:6: grace and truth (John 1:14).

Meanwhile, while all this is going on, the magi are following the light of the star until it comes to rest over the place where the child resides (Matt. 2: 9–11), who is the true light who lights everyone with life (John 1:4, 9). The magi's quest reminds us of Israel in the wilderness following the fire in the cloud to the place of promise (Exod. 40:38).

Jesus, who is consciously fulfilling his mission to spread the illumination of God's love, will tell Nicodemus, "Light has come into the world," thereby giving people a choice between embracing that light or remaining in the dark. Since "light" exposes human actions, many "love" the darkness because it hides their actions. But those who are working for God come to Jesus, embracing him as God's light that exposes everyone's deeds (John 3:19–21).

can hardly interpret these images in John as racist. The extent to which we share in the experience of darkness enables us to appreciate the light of the risen Lord's manifestation."

All this meaning infused in this image is why the Gospels continue to reference the Old Testament light motif. Isaiah 9:1–2 (which we saw echoed in Matthew's Gospel) is also present in Luke 1:78–79, as Zechariah sings and celebrates "the feelings of mercy of our God," who causes "the dawn out of heaven to shine on those sitting in darkness and in the shadow of death." That light is what shines in Jesus with a glory like his Father's glory, as the transfiguration reveals (Matt. 16:27–17:2; Mark 9:2–3; Luke 9:28–32), a glory that will appear again in Acts 26:13. When Saul, who came to be known as Paul, reports to King Agrippa about his change of heart and identity from Jesus' opponent to Jesus' proponent, he recalls being blinded "at midday" by "a heavenly light," "over and above" or "beyond" the capacity of the sun, blazing or "shining around me and my fellow travelers." When the trembling Saul asks, "Who are you, Lord?" out of the glory the reply he hears is: "I am Jesus, whom you are persecuting" (Acts 26:13–15). So the radiance of the glory of God envelops our world at Christ's birth, in his ministry, and after his resurrection and ascension.

No wonder Jesus tells his followers, "You are the light of the world." A lamp should not be put "under a bucket."[7] Instead it belongs "on a lampstand" so it can light up a whole house. This is the example that Jesus set for them and for us. In the same way, Jesus advises his followers, "Let your light shine in front of other people, so that they may see your good works and glorify your Father in heaven" (Matt. 5:14–16).

As these examples reveal, light references that teach about ultimate enlightenment from God powerfully link the two covenants.

As with any image, of course, light can be adopted by knowledge-oriented, heterodox movements that tend to demote Jesus from unique Savior of the world through once and for all sacrifice and restoration to one of many teachers who emphasize embracing right knowledge as the path to God.

One interesting example can be found in an eclectic movement well articulated by "Aakhun" George W. Singleton. After citing Genesis 1:1–4 that "*God said 'Let there be light*" (all emphases are original); 1 John 1:5: "*God is Light*"; James 1:17, "*The Father of Lights*"; and John 1:1–14, "*the life was the light*," he writes:

> In the above statement of St. John, there cannot be any doubts about the *nature of the Word*. It is clearly *the light and the life of the world, the creative life principle* in which we love, move, and have our being. *[The Word] is the spirit of God*, the very

7. *Modios* refers to a "grain-measuring container of about 8 quarts," according to BN, 118.

essence of the soul but now lost in the mighty swirl of the world and all that is worldly. *It is only the* contact with the Spirit [the Word] that shows the way back to God and thus *is the true religion.* This contact [or "initiation" into and with the Spirit/Word of God] is termed variously as the second birth, the resurrection, or the coming into life again.

Citing Kirpal Singh, Aakhun Singleton agrees, "Jesus was conversant with the thought and practiced the Path of the Masters of the Audible Life Current." What that implication means to him becomes clearer as he quotes from Kirpal Singh's *Crown of Life:* "The path that Jesus taught is one of self-abnegation and of rising above body-consciousness, a process which is tantamount to the experience of death in life. It means one has to sacrifice the Outer man, consisting of the flesh and the carnal mind, for the sake of the Inner man or soul. In other words, he has to exchange the life of the senses for the life of the spirit."[8]

Singleton's vision of light and life suggests Jesus' mission was not to die for humanity's sins but to share an enlightenment that is analogous to a "second birth" or "resurrection." God's "Word" in whom is "light and life" is a redeemer by divine words, a teacher who recommends austerity as God's requirement for redemption.

The task of a Christian evaluator, then, is to assess the use of the biblical metaphor being employed: has Jesus as the incarnated Word of God retained the biblical significance of his mission, or has it been transformed into a new and alien system with an alternate meaning and an alternate goal in mind, repackaged in a whole new, eclectic complex of assumptions? The reinterpretations of "second birth, the resurrection, or the coming into life again" as metaphorical posit the fleshed Word was a teacher and not an actual sacrifice, as suggested by the image of "the lamb of God, the one taking away the sin of the world" (John 1:29). This conclusion alters the central meaning of the gospel. In fact, the Eastern propensity to recast the biblical imagery of light from savior to teacher when discussing Jesus is the kind of transformation I notice that runs through most adaptations of the mission of Jesus by the Hindu tradition.

Consider another example from Ravīndra-svarūpa Dāsa of the Hare Krishna Movement, who keys off a quotation of the Hindu holy book the *Bhagavad-Gita* (*The Song of God*), to explain:

8. George W. Singleton, "Aakhun," in *Esoteric Atannuology, Egyptology and Rastafariology,* vol. 1 (Indianapolis: Enlightenment, 1997), ii–iii.

The path of religion is established directly by the Supreme Lord Himself" (Bhag. 6.3.19). For this purpose God descends many times. Kṛṣṇa announces the general principle governing His entry into this world: "Whenever and wherever there is a decline in religious practice, and a predominant rise of irreligion—at that time I descend. To deliver the pious and to annihilate the miscreants, as well as to reestablish the principles of religion, I Myself appear, millennium after millennium." (Bhag. 4.7–8)

The Hare Krishna movement's adaptation of Hinduism sees this statement of Krishna explaining the mission of Jesus Christ in the New Testament, which "tells of a descent in which 'the Word was made flesh.'" In the Hare Krishna perspective, God "expands Himself in different forms, showing Himself to His pure devotees in various ways, in response to the ways in which they approach Him. All these transcendent forms are eternally manifest in God's spiritual abode. And, from time to time one or another of Them will descend to show Himself in the darkness of the material world, lighting the way back home." Thus, for this religion, Jesus is an appearance of Kṛṣṇa as a teacher to spread the divine light so that seekers can come "back to Godhead."[9]

SUN AS AN IMAGE

In his song of celebration, John the Baptist's father, Zechariah, announced the mission of his prophetic son to prepare the way of the Lord as ordained by "the compassionate heart of God" with the imagery of the rising sun: "the dawn out of heaven, giving light in the darkness of the shadow of death," in which we stumble, "to direct our feet into the path of peace" (Luke 1:78–79). It is a beautiful, poignant image of the coming of day and its illumination, warmth, and reviving of hope, dissipating all the fears, depression, and sorrow associated with the long, lonely hours of the nighttime.

But just as the biblical imagery of light has its supporters and its reinterpreters, so has the imagery of the sun experienced a controversial reception from the Christian church, despite its many enthusiasts. One cautious commentator was John Calvin. In his commentary on the book of Hebrews, he noted the following under Hebrews 1:3's use of this image of the sun and its effects:

9. Ravīndra-Svarūpa Dāsa, "The Descent of God," *Back to Godhead* 20, no. 5 (1985): 8, 29. The Society for Krishna Consciousness was founded in New York City in 1966 by His Divine Grace A. C. Bhaktivedanta Swami Prabhupāda.

Who being the brightness of his glory, etc. These things are said of Christ partly as to his divine essence, and partly as a partaker of our flesh. When he is called *the brightness of his glory and the impress of his substance,* his divinity is referred to; the other things appertain in a measure to his human nature. The whole, however, is stated in order to set forth the dignity of Christ.

But it is for the same reason that the Son is said to be "the brightness of his glory," and "the impress of his substance:" they are words borrowed from nature. For nothing can be said of things so great and so profound, but by similitudes taken from created things. There is therefore no need refinedly to discuss the question how the Son, who has the same essence with the Father, is a brightness emanating from his light.

Here we see, and rightly so, the Reformer's insistence on the equality of the Son with the Father, a theme he emphasizes throughout all his writing. What is surprising, however, is what looks like a critique of the biblical imagery when his next sentence states, "We must allow that there is a degree of impropriety in the language when what is borrowed from created things is transferred to the hidden majesty of God." The suggestion of "impropriety" in use of the sun imagery by the divinely inspired writer of Hebrews might at first glance seem like an impious presumption on Calvin's part, but one needs to go cautiously here when attempting to understand what Calvin is saying. He is, in fact, recognizing the inability of created things to mirror adequately the deep things of God. "But," as he himself explains, "still the things which are evident to our senses are fitly applied to God, and for this end, that we know what is to be found in Christ, and what benefits he brings to us."

Concerned that his readers might misunderstand, he warns, "It ought also to be observed that frivolous speculations are not here taught, but an important doctrine of faith." So he cautions us to use such imagery carefully: "When, therefore, thou hearest that the Son is the brightness of the Father's glory, think thus with thyself, that the glory of the Father is invisible until it shines forth in Christ, and that he is called the impress of his substance, because the majesty of the Father is hidden until it shews itself impressed as it were on his image."

And what about those who miss this point? Calvin admonishes, "They who overlook this connection and carry their philosophy higher, weary themselves to no purpose, for they do not understand the design of the Apostle; for it was not his object to shew what likeness the Father bears to the Son; but, as I have said, his purpose was really to build up our faith, so that we may learn

that God is made known to us in no other way than in Christ: for as to the essence of God, so immense is the brightness that it dazzles our eyes, except it shines on us in Christ." Here we see Calvin's concern for a high Christology: "It hence follows, that we are blind as to the light of God, until in Christ it beams on us."[10]

I notice that Calvin himself uses the image of the sun primarily for Christ, as he does in his *Institutes* (2.10.20; 3.25.1; 4.8.7). Calvin is picking up his image of the "Sun of Righteousness" from Malachi 4:2. He could not be clearer that he does use imagery and he centers it on the glory of God brought to us in Christ Jesus.

Even more bold in his denunciation of one use of the sun as an appropriate image for the Trinity is the outstanding Cappadocian theologian Gregory of Nazianzus (AD 329–389), who expresses his reaction to the teaching of Apollinarius, the overseer of the church at Laodicea, in a letter of concern to a priest named Cledonius:

> Apollinarius, while granting the Name of Godhead to the Holy Ghost, did not preserve the Power of the Godhead. For to make the Trinity consist of Great, Greater, and Greatest, as of Light, Ray, and Sun, the Spirit and the Son and the Father (as is clearly stated in his writings), is a ladder of Godhead not leading to Heaven, but down from Heaven. But we recognize God the Father and the Son and the Holy Ghost, and these not as bare titles, dividing inequalities of ranks or of power, but as there is one and the same title, so there is one nature and one substance in the Godhead.[11]

Clearly, for Apollinarius, the sun and its beams were being used to illustrate a theory of hierarchical subordination of the persons of the Trinity, indicating a number of erroneous ideas about Christ's incarnation, as Gregory explains to Nectarius, overseer of Constantinople:

> A pamphlet by Apollinarius has come into my hands, the contents of which surpass all heretical pravity. For he asserts that the Flesh which the Only-begotten

10. John Calvin, "Commentaries on the Epistle of St. Paul to the Hebrews," in *Calvin's Commentaries: Ephesians–Jude* (Wilmington, DE: Associated Publishers and Authors, n.d.), 2306–7.
11. Gregory of Nazianzus, "To Cledonius the Priest against Apollinarius" (*Ep. Ci.*) [4717], https://biblehub.com/library/cyril/select_letters_of-saint-gregory-nazianzen/to-cledonius-the-priest-against.htm.

Son assumed in the Incarnation for the remodeling of our nature was no new acquisition, but that that carnal nature was in the Son from the beginning. And he puts forward as a witness to this monstrous assertion a garbled quotation from the Gospels, namely, No man has Ascended up into Heaven save He which came down from Heaven, even the Son of Man which is in Heaven. John 3:13. As though even before He came down He was the Son of Man, and when He came down He brought with Him that Flesh, which it appears He had in Heaven, as though it had existed before the ages, and been joined with His Essence.[12]

If Gregory is right, such an idea would certainly be a gross departure from the orthodox position articulated by the Creed of Nicea. Rather than becoming human, if the Son brought his flesh from heaven, then we would wonder what his mother Mary contributed to his birth. Is pre-assumed human flesh all that Jesus Christ had on arrival, or did he bring any other human components not from Mary to his birth? In his letter to Cledonius, Gregory confirms just such a fear with more information: "Do not let the men deceive themselves and others with the assertion that the 'Man of the Lord,' as they call Him, Who is rather our Lord and God, is without human mind."[13] Apollinarius, apparently keying off the old idea that "the Word" was somehow in the mind of God the Father in eternity, was also claiming that the Word replaced the human mind as well in Jesus Christ.

Gregory has the same concern that we just expressed: "If anyone does not believe that Holy Mary is the Mother of God, he is severed from the Godhead. If anyone should assert that He passed through the Virgin as through a channel, and was not at once divinely and humanly formed in her (divinely, because without the intervention of a man; humanly, because in accordance with the laws of gestation), he is in like manner godless. If any assert that the Manhood was formed and afterward was clothed with the Godhead, he too is to be condemned."[14] Why this strong reaction? Gregory explains the central error: "If any introduce the notion of Two Sons, one of God the Father, the other of the Mother, and discredits the Unity and Identity, may he lose his part in the adoption promised to those who believe aright. For God and Man are two natures, as also soul and body are; but there are not two Sons or two Gods."[15]

12. Gregory Nazianzus, "To Nectarius, Bishop of Constantinople" (Epistle CCII [Letter 102]), http:www.newadvent.org/fathers/3103a/htmLetters (Division 1), accessed March 24, 2020.
13. "To Cledonius the Priest against Apollinarius" (*Ep. Ci.*) [4697].
14. "To Cledonius the Priest against Apollinarius" (Ep. Ci.) [4697].
15. "To Cledonius the Priest against Apollinarius" (*Ep. Ci.*) [4697].

The crux of the matter would be that Jesus Christ would not be an adequate sacrifice for human sin. Having a perfect body and divine mind from heaven, Jesus would not have been fully human, as Hebrews 2:17 had confirmed, made "according to all humans made alike" (from *homoioō*, "make someone like a person or thing").[16] Only someone who was fully human could be an adequate substitute to save us as a fully human sacrifice, and only someone fully God could defeat the forces of evil and be resurrected.

Before we leave Gregory's example, it is worthwhile for our study to ask two lingering questions. First, does his objection to Apollinarius' use of the imagery of the sun mean he rules out of order any analogy employing the sun in discussing the nature of the Trinity? The answer is no. In his "Third Theological Oration Concerning the Son," Gregory himself turns to the image of the sun and its light to illustrate how the Father, Son, and Holy Spirit can all be "coeternal" by explaining, "The sun is not older than its light. By some means they are without beginning in reference to time."[17]

The second is to ask, Are these just obsolete controversies, solved and forgotten back in the dust of history, or may we encounter those who still hold such views today? One of the roles I've assumed for several decades is serving as an acquisitions editor for a book series. I did indeed receive a proposal for a book claiming that Mary contributed nothing to Jesus' incarnation. It suggested she was simply a surrogate mother. The book proposal argued that God had gender. The infant Christ was conceived between the Father God, who, though a spirit, was claimed to be masculine, and the Holy Spirit, who was posited to be feminine. Their conceived child, with every component fully from God, was planted in the womb of Mary. In this view, God the Father becomes more like Zeus and the Holy Spirit more like Hera. It is an anthropomorphically pagan view. Needless to say, I had to turn the proposal down, carefully explaining to the author why this view was not in line with historic, biblically driven, Nicean orthodoxy. Where that book proposal was analogous to Apollinarius' view is in Jesus having arrived with preincarnate flesh and human components already.

16. BDAG, 707.
17. Gregory of Nazianzus, "Gregory of Nazianzus' Third Theological Oration Concerning the Son," 3.3, in *The Trinitarian Controversy*, ed. William G. Rusch, Sources of Early Christian Thought (Philadelphia: Fortress, 1980), 133. Worth noting is that Gregory's descriptions of the Trinity are often filled with illustrative language. In this particular sermon, he even discusses Jesus' two natures, one not being "prior and the other later," with the image of a "sea" dog and a "land" dog, "one is not a dog more than the other, and one less" (3.11, cited by Rusch, *Trinitarian Controversy*, 141).

Similarly, less than fifty years after the final censure of Apollinarius in 381, in August of 431 a council at Ephesus condemned Nestorius, a popular and zealous preacher who had been invited to become overseer of Constantinople for teaching and leading a vigorous campaign to ensure Mary was not considered to be the God-bearer. The council's ruling affirmed the contribution of "the Virgin Mary in respect of His manhood, consubstantial with the Father in respect of His divinity and at the same time consubstantial with us in respect of His manhood [humanity]." As the ruling explained: "For a union [henōsis] of two natures has been accomplished. Hence we confess one Christ, one Son, one Lord. In virtue of this conception of a union without confusion we confess the holy Virgin as Theotokos [the God-bearer] because the divine Word became flesh and was made man and from the very conception united to Himself the temple [body] taken from her."[18]

What appeared to drive Nestorius' view was the pervasive influence of Platonic thought, with its steady conviction that the Supreme God cannot muck around with matter directly. Therefore, a radical separation had to exist between the divine nature and human nature in Jesus Christ, so that Mary could be identified as the mother of the human Jesus but not the mother of the divine Jesus.[19]

The Assyrian Church that grew out of this event established a missionary movement that went on to plant churches throughout Asia. One of its church buildings in China, weathering a storm, is credited with inspiring John Newton to write the hymn "Amazing Grace." Constant opposition from a variety of Islamic, communist, and other adversaries throughout the east culminating in Iraq led the church's leader (called its Catholicos of the East) to immigrate to San Francisco.[20] But important to note is that since the beginning, right to today, a disagreement has existed over whether Nestorius himself was a "Nestorian."[21]

18. For the text of this ruling, approved by the eastern overseers at Ephesus, see J. N. D. Kelly, *Early Christian Doctrines,* 2nd ed. (New York: Harper, 1960), 328–29.
19. See for details a cautious summary of Nestorius' views and the troubles they caused him in "Nestorianism" in *ODCC,* 961–63. For an unpacking of the theological implications and the ruling of the Ephesian council, see ch. 12 of Kelly's *Early Christian Doctrines.*
20. See Donald Attwater and F. Wilcock, SJ, "Christian Churches of the East" [The Nestorian or 'Assyrian' Church], in William D. Halsey and Bernard Johnston, eds., *Collier's Encyclopedia,* vol. 6 (New York: Macmillan, 1987), 390.
21. Over the years, some have questioned whether Nestorius was actually a "Nestorian," or if his viewpoint was misunderstood. The clearest defense I have come across is from The Assyrian Church of the East itself, spelling out the controversy in accessible terms to defend Nestorius' orthodoxy and demonstrate that, in its opinion, the whole problem was a misunderstanding of his language as a Syrian monk using other terms than the orthodox simply to say the same thing about Jesus Christ. In its view, the misunderstanding came

Raised from being "a relatively obscure priest" to overseer of Constantinople in 428,[22] he stepped into the middle of this three-way disagreement, trying to adjust the title of the Virgin Mary from *theotokos* to *Christokos*, thereby being accused of positing "two separate Persons in the Incarnate Christ, the one Divine and the other Human, as opposed to the orthodox doctrine that the Incarnate Christ was a single person, at once God and man."[23]

The Assyrian Church of the East summarizes Nestorius' views:

> At the time, *Theotokos* "bearer/mother of God") was a popular term in the Western Church, (including Constantinople) used to refer to the Virgin Mary, but it was not used in Antioch, Nestorius maintained that Mary should be called *Christotokos* "bearer/mother of Christ"), not *Theotokos*, since he considered the former to more accurately represent Mary's relationship to Jesus. Nestorius promoted a form of dyophysitism, speaking of two natures in Christ (one divine and one human), but he was not clear in his use of theological terms. Nestorius spoke of Christ as "true God by nature and true man by nature. . . . The person [*parsopa*] is one. . . . There are not two Gods the Words, or two Sons, or two Only-begottens, but one." Alexandria understands him to mean that the second person of the Trinity was actually two persons: the man Jesus who was born, suffered and died and the divine *Logos*, eternal and unbegotten. Part of the problem lay in his use of the Greek word *prosopon* (Syriac *parsopa*) for "person"; this

with the "Western Church" following Tertullian's wording that "two natures united in one person" in Jesus Christ. The Eastern Church, however, had two competing positions. One, forged by the Church at Antioch, as "influenced by Aristotle," sought a plain reading of Scripture. Emphasizing "Jesus was fully human," these Antiochenes affirmed, "the Godhead dwelt in him but did not eclipse his humanity." The second position from the Church at Alexandria was "influenced by Plato" and more allegorical, claiming "Jesus' divinity must take precedence, even if at the expense of his humanity." As a result, the Antiochenes "spoke of two natures in Christ," while "the Alexandrians insisted upon one nature, at once divine and human." This attracted the charge of being "Monophysites" against the Alexandrians, that is, seeing his humanity subsumed under his divinity. Nestorius, a Syrian monk, was Antiochian in his view. He appeared to be an adoptionist, implying the Christ Spirit must have come on the man Jesus later. About twenty years after the controversy, he wrote an apology called *The Bazaar (Treatise) of Heracleides*, insisting he never meant such a conclusion and endorsing the Tome of Leo that was affirmed at the Council of Chalcedon. Still, Nestorius did indeed state, he held the natures apart in Jesus Christ. In this, he opposed Irenaeus' view, disagreeing the impassible Christ could experience suffering. (See Stephen M. Ulrich, Institute for Holy Land Studies, "The Lynching of Nestorius," http://www.nestorian.org/the_lynching_of__nestorius.html.)

22. Assyrian Church of the East, "Is the Theology of the Church of the East Nestorian? The Nestorian Controversy: Nestorian Theology," Nestorian.org (2020), http://www.nestorian.org/is_the_theology_of_the_church_of_the_east_nestorian-.html.

23. This explanation from the article "Nestorianism," ODCC, 961.

word was weaker in meaning than *hypostasis*, the word used by his opponents. At no time did he deny Christ's deity; he merely insisted that it be clearly distinguished from his humanity.[24]

On the other hand, J. N. D. Kelly puts the blame on Nestorius' "maladroit, crudely expressed exposition of the implications of the Antiochene position" as the fuse "that set the spark to the controversy." He suggests his "intemperate language . . . was calculated to inflame people," claiming, "God cannot have a mother . . . and no creature could have engendered the Godhead; Mary bore a man, the vehicle of divinity but not God."[25] Hence the conclusion that he was positing two Sons of God in Jesus Christ.

One religious group today who sees such a radical division in Jesus Christ is the Christian Science Church, whose founder, Mary Baker Eddy, claimed: "Christ is the ideal Truth, that comes to heal sickness and sin through Christian Science, and attributes all power to God. Jesus is the name of the man who, more than all other men, has presented Christ, the true idea of God, healing the sick and the sinning and destroying the power of death. Jesus is the human man, and Christ is the divine idea; hence the duality of Jesus the Christ."[26]

She too appeals for illustration to the sun and its radiance, but being non-Trinitarian (she claims "Jesus [is] not God"), she uses the imagery to express Jesus' mission. In Revelation, she believes John "the Revelator symbolizes Spirit by the sun." The "radiance" is "spiritual Truth," the light portrayed is really neither solar nor lunar but "spiritual Life, which is 'the light of men.'" Referencing the first chapter of the fourth Gospel, she sees "the coming of the immaculate Jesus . . . would baptize with the Holy Ghost—divine Science." So this view demotes Jesus to a mere human teacher promoting the theory of Christian Science, and not at all a savior whose righteous blood cleanses human sins: "The material blood of Jesus was no more efficacious to cleanse from sin when it was shed upon 'the accursed tree,' than when it was flowing in his veins." The battle over the term *theotokos* is nonexistent for her, and not only because she envisions God as "the divine Principle of the universe"

24. Assyrian Church of the East, "The Nestorian Controversy: Nestorian Theology," 4.

25. Kelly, *Early Christian Doctrines*, 310–11. Calvin's take on this issue is: "Away with the error of Nestorius, who in wanting to pull apart rather than distinguish the nature of Christ devised a double Christ! Yet we see that Scripture cries out against this with a clear voice: there the name 'Son of God' is applied to him who is born of the virgin [Luke 1:32p], and the virgin herself is called the 'mother of our Lord' [Luke 1:43]." Calvin, *Institutes* 2.14.4.

26. Mary Baker Eddy, *Science and Health with Key to the Scriptures* (Boston: The First Church of Christ, Scientist, 1906), 473.

and Jesus as merely "the highest human concept of the perfect man." Eddy confines her comment on Jesus' parentage to "Jesus called himself 'the Son of man,' but not the son of Joseph," and dismisses Mary with the terse comment, "As woman is but a species of the genera, he was literally the Son of Man."[27]

Another example, with even larger dimensions for the Christian church today, takes another tack, expanding on Apollinarius' view by wondering if all humans could be premortal like Jesus. In a previous chapter, we reviewed the strange attraction of Mormonism to self-identified evangelical Christians filling out the Lifeway/Ligonier survey. While neither Mormons nor evangelicals exactly share Apollinarius' view that Jesus had preincarnate flesh in heaven, the Mormons (and perhaps some of these evangelicals under their influence) might argue that we were all premortal as Jesus was with spirit bodies, even if we did not yet have physical bodies, as Apollinarius envisioned. This might happen if these Christians are indeed being influenced by missionaries from the Church of Jesus Christ of Latter Day Saints, whose teaching manual makes such a claim:

> Premortality refers to our life before we were born on this earth. In our pre-earth life, we lived in the presence of our Heavenly Father as His spirit children. We did not have a physical body. In this premortal existence, we attended a council with Heavenly Father's other spirit children. At that council, Heavenly Father presented His great plan of happiness (see Abraham 3:22–26). In harmony with the plan of happiness, the premortal Jesus Christ, the Firstborn Son of the Father in the spirit, covenanted to be the Savior (see Moses 4:2; Abraham 3:27). Those who followed Heavenly Father and Jesus Christ were permitted to come to the earth to experience mortality and progress toward eternal life.[28]

We might add this to the other Mormon departures from Christian orthodoxy the Lifeway/Ligonier survey turned up among evangelicals that we noted earlier.

As for Gregory's concerns with Apollinarius' subordinationism in his interpretation of Hebrews 1:3's sun and radiance imagery, today's scholars share similar hesitations. Robert Jenson, for example, citing Gregory's objection to the "Great and Greater and Greatest" interpretation of "Light

27. Eddy, *Science and Health*, 561–62, 25, 272, 482.
28. The Church of Jesus Christ of Latter Day Saints, www.churchofjesuschrist.org/study/ manual/gospel-topics/premortality?lang=eng, accessed March 25, 2020.

and Beam and Sun," focuses on Apollinarius' theory of graded levels in the Godhead:

> The Cappadocians finally discredited subordinationism intellectually by starkly stating the contradiction which it indeed contained and which had led to the chaos of parties. If subordinationists say the Son and the Spirit are *inferior* deity, they assert a plurality of sorts of deity, that is, they are polytheists. If they say Son and Spirit are simply *not* God, they must stop worshiping them or worship creatures; either way, they again have defected to paganism. The entire principle of mediating degrees of divinity, which had been traditional for centuries, is now clearly perceived and rejected.[29]

Roderick Leupp, whom we cited earlier, focusing on our topic of the use of imagery, has decided, "Not all word pictures are acceptable to trinitarian orthodoxy. In fact Gregory of Nazianzus (329–389), one of the Cappadocian Fathers of the fourth century, explicitly excluded metaphors that harkened back to the old pagan degrees of divinity." And he cites the same passage of the image of the sun, in graded order "Great, Greater, and Greatest, as if of Light and Beam and Sun," to conclude: "That Gregory excludes this particular luminous metaphor from true trinitarian witness serves to remind us that not all metaphors are capable of carrying this profound truth. In fact it is the truth of God's triunity that lends such credence as any metaphoric approach to God may bear. For obviously it is not for the sake of the metaphor that the Trinity exists but rather exactly the reverse."[30]

Now of course these two examples of wise counsel are not suggesting that Gregory did not use metaphors or imagery to illustrate his explanation of the Trinity. Not at all. Gregory provides an example of metaphorical language in his "Oration 39: On the Holy Lights," a meditation on the biblical light imagery we reviewed earlier. It centers on Jesus' baptism and resultant ministry as the "light of the world," which is "the true light, which enlightens every man and woman coming into the world." Specifically it "shines in the darkness . . . of this life," so that we who are "darkened and confused by sin"[31] find "our natures made anew."

29. Robert W. Jenson, *The Triune Identity: God According to the Gospel* (Philadelphia: Fortress, 1982), 90.
30. Roderick T. Leupp, *The Renewal of Trinitarian Theology: Themes, Patterns and Explorations* (Downers Grove, IL: InterVarsity, 2008), 20.
31. Gregory of Nazianzus, "Oration 39: On the Holy Lights," 1–2, cited by Brian E. Daley, *Gregory of Nazianzus,* The Early Church Fathers (New York: Routledge, 2006), 128.

How? "God becomes human, the one who 'rides on the heaven of heavens in the sunrise' of his own proper glory and splendor, is glorified in the sunset of our ordinariness and lowliness, and the Son of God allows himself to become and to be called Son of Man: not changing what he was—for he is changeless—but taking on what he was not—for he loves the human race."[32]

Gregory fills this address with his own picture language, telling hearers, "We might put off our garments of darkness and draw near the light," and assuring us what he is offering is not "a kind of legal, shadowy purification." He contrasts mature worship according to the gospel to pagan religion, which he dismisses to "the children of Greece," who "play these games with the demons."

When Gregory attempts to explain how the Trinity can be one by incorporating into his explanation the theories of the begetting of the Son and the processing of the Spirit from the Father in eternity, he finds himself getting rather technical. He begins clearly enough:

> The Father is Father and without beginning, for he is from no one. The Son is Son and not without beginning, for he is from the Father. If you understand "beginning" in the sense of time, however, he too is without beginning; for he is the maker of all time, not subject to time. The Holy Spirit is truly Spirit, coming forth from the Father, but not in the manner of a son or by generation, but by procession (if one must create new terminology for the sake of clarity). The Father does not cease from his unbegottenness because he has begotten, nor the Son from his begottenness because he is from the Unbegotten—how could that be?—nor does the Spirit change into either a Father or a Son, because he has proceeded and because he is God, even if that is not acceptable to atheists.[33]

So far Gregory has expressed Justin Martyr and Theophilus of Antioch's theories of the Trinity's beginnings clearly enough, but as he gives more explanation, he becomes more complex in his language. For some, he may be beginning to distance his speech from the right kind of tone for an Epiphany sermon in the Church of the Holy Apostles, "probably during the night-vigil preceding January 6, 381."[34] He touches on the certainly worthwhile thought

32. Gregory of Nazianzus, "Oration 39: On the Holy Lights," 13, cited by Daley, *Gregory of Nazianzus,* 134.
33. Gregory of Nazianzus, "Oration 39: On the Holy Lights," 12, cited by Daley, *Gregory of Nazianzus,* 133.
34. Gregory of Nazianzus, "Oration 39: On the Holy Lights," cited by Daley, *Gregory of Nazianzus,* 127.

that the Son's "characteristic property is unalterable. How, after all, could it remain a property if it altered and changed?"[35] One can almost hear the muffled snores being stifled by even the most stalwart of believers. So, rather than get too convoluted at what may have become a late hour, the seasoned orator Gregory decides to appeal to an analogy for clarification. This he approaches in reverse, putting it as an objection in the mouths of theorized atheistic opponents. The heart of his analogy beats this way: Adam was created directly by God as "a formation of God" (Eve by God from Adam's ribcage). Seth, however, was born naturally from Adam and Eve's union. The fact that his parents had direct creation by God and Seth had a natural childbirth does not make them all "different in nature" from one another. So, Gregory draws a comparison to the nature of God, concluding: "There is one God, then, in three, and the three are one."[36] The analogy proves his point. Satisfied with his argument, as the congregation no doubt stirs back to life by his skillful use of analogy, Gregory moves to a new more attractive topic, adoration and worship, building on his theme of unity in heaven and in earth. He shows why "it was necessary that adoration not be confined to creatures in the upper world, but that there should be some worshippers down here as well, so that all things might be filled with the glory of God."[37]

So, given Gregory's use of metaphorical language, and particularly his demonstration of the Trinity with imagery in his own example, he obviously did not rule out analogy as a means to explain the Trinity. He may not even have meant his words to be taken as a license to jettison the image of the sun and its effects as inappropriate, rather only disagreeing with the way opponents used it to create divine degrees of superiority and inferiority. Thus, a decision by us today to rule out all illustrative use of metaphorical language for describing the Trinity, as we saw proposed in an earlier chapter and from time to time since, would be hard to sustain if we were to consider such an example as Gregory's in the early church.

Instead I am convinced that the issue is not the use of metaphor itself but the theology conveyed in the way some teachers spin images to generate an alternative meaning to the orthodox one. How can I be so sure? Why can

35. Gregory of Nazianzus, "Oration 39: On the Holy Lights," 12, cited by Daley, *Gregory of Nazianzus,* 133.
36. Gregory of Nazianzus, "Oration 39: On the Holy Lights" 12, cited by Daley, *Gregory of Nazianzus,* 133.
37. Gregory of Nazianzus, "Oration 39: On the Holy Lights" 13, cited by Daley, *Gregory of Nazianzus,*133.

this specific sun metaphor not simply be dismissed? Because it is introduced in the Bible to explain the relationship of the Father and the Son (Heb. 1:3). So, if we reject it outright, we may find that we are disagreeing with Scripture itself. No wonder the image of the sun and its radiance was so enthusiastically received by the early church that we find it everywhere in use as all sides debated the doctrine of Trinity.

Therefore it is imperative to review how the Bible itself uses imagery before we start making pronouncements about such imagery being inappropriate. We should then survey how it was applied and misapplied by those who set up the discussion on the existence and nature of the Trinity from the early church right into the present day. In short, the real question before us is the theme of our present book: what exactly does an analogy like this one mean for a biblical writer, and how has it been interpreted or reinterpreted and then applied or misapplied by key players in the Trinity debate? To answer we can turn to its presentation in the book of Hebrews.

CHAPTER 5

THE IMAGE OF LIGHT IN
THE BOOK OF HEBREWS

H ebrews, like the Gospel of Matthew, is one of the strongest bridges
to the Old Testament we find in the New Testament. Commentator
James Moffatt admired it as "a little masterpiece of religious thought."[1] We
don't know for certain who wrote this elegant book,[2] but from the outset the

1. James Moffat, *A Critical and Exegetical Commentary on the Epistle to the Hebrews,* ICC
 (Edinburgh: T&T Clark, 1924), xiii. He notes that the first undisputed appearance of
 Hebrews by an early church writer is in *The Letter of the Church of Rome to the Church of
 Corinth, Commonly Called Clement's First Letter.* Cyril Richardson has noted the instances
 of Clement citing Hebrews in his translation of *First Clement* in the collection of early
 writings he edited *Early Christian Fathers* (New York: Macmillan, 1970); see notes on 52,
 60, 63, in addition to other possible allusions.
2. Walter C. Kaiser Jr. et al., eds., *NIV Archaeological Study Bible* (Grand Rapids: Zondervan,
 2005) notes in the introduction to Hebrews a number of candidates that have been put
 forward as author for Hebrews: "Luke, Clement of Rome, Barnabas, Apollos, Epaphras,
 Silas, Priscilla and others." When I was growing up, I learned the apostle Paul was the
 most probable author. John Calvin, however, sees Hebrews 2:1–3 as ruling Paul out:
 "This passage indicates that this epistle was not written by Paul," because "it was not Paul
 who wrote that he had the Gospel by hearing and not by revelation." (See the obviously
 misnamed "Commentaries on the Epistle of St. Paul to the Hebrews" 2.3 in *Calvin's
 Commentaries: Ephesians–Jude,* vol. 12 [Wilmington, DE: Associated Publishers and
 Authors, n.d.], 2315.) Calvin's conclusion is supported by Acts 9:5, 26:15; and Galatians
 1:16, where Paul reports he saw Christ when, out of the shekinah glory, he was called on
 the Damascus road. To me, one of the most serious objections against Paul's authorship
 may be that Paul was probably dead when the author first began to circulate this book.
 I would also add as a possible candidate Phoebe, whom Paul honors in Romans 16 and

writer of Hebrews in 1:3 speaks of the Son of God as "being the radiance [*apauyasma*] of the glory" and "representation" (*charaktēr*, a term used for the "stamp," as on coins, or "the features of the face" in classical Greek)[3] or of God's "substantial nature, essence" (*hupostasis*).[4] God the Father is like the sun in the sky. Jesus, as God-Among-Us, is like the radiance of the sun, entering our midst giving us life and new life, illuminating us with God's knowledge, and lighting the right path so our feet will not stumble.

Liddell and Scott's classical Greek lexicon tells us that in ancient Greek *apaugasma* meant "radiance, effulgence, of light beaming from a luminous body."[5] Bauer's *Greek-English Lexicon of the New Testament and Early Christian Literature* defines it in the active as "radiance, effulgence, in the sense of brightness from a source" but also, in the passive, as "reflection, i.e. brightness shining back."[6] So the writer of Hebrews pictures Jesus glowing with God's *Shekinah* glory, a radiance shining with the brightness from the Godhead, the source from whence Jesus Christ came.

The Jewish philosopher Philo Judaeus, who lived in Alexandria, Egypt, from c. 30 BC to AD 45,[7] employs the same Greek word (*apaugasma*) to "the relation of the Logos to God."[8] For Philo, however, the light of God's "word" would be more in the category of "reflection" than "radiance," as he indicates

to whom Paul entrusted the delivery of his letter to the Romans and, therefore, its initial interpretation. Since both Prisca and Phoebe were learned women, if either wrote it, she may have remained anonymous, given the cultural prejudices of the times.

3. LSJ, 1977.
4. BDAG, 1040. Also see LSJ, 1895.
5. See *apaugasma*, LSJ, 181.
6. BDAG, 99.
7. Piero Treves, "Philo," in OCD, 822–23. See c. 20 BC–c. AD 50 as an alternative set of dates for Philo's life in "Philo," *ODCC*, 1083. He is noted for his great courage in representing the Jewish community on a delegation to Rome in AD 39–40, pleading for "exemption from the duty of worshipping the Emperor" to the notorious Gaius, better known as Caligula, or "Baby Boots" (a nickname the soldiers gave him for the little military outfit he loved to wear as a small child). This was no small feat. Just as Gaius had begun his rule in AD 37 at the age of twenty-five, he was suddenly struck with a serious illness that Philo believed "unhinged his mind." Immediately afterward this emperor became unstable, cruel, and murderous—turning on his own supporters, becoming autocratic and bloodthirsty, suspected of incest, and self-deifying—and he was in constant danger of assassination. This was accomplished some three years later when, at age twenty-nine, he along with his fourth wife and only child were murdered in his palace on January 1, AD 41. Among the atrocities he had planned but could not accomplish was to set up his own statue in the Jews' Jerusalem temple. (See details of Gaius' short and lethal life in John Percy Vyvian Dacre Balsdon, "Gaius," OCD, 452–53.) Thus, for Philo to lead a mission to this crazed autocrat at the height of his rampages to intercede for a population under his power not to worship him was a perilous mission, fraught with lethal danger.
8. BDAG, 98.

in his *Allegorical Interpretations:*[9] "And the word of God [*ho logos tou theou*] is above all the world, and the oldest and the principal[10] of those which were created."[11] For Philo, the "word" is clearly understood as a creation, and not a person of the triune Godhead. As many Jews, Philo may not have been expecting God's messiah to be revealed as the divine Word incarnated in our world, as the apostle John notes: "In among his own he came, and his own did not receive him" (John 1:11).

The illustration of light is appropriate. How salutary and nourishing to our spirits is God's light in us, as the vitamin D of the sun is nourishing to our bodies. No wonder this image became so popular in the early church.

But how this simple illustration was understood by Origen, Clement of Alexandria, Tertullian, Athanasius, and others proved to be very different and very revealing in its difference. Exploring their interpretive variations illuminates our understanding, since these early church scholars were Gentiles. Some of their conflict can be traced to the influence of the sun's meaning in the pagan contexts surrounding Israel, affecting the thought of various Gentiles as they came to faith in Christ, the light of the world. Their varied understandings and misunderstandings set forth a variety of views of God and creation still held among some today.

To the ancient polytheistic world, the sun was sacred. To some Greeks, the sun god was male, as can be seen in an Orphic hymn, "Zeus is the sun . . . the ruler of all things, he with the gleaming lightning."[12] To some Egyptians, the sun was a female, Nut, "the goddess of heaven."[13] Sun worship was so prevalent that it could even be found in Israel, as we see in 2 Kings 23, when Josiah defiled the pagan shrines, eliminated horses from the temple entrance, and burned chariots, which had all been dedicated to the sun. Again, in Ezekiel's vision in 8:16, the flaming appearance—or, perhaps, messenger—of God transported him to the temple entrance where twenty-five men, with their backs to the temple, knelt before the sun.

The Bible, however, is very clear that the sun is merely a creation of God. God has appointed it to its place, and it serves God, as we see in Psalms 19:1–6; 74:16, and 104:19. Psalm 148:3 tells us metaphorically that the sun itself

9. Philo, *Allegorical Interpretations of Genesis* 3.61 [175].
10. From *genikos,* or "typical" = type, LSJ, 344.
11. *Gegona,* from *ginomai,* BDAG, 190: "To come into being through process of birth," "to come into existence, be made, be created, be manufactured." BDAG, 197.
12. Charles H. Long, *Alpha: The Myths of Creation* (New York: George Braziller, 1963), 119.
13. Adolf Erman, *Die Religion der Ägypter* (Berlin: Walter De Gruyter, 1934), 62–63, cited in Long, *Alpha,* 99.

praises God. Jeremiah explains in 31:35 that the sun is God's gift to us, and Jesus reiterates that point in Matthew 5:45. When God is not pleased, God darkens the sun, as on the day of God's judgment.[14]

To the early Christians, as a result, the sun was viewed as merely a creation, but one that could serve as an effective illustration to explain the triune Creator. John 1:4 speaks of Christ lighting humans. We might supplement that revelation with what Hebrews 1:3 depicts was happening uniquely in Jesus: God's divine as well as human child was shining forth the "radiance [*apaugasma*] of [God's] glory." Many early Christians depicted the Father as the sun illuminating Christ, as the radiance of the sun sheds light on the earth. But a closer look at the language with which this "lesson of light" is presented in such teachers as Origen (and his predecessor at the catechetical school in Alexandria, Egypt, Clement of Alexandria) versus Athanasius (and the imagery of light in the Creed of Nicea) discloses a radical divergence in understanding the Trinity.

Inspired by Sir Isaac Newton's discovery that light through a prism breaks into colors of shorter and longer waves, British physicist Sir George G. Stokes found that minerals can convert the wavelengths of light and give them back in beautiful colors. We can contrast that with what Exodus 34:29–35 tells us happened to Moses. His face continued to glow after he left God's presence, but eventually, Paul tells us, the veil that he put over his radiant face from being in God's shining glory became a tool to hide the "end [*telos*, also 'termination, cessation'] of the wiping out" (*katargeō*)[15] of the residue of his reflection of that glory (2 Cor. 3:13).

While Jesus Christ—who was God-Among-Us, yet in whom God chose to settle all the divine fullness (*plērōma*)—could fluoresce continually with heavenly light provided him in his incarnated state by his heavenly Father, Moses could only phosphoresce after meetings with God, reflecting God's glory for a limited time until the effect faded away. These two conflicting understandings of what passages like Hebrews 1:3 illustrate instigated the controversy over the nature of Jesus Christ.

THE LIGHT IMAGE IN ORIGEN AND CLEMENT

Origen was not a believer in accepting half measures. According to Eusebius of Caesarea, he was born c. AD 185 or 186, "when the flames of

14. As we see in Isaiah 13:10; Ezekiel 32:7; Joel 2:10, 31; 3:15 (which is referenced in Acts 2:20); Amos 8:9; Micah 3:6; Mark 13:24; and at the death of Jesus in Luke 23:44–45.
15. Michael H. Burer and Jeffrey E. Miller, *A New Reader's Lexicon of the Greek New Testament* (Grand Rapids: Kregel, 2008), 336.

persecution became a fierce blaze and countless numbers received the crown of martyrdom." In the persecution that took his father from him, Origen's own passion for martyrdom was thwarted only by his mother, who "hid all his clothing and so forced him to stay at home."[16] Eventually, his life would end from the effects of "prolonged torture" in the persecution of Decius (c. 254–255).[17]

When Origen summons up the image of the sun and its light to depict God the Father and Jesus Christ in his book *On First Principles,* he explains it in a manner that may make some of today's evangelical readers somewhat uncomfortable. The analogy, of course, predates Origen. An allusion to light as a metaphor for the Son can be found, among other places, in the thought of his predecessor, Titus Flavius Clemens, known to us as Clement of Alexandria (who lived from AD 150 to c. 211–216) and head of the catechetical school of Alexandria.

We see it, for example, in Clement's book *The Miscellanies,* where he describes the Son as "the complete paternal light" and "an energy": "Now the energy of the Lord has a reference to the Almighty; and the Son is, so to speak, an energy of the Father."[18] Describing the Son as "an energy" may be intended to leave room for another energy to emerge (i.e., the Holy Spirit), but this mode of description seems to subordinate the Son unduly far beyond "begetting language." Clement further refers to "the nature of the Son, which is

16. Eusebius, *Church History* 6.2–3.
17. See "Origen," *ODCC*, 1008. Interesting to note is that Arius, the theological unitarian, whose confrontation with Overseer Alexander over the proper understanding of the relationship of God the Father and God the Son precipitated the controversy at Alexandria that caused the forging of the Creed of Nicea (325), counted Eusebius of Caesarea among his supporters (R. P. C. Hanson, *The Search for the Christian Doctrine of God: The Arian Controversy, 318–381* [Grand Rapids: Baker, 1988], 6). Eusebius' own low Christology may account for his featuring Origen in his church history. In fact, to Eusebius, we owe the preservation of much of what we know about Origen's life. That Origen was brilliant and fearless is manifestly clear in his writing, as is the fact that he was both passionate and, at times, painfully literal in his understanding of Scripture, despite his penchant for allegorical interpretation. He practiced an austerity in applying Scripture to his own life, so that he "fasted" and "restricted the time for sleep, which he took on the floor—never in bed." Understanding Jesus to want disciples "not to own two coats or wear shoes or worry about the future," he scraped by "enduring cold, nakedness, and extreme poverty" and thereby "astonished his concerned followers, who begged him to share their possessions." But "he did not bend: for many years he is said to have walked shoeless, to have refrained from wine and all but the most necessary food, so that he actually risked his health" (Eusebius, *Church History* 6.3). I mention these data to illustrate an intensely literal strain that can be found threading its way through his often allegorical perspective on the Bible.
18. Clement of Alexandria, *The Miscellanies* 7.2, Ante-Nicene Christian Library 12, eds. Alexander Roberts and James Donaldson (Edinburgh: T&T Clark, 1869).

nearest to Him who is alone the Almighty One," appearing to regard only the Father, not the Son, as being "almighty"—a perspective, as we will soon see, which is in conflict with the view of Athanasius, who specifically identifies both the Father and the Son as "almighty." So, if the Son is not "almighty," how then is the Son to be understood for Clement? He views the Son as "complete mind," "the paternal Word, exhibiting the holy administration for Him who put [all] in subjection to Him," "the counselor of the Father," "His Wisdom," and "the Teacher of the beings formed by Him." In this role, Clement believes the Son "is the Teacher, who trains the Gnostic by mysteries," and "it is He who also gave philosophy to the Greeks by means of the inferior angels."

Seeing a connection to Greek philosophy influences Clement to view the Son in Neoplatonic terms, for example, as impassible. He explains, "Nor can He who is the Lord of all, and serves above all the will of the good and almighty Father, ever be hindered by another. But neither does envy touch the Lord, who without beginning was impassible." His goal herein, of course, is to protect the Son from human sin and suffering, affirming, "Nor does He ever abandon care for men, by being drawn aside from pleasure, who, having assumed flesh, which by nature is susceptible of suffering, trained it to the condition of impassibility."[19]

The term *impassible* comes down freighted from Greek philosophy with the understanding that Christ is both without feelings before the incarnation, as well as unable to suffer harm from humanity. While the second point prevents God from being seen as being conditioned by humanity, the first

19. Justo L. González in his book *Essential Theological Terms* (Louisville: Westminster John Knox, 2005), 84, points out that impassibility is "one of the traditional attributes of God, resulting from the philosophical notion that being changed by another—or being capable of such a change—is an imperfection. Strictly, it does not mean that God is incapable of passion or compassion, but rather that God is never the passive object of action by another." González adds, "Clearly, the God of Scripture suffers with the pain of creation, and therefore many theologians have claimed that impassibility is not a proper divine attribute. Others respond that God suffers the pains, and shares the joys, of creation, not because creatures have the intrinsic power to affect God, but because God has determined to share in that pain and those joys. Thus, even when being compassionate toward creation, God is not the passive object of creaturely activity." Perhaps this is why Clement is careful to spell out his explanation that "having assumed flesh, which by nature is susceptible of suffering," the second person of the Trinity "trained it to the condition of impassibility." That would mean not being able to be "changed by another," and so accomplishing human salvation by his sacrificial death on the cross for human sins. Clement of Alexandria, *The Miscellanies* 7.2.

opens the door to see the divine nature of Christ as potentially aloof from human nature.[20]

In such choice of language, Clement comes into conflict with his great contemporary Irenaeus, who was born twenty years his senior in c. AD 130–c. 202, and who had become the overseer of the early Christian gathering in the ancient city of Lyons, in what is France today. Irenaeus, in the third book of his masterful work *Against the Heresies,* when commenting on Ephesians 2:13, Galatians 3:13 (see also Deut. 21:23), and 1 Corinthians 8:11 (and perhaps Ps. 3:6 and Eph. 4:10), warned his people, "It was not an impassible Christ who descended on Jesus, but, since He was Jesus Christ, He Himself suffered for us; He who lay in the tomb also rose again; He who descended also ascended, the Son of God having been made man, as the very name indicates."[21]

Therefore, at first glance, Clement's approach might more appear to anticipate the thought of another near contemporary, the great non-Christian philosopher and interpreter of Plato, Plotinus, who was born in AD 205 and died c. 269–70, and who also pictured God as impassible. For Plotinus, who was a driving force of what has come to be called Neoplatonism, God was a divine creating principle that "does not desire us, so as to be around us, but we desire it, so that we are around it."[22] Clearly, Plotinus does not appear to consider God being intensely involved in human history, as we see God depicted in the Bible. Instead, for Plotinus God is impersonal and the still point around which the universe moves, where "when we do look to him, then we are at our goal and at rest and do not sing out of tune as we truly dance our god-inspired dance around him."[23] Plotinus' God does not delight in honest people as the Bible's God does in Proverbs 12:22. In fact, this God "does not think, because there is no otherness; and it does not move; for it is before movement and before thought. For what will he be able to think? Himself?"[24] Plotinus' is a consistency of thought with which, had Clement lived to read it, he would definitely not have agreed, for Clement clearly states: "Therefore, a hater of man, the Saviour can never be; who, for His exceeding love to human flesh, despising not its susceptibility to suffering, but investing Himself with it, came for the common salvation of men."[25] Clement's target

20. Clement of Alexandria, *The Miscellanies* 7.2.
21. St. Irenaeus of Lyons, *Against the Heresies* 3.18.3.
22. Plotinus, Ennead VI, 9.8:36–37.
23. Plotinus, Ennead VI, 9.8:43–45.
24. Plotinus, Ennead VI, 9.6:43–44.
25. Clement of Alexandria, *The Miscellanies,* 7.2.

is not whether the preincarnate Son could love but establishing that only when becoming human could the Son be able to suffer. But despite that clear conclusion, his remark on the Son not feeling a passion, such as envy, holds up to question the Son's divine ability to feel any passion, even "exceeding love," or be tempted in every way that we humans are (Heb. 4:15).

Clement, of course, could be recasting divine love to be a mild, passionless characteristic of benevolence. But then it would not have been appropriate for him to use such language of passion and, particularly, employ such an excessive adjective as *exceeding*. If, on the other hand, Clement means the preincarnate Christ could feel only good passions, then the term *impassible* would still not have been appropriate, since God would have feelings generated from within. Being God's feelings, they would necessarily only be righteous ones. Then Clement should have qualified the term *impassible* as only intended to mean incapable of suffering or being conditioned by an outside force.

Why is this important? Because a "God" with no emotions does not represent the God we find in the Bible, namely a God the Father who loves people (John 3:16) and hates sin (Mal. 2:16), a Holy Spirit who grieves (Eph. 4:30), and Christ, who wept over Jerusalem (John 11:35). Only the two-Son or two–separate-natures theory that we saw historic Christian orthodoxy rejecting would support the view of a separate, compassionate, crying human nature beside a separate, completely tranquil deity. The categories would appear to fit better with Mary Baker Eddy's separation: "Jesus is the human man, and Christ is the divine idea; hence the duality of Jesus the Christ." A human nature would be more personal; a divine nature would be more impersonal, and therefore more Plotinus' vision than the Bible's.

In short, a certain degree of Platonic thought leavened, and at times compromised, the theologies of Clement and then Origen, illustrating the danger of importing words from philosophy that are not in Scripture (like "impassible"). Couching Christian thought in contemporary philosophical language, of course, is a danger all of us face. So we all need to be very careful as we contextualize our teaching.

Origen, as opposed to Clement, was a contemporary of the mature Plotinus, but Origen died just as Plotinus began to write at the age of fifty (c. AD 255). Origen continues to develop Clement's imagery of "paternal light" along philosophical lines:

> Sometimes our eyes cannot look upon the light itself, that is, the actual sun, but when we see the brightness and rays of the sun as they pour into our windows,

it may be, or into any small openings for light, we are able to infer from these how great is the source and fountain of physical light. So, too, the works of divine providence and the plan of this universe are as it were rays of God's nature in contrast to his real substance and being.

Origen, at this point, is simply referring to God's creation of "the universe" and the "comeliness of his creatures."[26] However, we can see paralleled to this statement a similar one about creation in *The Enneads*: "For every beautiful thing is posterior to the One, and comes from it, as all the light of day comes from the sun."[27]

But now Origen's Christian concerns diverge from Plotinus' pagan ones. Having set up the metaphor of the generating sun and what it generates, Origen moves on, extending the analogy to the begetting of a unique Son of God (a place Plotinus would not go), but he does so in a philosophical framework that takes him where Christian thought should not go.

Moving to Scripture, Origen passes first to Paul in Colossians 1:15, citing Paul's explanation that the Son is "the image of the invisible God" and "firstborn of all creation." Next Origen moves to Hebrews 1:3 (which he also assigns to Paul), noting the Son of God is the "brightness of God's glory and the express image of his substance." Then Origen centers in on the figure of wisdom we find in Proverbs 8. But in a more extended explanation from "the book of Wisdom, which is said to be Solomon's," he notes "a certain description of the wisdom of God in the following terms," and here is where his illustrations become problematic. Speaking of wisdom, he writes:

"For she is a breath of the power of God, and a pure effluence (that is, emanation) of the glory of the Almighty." Therefore, "nothing that is defiled can enter into her. For she is the brightness of the eternal light and an unspotted mirror of the working of God and an image of his goodness." Now, as we said above, the wisdom of God has her subsistence nowhere else but in him who is the beginning of all things, from whom also she took her birth. And because he himself,

26. Origen, *On First Principles* 1.1.6.
27. Plotinus, Ennead VI, 9.4 [10]. I notice that Johannes Quasten in his *Patrology, Vol. 2* (Westminster, MD: Christian Classics, 1986) also deplores Origen's dependence on Platonism: "Origen made the mistake of letting the philosophy of Plato influence his theology more than he thought. This led him to very serious dogmatic errors" (42).

who alone is a Son by nature, is this wisdom, he is on this account also called the "only-begotten."[28]

This quotation attributed to Solomon is not from Proverbs 8 but from the apocryphal *Wisdom of Solomon* 7:25–26, a Greek expansion of Proverbs 8 that appears to have been composed in the first century BC in Alexandria, the same city where some two centuries later both Clement and Origen will be based.[29] Verses 25–26 give an intertestamental picture of the sun and its ray, with God as the sun and the female attribute wisdom as its beam: "For she is a vapor [or 'breath,' *atmis*] of the power of God, and a pure emanation [*aporroia*] of the glory of the Almighty, therefore, no stained thing can fall into her. For she is radiance 'brightness,' *apaugasma*] of the eternal light, and the spotless mirror of the workmanship [*energeia*] of God, and image of his goodness."

As we can see, Origen must go outside the Bible and appeal to an apocryphal book to locate the same term for radiance or brightness to portray wisdom that the author of Hebrews uses to depict God's Son. We do not find the canonical Proverbs 8:22–31 in either the Hebrew text (MT) or the Septuagint (LXX) using the imagery of sun and radiance to picture the relationship between the Father and wisdom.

Origen's expressed intention here, of course, is to show that the personified "Wisdom" that accompanied the Father in creation originated in the Son, through whom the Father created all. But his need to go outside Scripture and appeal to the Apocrypha to support Wisdom as God's "radiance" (and particularly his final phrase) muddies his explanation by equating the Son and Wisdom and arguing that somehow this equation explains the designation "only-begotten." His adding that the Son as Wisdom births wisdom does not offset the deleterious effect of an analogy that suggests that the creation of Wisdom in Proverbs 8 somehow explains the Father's begetting of the Son of God. Proverbs 8:22–25 states clearly of Wisdom: "The LORD created [*qānāh*, 'God as originating, creating']³⁰ me at the beginning of his work, the first of his acts of long ago. Ages ago I was set up, at the first, before the beginning of the earth. When there were no depths, I was brought forth, when there were no springs abounding with water. Before the mountains had been shaped, before the hills, I was brought forth."

28. Origen, *On First Principles* 1.2.5.
29. My translation from Wisdom of Solomon 7:25–26 LXX. For further background on this apocryphal book, see Moses Hadas, "Wisdom of Solomon," in *IDB*, 4:862.
30. BDB, 888.

Wisdom is clearly a creation. And this is the way Origen understands it, as we see in *On First Principles*: "Now this Son was begotten of the Father's will, for he is the 'image of the invisible God' and the 'effulgence of his glory and the impress of his substance,' 'the firstborn of all creation,' a thing created, wisdom. For wisdom itself says, 'God created me in the beginning of his way for his works.'"[31]

This statement alone would be enough to make Origen the father of Arian thinking, if Origen had not added directly after, "And I would dare to add that as he is a likeness of the Father there is no time when he did not exist. For when did God, who according to John is said to be 'light' (for 'God is light') have no 'effulgence of his own glory'. . . Let the man who dares to say, 'There was a time when the Son was not,' understand that this is what he will be saying, 'Once wisdom did not exist, and word did not exist, and life did not exist.'"[32]

Origen's view, while containing a very low Christology, at least recognizes the Son is eternal, as opposed to Arius' view, which did indeed say the Son was neither eternal nor coequal with the Father, being "as a Son to Himself by adoption. He has nothing proper to God in proper subsistence. For He is not equal, no, nor one in substance with Him. Wise is God, for He is the teacher of Wisdom."[33] Thus Arius' reading of Proverbs 8:22 is of a created Son, unequal in substance or in understanding. The Arians who followed some seventy years or so after Origen's death would later claim this created Wisdom became the Christ. Origen's comparison of Wisdom's birth and the Son's begetting could be easily misconstrued by such thinkers.

One can also find an appeal to Proverbs 8 in the discussion of Origen's predecessor, Clement, in the passage from *The Miscellanies* we have been citing: "It cannot be said that it is from ignorance that the Lord is not willing to save humanity, because He knows not how each one is to be cared for. For ignorance applies not to the God who, before the foundation of the world, was the counsellor of the Father. For He was the Wisdom 'in which' the Sovereign God 'delighted.'"[34]

Clement and Origen set up a differentiation between the Father and the Son that inevitably made the Son appear inferior to the Father by equating the created wisdom of Proverbs 8, or its apocryphal expansion, with the begotten Son of God. Clement equates Proverbs' term "Wisdom" with the apostle

31. Origen, *On First Principles* 4.4.1.
32. Origen, *On First Principles* 4.4.1.
33. Arius, *Thalia* 8.1.2.15.2, cited by Athanasius, *De Synodis* 2.2.
34. Clement, *The Miscellanies* 7.2.

John's term "the Word" to describe Christ, and Origen insists that the term "Almighty One" be reserved for the Father alone, whom "we cannot even call God almighty if there are none over whom he can exercise his power."[35] Clement describes the Son as an "energy" of the Father, "the complete paternal light," and Origen employs the sun, rays, brightness, and light imagery as appropriate both for creation (where he distinguishes the "rays of God's nature in contrast to his real substance and being") and for the begetting of the Son of God. These views provided a reference for those who would later claim that Christ is only a created being, the first of God's creation. In short, the use of Greek philosophical language that is more suited to Platonic thought and an overeagerness to identify Old Testament images with Christ seriously compromised their doctrinal presentations.[36]

Indeed, such an inferiority becomes explicit in Origen's *Commentary on John,* where he suggests of John 1:1, "John has used the articles in one place and omitted them in another very precisely, and not as though he did not understand the precision of the Greek language. In the case of the Word, he adds the article 'the,' but in the case of the noun 'God,' he inserts it in one place and omits it in another." Origen contends, "The noun 'God' stands for the uncreated cause of the universe, but [John] omits it when the Word is referred to as 'God.'" Origen's view is that "the Word has become God because he is 'with God,'" therefore, "God, with the article, is very God, wherefore also the Savior says in his prayer to the Father, 'That they may know you the only true God.' On the other hand, everything besides the very God, which is made God by participation in his divinity, would more properly not be said to be '*the* God,' but 'God.'" So, Jesus Christ has "drawn divinity into himself," though "he would not remain God if he did not continue in unceasing contemplation of the depth of the Father. . . . *The* God, therefore, is the true God."[37]

So, the "radiance" for Origen must continue as beam of the sun to shed light. There is no equal glory in his "Trinity." This disturbing argument is adopted by other prominent early church leaders, including the historian Eusebius of Caesarea, who is quoted in the Seventh General Council, Act 6 claiming, "The Son Himself is God, but not Very God."[38]

35. Origen, *On First Principles* 1.2.10.
36. See more of my analysis of these positions in William David Spencer, "The Need for Caution in the Use of Eternal Birth Language for Jesus Christ in the Early Church and Today," *Africanus Journal* 10, no. 1 (2018): 5–22.
37. Origen, *Commentary on the Gospel According to John,* 2.12–14, 17–18.
38. See John Henry Cardinal Newman's note p in Athanasius, *De Synodis* 2.4.17. In his *De Synodis* note e to 3.3.34, Cardinal Newman notes, "Eusebius calls our Lord 'the light

The Jehovah's Witnesses and Origen

Taking denial a step further, in their booklet of answers *Reasoning from the Scriptures*, the Jehovah's Witnesses build on Origen's view, explaining John 1:1 as follows: "The definite article (the) appears before the first occurrence of *the-os* (God) but not before the second." Treating the second appearance of *theos* as a predicate adjective rather than a predicate nominative, they conclude that "the text is not saying that the Word (Jesus) was the same as the God *with whom* he was but, rather, that the Word was godlike, divine, a god." Thus they question: "was John saying that Jesus was God?" And they answer, "Obviously not."[39]

So then, if Jesus was not God-Among-Us, who was he? Denying that the Godhead is triune and that Jesus is a person of the Trinity, the Jehovah's Witnesses speculate that "the evidence indicates that the Son of God was known as Michael [the archangel] before he came to earth and is known also by that name since his return to heaven where he resides as the glorified spirit Son of God."[40] On what evidence exactly is this based? The proof they submit is (1) on the name "Michael," meaning "Who Is Like God" (1 Thess. 4:16); (2) that Jesus' second coming arrives with his command, "in the voice of the archangel and the trumpet of God"; (3) that "archangel" is never plural in the Bible, so there must be only one; and (4) that Michael protects Israel as its "Prince" in the end times as prophesied in Daniel 12:1 and battles Satan in Revelation 12:7–12.[41]

Of course, the Old Testament is full of Michaels, all of whose names mean "who is like God." We find them in Numbers 13:13; 1 Chronicles 5:13; 6:40; 7:3; 8:16; 12:20; 27:18; and 2 Chronicles 21:2, all of whom are from different tribes and parentage, as well as the Michael in Ezra 8:8. "Who is like God?" is also the meaning of the name of the prophet Micah, whose book is placed between Jonah's and Nahum's, as well as the other Micahs in Judges 17–18 and 1 Chronicles 5:5. This is also true of Micaiah, a prophet in the time of Ahab

throughout the universe,' moving *round* (*amphi*) the Father" (*De Laudibus Constantini* [*Praise of Constantine*], 501) and explains, "It was a Platonic idea, which he gained from Plotinus, whom he quotes speaking of his second Principle as 'radiance around, from Him indeed, but from one who remains what He was: as the sun's bright light circling around it (*peritheon,*) ever generated from it, which nevertheless remains'" (*Praeparatio evangelica* 11.17).

39. Watchtower Bible and Tract Society of Pennsylvania, *Reasoning from the Scriptures* (Brooklyn, NY: Watchtower Bible and Tract Society of New York, 1989), 212–13.
40. Watchtower Bible and Tract Society, *Reasoning from the Scriptures*, 218.
41. Watchtower Bible and Tract Society, *Reasoning from the Scriptures*, 218.

(1 Kings 22:8), and other Micaiahs, all of whose names mean "who is like God" (2 Chron. 17:7; Jer. 36:11, 13; Neh. 12:35).[42] No one concludes that their names mean they are all angels or divine, so why should Michael be the celestial name for Jesus, which means "God is salvation," the Old Testament name Joshua?

Even further, how does this theory that Jesus is Michael the archangel correlate with Hebrews 1:5, which asks, "For to which of the angels did God ever say, 'My son are *you*?'" The question's construction evokes the answer: none. If Michael were an exception, here is where that would be specified. But the whole point of the question is to evoke a negative answer: no angel could ever be God's Son. That would violate God's expressed announcement in Isaiah 42:8, as Athanasius explains, building an entire argument for the Son's divinity out of this key Scripture. He points out that if we claim the Son is "of other origin" than the "Father," we would be "transferring what is proper to the Father to what is unlike Him in substance, and expressing the Father's godhead by what is unlike in kind and alien in substance." Thereby, "we introduce another substance foreign to Him" and open ourselves to be "silenced by God Himself, saying, *My glory I will not give to another*, and be discovered worshipping this alien God."[43]

As for 1 Thessalonians 4:16, this passage states that the Lord's command comes "in, on, at; near, by, before; among, within,"[44] not "as" the archangel's voice and trumpet. So, this passage does not suggest Jesus is doing them all simultaneously, but at his command the fanfare announcing the end begins. And Daniel 12:1, equating the angelic prince with the Son empowered by the Ancient of Days to rule as king with an everlasting and indestructible rule in Daniel 7:13–14, is hardly presented as equal. Neither is Revelation 12:7–12 equating the leader of God's angelic army with the sacrificial lamb of Revelation 21 and 22. Such evidence under scrutiny is not even circumstantial.

In addition, Greek is a rhetorical language, beautiful and sweeping in its ability to be crafted gloriously by each orator. It does not depend on word order but on case endings. Thus, John 1:1, being a sentence with the verb "to be," has two nouns, both with nominative case endings. But which is the subject and which the predicate, since both nouns have nominative case

42. All of these passages I double-checked in the Jehovah's Witnesses' own Bible, and they are all present specifying these names. Watchtower Bible and Tract Society of Pennsylvania and International Bible Students Association, *New World Translation of the Holy Scriptures* (Brooklyn, NY: Watchtower Bible and Tract Society of Pennsylvania and International Bible Students Association, 1984).
43. Athanasius, *De Synodis* 3.21.50.
44. *en*, BN, 59.

endings, and word order doesn't help out? Here is the answer: the reader must look for which noun is highlighted by having the definite article to identify its subject. Lack of an article identifies the predicate noun and distinguishes it from the subject noun, which is identified by having the article. It is a neat and simple rule for sentences built with the verb "to be."

Since in John 1:1 "word" (*logos*) has the definite article (*ho logos*, i.e., "the Word"), then "Word" is being identified as the subject of the final clause, "and the Word was God." No indefinite article ("a") can be added, or the sentence is immediately thrown into chaos; nothing would then be able to distinguish the subject (the Word) from the predicate nominative (God). Therefore, *The Kingdom Interlinear Translation* translators put the literal translation on the left side of the page without adding an "a" before God because, obviously, they knew they could not put in the indefinite article without damaging the sentence structure. They omitted it. That was the sensible and grammatically correct choice to make. Therefore, the decision to add the "a" on the right-hand side of page 401 to make the predicate read "and the Word was a god"[45] is simply a theological decision.

In addition, their low view of Jesus as a creation also poses problems. To say something in Origen's defense, unlike the Jehovah's Witnesses, who deny Jesus Christ is a person of the Trinity, Origen is attempting to preserve the Father's self-existence (never having a beginning). But he is also attempting to preserve some kind of divinity for the Son by affirming the Son sharing the Father's deity,[46] though Origen does so by maintaining eternal subordination and complete dependence on the Father. That's his good intention. But what is the cost of this inadequate solution? Such reasoning depicts the Trinity as a God in tandem (a descending order). Origen's understanding seems to me to threaten monotheism, because it affects the equality of the essence of these two persons of the Trinity and makes God the Father and God the Son more like two gods (a greater and lesser one) than one God in three.

Millard Erickson explains this threat quite clearly in what we might call "Millard Erickson's rule":

45. New World Bible Translation Committee, *The Kingdom Interlinear Translation of the Greek Scriptures* (New York: Watchtower Bible and Tract Society of New York, 1985), 401.
46. E.g., "'And the Word was God,' that we might understand that the Word had become God because he is 'with God.'" Origen, *Commentary on the Gospel According to John* 2.12.

If authority over the Son is an essential, not an accidental, attribute of the Father, and subordination to the Father is an essential, not an accidental, attribute of the Son, then something significant follows. Authority is part of the Father's essence, and subordination is part of the Son's essence, and each attribute is not part of the essence of the other person. That means that the essence of the Son is different from the essence of the Father. The Father's essence includes omnipresence, omniscience, love, etc., and authority over the Son. The Son's essence includes omnipresence, omniscience, love, etc., and submission to the Father. But that is equivalent to saying that they are not *homoousious* with one another. Here is surely a problem for the gradationists, for they want to affirm the *homoousious*, in order to reject Arianism. On face value, therefore, there seems to be an internal contradiction in this doctrine.[47]

Arius' view, the ancient predecessor of this low Christology we see in the teaching of today's Jehovah's Witnesses, of course, used the lesson of light to draw out just such a difference in essence, as he wrote of God the Father:

> Equal or like Himself He alone has none, or one in glory. . . .
> The Unoriginate made the Son an origin of things generated;
> And advanced Him as a Son to Himself by adoption.
> He has nothing proper to God in proper subsistence.
> For He is not equal, no, nor one in substance with Him. . . .
> Thus there is a Three, not in equal glories.
> Not intermingling with each other are their subsistences.
> One more glorious than the other in their glories unto immensity.
> Foreign from the Son in substance is the Father. . . .
> Hence He is conceived in numberless conceptions.
> Spirit, Power, Wisdom, God's glory, Truth, Image, and Word.
> Understand that He is conceived to be Radiance and Light.[48]

For Arius, "Radiance and Light" are merely reflected glory, diminished as unequal to the glory of the Father. To him, the Son is like a mirror reflecting back but not having a brightness of its own. Consequently, Arius posits an inequality of attributes ("glory," for example) to illustrate a difference in

47. Millard J. Erickson, *Who's Tampering with the Trinity? An Assessment of the Subordination Debate* (Grand Rapids: Kregel, 2009), 172.
48. Arius, *Thalia*, cited by Athanasius, *De Synodis* 2.2.

substance, just as Athanasius in his day and Millard Erickson in our day both warned would happen. And once again, the image of "Wisdom" is proffered as further proof that the Son is a mere creation, divine only in the sense that he reflects the Father (having "subsisted from God," though not shared the same substance). This is spelled out in the subsequent semi-Arian creeds that attempted to moderate Arius' language.

Origen, to his credit, seems to have perceived this difference, so he is content to avoid a complete Arian-type conclusion by calling the Son God, but he still distinguishes the Son as not "very God" or "true God," which is a solution that should part his company from Nicean Creed–oriented evangelicals.

His view also leads Origen consistently to transfer his conclusions on eternal subordination in the Trinity to a reflecting subordination within human society. His argument is that since the Son and Spirit's eternal subordination is necessary for the Father to maintain the attribute "almighty," "one cannot be a father apart from having a son, nor a lord apart from holding a possession or a slave, so we cannot even call God almighty if there are none over whom he can exercise his power."[49] This is an argument that makes human slavery an appropriate and perhaps even necessary reflection of the creating Godhead: in his reasoning, God must have a divine subordinate as human leaders must have human slaves! But in opposition to this view, the apostle Paul advocated with the master Philemon to free his slave Onesimus and let him work in ministry with Paul (see Philem. 13–16). Further, Origen even applies eternal subordination to worship, arguing, despite the example of Stephen's prayer in Acts 7:59,

Are we not divided if some of us pray to the Father, others to the Son? Those who pray to the Son, either with the Father or apart from the Father, sin with great simplicity through ignorance of the subject due to lack of examination and inquiry. Let us pray, then, as to God, let us make intercession as to a Father, let us make supplication as to a Lord, let us give thanks as to God and Father and Lord, and in no wise as to the Lord of a slave. For the Father might rightly be reckoned both as Lord of the Son and Lord of them who have become sons through him.[50]

49. Origen, *On First Principles* 1.2.10.
50. Origen, *On Prayer* 16.1. Although Jesus did indeed instruct his disciples to pray to our Father in heaven (e.g., Matt. 6:9), we see *Adonai*, which equals the Greek word *kurios,* the title given for God throughout the Bible, is applied to Jesus in prayer, as the dying Stephen did when he cried out in a loud voice, "Lord Jesus, receive my spirit" (Acts 7:59). Peter also appears to apply the title to the Holy Spirit, when he is given the vision of unclean animals and ordered to "stand up, Peter, kill and eat!" and he replies, "Not so, Lord!" (Acts 10:13–14). Acts 10:19 reveals he is in conversation with the Holy Spirit. Another

Small wonder, then, that J. N. D. Kelly summarizes Origen's position as follows: "The impact of Platonism reveals itself in the thoroughgoing subordinationism which is integral to Origen's Trinitarian scheme. . . . In relation to the God of the universe He [the Son] merits a secondary degree of honour; for He is not absolute goodness and truth, but His goodness and truth are a reflection and image of the Father's." And, if "Origen's language" seems to be "suggesting that the Son is God from the beginning, very Word, absolute Wisdom and truth, the explanation is that He may appear such to creatures, but from the viewpoint of the ineffable Godhead He is the first in the chain of emanations." Therefore, "This conception of a descending hierarchy, itself the product of his Platonizing background, is epitomized in the statement that, whereas the Father's action extends to all reality, the Son's is limited to rational beings, and the Spirit's to those who are being sanctified."[51] One can see here debts owed to Origen not only by the semi-Arians for his restrictions on the Son's nature but by the "Christian Gnostics" who saw the Son as just one of many emanations from the Father.

Origen's viewpoint contrasts radically with what we shall see next: Athanasius' painstaking, biblically based identification of the Son as almighty, worthy of worship, and equal in honor, goodness, truth, and other such attributes with the Father. The subordinationism we find in Origen, even when leavened by his theology of continuous derivation of divinity from the Father to the Son, is far less than the high Christology that we will now note in Athanasius.

THE LIGHT IMAGE IN ATHANASIUS

Like those we have cited and many others, the great fourth century champion of the Nicean Creed Athanasius, c. AD 295–373, also summons the "lesson of light" to explain the relationship between the Father and the Son

passage very hard to work into Origen's schema is Acts 13:2, where believers are fasting and ministering [or worshiping, *leitourgeō*] "to the Lord," and the Holy Spirit replies, "Appoint (or set apart) to me Barnabas and Saul into the work which I have called (or summoned) them." William David Spencer, "How to Address God in Prayer," in *Giving Ourselves to Prayer: An Acts 6:4 Primer for Ministry*, ed. Dan R. Crawford (Terre Haute, IN: PrayerShop, 2008), 202. I conclude the rule is to pray to the Father, as Jesus instructed, but as these examples reveal, to pray also at appropriate times to Jesus Christ and the Holy Spirit can hardly be called "sin," when the Bible neither reproves Stephen nor Peter nor the believers at Antioch of Pisidia for these heartfelt prayers. After all, we worship not three gods but one God with three eternal faces turned benevolently toward us, so as to say, filled with love and concern for our spiritual well-being. We must be careful to remain monotheistic and love and honor each person of the Trinity but together as one loving, supreme God who creates and redeems us.

51. Kelly, *Early Christian Doctrines*, 131–32.

not to stress a difference but to underscore the equality of the substance that they share.

In *Defence of the Nicene Definition*,[52] Athanasius writes:

> The illustration of the Light and the Radiance has this meaning. For the Saints have not said that the Word was related to God as fire kindled from the heat of the sun, which is commonly put out again, for this is an external work and a creature of its author, but they all preach of Him as Radiance, thereby to signify His being from the substance, proper and indivisible, and His oneness with the Father. This also will secure His true unalterableness and immutability; for how can these be His, unless He be proper Offspring of the Father's substance? for this too must be taken to confirm His identity with His own Father.[53]

For Athanasius, the lesson of light illustrates that Jesus Christ is the "Offspring" of the Father, and he continually uses the offspring image with the radiance image in his critique of the semi-Arian counsels and their creeds. He sets forth "the Son's genuine relation toward the Father, and the Word's proper relation towards God, and the unvarying likeness of the radiance towards the light: for as the words 'Offspring' and 'Son' bear, and are meant to bear, no human sense, but one suitable to God." Athanasius, of course, is interested in highlighting "the phrase 'one in substance,'" stressing, "Here again, the illustration of light and its radiance is in point. Who will presume to say that the radiance is unlike and foreign from the sun? rather who, thus considering the radiance relatively to the sun, and the identity of the light, would not say with confidence, 'Truly the light and the radiance are one, and the one is manifested in the other, and the radiance is in the sun, so that whoso sees this, sees that also?'" And, again, he brings the point home: "Such a oneness

52. Athanasius, *Defence of the Nicene Definition* 5.9.23. Please note that John Henry Cardinal Newman, whose classic rendition of these two great works of Athanasius I am using, employs the British spellings throughout. I am quoting from his stellar translations. The switching back and forth between capitals and small letters, for example, for "radiance" and "sun," are also his, as are the lack of capitals for some sentences, as he tries to capture Athanasius' own particular style of writing.

53. Translator and annotator Joseph Hugh Crehan sees Athenagoras proposing equality in his interpretation for this image: "The term *aporroia*, or outflow, is applied to the Spirit in *Emb.* 10 and 24. This cannot imply subordination of the Spirit to the other two persons, for the three are joined several times (*Emb.* 10, 12, and 24) in expressions where no distinction of rank between the three is made. 'That two Divine Persons and an impersonal emanation should be thus enumerated together, by so philosophic a writer as Athenagoras, is not conceivable.' This verdict by H. L. Mansel (*DCB* 1.206) must surely be accepted." Athenagoras, *Embassy for the Christians* 24, 10n35.

and natural possession, what should it be named by those who believe and see aright, but Offspring one in substance? and God's Offspring?"[54] Again in his critique of the semi-Arians, he chides, if they "understood Him to be the proper offspring of the Father's substance, as the radiance is from light, they would not every one of them have found fault with the [Nicean] Fathers; but would have been confident that the Council [of Nicea, AD 325] wrote suitably; and that this is the orthodox faith, concerning our Lord Jesus Christ."[55] Also, "They have called the Father the Fount of Wisdom and Light, and the Offspring from the Fountain, as He says, *I am the Life,* and *I Wisdom dwell with Prudence.*[56] But the Radiance from the Light, and Offspring from Fountain, and Son from Father, how can these be so suitably expressed as by 'One in substance?'" Even again, the Son is "genuine from the Father, as Life from Fountain, and Radiance from Light. Else why should we understand 'offspring' and 'son,' in no corporeal way, while we conceive of 'one is substance?'"[57] This is how he uses the radiance/sun image over and over.

This illustration supports his charge: "Speak not of two Gods but of one God; there being but one Face of Godhead, as the Light is one and the Radiance . . . sun and radiance are two, but the light one, because the radiance is an offspring from the Sun." So, he reasons, "not more divisible, nay less divisible is the nature of the Son towards the Father." "The godhead" is "not accruing to the Son," as if the Son had to acquire it, as Origen seems to suggest, but "the Father's godhead being in the Son, so that he that hath seen the Son hath seen the Father in Him; wherefore should not such a one be called One in substance?"[58]

Athanasius amplifies his explanation of "the Son's genuine relation towards the Father, and the Word's proper relation towards God, and the

54. Athanasius, *Defence of the Nicene Definition* 5.11.24.

55. Athanasius, *De Synodis* 3.9.40.

56. In his *Defence of the Council of Nicea's Definition*, when Athanasius uses Proverbs 8's image of Wisdom for Jesus Christ, he is illustrating the incarnation, as he specifies in 3.12.14: "whereas He is Son of God, He became Son of man also . . . He took on Himself a body from the Virgin Mary . . . He took a body and said, *The Lord has created Me a beginning of His ways unto His works.* For as it properly belongs to God's Son to be everlasting, and in the Father's bosom, so on His becoming man, the words befitted Him, *The Lord created Me.* For then it is said of Him, and He hungered and He thirsted, and He asked where Lazarus lay, and He suffered, and He rose again. And as, when we hear of Him as Lord and God and true Light, we understand Him as being from the Father, so on hearing, *The Lord created,* and *Servant,* and *He suffered,* we shall justly ascribe this, not to the Godhead, for it is irrelevant, but we must interpret it by that flesh which He bore for our sakes."

57. Athanasius, *De Synodis* 3.11–12. See also 2.23.1.

58. Athanasius, *De Synodis* 2.24.

unvarying likeness of the radiance towards the light" by noting, "When we hear the phrase 'one in substance,' let us not fall upon human senses, and imagine partitions and divisions of the Godhead, but as having our thoughts directed to things immaterial, let us preserve undivided the oneness of nature and the identity of light; for this is proper to the Son as regards the Father, and in this is shewn that God is truly Father of the Word."[59]

Athanasius realizes this illustration of the sun and its radiance is "mean indeed and very dim" when imaging God, but it does lift our eyes above our nature. And by doing so, Athanasius hopes, "who can even imagine that the radiance of light ever was not, so that he should dare to say that the Son was not always, or that the Son was not before His generation? Or who is capable of separating the radiance from the sun, or to conceive of the fountain as ever void of life, that he should madly say, 'The Son is from nothing,' who says, *I am the life,* or 'alien to the Father's substance,' who says, *He that hath seen Me, hath seen the Father?*"[60]

We note here that Athanasius also identifies God the Son with the term "Wisdom," and we may wonder why that is. After the deaths of Clement and Origen, a unitarian teacher named Paul of Samosata was condemned in AD 268 at the Synod of Antioch. According to the *De Sectis,* written in the 500s, Paul of Samosata restricted "the name of God to the Father Who created all things, that of Son to the mere man, and that of Spirit to the grace which indwelt the apostles."[61] Epiphanius, overseer of Salamis on Cyprus, who himself lived in the 300s "and violently opposed both Origen's followers and the Arians as heretics adulterating the faith with 'hellenism,'"[62] still recorded that Paul of Samosata was censured by followers of Origen who were "committed to the belief in three eternal, subsistent Persons" in the Godhead,[63] thus distancing Origen's followers' views from such complete unitarian conclusions about the nature of God. According to John Henry Newman, those like Athanasius who lived after Paul of Samosata were obliged to defend historic titles like "Word," "Wisdom," and "Son," and images like "Radiance," against the charge that these titles and images indicated a being different from God. Cardinal Newman notes,

59. Athanasius, *Defence of the Nicene Definition* 5.11. Athanasius does refer to Jesus as being seen by human witnesses as "the Wisdom and the Power of God" during the incarnation, but without the Proverbs 8 reference in his *On the Incarnation* 19.

60. Athanasius, *Defence of the Nicene Definition* 3.10.12.

61. J. N. D. Kelly, *Early Christian Doctrines,* 2nd ed. (New York: Harper, 1960), 117–18.

62. Henry Chadwick, "Epiphanius," in *OCD,* 399.

63. Epiphanius, "Panarion (*Adversus haereses*)," cited in Kelly, *Early Christian Doctrines,* 118.

The point in which perhaps all the ancient heresies concerning our Lord's divine nature agreed, was in considering His different titles to be those of different beings or subjects, or not really and properly to belong to one and the same person; so that the Word was not the Son, or the Radiance not the Word, or our Lord was the Son, but only improperly the Word, not the true Word, Wisdom, or Radiance. Paul of Samosata, Sabellius, and Arius, agreed in considering that the Son was a creature, and that he was called, made after, or inhabited by the impersonal attribute called the Word or Wisdom. When the Word or Wisdom was held to be personal, it became the doctrine of Nestorius.[64]

In an earlier chapter, we saw the doctrinal difficulties into which Nestorius plunged when he campaigned against Mary being considered the mother of Jesus, the God-bearer. The concern of Athanasius and all the orthodox scholars at the rejection of Mary as Jesus' mother is that it raises all kinds of questions about how human or divine Jesus really was. If Mary was only a kind of surrogate mother and added no human dimension to him, or if she were only the mother of a human being and the Holy Spirit did not implant the divine seed in her womb, then was Jesus really an adequate substitute for humanity? Did he really share in our humanity? Or was this another form of Adoptionism?

The problem with the thinking of Paul of Samosata (or those like Arius before him) is that in making the Son simply a creature—whether the first created, or created more recently—then one is positing he was being used as a temporary residence for a divine Spirit. No orthodox believer wanted to retread that stony ground, for this was the error being promoted by Cerinthus, the Gnostic opponent of the apostle John, as Irenaeus reports his heretical teaching: "After his baptism Christ descended on [Jesus] in the shape of a dove from the Authority that is above all things. Then he preached the unknown Father and worked wonders. But at the end Christ again flew off from Jesus. Jesus indeed suffered and rose again from the dead, but Christ remained impassible, since he was spiritual."[65]

Likewise, for Athanasius, the focus is always clearly on establishing that the Son and the Father are equal in substance. His proof not only rests on showing the equality inherent in the image of light and the commensurate titles but also

64. John Henry Newman, Note e to Athanasius, *Defence of the Nicene Definition* 5.12.24. Nestorius, of course, was the opponent of the term *theotokos*, or God-bearing for the virgin Mary, who claimed Mary only bore a man, Jesus, and could not have carried the Godhead in her womb. See also Kelly, *Early Christian Doctrines*, 311–12.

65. Irenaeus, *Against the Heresies* 1.26.1.

in the assignment of attributes, a position that eventually differs both with Clement's and Origen's about shared characteristics of the persons of the Trinity, as he calls not only the Father but also the Son "the Almighty." For Athanasius, as we have seen, equality of attributes is the proof for equality of substance (being). Lose the first, and one loses the second. So he declares of the Christ, "This is why He has equality with the Father by titles expressive of unity, and what is said of the Father, is said in Scripture of the Son also, all but His being called Father."[66]

Athanasius illustrates his position by citing Bible verses in which Jesus claims to possess all the Father possesses, for example, being named "God," "*the Almighty*," and "Light"; making "*all things*"; doing "*whatsoever*" the Father does; and "being Everlasting" with "*eternal power and godhead*." He also notes parallel Scriptures in which the Son and the Father are described with the same terms:

- "being *Lord . . . through whom [are] all things*"
- being "Lord of Angels" and "worshipped by them"
- "being honoured as the Father, for *that they may honour the Son,* He says, *as they honour the Father*—being equal to God, *He thought it not robbery to be equal with God*"
- "being Truth," "Life"
- being "*The Lord God*" and "*The God of gods*," who forgives sins
- being "*the King eternal*" and "*the Son*," "*the King of glory*"
- "God" verifies, "My glory I will not give to another"[67]

66. Athanasius, *De Synodis* 3.20. This concern for and attention to the relationship between equality in substance and attributes can be seen in The Westminster Confession of Faith, which maintains the language of the eternal generation of the Son and recognizes equality of attributes and substance: "In the unity of the Godhead there be three Persons of one substance, power, and eternity: God the Father, God the Son, and God the Holy Ghost. The Father is of none, neither begotten nor proceeding; the Son is eternally begotten of the Father; the Holy Ghost eternally proceeding from the Father and the Son" (2.3); "the Holy Spirit, the third Person in the Trinity, proceeding from the Father and the Son, of the same substance and equal in power and glory, is, together with the Father and the Son, to be believed in, loved, obeyed, and worshipped throughout all ages" (9.2). The Westminster Shorter Catechism continues this equation in its answer to Question 6, "There are three Persons in the Godhead: the Father, the Son, and the Holy Ghost; and these three are one God, the same in substance, equal in power and glory." The Westminster Larger Catechism slightly amplifies this statement in its answer to Question 9: "There be three persons in the Godhead: the Father, the Son, and the Holy Ghost; and these three are one true, eternal God, the same in substance, equal in power and glory; although distinguished by their personal properties." *The Constitution of the Presbyterian Church (USA), Part 1: Book of Confessions* (Louisville: The Office of the General Assembly, 1999).

67. Athanasius, *De Synodis* 3.20–21.

Athanasius concludes, "If then any think of other origin, and other Father, considering the equality of these attributes, it is a mad thought."[68]

Therefore, maintaining an understanding of the equality of the attributes of each person of the Trinity is, for Athanasius, necessary to maintain a proper confession of each person's equality of substance. Reduce one's belief in the equal status of the attributes of any of the persons of the Godhead, and one has eliminated one's proof of the existence of the Trinity, having reduced one's understanding of the doctrine to an ascending relationship of three gods in tandem.[69] Arius made just such a mistake.

Instead, by providing the image of shared light to illustrate his scriptural proofs of shared equality of characteristics and titles as proof of the equality of the Father and Son in these quotations from the *De Synodis,* Athanasius proceeds to the question of rank in *Epistulae quattuor ad Serapionem.* He explains, "But of such rank [*taxis*] and nature the Spirit is having to the Son, so the Son has to the Father."[70]

What does he mean by this? Is he suggesting that the Son, who comes from the Father, is equal to the Father, and the Spirit who is sent by the Son and the Father is equal? Or does he mean the Son is of lower rank to the Father, and the Spirit is of lower rank to the Son? The *Sermo contra Latinos,* which was written in the 300s, probably by a disciple of Athanasius, confirms the first conclusion: "But the Father is first not according to time, and not according to rank, surely not!"[71] But, if this sermon is not actually by Athanasius himself, can we be absolutely certain this disciple is right? How can we know what Athanasius truly meant?

68. Athanasius, *De Synodis* 3.21.
69. Athanasius, *De Synodis* 3.21.50.
70. *Thesasrus Linguae Graecae: Canon of Greek Authors and Works,* 26:580, line 24, stephanus. tlg.uci.edu/lexica.php.
71. Literally, "May it not happen [*mê genoito*]!" Athanasius, *Sermo contra Latinos,* in *TLG,* 28:829, line 47. Translation mine. The statement cited in our text is included in a discussion of the theory of the "eternal emergence" of the Son and Spirit, which seeks to clarify that the Spirit is "conjoined and together and not being inferior according to the emergence after the Son. . . . For just as the Son immediately and closely is out of the first, which implies the Father, so also the Spirit is immediately out of the Father, with reference to the eternal emergence. But the Father is first neither according to time, nor according to rank—surely not!" As we can see, the Son and Spirit proceeding from the Father may be understood as *order,* but without an eternally hierarchical *ordering.* In addition, we can notice this concern is also expressed in the Second Helvetic Confession: "Thus, there are not three gods, but three persons, consubstantial, coeternal, and coequal; distinct with respect to hypostases, and with respect to order, the one preceding the other yet without any inequality" (The Second Helvetic Confession 3, in *The Constitution of the Presbyterian Church [USA], Part 1: Book of Confessions,* 5.017).

ATHANASIUS ON RANK IN THE TRINITY

To find out the answer, I decided to examine every instance I could find in the extant writings of Athanasius that uses the word for rank: *taxis*. I discovered that Athanasius was deeply disturbed by the creed offered at the dedication celebration of Emperor Constantine's "Golden Church." He realized it was intended to be a subtle substitute for Nicea's creed (AD 325). Created by Semi-Arians, it began well enough, specifying "one Lord Jesus Christ" who was "God out of God," "God the Word," "Lord from Lord," and "immutable [*atreptos*] and unchangeable [*analloiōtos*]."[72] Picking up Paul's language, it explicated the Great Commission literally: "having signified of a Father, truly a Father being, and of a Son truly a Son being, and of the Holy Spirit truly a Holy Spirit being, the names neither simply nor uselessly appointed [or destined, or set, or given, or legally valid], but noting accurately the belonging to each one named subsistence [*hupostasis*, that is, substantial nature, reality or essence],[73] rank [*taxis*, or order],[74] and glory [*doxa*], in such a way to be on the one hand three in essence, but on the other hand in agreement [or harmony] one."[75]

This Dedication Creed also reaffirms no "time or age to be before the generation of the Son of the Father." But despite all this orthodox-sounding language, Athanasius immediately recognized, as Henry Bettenson notes, that "The Dedication Creed" of 341 was one of the earliest "attempts to overthrow the Nicene Formulas . . . a shorter version of this creed was made soon afterwards, and this became the basis of Arian confessions in the East."[76] Athanasius realized that distinguishing by rank and glory works hand in hand with an increasing withdrawal from the affirmation of equal or like substance, ultimately to end in distinguishing the Trinity in terms of degree of Godhood. Going full circle at the Confession at Seleucia in AD 359, "the authentic faith published at the Dedication at Antioch" is reaffirmed. However, statements on "One in substance" and "Like in substance" are "reject[ed]," though Christ is still called "God the Word" and "God from God."[77]

72. LSJ, 111, 272.
73. BDAG, 1040; LSJ, 1895; Thayer, 644–45.
74. LSJ, 1756.
75. See also J. H. Newman's translation of Athanasius, *De Synodis* 2.10.23.
76. Henry Bettenson and Chris Maunder, eds., *Documents of the Christian Church*, 4th ed. (Oxford: Oxford University Press, 2011), 43–45.
77. Athanasius, *De Synodis* 2.16.29.

What Was Athanasius' Response?

Just as we have seen, Athanasius' objection is that equality of attributes is evidence of equality of substance. Dissimilarity in attributes would indicate a dissimilarity in substance (*De Synodis* 3.19.49). The Dedication Creed had separated the Son from the Father in subsistence, rank, and glory.

So Athanasius goes to the heart of the first term ("subsistence" = *hupostasis*) by centering on equality in substance, addressing the Dedication Creed's posited differences between the Father and the Son in glory (*doxa*) and rank (*taxis*). This apparent omission once again raises the question: Does Athanasius see the Son as equal in all aspects to the Father except in rank or order? Can the person of the Godhead we know of as the second person of the Triad (as Athanasius literally writes; or the Trinity, as we translate the term *trias*) be equal in all but subordinated in position in the Godhead?

A Summary of the Use of *Taxis* in Athanasius' Theology of the Trinity

Taxis is a flexible word for Athanasius, and a chart of the meanings of the word *taxis* I discovered in the extant writings of Athanasius can be found in the appendix. The preponderance of his uses has to do with the order of nature revealing a single Creator who has constructed and so ordered it—though, as we see, Athanasius uses it in many other instances as well. When applied to the Trinity, much of his discussion is incarnationally oriented. For example, he focuses on the creation revealing the Son (or Word, or Lord) to be the one Creator. He also has special interest in Psalm 110:4's application to Jesus, who is God by nature, but took flesh by Mary and became a priest forever in the order of Melchizedek.[78] But four passages clearly seem to deal with the preincarnate Trinity. (1) In the *De Synodis* in his critique of the semi-Arian creeds, he quotes the words of the Dedication Creed (presented at the inauguration of Constantine's Golden Church) before he refutes them. This creed clearly suggests that the Son is secondary in rank (*taxis*), but it is semi-Arian. (2) In *Epistle Quattuor ad Serapionem*, Athanasius contends, "But as of such rank [*taxis*] and nature the Spirit has to the Son, so [this is the *toioutos/oious* construction = 'as/so'] the Son has to the Father, how does one saying this one is a created being not also out of necessity think the same of the Son?" He follows this question with another inference: "For, if the Spirit is a created being of the

78. Hebrews 7:17; cf. *Dialogus Athanasii et Zacchaei* 39.81; *Expositiones in Psalmos* 70.

Son, it would follow them to call [the Holy Spirit] and the Word of the Father to be a created being." Athanasius labels this view a form of Judaism and complains "those of Arius" desire to think such things and should not blaspheme against the Holy Spirit" (lines 27–34). (3) In *Testimonia E. Scripture,* he notes: "The heretics say that the deity has been established by rank [*taxis*] and numbering." J. N. D. Kelly points out that after the public presentation of the creed, the orthodox labeled it the "Blasphemy of Sirmium" in AD 357. "In its developed form this new Arianism was given the name Anomoeism because of its watchword, 'The Son is unlike [*anomoios*] the Father in all things.'"[79] Such an Arian conclusion is, of course, the exact opposite of Athanasius', since he goes to great pains to establish the Son is exactly like the Father in all things. Athanasius points out that the one who is numbered after can even take precedence over the human who went dishonorably before. His example is that Jesus came after Adam. Athanasius' reasoning here is that someone coming after someone else is not *ipso facto* inferior but can be superior. As we saw, however, he is appalled if a hearer concludes he is claiming the Son is superior to the Father; his point is to stress their equality. (4) In the *Sermo Contra Latinos* (100.28.829), which summarizes Athanasius' teaching, we read: "For just as the Son [is] immediately and recently out of the first, which implies the Father, so also the Spirit is immediately out of the Father, with reference to the eternal emergence. But the Father is not first according to time, nor according to *taxis* (rank or order). Absolutely not!"

An impressive consistency exists in Athanasius' and his disciples' thought. As for Athanasius, equality of substance is established by equality of attributes among the Father, Son, and Spirit. Nowhere in any of the 110 instances of his use of the term *taxis* does he contend that either the Son or the Spirit is of inferior rank to the Father prior to the incarnation. In fact, quite the opposite, this great champion of Nicean orthodoxy is accused on at least two recorded occasions with making the Father and the Son so equal that the Father appears as brother to the Son, or even that the Son is greater. In both instances, he disagrees strenuously but continues to fill his writings with the language of divine equality. For him, there is clearly no equality of substance without equality of attributes, and he adds no qualification to that conclusion in his use of the term *taxis* to mean "rank."

79. Kelly, *Early Christian Doctrines,* 249.

One evangelical scholar writes, "The egalitarian movement in our evangelical circles, sadly, seeks to deny this very *taxis*, both in God's trinitarian structure of relations and in those elements of the created order that he made to reflect the same kind of *taxis*. Surely this must be grieving in God's sight."[80] I am persuaded, however, that the case is quite the opposite, according to Athanasius. Far from grieving God, opposing rather than supporting Athanasius' key argument would no doubt be grieving both to the triune God and this great saint Athanasius. Why do I say this? Because for contemporary evangelicalism ever to arrive at the point where those following Athanasius' arguments are deemed "grieving in God's sight" appears similar to the progressive escalation to greater and greater subordinationist positions that we see in the semi-Arian creeds. It is a direction any true Christian, not to mention orthodox evangelicals specifically, should not be going.

A proper understanding of Hebrews 1:3's lesson of light underscores this truth: like comes from like. The phrases "Light of Light" and "*true God of true God*" were considered significant enough to be included in the actual Creed of Nicea itself. Brief as it is, this creed of AD 325 captures the central themes that Alexander, the overseer who preceded and mentored Athanasius, had preached in his sermon on equality in the Trinity that had so upset Arius. Athanasius would emerge as the Creed's greatest champion of his time, consistently defending our "Lord Jesus Christ" as "the Son of God, *begotten of the Father, only-begotten, that is, of the substance of the Father,* God of God, Light of Light, *true God of true God, begotten not made, of one substance with the Father.*"[81]

As Paul reminds us in Philippians 2:6, the preincarnational second person of the Trinity was already equal (*isos*) within the Godhead when choosing not to regard that equality as something to hold on to (*harpagmos*). Rather he actively emptied, not substance or ontological status, but divine glory and limitlessness. He became limited to human form so that, as the Son of God, the incarnated God-Among-Us, Jesus Christ could be the necessary sacrifice for our sins. That is the good news of the faith "once for all given to the saints" (Jude 3), for which we in our generation should "contend" as Athanasius did in his.

80. Bruce A. Ware, *Father, Son, and Holy Spirit: Relationships, Roles, and Relevance* (Wheaton, IL: Crossway, 2005), 72–73.
81. "The Creed of Nicaea," in Bettenson and Maunder, eds., *Documents of the Christian Church*, 27.

SUMMARY OF THE LIGHT IMAGE OF THE SON'S RELATION TO THE FATHER	
Early Church Theologian	**Son's Relation to the Father**
Clement (c. 150–211)	Light of the Father
Origen (c. 185–254)	Light of the Father
Arius (c. 250–c. 336)	Reflected glory of the Father
Athanasius (c. 296–373)	Radiance from shared substance with Father
Apollinarius (c. 310–c. 390)	Sun, ray, light

So what should the lesson of light tell us? It should confirm, as Athanasius indicates, that we worship one, great triune God in three coeternal, coequal persons. As the light images tell us, God lights up our world with life and love and justice. Ours is a world God created, redeemed, and is now reconciling. We should follow the light of Christ, joining him through the power of the Holy Spirit to spread that light of God's redeeming love and justice; illuminating the minds of all around us by sharing in the task of the great light and life giver; dispelling the night of ignorance and sin; and helping God bring in the eternal day of love and truth.

CHAPTER 6

IMAGES THAT MOVE AND CHANGE

K inetics is the science of movement. In its application to theories about gases, heat, and matter, it focuses on the effect of movement to bring about change. If we adapt this theory to theology and posit it as a rough picture of the nature of God, then God, who is understood as immutable, would at the same time be a Being in motion who would change but not in nature. In this chapter, we see illustrations of and responses to moving and changing images from orthodox and heterodox Christians today and in the past.

Consider the illustration of the whirlwind out of which God answers Job in 40:6 (MT), which is also a sign of God's presence (as when God takes Elijah to heaven in 2 Kings 2:11) and God's judgment and punishment (as in Zechariah 7:14). Thunderstorms begin with strong updrafts and then end with strong downdrafts of rain. As with God, the wind is invisible, but we can see the effects and feel the great force moving in three different ways, ultimately coordinated in a powerful unity all roaring toward us. Each of these gusts are wind, but they are distinguished in being an updraft, a downdraft, and a vortex.

Philosophically, such imagery suggests that God is not simply the Platonic still point in the universe around which all dances but the active force in all history making things happen. When we use the term *force* these days, of course, we must be clear we are not referencing the Star Wars concept of "the Force" that collects consciousness and can therefore be good or bad; Edmond

Hamilton's prior vision of "the Force" on which Atlantis depended;[1] James Lovelock's theory of earth as the living organism "Gaia";[2] or even the Rastafarian concept of a natural mystic that surrounds and flows through all that exists. All of these are in their essence impersonal. The God who created us, however, is intensely personal. Therefore, we must continue to keep in mind the constant need not to confuse but continually to separate the reference from the referent. Imagery is not always a point-by-point allegory. It is often a one-point to one-other-point analogy. In this case, an image attempts to illustrate one or some but not all truth about God. Our task is always to evaluate the point being highlighted and ask if it is indeed valid and helpful.

Over the years, my students have offered a number of intriguing images in the category of nonhuman images that move and change. Several scientists in my classes have suggested the accumulating plant material in ancient sea-level swamps, which becomes peat, which then becomes coal over the eons (or we could say organic matter that turns into carbon, which crystallizes into a diamond). Other suggest dinosaurs that die and become decomposed matter, which liquefies into petroleum (fossil fuel). These are all different applications of a single substance. Bible students have offered three different versions of the one Bible: the Hebrew Bible, which is translated into the Greek Septuagint, and then rendered into a modern language. Each version is still in essence the Old Testament. One of my students is pastor of a church with an active homeless ministry. On weekends, a large meeting room is a winter homeless shelter. Then the room is hosed down afterward, and it serves as a meeting room for a local Alcoholics Anonymous meeting. In the summer, it becomes a storage room for canned food and other supplies. One room has three identities.

1. See Edmond Hamilton, "The Avenger from Atlantis," *Weird Tales* 26, no. 1 (1935): 2. "In all Atlantis there was no one who did not know and honor the name of Ulios, the Guardian of the Force. And that was as it should be, since he who held the Force held Atlantis itself in the hollow of his hand."

2. Theorized by the British chemist and inventor James Lovelock, named by his friend William Golding (author of *Lord of the Flies*), and linked to the idea of symbiosis, that all of life works together for mutual benefit, by the renowned North American microbiologist Lynn Margulis, the Gaia hypothesis has been controversial since its inception. See our report on the religious dimensions in *The Goddess Revival: A Biblical Response to God(dess) Spirituality*, eds. Aída Besançon Spencer et al. (Eugene, OR: Wipf and Stock, 2010), 27–30, but as well throughout the book. Also see the insightful article by Florida State University professor Michael Ruse, who traces the theory back to Plato's *Timaeus*, in "Earth's Holy Fool?: Some Scientists Think That James Lovelock's Gaia Theory Is Nuts, but the Public Love It. Could Both Sides Be Right?" *Aeon Newsletter*, January 14, 2013, https://aeon.co/essays/gaia-why-some-scientists-think-its-a-nonsensical-fantasy.

A repeating personal image I found particularly popular among my Asian students was that of a human with three roles. One Chinese student hesitates, "I seldom use those images . . . I am not comfortable with them" but admits, "It is almost impossible to explain Trinity. I sometimes try to explain using myself as an example: I am a father, I am a son, and I am a worker. I use this explanation only for the young children or some elderly people who do not have a lot of education." Another pointed out, "A person, for example myself, can play three different roles, like student, wife, and mom." A Korean student explained, "I am a human being, a man at the same time, but I am 'David.'" While acknowledging he does not like images that move "because they change properties too much," he finds, "Even though being a human/ man/David has differing definition, so far it seems closest ontologically." Of course, such imagery is not exclusive to an Asian perspective, as an African American student demonstrated: "I am a father, son, and engineer."

The most prominent image in this category, however, is the "liquid-gas-solid (water-steam-ice) pictures," as one Anglo-American New Englander described: "I like the water-ice-steam image best because they have essentially the same molecules, and all exist with each other but have distinct functions." To similar students, the appeal was shared substance, "simultaneously three-in-one," as "the Father, the Son, and the Spirit are one God." But others were put off by this image's limitation: "Water: all three parts don't exist at one time." And "it is one substance" but may mislead in suggesting that in the Trinity "one person can only be existing in one role/status at a time. But, when Jesus died on the cross, the other two persons of the One Triune God [were] still there." Another African American student who preferred images that move reported, "I used to frequently use water (three forms), but I strayed away from it because it supports modalism more easily."[3]

3. As we noted, Modalism is the ancient idea that the one God is not a Trinity. Father, Son, and Spirit are either successive forms the one God takes at different times in earth's history (e.g., Father in the OT, Son in the NT, Holy Spirit today) or temporary appearances, manifestations, or emissions that God sends out and then draws back, making the one God appear to be a triune being. One interesting discussion on this image and its limitation was initiated by theologically trained Christian magician Brad Brown on his Brad Brown Magic website, when he attacked the water/ice/steam analogy with some good reasoning, and readers pushed back with some alternative good reasoning as well. He termed the water analogy as "bad science" and "bad theology." How exactly is it "bad" science? He explains: "First the scientific problem with this bad analogy. There are a lot more than three states of matter. There are four classical states that are commonly seen: solid, liquid, gas, and plasma. There are many less common states, including Bose-Einstein condensate, degenerate matter and superfluid. And there are even more theoretical phases that haven't been observed." That's an impressive argument and reminds us to avoid absolute statements

Despite such qualifications and, in some cases, objections, the image of water or its variations—a spring, a river, an ocean (or an irrigation channel)—was still the most popular moving illustration for the Trinity both on the internet and with my students. Worth considering, then, is who first applied water with its different modes of the same substance to the triune God. And one prime source, at least in regard to depicting the Holy Spirit, is the Bible.

The Hebrew word for spirit, *ruḥa*, "breath, wind, spirit," is related to the verb *rawah*, meaning to "be saturated, drink one's fill,"[4] so we can easily see how the image of liquid and being filled by the Spirit is embedded in the language. Paul, developing this imagery, draws a contrast, exhorting the Ephesians, "Do not be drunk on wine, in which is debauchery, but be filled [*plēroō*, 'to make full, fill,' as 'a ship's sail filled out by the wind,' or 'the house was filled with the fragrance'[5]] in the Spirit" (Eph. 5:18).

John W. Ritenbaugh centers on Jesus' use of water imagery for the Holy Spirit, citing Jesus' cryptic remark to Nicodemus in John 3:5, Jesus' reply to the woman at the well in John 4:13–14, and other verses. He concludes, "This water that Jesus speaks of can in no way be literal water." Adding John 7:37–39, he notes, "These verses clarify that the Bible uses water as a figure of the Holy Spirit both in terms of its cleansing properties and as a source of power."[6]

In the 1800s, the amazingly creative Ada R. Habershon saw all kinds of references to the persons of the Trinity in the waters of significant events in the Old Testament. The flood symbolizes "Christ passing through the waters of death" all through the OT, not only in the account of Jonah.[7] We will return to her work on typology (the study of Christ imagery in the Bible) in a later chapter.

when we are talking about material things. In this case, we should make no claims about exclusiveness and simply say, "Three common modes of water are ice, steam, and liquid." As for his readers, their push-back responses were equally intelligent. Sierra Pollock reminded him that water is always composed of two hydrogen atoms and one oxygen atom, no matter its state. Then extending the analogy to the Persons of the Trinity, Sierra likens Jesus' physical incarnation to the "solid" state and for the Holy Spirit, agreeing with the water imagery, "because of all the scriptural references," while "gas" would image the Father, whom we can realize is present but cannot see. That's clever. Brad Brown obviously thought so too and agreed with the point on the atoms. But he pointed out that God is not in three parts, but all the Persons of the Trinity are in essence God, and "God is one." See all under https://www.bradbrownmagic.com/2015/01/29/the-trinity-and-states-of-matter-a-bad-analogy/, posted Jan. 29, 2015, accessed April 17, 2020.

4. See BDB, 924.
5. BDAG, 828.
6. John W. Ritenbaugh, "What the Bible Says About Water as Symbol of God's Holy Spirit (from *Forerunner Commentary*)," https://www.bibletools.org/index.cfm/fuseaction/Topical.show/RTD/cgg/ID/4978/Water-as-Symbol-Gods-Holy-Spirit.htm.
7. Ada R. Habershon, *Study of the Types* (Grand Rapids: Kregel, 1997), 2, 40–42.

THE EARLY CHURCH'S USE AND MISUSE OF WATER IMAGERY

The water image (water, ice, and steam) and those like it are indeed attractive, kinetic, living, and vibrant, but at the same time they suggest that their modes are not permanent. From the days of the early church to our contemporary times, this position, in various expressions and called by several names, has been dismissed as less than orthodox by the vast majority of Christendom—the Roman Catholic, Eastern Orthodox, mainline, and independent Protestant churches. Why is that? Because a theory of temporary appearances would not reveal the coeternal persons of God but only suggest a single monad making temporal manifestations. This is hardly an adequate description of the coequal, coeternal triune Godhead.

About AD 190, a teacher named Noetus gained notice for avidly promoting just such a theory. Noetus hailed from one of the seven churches addressed directly in the book of Revelation (Rev. 2–3). This was Smyrna in Phrygia, which today is Izmir in the nation of Turkey, and it was and remains a beautiful port city.[8] The apostle John's own disciple Polycarp had pastored this church until he was martyred in AD 155 for refusing to worship the emperor. About thirty-five years had passed after the death of the staunch Polycarp when Noetus became prominent for contending that God chose to relate to humans in different modes. According to Hippolytus (c. AD 170–236), Noetus "alleged that Christ was the Father Himself, and that the Father Himself was born, and suffered, and died." Questioned about his doctrine, at first he denied it, and then Noetus responded: "What evil, then, am I doing in glorifying Christ?" The error became very evident when his disciples reported what he had taught them: "If therefore I acknowledge Christ to be God, He is the Father Himself, if He is indeed God; and Christ suffered, being Himself God; and consequently the Father suffered, for He was the Father Himself."[9] So, he held on to his

8. When we visited Smyrna with the Gordon-Conwell faculty, a group of young Muslim students engaged us in conversation, asking if they could practice their English. We told them we were Christian professors, and they were very cordial. One of our party asked them if they knew any Christians, and they all paused and asked each other, finally shaking their heads. We were the first, they said, they had ever met. What a sad state that the seat of the wonderful Polycarp now has little or no Christian presence.

9. Hippolytus, *Against the Heresy of One Noetus* 1–2, in *Anti-Nicene Christian Library* 9 (Edinburgh: T&T Clark, 1869). Also see J. N. D. Kelly, *Early Christian Doctrines*, 2nd ed. (New York: Harper, 1960), 117–23, where one can find an illuminating discussion of these positions.

theory that God was revealed as the creating "Father" in the Hebrew Bible and then was incarnated, being born as the "Son" in the New Testament. As we can see by his language, he saw "glorifying Christ" as the mode of God that most impacted humans by saving us at great sacrifice. Logically, as this doctrine developed, it seemed to make sense to those who followed it that, since the Son's resurrection and ascension, God took on a new role within the church and became known primarily as the Holy Spirit, a mode in which God still acts today.

Noetus' version of the Trinity was composed of a simple form of what has come to be called modalism: God was a monarch (*monos* = "only or alone"; *archōn* = "ruler") who "morphed" (as we might put it) into three different modes. Since God is an undivided monad who adopts these successive modes to relate to us, the theory came to be called "modalistic monarchianism," its key teaching being the divine monad assuming three different identities or modes of relating to us. A variation of this view also came to be called patripassianism, the suffering or passion of the Father for us, since it speculated that the Father came and died for us on the cross in the form of the Son. So, if the Father was the Son, to some adherents (as we saw when we visited the dispute between Tertullian and Praxeas) it seemed right to center not on Christ the Son, as did Noetus, but instead on the Father as the one we humans know best, since the Father was actually the one who died on the cross for us. Adherents picked their favorite divine mode through which to worship God. This theory was understandably rejected definitively as completely unorthodox at a meeting of the Smyrnan elders c. AD 200.

After Noetus' view was declared heretical, another teacher named Sabellius arose, refining the theology by suggesting that the modes were temporary manifestations and could be concurrent. They would appear for a time and then disappear back into the divine monad: sometimes the Father appeared, sometimes the Son, sometimes the Holy Spirit, and sometimes all three at once. But all of these were temporary appearances only.

Becoming prominent in Rome during the time when Callistus was overseer (or bishop or pope, AD 217–222), Sabellius referred to God as the "Sonfather" (*huipator*). This terminology made his affinity for Noetus' error very clear. Pertinent to our discussion is that Sabellius used the analogy of the sun and its radiance for Jesus and his heavenly Father. Epiphanius, the overseer of Salamis, reports Sabellius' particular slant on the sun/ray analogy worked like this: "The Son was at one time emitted, like a ray of light; he accomplished in the world all that pertained to the dispensation of the Gospel

and man's salvation, and was then taken back into heaven, as a ray is emitted by the sun and then withdrawn again into the sun."[10]

Even without scientific discoveries,[11] orthodox early church leaders were disturbed by the temporal quality of Sabellius' use of the image of the sun and its radiance for the relationship of the Father and the Son. Clear to all was that Sabellius was building on ideas already declared heretical. He owed much to the teacher who proceeded him, Noetus, and as well to the patripassian Praxeas (c. AD 200) and perhaps others.

His refinement of Noetus' doctrine had not rescued it from error, for Sabellius was still positing that God was actually a single monarch who was not, perhaps, adopting a lengthy modal existence, as Noetus proposed. Instead God emitted temporary emanations that manifested temporarily to humans, then returned to the divine monad, just as his reading of the image of the sun and its rays viewed the rays erroneously as returning to the sun. As a result of its language, Sabellius' view was grouped under the title "Monarchianism," or "Dynamic Monarchianism," for the fluid nature of the manifestations of God ruled out of theological order.

Other variations of modalism also existed. As we saw, the great lawyer and defender of the faith Tertullian (c. AD 160–c. 225), who was a contemporary of Noetus, attacked one variation in his book *Against Praxeas*, wherein he accuses Praxeas as being among those who "distinguish the two things—Father and Son—within one person":

They say that the Son is the flesh (i.e., the human being—Jesus) while the Father is the Spirit (i.e., God—the Christ). So those who argue that Father and Son are one and the same now start dividing them rather than identifying them! If

10. Epiphanius, *Adversus haereses* 62.1. This accessible translation can be found in Henry Bettenson and Chris Maunder, eds., *Documents of the Christian Church*, 4th ed. (New York: Oxford University Press, 2011), 41.

11. Today, of course, we would question both Sabellius' theology and his scientific reading of the activity of sunrays. In 1939, Hans Bethe posited that thermonuclear transmutations of hydrogen to helium were the source of the sun's luminosity. A vast amount of energy radiates out; some of these racing to the earth at the speed of light from these explosions are not pulled back into the sun. Spicules, jets of gas that are some 600 miles in diameter, may shoot up from the chromosphere layer that lies between the sun's blazing corona and its photosphere. They can reach heights of 6,000 to 9,000 miles at some 19 miles per second, blaze for ten minutes, and then fall back inward, but they hardly reach the earth. Once a sunray has propelled out of the sun's gravitational pull, it is gone. It is not being withdrawn again. So, Sabellius' picture of the Father, Son, and Spirit being temporary appearances (or manifestations) sent out then drawn back to the Monad is not what happens with his parallel to sunrays. See J. B. Zirker, "Sun," in *Collier's Encyclopedia*, vol. 12 (New York: MacMillan, 1987), 626–30.

Jesus is one thing and Christ another, the Son will be different from the Father, since the Son is Jesus and the Father is Christ. This kind of "monarchy"—which makes two different things out of Jesus and Christ—they must have learned from Valentinus.[12]

Today these views, and particularly Sabellius', are grouped under the category that is primarily called "Oneness" doctrine. In some cases, when the Son is exclusively emphasized, as Noetus did, this view is termed "Jesus Only" doctrine, though I notice present-day Sabellians prefer the designation "Oneness." Here is a statement of doctrine from The United Pentecostal Church International's General Superintendent David K. Bernard, who notes that "water baptism" in this church is done "in the name of Jesus Christ" alone rather than in the name of the Trinity. This practice comes from "An Appreciation of God's Identity," as he explains:

The beautiful message of Scripture is that our Creator became our Savior. The God against whom we sinned is the One who forgives us. God loved us so much that He came in flesh to save us. He gave of Himself; He did not send someone else. Moreover, our Creator-Savior is also the indwelling Spirit who is ever-present to help us. God told us how to live and then came to live among us. He showed us how to live in the flesh and laid down His human life to purchase our salvation. Now He abides within us and enables us to live according to His will. Jesus Christ is the one God incarnate, and in Him we have everything we need: healing, deliverance, victory, and salvation (Colossians 2:9–10). By recognizing the almighty God in Jesus Christ, we restore correct biblical belief and experience apostolic power.

12. Tertullian, *Against Praxeas* 27, in *The Christological Controversy*, ed. and trans. Richard A. Norris Jr., Sources of Early Christian Thought (Philadelphia: Fortress, 1980), 61. Valentinus, who lived at Rome from c. AD 136 to c. 165, was a gnostic who embraced a number of heretical views. From the Greek word for "knowledge" or "investigation" (*gnosis*), in this case "higher, esoteric knowledge" (LSJ, 355). Gnosticism of the Valentinian type was an attempt to synthesize Platonism with Christianity with, in his case, corrupt results, as it posited that Jesus was born of a divine "Mother" ("Wisdom") "after she had gone out of the Fullness" (the *plērōma* of the Godhead). Later she gave birth to "another son. This is Demiurge, whom [Valentinus] calls the all-powerful of all things under him," according to what Irenaeus reports (*Against the Heresies* 1.11.1). He also notes Gnostics believe this lesser being (Demiurge) "became Father and God of all things outside the Fullness, inasmuch as he is the Maker of all the ensouled and material beings" (1.5.2). He also observes that Valentinus apparently couldn't make up his mind who emitted Jesus but at different times named different options like "Man," "Church," even "Christ," among others (1:11.1).

Therefore, in this unitarian church's view, "There is one God, who has revealed Himself as our Father, in His Son Jesus Christ, and as the Holy Spirit. Jesus Christ is God manifested in flesh. He is both God and man (see Deuteronomy 6:4; Ephesians 4:4–6; Colossians 2:9; 1 Timothy 3:16)."[13]

A form of this ancient heterodoxy has even appeared to have worked its way into Joseph Smith's first formulation of Mormonism, as we can see in *The Book of Mormon*, Ether 3:14, when "the Lord" announces: "Behold, I am he who was prepared from the foundation of the world to redeem my people. Behold, I am Jesus Christ. I am the Father and the Son."[14]

CONCLUSION

One of the problems modalism is trying to combat is that images like "water as solid, liquid, and gas" are inadequate. However, by making God one being in three roles rather than one being in three distinct persons, modalism

13. United Pentecostal Church International, "Our Beliefs," http://www.upci.org/about/our-beliefs, accessed May 9, 2017. This fuller statement has been replaced with "There is one God, who has revealed Himself as our Father, in His Son Jesus Christ, and as the Holy Spirit. Jesus Christ is God manifested in flesh. He is both God and man. (See Deuteronomy 6:4; Ephesians 4:4–6; Colossians 2:9; 1 Timothy 3:16.)." This newer wording sounds much closer to orthodoxy.

14. The development of doctrine of the Church of Jesus Christ of the Latter-day Saints, the Mormons, appears to me to be long and confusing and replete with a number of contradictions. The entire verse in *The Book of Mormon*, Ether 3:14, quotes Jesus as saying, "Behold, I am he who was prepared from the foundation of the world to redeem my people. Behold, I am Jesus Christ. I am the Father and the Son. In me shall all mankind have light and that eternally, even they who shall believe on my name; and they shall become my sons and my daughters." A month before I wrote this footnote, my wife and I invited two female Mormon missionaries to join us at our home for lunch. Very dedicated young women, they asked us to raise any questions about their faith. I asked them the meaning of this verse. They confessed they didn't understand it either. These days, the Mormons usually tell me that God the Father, formerly a human, fathered with a divine wife Jesus and Satan (which sounds reminiscent to me of Valentinus' idea that Christ and the Demiurge were brothers of a divine Mother). Vying to come up with a plan to handle sinful humanity, Jesus took the salvation solution, Satan the more lethal alternative. Jesus' plan won God the Father's favor, and Satan has been jealously trying to ruin his brother's reputation by thwarting his work ever since. How these two statements come together and who actually is the human or the personage who was voted the God of our world by the pantheon of gods is mystifying to them as well as to us. These latest Mormons who visited us clearly explained that they worship three cooperating gods. Evangelicals who think that Mormon doctrine and historic Christian orthodoxy are closely related are mistaken. The Mormons believe, if they are faithful, they will become gods or goddesses (as these young women told us they hoped to become), ruling over some other world. No truly evangelical Christian believes that he or she will become God of a planet, similar to the way that God is God to our planet. For Ether 3:14, see *The Book of Mormon* (Salt Lake City, UT: The Church of Jesus Christ of Latter-day Saints, 1968), 484.

opens itself up to all kinds of problems. Not least of these problems is the question of who maintained the world when God died. The monad emitting temporary manifestations may attempt to address that issue, but either God died at the crucifixion, or God did not die, and the sacrifice was incomplete. A manifestation is not an incarnation. The warning of God that rebellious sin brought inevitable death, which meant eternal separation from God (which even Satan knew and parried in Gen. 3:4 to veer the gullible Eve to fall for self-advantage), laid the groundwork for the entire theme of sacrifice from Abel's offering of blood sacrifice (Gen. 4:4) right through Jesus' sacrificial death. What was at stake was vastly greater than that admitted by Satan, the serpent, in the glib confidence-game scam pulled off on humanity's first couple. Adam and Eve surely did die, as became every one of their descendants' post-fall lot (Heb. 9:27).[15] But that was not the whole issue. Jesus did not come simply to salvage humanity so that we would all live forever here on earth. Jesus came to deal once and for all with the specter of the second death, the eternal one, which is the one that really counts (Matt. 10:28). This is the sacrifice that a personal, loving God made for us.

What images that move and change (such as air, matter, and human roles) provide is an illustration of shared equality, showing that three can be one substance. This is a very helpful contribution. So, we want to emphasize this aspect but disavow the modal change interpretation that promotes a unity of God at the risk of undermining the integrity of the eternal threeness.

15. Enoch (Gen. 5:24; Heb. 11:5) and Elijah (2 Kings 2:11–12) may have had different transfers out, but both were absent from earth thereafter (Elijah only making a brief reappearance at Jesus' transfiguration; see Matt. 17:3–4).

CHAPTER 7

NONHUMAN IMAGES
THAT ARE STATIC

Although the biblical images of the sun and water as depictions of God are very popular among all my students of a variety of ethnic backgrounds, they supplement them with an interesting variety of static, nonmoving images they have acquired over the years. Some, even the students who express a preference for images that do not change, are troubled by the fact that many of these images appear to be advocating for the Godhead to be seen as three parts comprising a whole. Others, taking that problem for granted, attempt to handle it by balancing fluid and static imagery. And some simply choose among the options while remaining frustrated, unable to dispel the fear that they are presenting the Father, Son, and Holy Spirit as mere components of the Godhead.

TOPOGRAPHY

One of the most fascinating ways to deal with a static image's limitations is to select a nuanced topographical answer, as one Indian-Jamaican student suggested: "Water (sea), land, sky (heaven)." The idea implied here was that water becomes sky, so the essence is the same, while land is composed of elements that include water.[1] The point being raised was to stress their shared

1. Other interesting, related imagery that emerged in class discussions were "time, space, matter," and "unlimited coverage, e.g., Wi-Fi, unlimited network, total coverage, unlimited

essence, yet note that water, sky, and land appear to remain permanent realities and are therefore distinct from one another.

Another non-modal, topographical water image that I think is quite beautifully expressed is found in Alexander Maclaren's commentary on Colossians: "That great fathomless, shoreless ocean of the Divine nature is like a 'closed sea'—Christ is the broad river which brings its waters to men, and 'everything liveth whithersoever the river cometh.'"[2]

A further interesting example of topographical imagery for the Trinity is found in a book of studies of biblical typology by Ada R. Habershon (1861–1918).[3] In Habershon's vision, theology and the arts met powerfully. Her fascinating book *Study of the Types* combs through the Old Testament, identifying an amazing list of images presaging New Testament people and events. Here is one for the Trinity: "The three persons of the Trinity in type are all linked together in connection with the Ark; for while it foreshadows the work and person of the Lord Jesus, the cloud that rests above it seems to typify the Holy Spirit: and God spoke to the people from above the mercy-seat."[4]

Keying off Paul's explanation of why God endured the sinful misadventures of Israel in its exodus in 1 Corinthians 10, especially verse 6, Ada Habershon observes, "It is very important to understand what is meant by a type." She stresses this term's functional aspect: "the record of these events is given to us in the Bible for a special purpose, viz., to teach us certain lessons." But

data or network." A Chinese scientist added, "Looking at an object at different dimensions: a dot, 1D; a circle, 2D; a cylinder, 3D."

2. Alexander Maclaren, *The Epistles of St. Paul to the Colossians and Philemon* (New York: Armstrong, 1897), 74.

3. Habershon is a "formally trained" British Bible scholar who was a "devoted" colleague of D. L. Moody, Charles Spurgeon, and R. A. Torrey. This scholar wrote eight detailed studies of Bible data and, also having been gifted creatively and being a friend of famed hymn writer Ira Sankey, composed hundreds of hymns.

4. Habershon, *Study of the Types* (Grand Rapids: Kregel, 1997), 64. She adds: "The type would not be complete if there were nothing in it to speak of the death of our Lord Jesus Christ; but we have this also, for it was a 'blood-stained mercy-seat.' The blood of the sacrifices—first of the bullock, then of the goat—was sprinkled upon it on the day of atonement. The Cherubim bent their gaze upon that blood, and God's eye rested upon it; and because of the blood He could accept the people. It was an atonement, or covering; for God Himself cannot see through the precious blood. It is an all-sufficient covering for our sin; so that we read, 'On that day shall the priest make an atonement for you, to cleanse you, that ye may be clean from all your sins before the Lord.' It might be said in this type as at the passover, 'When I see the blood, I will pass over you.' In each the blood was for the eye of God alone; for none might enter the Holiest of All save the high priest, and he only on this one occasion."

she warns us, "although teaching spiritual lessons, the incidents really took place," underscoring her belief in "the inspiration of the Bible."[5]

Among the hundreds of references to the events she sees as presaging the person and mission of Jesus Christ, she includes what she views as symbolic topographical choices of God, for example, intentionally not leading Israel through Philistine land in Exodus 13:17 but providing images of "the truth taught by the crossing of the Red Sea." As she explains, "Both it and the passage of the Jordan speak to us of the death and resurrection of Christ; but the former tells of deliverance *from* Egypt, the latter of entrance *into* the land." Categorizing these events as "double types," she sees their significance as both true to Israel's experience and prophetic of the spiritual deliverance by Christ to come. What she is doing here is employing an older exegetical style of interpretation, an allegorical one of multiple-point correspondence. This is somewhat refashioned into what today is part of the interpretive approach called intertexuality, or "studying these and other double types" by putting "the two side by side if we would see the full meaning."[6]

Although her book is centered on exploring Christ types and not directly on images of the Trinity, she does include at least two examples. First, she draws comparisons between the ornamentation in the temple with the splendor of Christ's transfiguration and the ministry of the Holy Spirit. She speculates, "It may be that the gold, white raiment, and eye-salve, represent God Himself— Father, Son, and Holy Ghost: for we read in Job xxii.25 (*marg.*) 'The Almighty shall be thy gold'; in Rom. xiii.14, 'Put ye on the Lord Jesus Christ'; and in 1 John ii.20, 'Ye have an unction from the Holy One, and ye know all things.' It was God Himself that the Church at Laodicea wanted; and He was willing to come and dwell with any who heard His voice and would open the door to Him.'"[7]

Second, despite her conviction that "it is helpful to compare the types one with another," she recognizes "it is also necessary to study each one separately. For example, in the Tabernacle it is well to examine each piece of furniture, and to trace through the Word the various references that are made to it." When she arrives at the ark of the covenant, she sees many connections with the persons of the Trinity, principally of course with Christ Jesus. His two natures are represented by the ark being made of acacia wood overlaid with gold, and his ministry is symbolized not only by pieces like the mercy seat but

5. Habershon, *Study of the Types*, 11.
6. Habershon, *Study of the Types*, 22–23.
7. Habershon, *Study of the Types*, 59n9.

by "the purposes for which [the Ark] was used." How she sees the Trinity illustrated is that "the tables of the covenant were safe within the ark, reminding [Solomon] that God was a God that kept His covenants." Also, she views "the pot of manna, and Aaron's rod that budded" as "proofs of God's wilderness provision and His choice of the Anointed One." Amidst all this symbolism, she suggests, "The three persons of the Trinity in type are all linked together in connection with the Ark; for while it foreshadows the work and person of the Lord Jesus, the cloud that rests above it seems to typify the Holy Spirit: and God spoke to the people from above the mercy-seat."[8]

THE EGG

Typology, as we have just seen, is a sophisticated enterprise that has existed since Bible times. What was interesting for me to discover, then, was that no one who filled out my survey went this route. Most of my students listed the egg ("eggshell, white, yolk") as the image they most frequently used when ministering today. As one Anglo-American student explained, "For a concept like the Trinity, everyone needs a simple way to conceptualize it." This student listed both the egg and "water—solid, liquid, gas," claiming to prefer both because "different images have different pros/cons and emphasize different aspects of the Trinity."

The pros were spelled out by one student who commented, "I have used the image of an egg, which is old as dust but effective. . . . I like all imagery . . . the simpler the better." It illustrates that "God is creative, redemptive, and prescriptive in his triune ministry to us." Another Anglo-American student agreed, answering by highlighting the egg's superiority: "three parts, one entity. All parts are equal." In water imagery, by contrast, "all three parts don't exist at one time." What I found particularly interesting was the use of "part" language when critiquing the modal image rather than switching to "mode" language. This demonstrated to me that the student's frame of reference was dominated by static imagery. Such endorsements were backed up by a Macedonian student who selected the egg along with water for their "three physical dimensions." This student selected illustrations "as I think fit best for the audience," providing this example: "When I have discussed with Muslims, I have used the illustration with water. When I explain the Trinity to children, I have used the egg illustration." He found by practice that the simplicity of the egg appealed to a less sophisticated audience. With a more nuanced

8. Habershon, *Study of the Types*, 61–64.

adult audience, this student explained, "I would like to emphasize as the water transfigures, so [did] God's incarnation to become man. In order for God really to understand humans, he had to become one of them and to suffer, so that he can be truly Son of Man." The lesson here is that various audiences are reached by various approaches.

The cons were illustrated by a visitor one student brought to class who asked for permission to fill out a survey and submitted this answer: "The father is 50 percent of God, the Son (Jesus) is 25 percent of God, and the Holy Spirit is 25 percent of God = 100 percent of God." Apparently sensing that he might not be capturing the point of this analogy, this visitor added a note to clarify: "100 percent of God is in Jesus, but Jesus is not 100 percent God (Jesus is not the Father)." I didn't have a chance to review these responses until the next day, and this short-time visitor had already left the area. But I could see he was groping for clarity, which is why studying systematic theology from a historically orthodox, evangelical perspective is so necessary. People do sincerely want to know the truth, but as this visitor demonstrates, the bits and pieces of information they pick up without systematic study provide no guarantee they will synthesize that information accurately. Parts imagery can be a help or a hindrance.[9]

THE SHAMROCK

Along with the egg, the three-leaf clover (known in Gaelic as the shamrock) and the triangle were sometimes cited together, for example by a student who noted, "I grew up hearing the Trinity described with a shamrock (I come from an Irish family)." Not restricted to the Irish, a self-identified New Englander noted, "Though incomplete and imperfect, I've been helped by and more used the 'three-leaf clover' and the liquid-gas-solid (water-steam-ice) pictures." The student preferred the latter "because they have essentially the same molecules, and all exist with each other, but they have distinct functions." A Chinese student agreed but divided the audience by age: three-leaf clover for children, states of water for adults, and for the "well-schooled, three pitchers pouring water in each other. There is no beginning or end."

What I myself see as the three-leaf clover's value in its analogy is that the petals are connected to a whole, so one who uses it is able to illustrate three distinctions connecting in a greater mass. But of course it's an analogy.

9. Parts language is very appealing across theological lines. For example, conservative evangelical author Tracie Peterson in her interesting book *A Sensible Arrangement* (Minneapolis: Bethany, 2014) writes, "Jesus is a part of God," 104.

The Father, Son, and Holy Spirit are not connected to a Godhead by a stem with a root!

The Irish student I cited had a similar take on the shamrock's value and limitations, noting, "It illustrates the three-in-oneness but fails to describe anything about the nature of God or how the three interact as one." Imagery is limited, but so is discourse when trying to teach truths about God, and the experienced teacher knows that flexibility is important.[10]

TOOLS AND PRODUCTS WITH THREE PARTS

In the years before I did the formal survey, I used to start out my lecture on the Trinity by asking an open-ended question to the class on what images they used in their ministries to explain the mystery of the nature of the Godhead. The results of the discussions and the later surveys were always very enlightening. A Korean student wrote on the survey, "I would like to describe the Trinity as a illustration of a bottle opener. One tool can be used for three functions—to open bottles, open cans, and remove corks."

Students with children or grandchildren or who taught children in Sunday School classes reported they communicated about God through the illustration of "red, yellow, and blue crayons all in one box." An African American parent referred to a fidget spinner. This is a toy composed of three circles spinning around a ball bearing, suggesting a vibrant, connected, three-in-one image appropriate for children.

This particular student added music: "harmony, rhythm, melody." A Korean musician in my class reported an illustration given by popular artist Naul in Korea in a 2010 interview in *GQ Korea*. She explained, "The Trinity is a basic triadic harmony: Do, mi, and so. When you play these together, it is one chord. Yet do, mi, and so are distinct." This artist cited "three primary colors of pigment" and light. In a very clever parallel, she points out that, when one mixes red, yellow, and green, the result is black, since pigments "belong to the earth," but "light is the sky, in my opinion; light is God and life." Together they become white.[11] The

10. Mindful of the Second Commandment (Exod. 20:4–5), Christian artists have used symbols like the three-lobed universal trefoil knot, or the ever-popular equilateral triangle, whose strength is containing three distinct and equal sides, corners, and points. Its weakness is the triangle's top point usually appears to preside over the others, unless the triangle is turned upside down. Our present book's cover and chapter symbol is a variation of the triquetra (meaning three cornered), being three arcs reaching toward each other in a unified circle, representing perichōrēsis (indwelling each other). None of the arcs presides over the others.

11. The translation into English is by my student, and these are her words. Some simplified the music illustration to notes G-C-D or C-F-G creating a chord.

conclusion? Trinity is "Father, Son, and Spirit: each of the three are different, but they are one." Another Korean contributed an "image of [the] Trinity in relation to singing: singer, text, and composer relation," explaining, "They are separate but one unity in the moment of singing." And one expanded the musical image with an orchestra: "strings, woodwinds, and percussion."

Another image that came up one year around Christmas was the use of three voices speaking in unison to represent the one God with three eternal faces, as in a performance of the York mystery play cycle, while a student who was a pictorial artist offered another ancient form: "A triptych: three parts but all connected into one united picture."

Some students came up with several images based on tools. One suggested, "A pen with three cartridges: you can push it and get three points with three different colors of ink." A Brazilian class member preferred a "three-in-one printer: fax, copy, print" as an image that could work with both children and adults. One student mentioned "trifocal eyeglasses: the top for distance, the middle for computer screens, and the bottom for reading." Inevitably, one summarized the whole enterprise as "God as a machine with three parts."

The positive effect of these static images is achieved when the stress is put on their unity in plurality: three things, often made of the same substance, unified in one being and cooperatively at work in sync at a common task. The drawback is, as with Junipero Serra's blanket folds, these components are only parts of a whole, as in the example of a machine with three parts. God is depicted as impersonal in each of these examples, made up of three components, each being about one third of the entire whole. The Trinity, however, is far greater than any of these illustrations. The revelation of Colossians 2:9 that all the fullness of the Godhead resided in Jesus—while at the same time the Father was not the Son, the Son was not the Spirit, the Spirit was neither Father nor Son, and yet all were One God—has no absolutely accurate representation from any of these images we just read. This is why we need to understand any analogy's limitations and, at the same time, why one may be so helpful to a congregation to glimpse a truth about God. An analogy only purports to highlight one aspect, one point of correspondence in what it is imaging.

Another functional image is an illustration that figured into the trial and execution of Jesus' brother James. The early church historian Hegesippus (second century), in his *Memoirs*, records that the scribes and Pharisees forced James to teeter on the Temple heights while they demanded to know, "What does 'the door of Jesus' mean?" The courageous James shouts back so that everyone below can hear, "Why do you ask me about the Son of Man? He is sitting in

heaven at the right hand of the Great Power, and he will come on the clouds of heaven." To his accusers' dismay, many in the crowd below are convinced and begin shouting back, "Hosanna to the Son of David." Nonplussed, "the scribes and Pharisees said to each other, 'We made a bad mistake in providing such testimony to Jesus, but let us go up and throw him down so that they will be afraid and not believe him." And this is what they did.[12]

James' imagery was apparently a popular way to describe the mission of Jesus, and we see it resounding in the early church, for example in the letter Ignatius writes to the Philadelphians: "The priests are good, but the high priest [Jesus Christ] who has been entrusted with the holy of holies is better; he alone is entrusted with the hidden things that belong to God. He is the door of the Father, through which Abraham and Isaac and Jacob and the prophets and the apostles and the church enter."[13]

Exploring the implications of this image, we see the reference grounded in Jesus' self-revelation in John 10:7, where Jesus says, "I am the door [thura, which means 'door, gate, or entrance'] of the sheep," and again in 10:9, "I am the door [also thura], through me, if anyone might enter in, that one will be saved."[14] Looking at this with a trinitarian perspective, we ask, If Jesus is the door, would the Holy Spirit be the passageway and the Father the room? The only way to the Father is through the only entrance, Jesus, as we see in John 14:6. If Jesus is the way, the Father would be the goal, and the Holy Spirit the empowerment to get there. The prompting of the Spirit in this life draws us to that door through which we must pass to enter into the presence of God. If Jesus is also the entrance to the Holy of Holies of the sacred place, given this temple imagery, the Holy Spirit may be the doorkeeper, Christ the door (instead of a temple veil), and the Father the Holy of Holies. Any way we look at the implications of this wonderful imagery, in Jesus' time, the nonbelieving Jewish faithful would call us blasphemers. We note that the Pharisees (who are mostly laity) and the temple scribes are the ones who kill James. Acts 23:9 uses the word *grammateus* (scribe or teacher of the law) to describe those who

12. Eusebius, *Church History* 2.23.

13. Ignatius, *To the Philadelphians* 9.1.

14. This important image of Jesus as the only proper gate to God is developed from John 10:7–9 and paralleled in John 14:6, when he declares he is the way (*odos*, which also means road or journey). We might be tempted to see the gates in Revelation 22:14 as another type of Christ, but what is used there is the plural form of another word, *pulōn* ("gate, entrance"), for entering into the gates of God's new Jerusalem. I would think it wiser simply to follow Jesus' explicitly clear teachings.

stood up for Paul against the Sadducees, so the scribes appear to have been of either persuasion, believing in or rejecting the resurrection of the dead.[15]

Today we don't usually hear images such as Jesus as the "door," which was popular in the early church, to describe the new revelation that the one God was in three persons. Origen (AD c. 185–c. 254), for example, in a sermon on the parable of the good Samaritan (Luke 10:25–37), told his congregation that "one of the elders wanted to interpret the parable" as seeing "the two *denarii*" (coins the rescuer paid the innkeeper to care for the victim he'd found in the road) as types of the Trinity, representing "the Father and the Son." Origen attempted to refine that thought, explaining, "Two *denarii* appear to me to be knowledge of the Father and the Son, and understanding of how the Father is in the Son and the Son is in the Father. An angel is given this knowledge as if it were a payment. He is to care diligently for the man entrusted to him." In his allegorical reading, Origen felt "the inn-keeper was the angel of the Church," while "the Samaritan," whose "name means 'guardian,' he is the one who 'neither grows drowsy nor sleeps as he guards Israel. . . . This Samaritan . . . who took pity on the man who had fallen among thieves . . . bears our sins and grieves for us.'" Origen points out that, when the Jews charged Jesus, "'You are a Samaritan and you have a demon,' though he denied having a demon, he was unwilling to deny that he was a Samaritan, for he knew that he was a guardian."[16]

About a century and a half later, Cappadocian theologian Gregory of Nyssa (c. AD 335–c. 394) followed Origen's lead with an analogy between God and gold coins. How does he do that? He argues, "We say of gold, when it is made into small coins, that it is one and that it is spoken of as such. While we speak of many coins or many staters ['a small gold coin,' n. 16] we find no multiplication of the nature of gold by reason of the numbers of staters." Therefore, he reasons, "the word 'God'" is carefully used "in the singular, guarding against introducing different natures in the divine essence by the plural significance of 'gods.'" And he cites Deuteronomy 6:4, "The Lord God is one Lord," noting "Godhead" is singular, to complete his analogy that, as gold is one metal, despite being made into distinct coins, "the only-begotten God . . . does not divide the unity into a duality so as to call the Father and the Son two gods, although each is called God by holy writers. The Father is God, and the Son is God; and yet by the same affirmation God is one, because

15. See a helpful description by Matthew Black, "Scribe," in *IDB*, 4:246–48.

16. Origen, *Homily* 34, cited in *Origen: Homilies on Luke, Fragments on Luke,* trans. Joseph T. Lienhard, FC (Washington, DC: Catholic University of America Press, 2009), 137–41.

no distinction of nature or of operation is to be observed in the Godhead." He concludes that "those who are misled suppose, there are differences of nature in the holy Trinity." Such a misstep leads to the error of extending the Godhead "to a plurality of gods," or tritheism, but "the divine, single, and unchanging nature eschews all diversity of essence, in order to guard its unity, it admits of itself no plural significance." Therefore, God is of "one nature, so all the other attributes are numbered in the singular—God, good, holy, saviour, righteous judge."[17] Gregory of Nyssa's explanation acts like an internal summary of the orthodox theology of the early church about the Godhead we have been seeing: one essence, not a plurality of essences, with equal attributes, not a great diversity of differing attributes, a point we noticed Athanasius underscoring in our chapter on the image of light in the book of Hebrews in order to establish one divine substance.

NATURE

One of my favorite illustrations is Mount Rushmore's sculpted depictions of four major United States presidents: George Washington, Thomas Jefferson, Theodore Roosevelt, and Abraham Lincoln. All of these four differentiated faces are carved on one and the same mountain, sharing the same substance (rock).[18] The basis for this image is to recall that the Bible uses the illustration of a rock for God's protective reliability (e.g., Ps. 18:2, 31) and generosity (e.g., Ps. 78:15–16) throughout the Old Testament. And the image is used for Jesus Christ in the New Testament as well. First Corinthians 10:4 reveals it was also a Christ-type in Exodus 17:6, where Moses is directed to strike the rock (a foreshadowing that the savior would be beaten?) and later Numbers 20:7–11, wherein Moses' failure to honor God's new instructions to speak to the rock (a personification image of the giver of living water) and not strike it lost him entry into the Promised Land, as recounted in Numbers 20:12.[19] Jesus even made a wordplay out of Peter's name in Matthew 16:18: "You are Peter ['a stone,' 'a rock,' 'a ledge,' or 'cliff,']"[20] and

17. Gregory of Nyssa, "An Answer to Ablabius: That We Should Not Think of Saying There Are Three Gods," in *Christology of the Later Fathers*, eds. Edward Rochie Hardy and Cyril C. Richardson, LCC (Philadelphia: Westminster, 1950), 265–66. In this same argument, he also uses the illustration of Peter, James, and John being distinct individuals but also all human.
18. When I use this illustration, I always accompany it with the plea that the class ignore these are four, not three, male depictions with facial hair and conflicting political philosophies!
19. See also Romans 9:33 on Isaiah 28:16 and 1 Peter 2:8 on Isaiah 8:14, in clear reference to the Omnipotent Lord.
20. Thayer, 507.

on this rock [*petra*, 'bedrock, or massive rock formations, rock, as distinguished from stones']²¹ I will build my church." But none of these references attempted to depict the Trinity as parts, pieces, or degrees of rock (e.g., Father as a boulder, Son as a chip off it, and Holy Spirit as dust off the divine rock).

Elijah Muhammed, founder of the Nation of Islam, criticized what he considered to be the normal Christian doctrine of breaking God up into parts: "The Christians refer to God as a 'Mystery' and a 'Spirit' and divide Him into thirds. One part they call the Father, another part the Son, and the third part they call the Holy Ghost; which makes the three, one." This picture

21. BDAG, 809. A. T. Robertson adds, "*Petros* is usually a smaller detachment of the massive ledge." *Word Pictures in the New Testament, Vol. 1: The Gospel According to Matthew; The Gospel According to Mark* (Nashville: Broadman, 1930), 131. John Nolland of Trinity College, Bristol, mentions that both words *petros* and *petra* "exhibit significant flexibility of meaning. Originally *petra* was used of a solid mass of rock and *petros* of a (free standing) rock/stone," but "*petros* eventually fell into disuse, with *petra* taking the sense 'stone'" and another word, "*brachos* being used for 'rock.'" Usage in the Septuagint and the New Testament are in the period of "transition." Therefore, while he agrees "this means that while there is no necessary difference of meaning between the two words," he also points out that "the very fact of the choice of different words suggests that in this case some difference of meaning is intended" (John Nolland, *The Gospel of Matthew: A Commentary on the Greek Text*, NIGTC [Grand Rapids: Eerdmans, 2005], 669). So who is the massive rock on which the church will be built? A. T. Robertson observes, "Not on Peter alone or mainly or primarily." He opts for faith in Christ, "the same kind of faith that Peter just confessed" (132). John Nolland also concludes, "This confession will, however, be 'this rock' precisely as Peter's confession since this is what gives substance to the wordplay. Or it may be that we should express this by saying that Peter is 'this rock' not in general but precisely in the act of confessing Jesus as the Christ. As the recipient of what has been revealed by the Father, and as he here takes the lead in the profession of the faith, and later in the propagation of the faith, Peter becomes the foundation stone for the church" (669). Back in 1708, Matthew Henry presented the options: "Some by this rock understand Peter himself as an apostle"; "others, by this *rock*, understand *Christ*"; "others by this *rock*, understand this confession which Peter made of Christ." He, as did the scholars just cited, chooses this final option, as summarizing all three choices: "and this comes all to one with understanding it of Christ himself." Matthew Henry, *Commentary on the Whole Bible: Genesis to Revelation*, ed. Leslie F. Church (Grand Rapids: Zondervan, 1961), 1287. Robert Jamieson, A. R. Fausset, and David Brown in their *Commentary Practical and Explanatory on the Whole Bible* (Grand Rapids: Zondervan, 1961) summarize this interpretation well: "I will build my Church—not on the man Simon Barjona; but on him as the heavenly-taught confessor of a faith. 'My Church,' says our Lord, calling the Church His own" (931). Zambian Baptist Joe M. Kapolyo in *Africa Bible Commentary* makes an interesting bridge-building attempt to include two interpretations: "the Roman Catholic Church argues that Jesus was saying that he would build his church on Peter, a position that has led to the dominance of the papacy. Evangelical scholars prefer to interpret the rock not as Peter himself, but as the confession he made. While their high regard for Peter's statement is valid, it is also important to acknowledge that Peter himself does have a special place in church history. He was the chief of the apostles in Jerusalem. . . . Peter and the other disciples were here given the authority to build the church" ("Matthew," in *Africa Bible Commentary*, eds. Tokunboh Adeyemo et al. [Nairobi, Kenya: Word Alive, 2006], 1143).

of the Christian faith strikes him as illogical: "This is contrary to both nature and mathematics. The law of mathematics will not allow us put three into one." Further, he objects, "Our nature rebels against such a belief of God being a mystery and yet the Father of a son and a Holy Ghost without a wife." And he reasons, "The Christians do not believe in God as being a human being, yet they believe in Him as being the Father of all human beings. They also refer to God as He, Him, Man, King and the Ruler."[22]

In defense of the intention of the rock image, of course, the idea here is to preserve the same essence for all three persons of the Godhead and show them together as ontologically equal, and that is a good aim. I would not see that aim reached, however, if we were to accept the interpretation that makes the Son merely a piece of God and the Holy Spirit less than that: dust flowing from the rock. That use of the image for the Trinity would distort the relationship by making the Son a secondary God, as a piece of the Father, and the Holy Spirit a mere residue of gravel from the bedrock of the Father.

A fascinating reference in Zechariah 3:8–9 might provide yet another natural set of images for the Trinity, while salvaging the symbol of a rock as an appropriate entry in trinitarian typology. In a vision, the prophet is helping an angel fit a high priest for service. The angel sets a stone with seven eyes before the priest and promises to bring a branch. That there are seven eyes reminds us of the seven spirits before the throne (Rev. 4:5), depicted as blazing lamps illuminating everything. With seven being the perfect number in biblical typology, this passage in Zechariah, steeped in imagery as it is, may be referring to the Holy Spirit. The branch, of course, summons up the "branch of Jesse," out of which comes the Messiah in Isaiah 11:1–11, which Paul references in Romans 15:12. Zechariah is then directed to announce the "branch" as the one to rebuild the temple, with a crown he fashions and puts on the head of the high priest Joshua, son of Jehozadak. But the crown is not solely Joshua's, as it is given to four other priests as well (see Zech. 6:9–14).

Could this all be considered a type of the Trinity? Not according to the renowned Old Testament interpreter Carl Friedrich Keil, who rejects the interpretation that seven eyes are directed toward the stone rather than being on the stone: "this overthrows the view held by the expositors of the early church." Instead, Keil agrees that this image references "the seven Spirits of God (Rev. v. 6), and with the seven eyes of Jehovah (Zech iv:10), they are the

22. Elijah Muhammad, *Message to the Blackman in America* (Philadelphia: House of Knowledge, 1965), 15.

sevenfold radiations of the Spirit of Jehovah (after Isa. xi.2)."[23] And as for the branch, even today the *Archaeological Study Bible* reminds readers that the postexilic governmental leader and the high priest "Zerubbabel and Joshua represent, respectively, the two separate offices of king and priest. . . . The 'Branch' (6:12) would hold both offices (v. 13). According to the Aramaic Targum (a paraphrase), the Jerusalem Talmud (a collection of religious instructions) and the Midrash (practical exposition), Jews early on regarded this verse as Messianic."[24]

While this may not be the kind of exegesis many of us engage in these days, such types of the Trinity, imaging natural items as a branch and a stone,[25] may be among the references in the prophets to which Jesus directed his enthralled companions on the road to Emmaus.

TOTEM POLE VERSUS CELTIC KNOT

Contrary to appearance, the totem pole is not a set of nature gods with the supreme god on top that moves down the scale of lesser gods to the bottom god underneath, as in the order of the gnostic pleroma taught by teachers like Valentinus.[26] Totem poles are clan, family, or even village heraldic crests representing clans or telling traditional stories.[27] Noted Christian leader Richard Twiss of the Rosebud Lakota/Sioux tribe explains, "Most North American tribes were in fact monotheistic, believing in one universal, absolute being who furnished moral guidelines for their conduct and who motivated every living thing."[28]

While correcting this misunderstanding for my students, I contrast the totem pole with the Celtic knot. Traditionally, this triquetra-type design made of loops, or with no beginning or ending, has been a symbol for eternity. As art historian F. R. Webber reports, "This mystical symbol is quite

23. Carl Friedrich Keil, *The Twelve Minor Prophets*, vol. 2, in *Biblical Commentary on the Old Testament*, eds. C. F. Keil and F. Delitzsch (Grand Rapids: Eerdmans, 1949), 261.

24. Walter C. Kaiser et al., eds., *NIV Archaeological Study Bible* (Grand Rapids: Zondervan, 2005), 1533.

25. Other images from nature students mentioned were one cluster of three grapes; a copse of three trees; a tree comprised of trunk, branches, and roots; and three fruits on the same apple tree.

26. See Irenaeus, "The System of Valentinus and His Followers," in *Against the Heresies* 1.11.

27. See examples in *Through Indian Eyes: The Untold Story of Native American Peoples,* eds. James J. Cassidy Jr. et al. (Pleasantville, NY: Reader's Digest, 1995), 237, 249–50. The totem was also used for protecting "birthing mothers" and lifting the bones of the dead above the ground (146) in "seaside sites," as well as for "heraldic and storytelling" purposes (146, 213). Philip Kopper et al., eds., *The Smithsonian Book of North American Indians Before the Coming of the Europeans* (Washington, DC: Smithsonian, 1986).

28. Richard Twiss, *One Church Many Tribes* (Ventura, CA: Regal, 2000), 94.

simple in form, yet full of meaning. The three equal arcs of the circle express the equality of the Three Divine Persons, their union expresses the unity of divine essence, their continuous form symbolizes eternity, and the fact that they are interwoven denotes the indivisibility of the Blessed Trinity."[29] Particularly, when this triquetra is woven around a circle, the theme of the eternal is underscored. Turned in any direction, it symbolizes the equality of the loops, reflecting the equality in the Godhead. When I ask my students what they think about when they see God depicted as a totem pole, they respond, "Hierarchy, descending order, ruling, and submission." When I ask them how they respond to God depicted as a Celtic knot, they reply, "Equality, eternity, and mutual submission."[30]

ANALYSIS AND CONCLUSION

So, what can we make of these static, impersonal illustrations for the triune God? Ways to convey the revelation of God's personal loving and saving nature have been written down for us in the Bible's words, but these concepts need to be explained in ways that each new generation can understand.

Static images for the one great, personal, living God can run the risk of being impersonal unless we balance the three components in a unified whole of a single entity, as we saw with the egg and clover images. But they can help our hearers discover dimensions of the nature of God that mere words obfuscate. The egg, clover, Mount Rushmore, and other "parts illustrations" avoid the problem of modes by being static, so the Father, Son, and Holy Spirit are shown to be permanent identities, not temporary manifestations, which is quite helpful. At the same time, each of these analogies is also inadequate in that each might reduce the Holy Trinity to a type of exclusive, three-member-only, divine club. At their worst, they might suggest three

29. F. R. Webber, *Church Symbolism: An Explanation of the More Important Symbols of Old and New Testament, the Primitive, the Mediaeval and the Modern Church*, 2nd ed. (Cleveland: J. H. Jansen, 1938), 43–45.

30. Much Christian art has used such symbols. For example, mindful of the second commandment and the command of Deuteronomy 4:15–19, Christian art has often forgone human-like representations and relied upon symbols to represent the Trinity, such as a variety of triangles; a trefoil; three lobes or circles with or without an added fourth circle connecting them; the Triquetra (composed of three fish-like shapes that wind into one another, or three actual fish depictions lying in a circle upon one another); the fleur-de-lis (a three-petal flower); and others. (See Webber, *Church Symbolism*, 39–48.) Another option is a sacred monogram, such as the Greek capital *upsilon* or small *gamma*, like the letter "y" in English, enclosed in a circle, and dividing the inner space into three parts (Alva William Steffler, *Symbols of the Christian Faith* [Grand Rapids: Eerdmans, 2002], 71, 78). One particularly striking mosaic is displayed at St. Mark's in Venice.

gods, all of the same substance, uniting to form one great Godhead—sort of a divine mechanism, like a machine with components that grind on with the work of creating, sustaining, and redeeming. And such a conclusion hardly expresses the full scope of what the apostle Paul, for example, is expressing when he writes of all the "fullness" (*pleroma*) of the Godhead dwelling in Jesus Christ (Col. 1:19). In this "parts of the Trinity" language, only some of the "fullness" would exist in each member, who are divided up in three partial sections, or a third of the Godhead, as Elijah Muhammed complained. But at the same time, mere words like *fullness* give us a clue but hardly an explanation illustrative enough to widen our comprehension.

The Bible presents God coexisting as Father, Son, and Spirit simultaneously. We can see an example at the baptism of Jesus: the Father speaks aloud, the Holy Spirit descends upon Jesus, and the Son is baptized by John the Baptist (Matt. 3:13–17; Mark 1:9–11; Luke 3:21–22; John 1:29–34). We are viewing not three gods but one great triune God,[31] who is present with us, providing and sustaining our existence, as Paul noted to the scholars on Mars Hill (Acts 17:27–28). We see reference to the three-in-one also in Jesus' Great Commission in Matthew's Gospel, when he tells his followers to make disciples, baptizing them "in the name [singular] of the Father and of the Son and of the Holy Spirit" (Matt. 28:19): three persons, but one name. And while Jesus describes the Holy Spirit as a separate person working in cooperation with Jesus and the Father to continue to minister to us (John 16:13–15), Jesus is continually conversing with his heavenly Father in prayer all through his ministry on earth (e.g., Matt. 14:23; Mark 6:46; Luke 6:12; John 17).

Yet despite the inherent flaws in these illustrations of the Trinity, as a whole, fluid and static images taken together correct each other. In this way they avoid all sorts of theological difficulties that arise and are compounded when any single explanation and/or illustration loses the central biblical revelation of one God eternally existing in three coequal persons or with three eternal faces.

31. On the road to Emmaus, Jesus opens up the OT revelation to his puzzled fellow wayfarers, revealing to them the places in the OT where he was prophesied. I believe Deuteronomy 6:4 must have been one of those places he expounded, for the obvious plurality in the name of God, *elohim* (the plural for *el*), juxtaposed with "the Lord" (the sacred Tetragrammaton, the four consonants YHWH, called radicals, which comprise the holy name of the Lord; the term is singular), posits a plurality and singularity inherent in God. As we noted, some like Gesenius and other Hebrew scholars have suggested other ways to read the use of the plural name of God, such as intensification, or the we of majesty, but use of both the plural and the singular names of God remains consistent from Genesis 1 on. God is singular but plural at the same time. Jesus was demonstrating what he was teaching in John 8:58 and 10:30, that he was indeed God-Among-Us, a fully preexistent person of the triune Godhead.

Further, such images stand as a corrective to avoid unitarian theologies attempting to smooth out the problems of comprehending a triune God in eternal relationship by positing God as one simple, solitary, undifferentiated monad sending out temporary manifestations, as we encountered earlier in the book: now you see the Father, now you see the Son, and now you see the Holy Spirit. Sometimes you can see all three (as proponents attempt to handle the multi-manifestations in the baptism of Jesus). However, static imagery reminds us of permanence, that all the persons of the Godhead are always present with us.

A parallel problem that static imagery may help to avoid is that of a monad taking up residence in the man Jesus, sometimes posited by heterodox theological discourse about Jesus' baptism. In this view, the Spirit descends on a faithful carpenter who has been preaching love and then clears out right when he is dying, since the divine Spirit inhabiting him cannot die. Such theorizing presents as proof Jesus' question of why the Father is abandoning him on the cross (Matt. 27:46), and dismisses the more profound concept that a holy God cannot be profaned by the sins of the world being taken on by the God-human, with a simple cowardly clearing out when the going gets tough.

Would anyone actually posit such an idea? Irenaeus, overseer of Lyons (in what today is France), tells us in the first volume of his fascinating defense of the faith *Against the Heresies*:

A certain Cerinthus taught in Asia that the world was not made by the first God, but by some Power which was separated and distant from the Authority that is above all things, and which was ignorant of the God who is above all things. He proposes Jesus, not as having been born of a Virgin—for this seemed impossible to him—but as having been born the son of Joseph and Mary like all other men, and that he excelled over every person in justice, prudence, and wisdom. After his baptism Christ descended on him in the shape of a dove from the Authority that is above all things. Then he preached the unknown Father and worked wonders. But at the end Christ again flew off from Jesus. Jesus indeed suffered and rose again from the dead, but Christ remained impassible, since he was spiritual. [32]

32. Irenaeus, *Against the Heresies* 1.26. From time to time one will encounter people with quasi-adoptionist views. I did when I was researching my study of Rasta views of Christology, *Dread Jesus* (Eugene, OR: Wipf and Stock, 1999) e.g., 129. Christian Science has a similar kind of spin on it in its claims: "Christ is the ideal Truth," "Jesus not God," "Jesus is the name of the man who, more than all other men, has presented Christ, the true

So powerful was Cerinthus' influence at the time of John the Apostle that Jerome tells us John "wrote a Gospel, at the request of the bishops of Asia, against Cerinthus and other heretics and especially against the then growing dogma of the Ebionites, who assert that Christ did not exist before Mary."[33] Irenaeus explains that the Jewish Ebionites had a low view of Jesus' divinity, used only the Gospel of Matthew, adhered to the Hebrew law, and rejected "the Apostle Paul, saying that he is an apostate from the law," while the Nicolaitans lived immoral lives. Cerinthus shared these doctrinal and practical shortcomings.[34]

But any of these formulations of a mode or a manifestation or a temporary visitation makes the atonement a sham. If the incarnation is just a temporary manifestation or a mode of God and is not a real, authentic incarnation—where Jesus is fully human and fully divine, having one divine parent and one human parent—then Jesus is not really as real and integrated as we are. And only his humanity is stuck in this contingent world until he dies. So how is he an adequate substitute for our sins?

As for the second formulation, if the humanity of Jesus is all that dies, then we would still have to ask: "How can the substitutionary atonement be adequate for all the sins done by all of us since humans appeared on the earth? Are we not, in reality, all still lost in our sins?" And if the divine presence in Jesus cleared out when things got tough at the crucifixion, then it was hardly around to overcome the forces of evil and make its vessel the "Christus Victor." The divine manifestation would be drawn back into the monad, perhaps again undifferentiated. What kind of divine presence would that be? Static illustrations, for all their shortcomings, help avoid some of these problems.

One other instructive illustration comes from a teacher of error and one of the earliest and most potent opponents of orthodoxy, the shipbuilder Marcion. Lamentably, Marcion, who fell into a profligate lifestyle, was the son of a church overseer and no doubt grieved his parents deeply. James 3:13–4:3 warns that wisdom disappears when evil desires take over. When confronted

idea of God, healing the sick and the sinning and destroying the power of death. Jesus is the human man, and Christ is the divine idea; hence the duality of Jesus the Christ." Mary Baker Eddy, *Science and Health with Key to the Scriptures* (Boston: The First Church of Christ Scientist, 1934), 473.

33. Jerome, *Lives of Illustrious Men 9*, in *The Nicene and Post-Nicene Fathers*, 2nd series, vol. 3, eds. Philip Schaff and Henry Wace (Peabody, MA: Hendrickson, 1999), 364, and in William Steuart McBirnie's interesting resource, *The Search for the Twelve Apostles* (Wheaton, IL: Tyndale, 1973), 117–18.

34. Irenaeus, *Against the Heresies* 1.26. Another report on Cerinthus, the Ebionites, and Nicolaitans can be found in Eusebius, *Church History* 3.27–29.

with church discipline, Marcion used his resources to start his own heretical movement by kicking out the Old Testament and its laws and reducing the New Testament to the book of Luke and ten epistles of Paul. In Marcion's view, the preference was for compassion over law. Among his many heterodox ideas, Marcion opposed both the doctrines that (1) the God of Jesus Christ would be offended by humans breaking Old Testament moral laws and (2) Jesus, God-Among-Us, was born to die as a sacrifice for human culpability that comes from breaking these laws. Tertullian reproached Marcion for his attacks on such central doctrines: "Was not God truly crucified? And being truly crucified, did he not truly die? And having truly died, was he not truly raised? Was it falsely that Paul determined to know among us only one who had been crucified? Did he falsely present him as buried? Did he falsely teach that he had been raised? In that case, our faith is false too, and everything we have hoped from Christ is a deceit."[35] As we noted earlier, Millard Erickson in his *Christian Theology* puts the same point well when he writes, "Redemption is available to us. The death of Christ is sufficient for all sinners who have ever lived, for it was not merely a finite human, but an infinite God who died. He—the Life, the Giver and Sustainer of life, who did not have to die—died."[36]

Because both Tertullian and Erickson recognize an eternally living triune God, they can both understand, as Marcion and those like him did not, how one person of the Godhead could die and overpower evil, while the two other persons of the one, great God were still alive and holding the universe together.

The Great Commission of Jesus means we have a story to tell the nations, as an old hymn declares, and stories need illustrations, as Jesus modeled for us. The task before us, then, is to see if we can tell that story with the help of contextual static and fluid images that can reach our specific audience. Remembering that images are illustrations, not ends in themselves, will help us steer clear of heterodoxy, for we keep refining our analogies and metaphors and similes with the truths we learn in Scripture.

35. Tertullian, *On the Flesh of Christ* 5.2–3, in *The Christological Controversy*, ed. and trans. Richard A. Norris (Philadelphia: Fortress, 1980), 69–70.
36. Millard Erickson, *Christian Theology*, 3rd ed. (Grand Rapids: Baker, 2013), 642.

CHAPTER 8

HUMAN IMAGES THAT ARE STATIC

John Calvin begins his masterpiece, *Institutes of the Christian Religion*, with this insight: "Nearly all the wisdom we possess, that is to say, true and sound wisdom, consists of two parts: the knowledge of God and of ourselves." His conviction is, "Without knowledge of self there is no knowledge of God." This is because "no one can look upon himself without immediately turning his thoughts to the contemplation of God, in whom he 'lives and moves' [Acts 17:28]."[1]

As if providing illustrations of his observation, my students' surveys were filled with imagery built on some aspect of our humanity, which served for them as helpful analogical insights into the nature of the Trinity.[2] This chapter

1. John Calvin, *Institutes of the Christian Religion*, vol. 1, ed. John T. McNeill, trans. Ford Lewis Battles, LCC 20 (Philadelphia: Westminster, 1960), 1.1.1.
2. Some examples are a Greek-Canadian student's "body, mind, soul = one person," "one being, three persons," the divine "one essence, three *prosopon* (three realities)" as depicted in the triangle. A Haitian student saw the Godhead reflected in our "tri-part being: humans. . . have a soul, spirit, and body; that's three different things but still one." An African American personalized the image as follows: "Sam has a spirit, soul, and body but is not separated. His soul, body, and spirit are him. That's Sam: three things but still one." Another African American submitted two body-parts images: "head → eyes, mouth, ears" and "the body: head, neck, and body." This student drew a circle with connecting arrows as follows: "Father → Holy Spirit → Son (Jesus)," depicting the relationships as a "cycle of Trinity," noting its strength as "interwoven, connecting the cycle/interrelationship." But its limitation is "explaining the non-hierarchical nature of Trinity." A self-identified Latin Hispanic student wrote, "My body—I was created in his likeness, so I have a body,

examines static analogies of humanity that depict aspects of God, such as ourselves traditionally understood as tripartite beings: a body, infused by a spirit (*pneuma*), the eternal breath of life God breathed into us (e.g., Gen. 2:7), and soul (*psuchē*), our temporal life force or self as a human being. We also look at the persons of God from our plurality in unity in groups, such as clubs, governments, armies, or businesses.

OUR BODIES: ONE PERSON, THREE PARTS, AND RELATED IMAGES

In *Latina Evangélicas: A Theological Survey from the Margins*, Zaida Maldonado Pérez reports: "It was only when I attended seminary that I noticed some non-Spanish speaking believers made a concerted effort to refer to the persons of the Trinity by their functions." Why? "The distinctions had nothing to do with tritheistic tendencies on their part," but with their quest for "finding orthodox ways for recovering nonsexist language and metaphors for a God that has been reified as male." So, her fellow students "focused on the economic Trinity, but they embraced the threeness." Citing Gregory of Nazianzus, she explains, "We all understood well enough that the division in the Trinity 'is of persons, not of Godhead.'" But though this solution of "referring to God as Creator, Redeemer, and Sanctifier" may have worked for the non-Spanish speakers, it did not work for her. Why not? "Because the Spanish language (and all Romance languages) has no neuter forms for persons and things." And in her church, she observes, "My

soul, and spirit. It's all me, but they have different uses." Other body parts offered in class as trinitarian imagery included one student offering one braid of hair with three strands. Another student suggested a hand with a thumb and two fingers and one brain with several lobes. While helpful by depicting a unity with three components, this image must commit selective dismissal. The hand has five fingers, while the brain image suffers from a similar numbers problem. The brain has been commonly identified as having not three but four lobes in its two hemispheres: the frontal, parietal, temporal, and occipital. I discussed in the previous chapter with Mount Rushmore the problem of four not three. So, technically speaking, for any of these examples to be adequately analogous to the three persons of the One God, we would have to ignore the fact that there are five fingers, four lobes, and four faces, and center on only three. But again, they are analogies, not allegories, so they are illustrating one simple truth: plurality in unity is evident all around us, even if the correspondence to the great, unique God is not exact. What is obvious is that this powerful analogy of a body, encompassing God's breath of life—the eternal, noncorporeal spirit within us, or the temporal life force that animates our being—can work well in an orthodox context, revealing a filling of our being as the Trinity is filled with the perichoretic presence of the three persons who are the one God. But at the same time it is not a perfect allegory, since a body is only a container and not a conscious, dynamic, and completely unlimited spiritual entity.

own experience as an *evangélica* was that we do not focus on distinguishing or defining the persons of the Trinity through traditional formularies that assign particular function to each." She credits this "to our emphasis on the unity of the Godhead versus what to us may seem to be an overemphasis on the distinctions." She also cites another *evangélica* who agrees, "I pray to all three [persons] as one, using the different 'names' at one point or another."[3]

Words do not necessarily convey the same meaning in separate languages though they may appear close enough to be cognates (words borrowed and adapted from one language to another). Further, the challenges of transferring the significance of the impact of gendered language to those accustomed to non-gendered tongues is even more complex. If we have not grown up with a gendered language, it is hard to understand its nuanced issues. When one factors in that we are attempting an inter-lingual discussion on the finer points of trinitarian doctrine, to say the least, we need to proceed cautiously before we declare we understand.

In addition, assuming that because God created us in God's "likeness" we therefore have a physical body like God's spiritual body also does not connect with Christian orthodoxy. None of the persons of God, including the one who would incarnate as Jesus, had "a body" in eternity.[4] This wording more expresses a Mormon idea, as we can see in *The Book of Mormon*, Ether 3:14–16:

> Behold, I am he who was prepared from the foundation of the world to redeem my people. Behold, I am Jesus Christ. I am the Father and the Son. In me shall all mankind have life (light), and that eternally, even they who shall believe on my name; and they shall become my sons and my daughters. And never have I

3. Zaida Maldonado Pérez, "The Trinity *Es* and *Son Familia*," in *Latina Evangélicas: A Theological Survey from the Margins*, eds. Loida I. Martell-Otero, Zaida Maldonado Pérez, and Elizabeth Conde-Frazier (Eugene, OR: Cascade, 2013), 54–55.

4. One student in class told me his pastor taught that after the resurrection Jesus had a permanent spiritual body in eternity. This apparently is a matter of debate among Christian leaders. If Jesus, after "having then discharged the office of Mediator, will cease to be the ambassador of his Father, and will be satisfied with that glory which he enjoyed before the foundation of the world," as Calvin notes in his *Institutes* 2.14.3, personally, I don't see why—as he was previously a spirit before he "became flesh" at the incarnation (John 1:14) and took on the outward form (*schēma*) of a servant (Phil. 2:7)—Jesus Christ would not return to the preincarnate spiritual state of possessing omniscience, omnipotence, and omnipresence in eternity. After all, if his resurrected body on earth was still located in one spot at a time, as we see in such post-resurrection passages as John 20:24–29, why would he retain that limitation and not receive his omnipresence back when he reclaims the glory of his attributes, which he emptied out in order to become our sacrifice (Phil. 2:7–8) once our redemption is completed?

showed myself unto man whom I have created, for never has man believed in me as thou hast. Seest thou that ye are created after mine own image? Yea, even all men were created in the beginning after mine own image. Behold, this body, which ye now behold, is the body of my spirit; and man have I created after the body of my spirit; and even as I appear unto thee to be in the spirit will I appear unto my people in the flesh.[5]

That God has an actual body is probably a misreading by the Mormons of an instance like the apparition of a hand that writes on King Belshazzar's wall in Daniel 5:5. Verse 5:24 specifies the hand was not God's but was sent (*shālah*, "to send") by God to announce the king's doom. Further, what Ether 3:14 means by "I am the Father and the Son" is certainly baffling, since today the Mormons' official website declares: "While some believe the three members of the Trinity are of one substance, Latter-day Saints believe they are three physically separate beings, but fully one in love, purpose and will." I should note here that this is why I am uncomfortable with "member" language for the persons of the Trinity. It lends itself to tritheism, which sees the three not as permanent persons of a single God but as three gods in agreement.

GOD AS A CLUB OR SOCIETY

One student wrote an excellent term paper on Mormonism for the Systematic Theology 2 class in 2016. After poring through an array of Mormon writing, she decided that what unified its theology was this image: God as the three Musketeers, with their rallying cry, "All for one, and one for all." What she perceived in this parallel is that the Musketeers in Alexandre Dumas' story were an inner circle belonging to an elite corps of warriors. What was analogous to Mormonism was that the inner circle was not closed. With the advent of D'Artagnan, these three musketeers became four. Thus this image depicts shared substance and unity of purpose but includes this danger: there is always the potential of having more gods applying for membership in the Godhead, just as there are more than three musketeers in Dumas' story. In parallel, the Mormon heaven is filled with other potential gods.[6]

5. *The Book of Mormon: Another Testament of Jesus Christ* (Salt Lake City, UT: The Church of Jesus Christ of Latter-day Saints, 1968), Ether 3:14–16. Their website clearly states that the Mormons' "Church teachings about the Godhead differ from those of traditional Christianity."

6. Ancient heterodox theologies have survived the condemnation of the creedal councils and are still living faiths that have even threaded their way as alternatives into the plurality of contemporary religious views, for instance, Rastafari. The Trinity is by no means a

But for historically orthodox Christianity, illustrating the Trinity as an exclusive group or cooperating coalition that shows unity in diversity can actually be very effective, as we see, for example, in this image from John Frame: "The New Testament reveals God Himself as a Trinity, a society of Father, Son and Spirit. The task associated with the image (Genesis 1:28) is one that no one can perform fully as an individual." Therefore, he notes, "Through Scripture, God calls to Himself as his children not only individuals, but also families, nations, churches. Like godly individuals, godly families image God."[7] Here he balances the oneness of God with the plurality of persons in the Godhead, showing its reflection in God calling individuals and groups. The illustration of singularity in plurality is helpful, while the danger we have to keep in mind is the problem my student highlights.

Karl Barth in the first volume of his *Church Dogmatics* draws the line at depicting the Trinity as having three personalities: "What we to-day call the 'personality' of God belongs to the one unique essence of God which the doctrine of the Trinity does not seek to triple but rather to recognise in its simplicity." And he elaborates, "'Person' as used in the Church doctrine of the Trinity bears no direct relation to personality. The meaning of the doctrine is not, then, there are three personalities in God." For Barth, "This would be the worst and most extreme expression of tritheism, against which we must be on guard." His concern is that "the doctrine of the personality of God is, of course, connected with that of the Trinity," because "we are speaking not of three divine I's, but thrice of the one divine I." Barth's concern is preserving "the concept of equality of essence or substance," since "identity of substance implies the equality of substance of 'the persons,'"[8] which, as we noted, was Athanasius' point.

given even among these religiously oriented people who have come out of a Christian background. I have noted a strong Hindu and Eastern religion influence on some of Rastafari's founders or early leaders like Joseph Hibbert, Leonard Howell, and Claudius Henry, who at times have appeared to be elevated (some by their own suggestion, others by followers) to occupy a place in the Godhead. For example, among those who were willing to add persons to the Trinity are Bobo Dreads, who did so with their leader, Prince Emmanuel Edwards. See Spencer, *Dread Jesus*, 79–88, esp. 83–85.

7. John M. Frame, "Men and Women in the Image of God," in *Recovering Biblical Manhood and Womanhood: A Response to Evangelical Feminism*, eds. John Piper and Wayne Grudem (Wheaton, IL: Crossway, 2006), 230.

8. Karl Barth, *Church Dogmatics* I/1, 2nd ed., trans. G. W. Bromiley (Edinburgh: T&T Clark, 1975), 350–51. One of the most enthusiastic books to embrace Barthianism among conservatives is by John B. Champion, who recommended, "One comes to see that Barth cannot be answered by argument; and that the only appropriate and profitable thing to do is, frankly and humbly, to examine one's self before God, and get down in utter humility

While I am not a Barthian myself, I recognize the validity of points like these, for his warning is well taken. I myself have used "personalities" previously for the persons, but I am now careful not to do so. I realize the use of "personalities" in the plural suggests a difference in essence. For example, one person of the Godhead might be forever sovereign other the others. This kind of hierarchy would indeed suggest three gods in ascending order, as we saw in Origen, who considered the Son a secondary god and the Spirit a tertiary (or third) god. In a club, one finds a presiding officer (often called a president), a vice president, and a secretary treasurer. Is this what the Trinity looks like? Not according to Athanasius' argument from the equality of attributes and substance that had his opponents charging him with making the Father and Son brothers.[9] Needless to say, they missed the point. Athanasius understood clearly that God is absolute, and the persons of the triune God must be "equal" to be God together. Otherwise no true equality in the Trinity exists.[10]

GOD AS A GOVERNMENT

One government with three branches—the executive, judicial, and legislative—is another image my students have sometimes cited. The advantage of this image is that the three parts of government are all equal, so one is not

to that relation to God which Barth teaches is foundational. Then God gets a man where He wants him in order to bless him" (*Personality and the Trinity* [New York: Revell, 1935], 25). Despite a tone bordering on fawning over Barth, sexist language (routine for his day), and a heavy subordinationist flavor throughout his book (e.g., "The Father occupies the principal place in the Godhead. This holds true of the functions of the other two Persons of the Trinity. Two hold a subordinate place to the third. In the Father's functions or offices origination or source is the chief . . . the Son is His Agent; so also is the Holy Spirit, each in His own way carrying out the Father's designs" [148]; "the Son is equal in substance, but subordinate in office" [162–63]), Prof. Champion still manages to recognize an ontological unity ("the Three Members of the Trinity are all of the same substance . . . the Father begetting the Word equal to Himself in every respect" [161]), so that, in a useful summary to our discussion, he concludes, "If the Persons of the Holy Trinity could be divided into separate existences, they would constitute not One Being, but three. Then they would not be interexistent interpersonality" (72–73). Melding "interpersonality" with the perichoretic "interexistent" assists us in understanding the point of Barth's concern. Seeing separate personalities within the Trinity replaces monotheism with tritheism. Another helpful contribution from Champion is his clear explanation separating a "triad" from a "trinity." He points out, being "non-complementary," a triad "is therefore without the possibility of true personal unity . . . a triad never reaches trinal unity." Even "uniformity" does not ensure "real unity," because "under the similarity of external form may lie all the disunity of greatest divergence or even disagreement" (71). We will revisit Prof. Champion's thought in the next chapter.

9. Athanasius, *De Synodis* 3.51.23.
10. Athanasius, *De Synodis* 3.49.20.

subordinated to another. Together they comprise the government. The disadvantage is each branch is only a third of the government.

Further, while one is positing a political image, hearers might be tempted to think of the triumvirate of rulers Rome attempted after the assassination of Julius Caesar, but that would be a mistake. Not having learned the lesson of war among equal rulers with separate wills from the example of Alexander the Great's generals falling out with each other and plummeting into a struggle for supremacy, this phrasing might evoke such an example of three separate and possibly conflicting wills rather than the one will of God shared in three distinct persons in perfect harmony. Each person contains all the fullness of the Godhead, being not simply a complementary third of deity but together comprising one God. Maybe the phrasing "who are the one God" rather than "within the one God" might work better to avoid sounding like a triumvirate.

GOD AS AN ARMY

This difficulty of maintaining a sense of equality among the Trinity also emerges when we image God as an army. As one student noted, "All are soldiers in the same army, but with different rank." God is indeed called the Lord of "Hosts" (*saba'*, "host, army, troop, host of heaven [angels or stars]")[11] in many passages in the Old Testament, for example, in David's prayer in 2 Samuel 7:26, when he announces people will extol God with this name. But is this image accurate for the Trinity?

In 2008, at a yearly conference of the Evangelical Theological Society (ETS), the president of the ETS spoke on the theory of rank in the Godhead. He made the following statement:

> One characteristic [among the inflexible ordering among the Trinitarian persons] is apparent over and again. . . . The *taxis* among the Trinitarian persons is marked unequivocally and eternally by an inherent authority and submission relationship that defines, as much or more than any other biblical category does, what constitutes the distinctiveness of the Father, the Son, and the Spirit. Yet, because of strong resistance by some contemporary theologians to this notion of an eternal authority-submission structure to Trinitarian relations (e.g., Kevin Giles, Millard Erickson, Tom McCall, Keith Yandell), I've been led to conclude that what we have here is nothing less than the proverbial elephant in the room.

11. Karl Feyerabend, *Langenscheidt Pocket Hebrew Dictionary to the Old Testament: Hebrew-English* (New York: McGraw Hill, 1969), 281.

Without question, one of the most widely attested biblical themes, especially of the Son's relation to the Father, is one in which the Father, *qua* (as; in the capacity of) *Father*, initiates, commands, governs, sends, and in every way directs the Son and his activities, while the Son, *qua Son,* for his part knows nothing of self-initiative but rather seeks in all he does to do the will of his Father. The Spirit in all of this supports, upholds, and honors the Son in his mission and work, seeking to fulfill the will of the Son, who in turn seeks to carry out the will of the Father.... The Father is Supreme in Position and Authority among the persons of the Trinity as the Grand Architect, the Wise Designer of Creation, Redemption, and Consummation.[12]

Is this what we saw in Athanasius' use of *taxis?* Did the guardian of orthodoxy and great defender of the Creed of Nicea in his 110 uses of *taxis* ever interpret the Bible to teach Christ had a lower rank than God the Father? No.

GOD AS A BUSINESS

One of my students suggested the Godhead functions like a corporation. Certainly, we could key off Jesus' parable of the vineyard owner sending his son to recalcitrant employees, who seize the son and murder him to try to take over the land for themselves (Matt. 21:33–41; Mark 12:1–9; Luke 20:9–16). Businesses are, after all, composed of people.

In the same way, as an analogy, we think of the active God who is in the "business" of rescuing, redeeming, and restoring humanity, a "corporation," as this student noted, that is "loving." At the same time, a business is still an enterprise out to make a profit to pay its workers and its stockholders. In that sense, it cannot perfectly represent the God who creates all and needs nothing.

John Gerstner once emphasized that a subordination in the Godhead was reflected in humanity with a rather odd wording: "As long as God has been, there has been a chain of command." Appealing to a "covenant of redemption or the council of peace," he explains: "This is the time when (if you will excuse the expression) the economic Trinity came into operation; that's the time when the three, equal-in-authority members of the ever blessed Trinity voluntarily agreed to subordinate themselves to one another in the interests of redeeming men anticipated as fallen." So, this is an act of mutual

12. Bruce A. Ware, "Christian Worship and *Taxis* within the Trinity," address given at the 60th Annual Meeting of the Evangelical Society, Providence, Rhode Island, November 20, 2008. https://equip.sbts.edu/ SBJT-V16-N1_Ware, accessed Dec. 15, 2021.

subordination or submission by "three" "equal in authority" persons of the Godhead to accomplish human salvation.

To illustrate this idea, he turns to a business image: "According to this voluntary compact, the Father would be head or executive; the Son would subordinate Himself to the Father in securing redemption for those whom the Father should choose; and, the Holy Spirit consented to be the purchase of redemption in cooperation with and in subordination to both the Father and the Son." This deal was "necessarily known to all persons eternally."[13] However, as Gerstner describes the agreement, the persons of the Trinity in this phrasing do not actually appear to "subordinate themselves to one another"—only the Son and Spirit did the subordinating, not the Father. This hierarchical image does provide a helpful illustration to understand the subordinationist position as an agreement among equals. It might not be imprinted in each divine person's nature but rather a "business venture" for the time of salvation. Once that task is accomplished, then presumably the Three return to their previous "equality-in-authority" in eternity. This would make the subordination of the Son and Spirit temporary as "economic" acts in time.

We could extend this schema's business imagery by suggesting the Father could be seen as the chairperson of the board (sending the Son to set up the business of redemption on earth), the Son as chief financial officer (since Jesus Christ paid off the penalty for human sin), and the Holy Spirit as the chief executive officer (CEO) left to run the business until the second coming.

However, not all the parables of Jesus about business are ones he would want us to accept as true depictions of the nature of God or emulate in our daily practice. For example, Luke 16:1–15 gives an interesting account of business intrigue, where a shifty manager cooks the books to assure future customer loyalty when his boss fires him for mismanagement of funds. When he learns about his shifty employee's subterfuge, the boss ends admiring the crooked bailout strategy (v. 8). That story is certainly not analogous to the Trinity (unless the rich owner can be speculated to be a conversive shadow image of God the Father, like the contrast Jesus draws between the unjust judge of Luke 18:1–8 and the always just God [vv. 7–8]). Jesus is certainly not the thieving manager! The shrewd manager is also not the kind of example we want our children to follow. Jesus draws a distinction between worldly business and using money to do good works.

13. John Gerstner, "Is Women's Ordination Unbiblical?," panel discussion, Gordon-Conwell Theological Seminary, 1980, 2.

As we can see, business images are relevant, but we can't take them all too literally to depict "God's business," which is all about acting generously. Ultimately, the church (and each of its agencies, e.g., a seminary) is more a nonprofit enterprise or charity built on grace than it is a business out to make financial profit (as a literal reading of the parable of the talents might be misconstrued in Matthew 25:14–30).

SUMMARY

Starting with our own being, in this chapter we surveyed images from the traditional understanding of a human person as composed of a body, soul, and spirit. The human body represented unity; the soul, our temporal life on earth; and the spirit, what is eternal within us. As God has three persons, we are composed of three components that are different but united. The point of these analogies is to depict three in unity.

There are benefits and liabilities to using images of groups of people, as with a club or society. That they are all related shows a connection in a way that others outside the group do not share. This is also true for a business with employees. A deficiency as a divine analogy occurs when one adds a hierarchical aspect of many businesses. Such an aspect does not reflect the equality we see in the one God, who is coeternal and coequal.

What keeps imagery from being co-opted completely by error is a healthy view of how images truly serve us. One of the best explanations I have read comes from the work of Charles Williams, a British minister and author of such profoundly theological novels as *All Hallow's Eve*, articulated perceptively by Mary McDermott Shideler in *The Theology of Romantic Love*: "Williams' epigram, 'This also is Thou; neither is this Thou,' while referring specifically to images of God, is equally pertinent to all images. The identities reveal and the differences conceal the greater things." She offers these examples: "Thus, the hurricane reveals God's power in nature, while it conceals his power in the still small voice." And "the mildness of an April day that speaks of his loving care, hides the majesty of his judgment." Images give us "revelation" when we discover and compare what they reveal and what they conceal.[14]

14. Mary McDermott Shideler, *The Theology of Romantic Love: A Study in the Writings of Charles Williams* (Grand Rapids: Eerdmans, 1962), 21–22.

CHAPTER 9

GOD AS A DIVINE FAMILY

An anonymous fragment from the early church passes on this image of the Trinity:

> Perhaps these three persons of our ancestors, being in an image the consubstantial representatives of all humanity, are, as also Methodius thinks, types of the Holy and Consubstantial Trinity, the innocent and unbegotten Adam being the type and resemblance of God the Father Almighty, who is uncaused, and the cause of all; his begotten son shadowing forth the image of the begotten Son and Word of God; whilst Eve, that proceedeth forth from Adam, signifies the person and procession of the Holy Spirit.[1]

No analogy should be pressed beyond its point of comparison. This one is clever, but it breaks down because although Adam was unbegotten, he was

1. This fragment of a lost manuscript referring to Methodius is collected in *The Writings of Methodius, Alexander of Lycopolis, Peter of Alexandria and Several Fragments* (Edinburgh: T&T Clark, 1869), 14:230. Methodius of Olympus, a bishop in Lycia and opponent of Origen, appears to have suffered martyrdom in a sad twist of timing, c. AD 311, just in the aftermath of the persecution of Diocletian, a year before Constantine's victory at the Milvian Bridge (AD 312) and his subsequent "Edict of Milan" (c. 313, "Milan, Edict of" in ODCC, 915), legalizing the Christian churches and establishing equal tolerance of all religions. This fragment attributed to Methodius is understandably considered "uncertain" since, among other reasons, he is mentioned in the third person.

indeed caused. The second point of comparison poses Cain, the firstborn, as a foreshadowing of Jesus Christ, God's "only begotten child." (This may have been Eve's possible misconception at Cain's birth that he was the crusher of the tempter's head to whom God refers in describing the curse in Gen. 3:15 cf. 4:1.) Cain, however, was not an only begotten child, as Jesus was from God and Mary. Abel is second born, and Seth is the third. While this analogy might work until his brothers' births, Cain is such an unworthy precursor for Jesus that the analogy might fail in readers' minds simply because of their refusal to accept the murderer Cain as a type of Jesus Christ, who was without sin (Heb. 4:15). The third image of Eve as proceeding from Adam's side, as the Holy Spirit proceeding from the Father (and the Son, in the Western church's view), has no parallel to Mary proceeding from anyone other than her natural mother in childbirth.

For those who resist the idea that the Holy Spirit is essentially feminine (though not female) and the Father is essentially masculine (though not male), the analogy also leaves a residue of questionable theology too thick to discern any helpful aspect to it. So, this is a clever analogy in that it relates the Trinity to metaphors of marriage and procreation. It is therefore understandable to humans but not necessarily wise or edifying.

One student suggested the analogy of husband, wife, and son. But by portraying a husband as a masculine God the Father, a wife as a feminine God the Mother, and a son as divine offspring, we have moved into gendered pagan mythology. Some have taken the next step into heresy by suggesting that they are not only created in the image of God but are themselves god with a spouse. We will consider some of these claims, ask if God has gender, and inquire as to what benefits and dangers exist in imaging God as a family or community.

DOES GOD HAVE A WIFE?

In Old Testament times, the Babylonian creation epic presented "Apsû," the "begetter," and "Tiamat, she who bore them all." Apsû ends up being the victim of patricide.[2] The Egyptians viewed "Seb [or Keb] and his spouse, the goddess Nut . . . as World Parents,"[3] while the Assyrians had more than 1,500 gods from all sorts of sources. Among this celestial army is Anu, who at one

2. "The Babylonian Creation Epic," in *Alpha: The Myths of Creation*, trans. Charles H. Long (New York: George Braziller, 1963), 81–82.
3. Long, *Alpha*, 99.

historical stage is viewed as married to Ishtar. At another time, he is considered to be her father. Ishtar herself is also a fertility goddess "connected with sexual life."[4] She is one prominent member of quite a sorority of goddesses.

All of these religious concepts infiltrated and subverted Israel's worship of the Lord to the extent that Solomon, its most glorious king, fell under the thrall of the gods of his foreign wives: the infant sacrifice–demanding Molech (Milcom of the Ammonites) and Chemosh of the Moabites (1 Kings 11:7), whom John Gray considers identical with each other as the god Athtar.[5] Along with these, the fertility goddess Athtarath (1 Sam. 31:10; 1 Kings 11:33; 2 Kings 23:13) with her consort Baal (or Hadad, Judg. 2:13, 10:6; 1 Sam. 7:3–4, 12:10) was revered at Sidon and Ugarit up the Mediterranean coast, and by the very Canaanites Israel conquered. So, a divine family, as the people around Israel conceived their gods, reflected a human family and was inappropriate to image Israel's spiritual God.

Such pernicious ideas, mixed in the worship of Samaria, may have provided the background for Jesus' opponents' slur against his true parentage, as recounted in John 8:31–59. In sneering they were not illegitimate, they may be implying Jesus was (v. 41). These insiders seem to have known that Joseph was not his father. In verse 54, Jesus states clearly, "My Father is the one who glorifies me, the One you say that is 'our God.'" A moment earlier, these opponents, getting the drift of Jesus' claims, demanded to know if he was a Samaritan and demon-possessed (v. 48).

Why a Samaritan? Because they descended from pagan people from Babylon and four other pagan nations who were sent into Samaria in northern Israel to resettle the land by Assyria, which was its normal policy with conquered nations. When these did not worship God, God punished them until the King of Assyria sent back one of the captured priests to teach them how to worship properly. If any Israelites had not been deported and remained in the land, they had apparently been ineffectual, but even the returned priest could not keep them, the Samaritans, from worshiping their own gods, which included Ashtoreth (Athtarath).[6] These exiles simply added Israel's "god" to each of their own nation's deities (2 Kings 17:7–40). Tensions remained between the Jews and the Samaritans; although the Samaritans later

4. A. L Oppenheim, "Assyria and Babylonia," in IDB, 1:297–98.
5. John Gray, "Molech," IDB, 3:422. For other information see "Chemosh," 1:556; "Ashtaroth," 1:254–55; "Ashtoreth," 1:255–56; and A. Haldar, "Canaanites," 1:494–98.
6. This plural form is an insult, replacing the vowels in the goddess' name with those of the Hebrew word for shame (Gray, IDB, 1:254–55).

strove to eliminate their syncretism, reforming their priesthood and building their own temple, these measures only heightened the conflict. Faithful Jews were infuriated that these quasi-pagans, as they historically viewed the Samaritans, were presenting themselves as the true followers of God, while the Jews still considered them as apostates. By Jesus' day, the hostility was traditional and pervasive in both cultures. So Jesus was being called illegitimate on several levels. For Jesus to claim God was literally his father was a pagan claim in Jewish eyes, something they may have expected out of syncretists like the Samaritans. They assumed Jesus was presenting a view of God as sexual, fathering children as pagan deities did. This anthropomorphic idea was understandably blasphemous to them.

What the Jews understood as the fatherhood of God had nothing to do with procreation, since the prophets were continually condemning any worship of a Queen of Heaven (e.g., Jer. 7:18; 44:17–28). That would include any attempts to marry the Lord off to this or any other fertility goddess.

The God of the Bible is a spirit and does not marry. Jesus himself is clear about his orthodox belief that spiritual, heavenly, and even resurrected humans who have spiritual bodies after death neither marry nor are given in marriage (Mark 12:25, Luke 20:35–36). Right at the outset, God had clearly rejected the possibility of having gender in the warning in Deuteronomy 4:15 to people that when they "observed" (*shamar*, "to watch, observe, regard") God speaking to them, they did not see any figure or form. They were strictly ordered not to make any copy or reproduction as an idol (*semel*, "divine image") of any figure, male/masculine (*zacar*) or female/feminine (*neqebah*), any other living creature, or anything else. This warning is codified as the second of the Ten Commandments.

DOES GOD HAVE GENDER?

If God is a divine family, as these examples claim, then does God have gender? The question of whether God has gender is an ideological morass into which any theologian can quickly sink. In 2004, the church in which I am ordained submitted for consideration a "Theological Statement on the Doctrine of the Trinity" for the Presbyterian Church (USA) to "Conduct a Series of Consultations Throughout the Church to Encourage Fresh Engagement with the Fullness of the Doctrine of the Trinity."[7] Concerned that the

7. PC(USA) General Assembly Council minutes, 2004, pt. 1, 17, 617, appended to the document "The Trinity: God's Love Overflowing," 1.

doctrine of the Trinity "is widely neglected or poorly understood in many of our congregations," the task force was "convinced that the doctrine of the Trinity is crucial to our faith, worship and service."[8] After a summary of various Scriptures and quotations from creeds to affirm the Trinity as central to the faith, the study centered on the balance between monotheism and the triunity of God: "The divine attributes are held in common by all three persons, all are holy, all are loving, all are wise and powerful." Along with the nature of God, the study recognizes the entire Trinity's involvement in the work of God: "Similarly, an action of God cannot be restricted to one of the three persons. All of the acts of the triune God are indivisible. The persons of the Trinity do not work independently. Each of God's acts is always the one work of the whole Trinity."[9]

While recognizing "the language of Father, Son, and Holy Spirit, rooted in scripture and creed, remains an indispensable anchor for our efforts to speak faithfully of God," the task force argued "an anchor provides both necessary stability and adequate freedom of movement." So, from this secure base, the study attempted to "cultivate a responsible trinitarian imagination and vocabulary that bears witness in different ways to the one triune God known to us from scripture and creed as Father, Son, and Holy Spirit," since "the language of Father, Son, and Spirit has too often been misunderstood to sanction hierarchies that some human beings arbitrarily impose on others." Thus, the task force sought to provide alternate images that address this problem by affirming that "a trinitarian understanding of God makes it clear that the Creator of gender is not subject to it."[10] So the goal was to retain as an anchor the biblical identity of God as Father, Son, and Holy Spirit, and at the same time to "draw on scripture and our confessions to speak of the triune God in historically faithful yet freshly imaginative ways," seeking supplementary images to describe God. The task force centered its guidelines on selecting triads that had "an inner relationship," were either "personal or functional," and would "enrich our understanding of God" without replacing "personal language."[11]

The task force's resulting report began by suggesting that "two analogies have been especially prominent. One likens the Trinity to the capacities of an individual human mind. Just as a human being is one and the same in each of the distinct acts of remembering, knowing, and willing, so God exists as

8. "The Trinity," 2.
9. "The Trinity," 7.
10. "The Trinity," 7.
11. "The Trinity," 8.

one-in-three and three-in-one." This "psychological analogy" emphasizes the "one-in-threeness of God. The other analogy likens the Trinity to a loving communion of persons," centering on the exchanging of "mutual love" in the Trinity. Being a "social analogy," it emphasizes "the three-in-oneness of God."[12] Thus, both monotheism and triunity are balanced.

The illustrations selected included such personal images as "Speaker, Word, and Breath" (with scriptural support, e.g., Heb. 1:1); "Lover, Beloved, and the Love [that] binds together Lover and Beloved (Augustine, *The Trinity*)"; and the feminine imagery of "Compassionate Mother, Beloved Child, and Life-giving Womb (Isa. 49:15; Matt. 3:17; Isa. 46:3)."[13]

This last image drew a strong oppositional response, especially when one commissioner ended a prayer "in the name of the 'Compassionate Mother, Life-Giving Womb and Beloved Child." An article in the Presbyterian Lay Committee's publication *The Layman* quoted Jonathan Lovelady, a pastor and delegate of Shenandoah Presbytery, who pointed out, "There is a difference between a name and a metaphor. . . . The question that cries to be answered is, 'What does God want to be called?'" Even some of the female pastors reacted against it, like the Rev. Debbie Funke of Yellowstone Presbytery, who was quoted as calling the study "problematic, confusing and divisive in a time when the church is already divided" and as "a threat to the peace, unity and purity of the church." Despite the expressed intention of task force leader Charles Wiley, he responded, "I've never seen anything spin out of control so fast in my life. The Trinity paper was my project. . . . The thrust of the paper was a reaffirmation of orthodox belief in the Trinity, including strong affirmation of Father, Son, and Holy Spirit language."[14] To the rest of the imagery proposed (water; light; gift; rock; cornerstone; temple; fire; sword; storm; states of being; even rainbow of promise; ark of salvation; dove of peace, drawn from a Lutheran book of services and prayers), *The Layman* reported no similar reaction. Feminine imagery, of course, is a legitimate part of the scriptural imagery of God, and its use demonstrates that women are made in the image of God, so there must be a correspondence of imagery between women and God. But the question raised was: Is this correspondence in the naming of God?

12. "The Trinity," 6.
13. "The Trinity," 9.
14. John H. Adams, "Trinity Paper: Mother, Child and Womb?" *The Layman* 39, no. 3 (2006): 1, 20.

Theologically, a problem with family imagery being applied outside of the incarnation, where it may work well for Father and Son, is that there is no metaphorical place for the Holy Spirit besides "mother" in an eternal family schema. "Compassionate Mother, Beloved Child, and Life-Giving womb" imagery is no solution, for it substitutes the Holy Spirit for Mary as the *theotokos*, the "God bearer." Rather than correcting male gender defining God, introducing female gender simply compounds the problem by creating two alternative bookends of gender language describing God, which is at best a quasi-pagan solution.

Historically, worshiping God as a feminine God is reminiscent of Athtarath, whose worship, as we saw, was forbidden to Israel. Praying to God in a completely feminine image may have appeared to hearers' minds as another attempt to posit an earlier spiritual entity, "Sophia," as the background for Proverbs 8, as in the World Council of Churches' "Re-Imagining . . . God, Community, and the Church" conference of November 4–7, 1993. Aída Besançon Spencer, in rejecting that attempt "to work out a compromise between Goddess spirituality and Christianity," explains, "The authors of *Wisdom's Feast* have taken a quality of God—wisdom—and made it into an intermediary figure not quite God." *Sophia* (Greek for "wisdom") is seen as a creating angel, so "at the practical level Sophia replaces God in worship and preaching as the one, not God directly, to whom one prays."[15] Given this recent background, one can understand the vociferous response. It may also have been seen as muting the essential validation of Jesus as God-Among-Us, as Abingdon Presbytery delegate Rev. Alan Gray explained, "The reason we call God Father is that he identifies himself as the Father of our Lord Jesus Christ."[16]

In the greater global context, Veli-Matti Kärkkäinen recognizes "with the rise of women's consciousness, a wide acknowledgment of the limitations of traditional ways of addressing the Triune God has emerged." Yet, he adds, "the

15. Aída Besançon Spencer et al., *Goddess Revival: A Biblical Response to God(dess) Spirituality* (Eugene, OR: Wipf and Stock, 2010), 7, 84 (see also 8, 143–46). Prof. Spencer suggests that those who, like the authors of *Wisdom's Feast*, equate Jesus with Sophia (e.g., in Prov. 8) have "divested Jesus of divinity. If Sophia is 'goddess like,' *not* God, and Jesus is Sophia, then Jesus is not God incarnate, in their thinking" (248n17). So, "what have women gained? God appears as some sort of immaterial male, whom men reflect. Women simply reflect a demiurge, an inferior to God" (85). Thus, women are settling for less than being made fully in the image of God. As a result, positing either masculine or feminine gender to God can end in losing Jesus and positing women as inferior, either from excluding them from imaging God or suggesting they image an inferior being.

16. Adams, "Trinity Paper," 20.

acknowledgment of the limits of tradition does not persuade me to replace Father, Son, and Spirit with other terms for speaking of God." He notes, "I am also of the opinion that complementary ways are needed." To this he adds an interesting insight that "alternative ways of addressing God" have not caught on because "many of them are nonpersonal in nature or they are mainly functional." In other words, we might say that God has been reduced to a series of "its" rather than maintaining the loving, familial image of a parent and child: the "Father" and "Son" of the biblical imagery. So, he recommends that "both men and women need to collaborate in finding more appropriate names that are complementary, especially ones in keeping with tradition." Prof. Kärkkäinen realizes that "it is not only women's consciousness that calls for investigating new ways of addressing the Christian God," but the one-third-world scholars must listen to "theologians from Asia, Africa, Latin America, and other cultures" for new imagery to engage an increasingly global population communicating multiculturally. He suggests, "Take ancestor-terminology as an example. What if African and Asian theologians would collaborate and find more appropriate and theologically suitable ways of utilizing this basic cultural element?"[17] Presumably, God could be pictured as the great primal ancestor from whom all are created and from whom all inherit (e.g., Acts 17:24–31).[18]

One engaging example of explaining God in a culture that honors ancestors is in John Crossley's brief though wise book *Explaining the Gospel to Muslims*. He tells of a Christian minister interviewing baptism candidates who is suddenly puzzled because he appeared to be facing one for a second time. Glancing at his roster, he read, "Samson Adeyemo . . . age forty-five," and then saw, "Philp Adeyemo . . . age eighteen." He realized, "Father and son were both coming for baptism at the same time! The Minister looked again and saw that their faces were the same; only one was the face of a youth, and

17. Veli-Matti Kärkkäinen, *The Trinity: Global Perspectives* (Louisville: Westminster John Knox, 2007), 398. Touching a tradition, of course, is a minefield of hidden dangers, since imagery can come freighted down with meanings that annul one's intent. A book like Bong Rin Ro, ed., *Christian Alternatives to Ancestor Practices* (Seoul: Word of Life and Asia Theological Association, 1985) would provide safe guidance through examples of adjusting a tradition that would help evangelists and teachers convey what they intend about God in relation to humans. Chapters 16–18 include suggestions employed in Taiwan and Malaysia, and among Chinese churches in Thailand.

18. An enlightening exploration of this passage is Jennifer Marie Creamer's *God as Creator in Acts 17:24: An Historical-Exegetical Study*, Africanus Monograph Series 2 (Eugene, OR: Wipf and Stock, 2017).

other the face of an adult. But when you saw the face of the son, you knew the face of the father."[19]

When the young Michelangelo was commissioned by Pope Julius II to paint the ceiling of the Sistine Chapel, in addition to a number of architectural challenges, he also had a number of theological and exegetical hurtles before him. The major one, for a theologian, was what to do about God the Father. He addressed this by boldly depicting this person of the Trinity as a well-muscled, vigorous, gray-haired, bearded man in a robe. God's intense eyes, set in front of his human face, leave the omniscient one technically unable to see what is going on among the creatures behind his head. He could certainly hear them, for this jostling crowd of angels appears to be holding God up in the air over Adam, bestowing life upon the first human, who is reclining on a rock on earth. This great masterpiece was begun in AD 1508. Later in that same century anthropomorphic images proliferated, such as Tintoretto's "The Trinity Adored by the Heavenly Choir" (a powerful painting of the crucifixion of Christ), which depicts a white-bearded Father supporting the dying Jesus (rather than abandoning him as he took on the sins of the world; see Matt. 27:46). The Holy Spirit in the shape of a dove radiates light beneath his feet.[20]

What this all tells us so far is that the heathen and the heterodox may be comfortable in viewing God as a reproductive masculine being, but Christians ought to take biblical warnings seriously when representing the persons of the Trinity anthropomorphically by depicting God the Father as an aged man. Also, given this long history of depicting the Father as an old man with white hair, do these portrayals reveal or influence our question of whether God indeed has gender?[21] Since Greek and Hebrew are gendered languages, the references to God are generally masculine. Gendered languages, of course, have limits to their interpretive usefulness. Spanish, for example, uses

19. John Crossley, *Explaining the Gospel to Muslims*, rev. ed. (London: Lutterworth, 1967), 10–11.

20. See this and many more classic images in George Ferguson, *Signs and Symbols in Christian Art* (Oxford: Oxford University Press, 1954), 96–97.

21. In the 300s, Eusebius, overseer of the church at Caesarea Philippi, reported having seen the bronze statue that the woman with the hemorrhaging had erected in front of her house depicting Jesus healing her (Mark 5:25–34). Pilgrims would flock to see it over the centuries, along with "likenesses" on "portrait paintings" of Peter, Paul, and "Christ himself." As Eusebius acknowledged, "This is to be expected, since ancient Gentiles customarily honored them as saviors in this unreserved fashion" (*Church History* 7.18). All believers long to see the face of Christ. But seeing the face of God the Father is impossible (see John 1:18). So we create analogies.

masculine language for a pencil and female for a pen. Does that make ink more feminine than graphite?

John Cooper, in his defense for using masculine language for God, grapples with the complexity of working with gendered languages. In consultation with Albert Marten Wolters, Cooper has recorded forty-three instances of grammatical gender in Hebrew referring to the Spirit in the Old Testament: "thirty-six are feminine and seven are masculine."[22] In order to dismiss the centrality of the feminine references to the Holy Spirit, he must side with the liberal interpretation of *ruah* as "power of God" and not a person of the Godhead, claiming: "Most modern biblical scholars, including evangelical and orthodox scholars who affirm the doctrine of the Trinity, agree that in the Old Testament *spirit* is a power of God and not the person of God himself. Not until the New Testament is the Lord the Spirit (2 Cor 3:17)."[23] This would mean that the reference in Genesis 1:2 that I read as the Holy Spirit brooding on the waters is actually the nonpersonal power of God.[24]

A major problem I see with this theory, since the Holy Spirit has not yet been revealed as a person of the Godhead in the Old Testament, is what we are to make of the fact that Jesus Christ has not yet been revealed as the Son of God. Would all the references to the Son of God throughout Isaiah (e.g., 7:14; 9:6–7) and other such messianic passages about this "son" refer only to Old Testament kings and other human figures, since the Son of God has not yet been revealed as a person? How, then, would Jesus have ignited the hearts of the travelers to Emmaus with his self-revelations in the Hebrew Scriptures? If Jesus was comfortable in showing the Old Testament proofs for himself in Moses and the prophets (Luke 24:27), why would we not follow his lead in the case of the third person of the Trinity?[25]

22. John W. Cooper, *Our Father in Heaven: Christian Faith and Inclusive Language for God* (Grand Rapids: Baker, 1998), 78.

23. Cooper, *Our Father in Heaven*, 80. He cites for proof Kittel's *Theological Dictionary of the New Testament* under the entry "*Pneuma*" (6:332), and, to his credit as a scholar, quotes Victor P. Hamilton, professor emeritus of Old Testament at Asbury University, who wonders whether "one should read 'spirit' or 'Spirit'" for Genesis 1:2. See his *The Book of Genesis, Chapters 1–17* (Grand Rapids: Eerdmans, 1990), 114.

24. Interesting to note is that the NRSV translation committee opts for the even more clearly non-trinitarian "a wind from God," despite the fact that the Jewish Publication Society of America in its *The Holy Scriptures According to the Masoretic Text* stays with "the spirit of God hovered over the face of the waters" (Philadelphia: The Jewish Publication Society of America, 1955), 3.

25. John Calvin cited as his "proof of the deity of the Holy Spirit": "that testimony of Moses in the history of the Creation is very clear, that 'the Spirit of God was spread over the deeps [Gen. 1:2, cf. Vg.]." Calvin goes on, adding Isaiah 48:16 to his Old Testament proof,

Turning to New Testament Greek, Cooper notes the word for "Spirit" is neuter except for "three masculine associations" in John 14:26 and 16:13–14. From this data, he speculates, these passages are "perhaps echoing the Old Testament's masculine cases of *ruah*."[26] Since the Holy Spirit can't be both neuter and masculine at the same time, this can simply be a case of common non–sex-specific grammatical practice.

The other alternative is to posit God as both masculine and feminine, as Cooper demonstrates when he writes, "Caution is appropriate here, but if it is plausible to find a maternal image in the Spirit's hovering over the waters in Genesis 1, it is equally plausible to see a paternal analogy in Luke 1." That might be true, but Cooper is correct to recommend caution. Cooper wisely concludes: "In the final analysis, however, four debatable references to *Holy Spirit* do not make a strong case for claiming it as a masculine term for God. The New Testament, like the Old, gives us little basis for conclusions about the anthropomorphic gender of the Spirit. In fact, *Holy Spirit* is as close as we get in the Bible to a gender-neutral personal reference to God."[27]

An even more nuanced position on the gender of God issue has been articulated by Donald Bloesch. Defending the use of exclusive language for God, he observes, "Such phraseology as Creator, Redeemer, and Sanctifier (or Sustainer) has biblical warrant, and it is therefore not questionable in and of itself. Indeed, it indicates that the God we worship is wider and deeper than the Trinitarian names can of themselves convey." He even thinks such terms can be "supplements . . . even in liturgy" but not "substitutes." Yet he realizes:

> At the same time, I think we need to be alive to the concern of women for wider
> acknowledgment of the feminine dimension of the sacred. The God of the Bible

concluding, "Because he is circumscribed by no limits, he is excepted from the category of creatures, but in transfusing into all things his energy, and breathing into them essence, life, and movement, he is indeed plainly divine." See Calvin, *Institutes of the Christian Religion* 1.13.14. Would not disregarding such traditional Christian recognition of the personal presence of the Holy Spirit in creation and throughout God's activity in the Old Covenant only encourage laity to be influenced by the Jehovah's Witnesses? They dismiss all the OT references to the Holy Spirit with the generalizing claim, "The correct identification of the holy spirit must fit *all the scriptures* that refer to that spirit. With this viewpoint, it is logical to conclude that the holy spirit is the active force of God. It is not a person but is a powerful force that God causes to emanate from himself to accomplish his holy will.—Ps. 104:30; 2 Peter 1:21; Acts 4:31" (Watchtower Bible and Tract Society of Pennsylvania, *Reasoning from the Scriptures* [Brooklyn, NY: Watchtower Bible and Tract Society, 1989], 381).

26. Cooper, *Our Father in Heaven*, 111.
27. Cooper, *Our Father in Heaven*, 111.

is not exclusively masculine, nor is he exclusively monarchical. He is not only Lord but also Friend, not only Father and Brother but also Mother and Sister. We need to be open to a certain amount of experimentation that does not deny or ignore the biblical fact that God chooses to relate himself to us primarily in the masculine gender.

Now, he takes an interesting historical step in being "more flexible in the language of private devotions," citing a prayer from Anselm (c. AD 1033–1109). "And you Jesus, are you not also a mother? Are you not the mother who like a hen gathers her children under her wings?" Bloesch himself offers this prayer for private and public worship: "Dear God, heavenly Father, you who are also our mother, brother, sister, and friend." He sees such prayers as acceptable because "the controlling symbol is still God the Father, and the motherhood and sisterhood of God are therefore seen in relation to this primal symbol."[28]

On the other hand, R. K. McGregor Wright, locating the discussion exactly where it belongs in the realm of linguistic description, states, "There are no grounds in Scripture for the popular assumption that God is essentially masculine or male." He explains, "Nothing could be more natural for the fallen mind than to create a god in its own image (Rom. 1:20–23)." That image (as we saw earlier) was intensely sexual in the pagan world. Ancient paganism believed that "eternal masculine" and "eternal feminine" principles brought in the seasons and made the world work, and this led to the highly charged sexuality of pagan worship with its temple prostitutes. "In contrast, no hint of sexuality attaches to Yahweh of the Hebrew Bible, while the pornographic images of the pagan idols are constantly treated with great contempt by God's prophets." In addition, "the Jews were never invited to speculate about the 'masculinity' of God, and God is never once said to be 'male' (zakar)."[29] "The claim that God must be masculine because he is never called 'Mother,'" he

28. Donald G. Bloesch, *The Battle for the Trinity: The Debate over Inclusive God-Language* (Ann Arbor, MI: Servant, 1985), 52–53.

29. R. K. McGregor Wright, "God, Metaphor and Gender: Is the God of the Bible a Male Deity?" in *Discovering Biblical Equality: Complementarity Without Hierarchy,* eds. Ronald W. Pierce and Rebecca Merrill Groothuis, 2nd ed. (Downers Grove, IL: InterVarsity, 2005), 287, 289. John Frame explains this preponderance of masculine imagery as contextualization, given Israel's position as an island of Yahweh worship amidst a sea of paganism: "Scripture also, of course, emphasizes God's masculinity over against the polytheism and degradation of pagan goddess-worship." "Men and Women in the Image of God," in *Recovering Biblical Manhood and Womanhood: A Response to Evangelical Feminism,* eds. John Piper and Wayne Grudem (Wheaton, IL: Crossway, 1991), 508n27.

dismisses as an "invalid . . . argument from silence," pointing out "God is never called a Trinity in the Bible either, but all the essential structural elements of the Trinitarian model can be exegeted from specific passages, and only this model of God includes all the textual material without contradiction."[30]

Further, the New Testament reveals that the person of the Trinity known as the "Father" did not impregnate Mary, as Zeus would have. Rather the Holy Spirit, described in the Old Testament in a feminine term and the New Testament in a neuter (and sometimes masculine) term, hovered over her and did a work of creation in her. At the same time, the Spirit conveyed the person of the Trinity who would incarnate as Jesus Christ into her womb (Luke 1:35). So, since this is the case, how then is God the Father the "Father" of Jesus?

First of all, the names "Father" and "Son" have to be in some way metaphorical language. Robert W. Jenson announces, "In the trinitarian inheritance, we find—I propose—first God's proper name: 'Father, Son, and Holy Spirit.'"[31] He rejects replacing this collective title "with, say, 'Ground, Logos, and Spirit' or 'Parent, Child, and Spirit'" because he considers nothing less than "fundamental in the trinitarian heritage is the triune proper name of Christianity's particular God : 'Father, Son, and Spirit.'"[32] Not that he believes these names are themselves miraculous: "The triune name did not, of course, fall from heaven; it was made by believers for the God with whom we have found ourselves involved." So he sees them as formulated on earth: "'Father' was Jesus' peculiar address to the particular Transcendence over against whom he lived. Just by this address he qualified himself as 'the Son,' and in the memory of the primal church his acclamation as 'Son' was the beginning of faith." Finally, "'Spirit' was the term provided by the whole biblical theology for what comes of such a meeting between this God and one to whom he takes a special relation." He sees our growing "involvement in this structure of Jesus' own event" in our "prayer to 'Father' with the 'Son' in the power of and for 'the Spirit'—that is faith's knowledge of God." His is a functional approach to faith: we identify the particular God we have met by this name (Father, Son, Spirit), which takes us into his relational presence. And, as for "the masculinity of 'Father,'" he believes "emerging consciousness of the historic oppression of women" means "Christianity has every reason to eliminate" expressions of oppression, but this cannot apply to God's proper name: "Trinitarian 'Father'

30. Wright, "God, Metaphor and Gender," 296.
31. Robert W. Jenson, *The Triune Identity: God According to the Gospel* (Philadelphia: Fortress, 1982), xii.
32. Jenson, *The Triune Identity*, x.

language cannot, however, be another [area], and the widely spread supposition that it is another is a breakdown of linguistic and doctrinal information and sophistication."[33] How does that work? Because the term "Father" in this schema is not about gender; it is about relationship.

In his book *Titles of the Triune God*, Herbert F. Stevenson calls "Abba, Father" the "most precious to us of all the titles of God." He decides "'Father' is essentially a New Testament name," reckoning, "There are anticipations of the title in the Old Testament, in a few scattered texts in which *Jehovah* declares Himself to be a Father to Israel, His chosen people (Exod. 4:22; Deut. 32:6; Jer. 31:9; Hosea 11:1). But as so used, the word was regarded as metaphorical: a figure of speech, expressing the tender love and patient grace of God toward the nation, unworthy and erring though it was." So here is an evangelical scholar who thinks even "the final unveiling of His person and grace as 'Father' had to await the Incarnation of the Lord Jesus Christ."[34]

Perhaps the most thoughtful analysis of these metaphors I've encountered is by Loraine Boettner, author of *The Reformed Doctrine of Predestination* and a number of related works. In one of his most interesting books, *The Person of Christ*, he weighs in on these familial titles for God:

> In theological language the terms "Father" and "Son" carry with them not our occidental ideas of, on the one hand, source of being and superiority, and on the other, subordination and dependence, but rather the Semitic and oriental ideas of *likeness* or *sameness of nature* and equality of being. It is, of course, the Semitic consciousness that underlies the phraseology of Scripture, and wherever the Scriptures call Christ the "Son of God" they assert His true and proper Deity. It signifies a unique relationship that cannot be predicated of nor shared with any creature. As any merely human son is like his father in his essential nature, that is, possessed of humanity, so Christ, the Son of God, was like His Father in His essential nature, that is, possessed of Deity. The Father and the Son, together with the Holy Spirit, are co-eternal and co-equal in power and glory, and partake of the same nature or substance. They have always existed as distinct Persons. The Father is, and always has been, as much dependent on the Son as the Son is on the Father; for self-existence and independence are properties not of the

33. Jenson, *The Triune Identity*, 12–13. For an interesting critique of this system, see Scott R. Swain, *The God of the Gospel: Robert Jenson's Trinitarian Theology* (Downers Grove, IL: InterVarsity, 2013).
34. Herbert F. Stevenson, *Titles of the Triune God: Studies in Divine Self-Revelation* (Westwood, NJ: Revell, 1956), 94–95.

Persons within the Godhead but of the Triune God. Consequently, the terms 'Father' and 'Son' are not at all adequate to express the full relationship which exists between the first and second Persons of the Godhead. But they are the best we have. Moreover, they are the terms used in Scripture, and besides expressing the ideas of sameness of nature they are found to be reciprocal, expressing the ideas of love, affection, trust, honor, unity, and harmony—ideas of endearment and preciousness.[35]

What do these familial metaphors mean? And again, how can a "Father" who is not a male nor masculine nor a biological parent be a "Father?" And how can a male human being who is an incarnation (one with human flesh and full humanity) be a Son to the spiritual God?

In *The Goddess Revival*, a critique of the goddess movement and biblical response to goddess spirituality, Aída Besançon Spencer carefully catalogues the various meanings of "father" in the Bible with a list of Scriptures. For our study, evaluating these categories will help us shed light on how a father who does not literally father a child can still "father" a child. The first meaning she lists is the "literal use: a man who can conceive children." Since this is a sexual statement, and God the Father did not impregnate Mary, this category is not directly applicable to God the Father. The second is figurative and applicable: "God is Father of Jesus not by physical intercourse nor creation." How that can be is spelled out in the following categories: "Synecdoche (one person who represents a larger entity), one person who begins something, as a nation, or who represents someone who begins something, e.g., Abraham, father of Israel, ancestor(s)." Another example one might consider is the patriot Juan Pablo Duarte, who is honored as the "father" of the Dominican Republic not because he gave birth to all the citizens that founded the country but because he led its fight for independence.[36] So this title is symbolic. Next are biological parents or adopting parents who rear a child as their own and are legally considered parents. Since the persons of the Trinity are one God, however, this category, like "Father and Son," is metaphorical when applied to God. "Source/Creator" would apparently apply best, for example, to John

35. Loraine Boettner, *The Person of Christ* (Eugene, OR: Wipf and Stock, 2009), 30–31.
36. On July 16, 1838, Juan Pablo Duarte became organizing director of "La Trinitaria," a "reformist movement" built on a trinity of values: "Dios, Patria y Libertad" ("God, Mother Country, and Freedom"). "Juan Pablo Duarte, 'The Father of the Country'/'*Padre de la patria*,'" Guide to the Colonial Zone and Dominican Republic, https://www.colonialzone-dr.com/people_history-Duarte.html, accessed January 29, 2021.

3:16, which tells us the Father's lovingkindness gave us the Son and thereby sanctioned the incarnation, when the uncreated person of the Godhead who became the Son entered creation as a human creature while still maintaining the uncreated divine nature.

"Metaphor: father, like today's everyday good father" is listed next, with God the Father being compared to earthly fathers who know how to give their children good gifts (Matt. 7:9–11). A list of applicable general categories follows: someone who is worthy of imitation, exhorts, champions a cause, and is worthy of respect. As the creator who "forms humans," God the Father "therefore deserves honor." God also teaches, forgives, is glorified when children obey and work for good, loves, disciplines, provides, and protects. God is the one through whom we inherit God's rule. God chooses heirs, sends the Holy Spirit to instruct them, and adopts them into God's family and domain. So, the categories under which we could group all these insights from the Scriptures are that God is Father because God is in charge of creation and offers people the privilege of being heirs, adopted through the sacrifice of God's premier and true heir: Jesus Christ, God's only son.[37]

GOD AS A COMMUNITY

God as a community, or a communion of equals, is a beautiful concept in that it stresses the unity and the cooperative nature of the Godhead. The image may be seen as anthropomorphic, as it reminds both human families and all Christians of sacred human communities. People join together to commune in peace and good fellowship, for example, the sharing that happens at the Lord's Supper (or Eucharist) at church. In our best moments, we sense our love relationship with God reflected in our community together.

God as a community, or a being who is in communion, may seem at first glance to be a postmodern way to describe God's nature to a lonely world desperately seeking networking and connections. Metropolitan of Pergamon John Zizioulas traces the best articulation of this concept back to the Cappadocian Fathers, who were champions of Nicene orthodoxy at the Council of Constantinople in AD 381. Citing *The Theological Orations* of Gregory Nazianzus, Zizioulas explains:

> As Gregory Nazianzen put it, the Trinity is a *movement* from the one to the three ("The monad moved to triad," he writes), which suggests that the One, that is, the

37. Spencer et al., *The Goddess Revival*, 211–15.

Father, *caused* the other two persons to be distinct hypostases. This causation, the Cappadocians insist, takes place (a) before and outside time, hence there is no subordination of the Arian type involved; and (b) on the hypostatic or personal level, and not on that of *ousia* [substance], which implies *freedom* and *love*: there is no coercion or necessity involved in this kind of causation, as would have been the case had the generation of the Son and the procession of the Spirit taken place at the level of substance.[38]

What appears to have inspired the Cappadocian theologians was the earlier work of the seminal theologian Justin Martyr, for example, in his *First Apology* (written c. AD 148,[39] nearly two hundred years before Gregory of Nazianzus was born, c. 326–330).[40] Justin writes, "Jesus Christ alone is properly the Son of God, since He is His Word, First-begotten, and Power, and that, having become man by His will." And again, "He is the Son of the living God Himself and [we] believe Him to be in the second place, and the Prophetic Spirit in the third."[41] Here we see the ideas of an eternal birth as well as a hierarchically graded Trinity being themselves born and brought forth before Christ's incarnation.

We can see these ideas being refined in Tatian, a disciple of Justin Martyr before he sadly began to deviate into extreme asceticism and heterodoxy after his mentor's death.[42] In his "Address of Tatian to the Greeks," Tatian writes, "God was in the beginning," but "for the Lord of the universe, who is Himself the necessary ground (*hupostasis*) of all being, inasmuch as no creature was yet in existence, was alone." Meanwhile, "the Logos Himself also, who was in Him, subsists. And by His [the Father's] simple will the Logos springs forth; and the Logos, not coming forth in vain, becomes the first-begotten work of the Father." For Tatian, this marks "the beginning of the world," as the Logos

38. John D. Zizioulas, *Communion and Otherness: Further Studies in Personhood and the Church*, ed. Paul McPartlan (New York: T&T Clark, 2006), 119.
39. See Thomas B. Falls, introduction to Justin Martyr, *The First Apology*, 26.
40. See Brian E. Daley, SJ, *Gregory of Nazianzus* (New York: Routledge, 2006), 3n5, 190.
41. Justin Martyr, *The First Apology* 13, 23.
42. Irenaeus reports: "After Justin's martyrdom, [Tatian] apostasized from the Church and as a teacher he was conceited and elated and puffed up as if he were superior to the rest." "Like Marcion," he preached abstinence from marriage, declaring "marriage was corruption and fornication," denied "salvation to Adam," and "related a myth about invisible Aeons similar to those of Valentinus." *Against the Heresies* 1.28.1.

came into being by participation, not by abscission [that is to say, not by slicing off a piece of the Father]; for what is cut off is separated from the original substance, but that which comes by participation, making its choice of function, does not render him deficient from whom it is taken. For just as from one torch many fires are lighted, but the light of the first torch is not lessened by the kindling of many torches, so the Logos, coming forth from the Logos-power of the Father, has not divested of the Logos-power Him who begat Him. . . . And as the Logos, begotten in the beginning, begat in turn our world, having first created for Himself the necessary matter.[43]

We can also see these ideas developing in the second century in Antioch's bishop Theophilus' defense to Autolycus, an idolater who was scornful of Christians. For example, Theophilus interprets Genesis 1: "For when God [the Father] said, 'Let Us make man in Our image, after Our likeness' . . . God is found, as if needing help, to say, 'Let Us make man in Our image, after our likeness.' But to no one else than to His own Word and wisdom did He say, 'Let Us make.'" Theophilus explains this Word preexisted creation:

the Word, that always exists, residing within the heart of God. For before anything came into being He had Him as a counsellor, being His own mind and thought. But when God wished to make all that He determined on, He begot this Word, uttered, the first-born of all creation, not Himself being emptied of the Word (Reason), but having begotten Reason, and always conversing with His Reason. . . . The Word, then, being God, and being naturally produced from God, whenever the Father of the universe wills, He sends Him to any place.[44]

This tradition also provides the background for Karl Rahner's claim, "The Bible and the Greeks would have us start from the one unoriginated God, who is already *Father* even when nothing is known as yet about generation and spiration."[45] Rahner sees "God as unoriginite person . . . as the origin of intra-divine, personalizing vital processes."[46] In other words, the Father is the "unoriginated" person personalizing the other two persons to form the Trinity. From these relationships flow the salvific relationship with humanity, so that the Trinity that appears to humanity is the Trinity that comprises God's

43. Tatian, *Address of Tatian to the Greeks* 5.
44. Theophilus, *Theophilus to Autolycus* 2.18; 2.22.
45. Karl Rahner, *The Trinity*, trans. Joseph Donceel (New York: Herder and Herder, 1970), 17.
46. Rahner, *The Trinity*, 20n15.

nature, as discussed in Rahner's famous maxim: "The 'economic' Trinity is the 'immanent' Trinity and the 'immanent' Trinity is the 'economic' Trinity."[47]

Therefore, Rahner offers an answer to the earlier question with which Cooper struggled: whether the Holy Spirit was simply presented as a power or a person of the Godhead in the Old Testament. He sees the Trinity everywhere in the old covenant in the "Word" of God that comes to each true prophet, the angel of God who appears to make announcements, and the Spirit of God who brings understanding: "an authentic secret prehistory of the revelation of the Trinity in the Old Testament."[48] In this way, a theologian would avoid the pitfall of tritheism since only one and not three consciousnesses or spiritual vitalities exist.

In Rahner's view, the presence of the Trinity in the Old Testament is non-negotiable, since "the Father is the incomprehensible origin and the original unity, the 'Word' his utterance into history, and the 'Spirit' the opening up of history into the immediacy of its fatherly origin and end." With such reasoning, "this Trinity of salvation history, as it reveals itself to us by deeds, is the 'immanent' Trinity . . . the self-communication of God to us in Christ and in his Spirit."[49]

In 1935 John B. Champion provided a rather unusual defense to similar arguments to those we have been citing:

> Some have objected to "the Social Trinity" as pure Tritheism. If the social state meant exactly the same in God as in man, they would not be far astray. While in a sense man is constituted for social life, yet it is voluntary; and man can and does act contrary to it. In God there is no choice in the matter. God does not choose to be God: He is God. He does not choose social unity: He is that unity to infinite degree. In God the social is as much constitutional and beyond choice as is the rest of His nature and existence. The *socius*-state in the companionship of the Triunity is as eternal as God Himself and as inviolable as His very holiness.

In his view, "because He is three inseparable interexistent interpersonalities in this absolute unity. . . we can speak of Him as One Being." But these "Three Members of the Trinity," as he calls the persons of the Godhead, are all in a graded hierarchy "by nature":

47. Rahner, *The Trinity*, 22.
48. Rahner, *The Trinity*, 40–43.
49. Rahner, *The Trinity*, 46–47. These points are repeated throughout the development of his argument.

While it is the right of the Son and the Holy Spirit to rule in their own offices, yet the ultimate in Divine authority is in the Father. He is the One by nature and office fitted to exercise ultimate Divine authority. The Son rules in manifesting the Father's sway. Up to the unlimited beyond, and in it, the reach of the Father's Sovereignty far transcends this world. The sway of the Son is mediate and expresses the Divine authority in relation to all created things. The Son is Lord over all, while the Father is Lord through all and beyond all. The authority of the Son is subordinate and official; while the Father's is sovereignty in priority.[50]

One notable scholar who would disagree with this reading of degrees of subordination within the title "Lord" was B. B. Warfield. When commenting on "the immense number of instances in which Christ is designated 'Lord'" in the writings of Paul, he observed, "*Kurios* [Lord] is not with Paul of lower connotation than *theos*." In fact,

Paul might very well call Christ "Lord over all" but not "God over all." "Lord over all" would have meant, however, precisely what "God over all" means, and it is singularly infelicitous to give the impression that Paul in currently speaking of Christ as "Lord" placed him on a lower plane than God. Paul's intention was precisely the opposite, viz., to put him on the same plane with God; and accordingly it is as "Lord" that all divine attributes and activities are ascribed to Christ and all religious emotions and worship are directed to him. In effect, the Old Testament divine names, Elohim on the one hand, and Jehovah and Adhonai on the other, are in the New Testament distributed between God the Father and God the Son with as little implication of difference in rank here as there."[51]

Warfield sees "Lord" as Christ's "proper name," "inter-trinitarian name," and "'personal' name." For Paul, "the only distinction which can be discerned between 'God' and 'Lord' in his usage of the terms is a distinction not in relative dignity, but in emphasis on active sovereignty. 'God' is, so to speak, a term of pure exaltation; 'Lord' carries with it more expressly the idea of sovereign rulership in actual exercise. . . . In a word, the term 'Lord' seems to have been specifically appropriated to Christ not because it is a term of function

50. John B. Champion, *Personality and the Trinity* (New York: Revell, 1935), 74–75, 140, 161.
51. Benjamin Breckinridge Warfield, *The Person and Work of Christ*, ed. Samuel G. Craig (Philadelphia: Presbyterian and Reformed, 1950), 224–25.

rather than of dignity, but because along with the dignity it emphasizes also function."[52]

Further, for an omnipotent one God to have one person "fitted" "by nature and office" to be "sovereign," and the other persons of the same being to be limited and "subordinate," once again raises up the problems of subordinationism, undermining as it does the absolute nature of God. As Royce Gordon Gruenler clarifies, "the incarnate Son who has voluntarily assumed a subordinate role in time and space" did so "for the work of salvation":

> The subordination of Son and Spirit to the Father is for the time of redemption only; hence Jesus' subordinationist language describes what have traditionally been called the "modes of operation" that pertain to the accomplishment of the redemptive task. Jesus' claims to coequality with the Father constitute on the other hand what theologians have technically termed "modes of subsistence" and describe the necessary relation of the persons of the Trinity.[53]

A key difference I see here is a freedom in the mutual "coequality" in the Godhead in Gruenler's reading against a tone of fatalism in Champion's view of the Trinity. The Father has been "fitted," Champion tells us. By whom? William of Ockham (c. AD 1284–1350) is renowned for his insistence on divine "voluntarism" (signifying the will as the fundamental agent or principle),[54] meaning that only God has true freedom of choice. Gruenler's description better captures that freedom of sacrificial love in the actions of the persons of the Trinity.

If I were to define "social Trinity" along these lines, I would do it in a way that was reflective of the initiative I see in the activities of the persons of the Trinity. In other words, I would see more loving responses than actions under compulsion in the work of the Trinity. As it is, even the Father, as was posited in the first quotation, has no freedom of choice, not even in choosing to be in "social unity." Instead, by necessity, in Champion's view, "The Father is the ultimate and transcendent source of all the outgoing activity of God. This is in keeping with His being the ultimate in Purpose and Authority."[55]

52. Warfield, *Person and Work*, 225–26.
53. Royce Gordon Gruenler, *The Trinity in the Gospel of John: A Thematic Commentary on the Fourth Gospel* (Eugene, OR: Wipf and Stock, 2004), xiv.
54. *Random House Webster's Unabridged Dictionary*, 2131.
55. Champion, *Personality and Trinity*, 148–49.

Now, factoring all these examples of related views along with the claims John Zizioulas is drawing and developing from Gregory of Nazianzus' view, we have to ask: What do all these speculations mean? One possibility is that, in eternity, instead of God always existing as a triune being, God the Father is a monad,[56] a solitary being who willingly generates a Son and also out of whom a Holy Spirit is spirated to become a divine Trinity.

What this would mean for philosophically oriented Christian theologians is that the Son and the Spirit in eternity are initially more like active divine attributes or potentialities within the Father until the Father emits them as distinct persons of the divine substance.

Zizioulas explains how Gregory of Nazianzus answered Arius' objection by pointing out that "this causation, the Cappadocians insist, takes place (a) before and outside time, hence there is no subordination of the Arian type involved."[57] The reasoning is thus: since the Father's "causation" of the Son and the Spirit to become distinct is in eternity and not in time, there was no "time" they did not exist. Son and Spirit, even while indistinct within the one Father God, all shared the same eternal "substance" of the Father God by being within the Father God before becoming distinct entities. Therefore, that basis in common makes the Son and Spirit also eternal, though previously undifferentiated. Son and Spirit are already eternal in substance when the Father causes them to become differentiated. They were apparently just not consciously so.

Such reasoning may technically wipe out Arius' more mundane arguments in regard to the Son and Spirit's substance being the Father's and not a substance created for them. However, could anyone have communed with the Holy Spirit or experienced the Son before God, becoming "the Father" in actuality, emitted them as distinct persons of a newly formed triune Godhead? Thus, Arius may have been wrong in locating the appearance of the Son (and Holy Spirit) in time, but in eternity he could still point at an eternal "when," when the Son (and Spirit) did not exist as persons with whom communication could be carried out. Rather they were simply qualities within the Father, God's "Word" and Wisdom.

56. In Greek, *monas* means "solitary," "alone, by oneself," "a solitary life," "solitude." In more recent times, the word has been made a cognate (adapted and transferred to English) to mean a single unit or entity. In John Zizioulas' view, as he understands the Cappadocian position, God the Father is eternally differentiated and chooses to differentiate the Son and the Spirit, who already share the Father's eternal substance, but not differentiation as persons until the Father causes that to happen, so that the divine Monad becomes a Triad: a triune Godhead.

57. Zizioulos, *Communion and Otherness*, 119.

And as for Zizioulas' concern about not promoting the idea of subordination in the Trinity by the Father not needing to ask consent of the substance that would be caused to be differentiated into God's Son and Holy Spirit, in *Being as Communion* he does indeed admit that "in making the Father the 'ground' of God's being—or the ultimate reason for existence—theology accepted a kind of subordination of the Son to the Father without being obliged to downgrade the *Logos* into something created."[58] But, if we apply Millard Erickson's rule to Zizioulas' supposition, we may be positing that the Father has an eternal conscious existence which the Son does not have in eternity. And the Son would have an eternal degree of subordination the Father does not have. Such permanent differences in nature cannot exist in an absolute being.[59]

The significance of this fallacy in subordinationist thinking can again be traced right back to the beginning of the sophisticated theological discussions of God's triunity when the early church was sorting out the biblical revelation of who God is and what exactly God's nature is, specifically according to the Bible's progressive revelation foreshadowed in the hints in the Old Testament prophecies right through to their clarifications by the New Testament writers. The controversy came to a head when Emperor Constantine first sent a plea to Alexander, bishop of Alexandria, and Arius, one of the ministers in his see, to reconcile their argument about whether Christ's origin was eternal or temporal.[60] Instead, the disagreement exploded across the church.

Alexander fired off an encyclical letter naming all the apostate leaders following Arius' false teaching, namely:

58. John D. Zizioulas, *Being as Communion: Studies in Personhood and the Church* (London: Darton, Longman, and Todd, 2004), 89. Interesting to note is that J. Scott Horrell asks, "Does the very deity of the Son and the Spirit derive from the Father? That is, does the Father have ontological priority in the Godhead so that he eternally gives equal deity to the Son and the Spirit?" ("The Eternal Son of God in the Social Trinity," in *Jesus in Trinitarian Perspective: An Intermediate Christology*, eds. Fred Sanders and Klaus Issler [Nashville: B&H, 2007]). And he answers, "The majority of Western trinitarians insist that the answer must be no. If the Son's or the Spirit's divinity is ontologically derived from another, then it cannot be equal to the deity of the unoriginated Originator, the Father." And he even reports, "Gregory of Nazianzus struggled with the implications of his own position, particularly before the Arianism he was fighting: 'I should like to call the Father the greater, because from Him flow both the equality and the being of the equals . . . but I am afraid to use the word Origin, lest I should make him the Origin of inferiors, and thus insult Him by precedencies of honour. For the lowering of those who are from Him is no glory to the Source.'" *Oration 40* (On Holy Baptism), 60.

59. Millard Erickson, *Who's Tampering with the Trinity? An Assessment of the Subordination Debate* (Grand Rapids: Kregel, 2009), 172.

60. See Socrates Scholasticus, "Victor Constantine Maximus Augustus, To Alexander and Arius," *The Ecclesiastical History* 1.7.

That God was not always the Father, but that there was a period when he was not the father; that the Word of God was not from eternity, but was made out of nothing; for that the ever-existing God (*the I Am*—the eternal One) made him, who did not previously exist, out of nothing; wherefore there was a time when he did not exist, inasmuch as, the Son is a creature and a work. That he is neither like the Father *as it regards his essence*, nor is by *nature* either the Father's true Word, or true Wisdom, but indeed one of his works and creatures, being erroneously called Word and Wisdom, since he was himself made by God's own Word and the Wisdom which is in God, whereby God both made all things and him also.[61]

Pertinent to our discussion is the familial language that Alexander employs in describing Arius' heresy: "that God was not always a father." Embedded in his complaint, then, is the theory that God was a father "always," implying eternity. Was he right? Was this truly Arius' position? In AD 320, the year after Alexander sent out his letter, Arius wrote to a supporter, Bishop Eusebius of Nicomedia, complaining,

I want to tell you that the bishop [Alexander] makes great havoc of us and persecutes us severely, and is in full sail against us: he has driven us out of the city as atheists, because we do not concur in what he publicly preaches, namely that "God has always been, and the Son has always been: Father and Son exist together: the Son has his existence unbegotten along with God, ever being begotten, without having been begotten. God does not precede the Son by thought or by any interval however small: God has always been, the Son has always been; the Son is from God himself.[62]

That same year, he also dispatched a letter in his own defense to Alexander, claiming his view is "from our forefathers, which we have learned also from thee":

We acknowledge One God, alone unbegotten, alone everlasting, alone unbegun, alone true, *alone having immortality* . . . who begat an Only-begotten Son before eternal times, through whom he has made both the ages and the universe; and begat him not in semblance, but in truth: and that he made him subsist at his

61. Socrates, *Ecclesiastical History* 1.6.
62. Arius, "Letter of Arius to Eusebius, Bishop of Nicomedia, c. 320," 283.1, cited by J. Stevenson and W. H. C. Frend, *A New Eusebius* (Grand Rapids: Baker, 2013), 367.

own will, unalterable and unchangeable; perfect creature of God, but not as one of the creatures; offspring, but not as one of things that have come into existence . . . at the will of God, created before times and before ages, and gaining life and being and his glories from the Father. . . . And God, being the cause of all things, is unbegun and altogether sole but the Son being begotten apart from time by the Father, and being created and found before ages, was not before his generation: but, being begotten apart from time before all things, alone was made to subsist by the Father. For he is not eternal or co-eternal or co-unoriginate with the Father, nor has he his being together with the Father, as some speak of relations, introducing two ingenerate beginnings, but God is before all things as being Monad and Beginning of all.[63]

As the controversy raged, Constantine ordered church leaders to hammer a solution to this dispute out at a meeting at Nicea, where he himself presided, and at this council and in its aftermath all these claims of Arius were rejected.

One supporter of Arius, the renowned historian Eusebius, bishop of Caesarea, showed up armed with the creed of his own church, campaigning to have it serve as the model for the Nicean Council's creed. The council adopted its first few sentences, "We believe in one God, the Father All-sovereign, maker of all things visible and invisible; And in one Lord Jesus Christ," but then forged its own statement, ignoring Eusebius' attempt to have "begotten of the Father before all the ages" added in. Instead, it declared, "Son of God, begotten of the Father, only-begotten, that is, of the substance of the Father," and "God of God, Light of Lights," while adding "true God of

63. Arius, "Letter of Arius to Alexander, Bishop of Alexandria, c. 320," 284, cited by Stevenson and Frend, *New Eusebius*, 369. For a charitable view of Arius and his supporters and a more severe view of Athanasius, see R. P. C. Hanson's massive work, *The Search for the Christian Doctrine of God: The Arian Controversy, 318–381* (Grand Rapids: Baker, 2005), chs. 1–5, 9. That Athanasius zealously resisted the Arians in his writing is a given, but, in Athanasius' defense, the extreme condemnations by Athanasius' opponents echoed by Prof. Hanson should be compared to Athanasius' actual writings, for example, with Athanasius' own graciousness: e.g., those "who accept every thing else that was defined at Nicea, and quarrel only about the One in substance, must not be received as enemies; nor do we here attack them as Ario-maniacs, nor as opponents of the Fathers, but we discuss the matter with them as brothers with brothers, who mean what we mean, and dispute only about the word [*ousia*, substance]." His example is Basil of Ancyra (see *De Synodis* 3.41.11). On Athanasius' behavior under fire, we should factor in the high opinions of his character and actions by much nearer contemporaries, the early church historians Socrates Scholasticus (c. AD 380–450) and Theodoret (c. AD 393–466), realizing the bulk of these character assassination–type charges reported by his opponents were "manifestly false" and did not hold up in court, as Hanson himself admits (e.g., *Search*, 257).

true God, begotten not made, of one substance with the Father."[64] Clearly, the doctrine of the eternal generation of the Son was omitted by Nicea's Council. As we can see, the doctrine had been compromised, infused by Arians with a subordinationist meaning. While the creed's defenders may themselves still have seen it as useful to demonstrate shared substance between divine Father and Son, it would not resurface in an orthodox creed of any import until 381, some fifty-six years later, at the Council of Ephesus. From there it finally worked its way into the Definition of Chalcedon in AD 451.

As the responses of semi-Arian creeds begin to pile up in the aftermath of Nicea's declaration, Athanasius would also attack the claim that the Son is solely generate and the Father only ingenerate by reminding all of the wisdom of Ignatius, bishop of Antioch: "One physician exists, fleshly [*sarkikas*] and also spiritual, generate [i.e., born, *gennētos*] and ingenerate [not born, *agennētos*] God becoming in flesh, in death true life, and from ['out of'] Mary, and from ['out of'] God, first suffering and after then not suffering, Jesus Christ, our Lord."[65]

Millard Erickson reminds us, "The doctrine of eternal generation does not play a large part in the discussions of subordination today. Philosophically, it has been deemed by many to draw a distinction that does not make sense: to insist on some sort of eternal derivation of being from the Father, or the Father being eternally the source of the subsistence of the other two persons, yet in such a way that they are not at all created by him. It is interesting that Calvin did not believe this to be a doctrine worth defending."[66]

Conversely, Kevin Giles, in *The Eternal Generation of the Son*, separates today's historically orthodox view of this doctrine from some of its early formulations. He observes, "For Justin and the other Apologists, God the Father is a monad who becomes triune for the purpose of creation and redemption."[67] Giles notes Justin Martyr's appeal to Proverbs 8:22–26, "The

64. See the creeds of Caesarea and Nicaea in Bettenson and Maunder, *Documents of the Christian Church*, 26–27.
65. See Ignatius' letter "To the Ephesians," 7.2. This is also cited by Athanasius in the *De Synodis*, "the blessed Ignatius was orthodox in writing that Christ was generate on account of the flesh (for He was made flesh) yet ingenerate, because He is not in the number of things made and generated but Son from Father" (3.47.18).
66. Erickson, *Who's Tampering with the Trinity?*, 184n42. Calvin writes, "It is foolish to imagine a continuous act of begetting, since it is clear that the three persons have subsisted in God from eternity," *Institutes* 1.13.29.
67. Kevin Giles, *The Eternal Generation of the Son: Maintaining Orthodoxy in Trinitarian Theology* (Downers Grove, IL: InterVarsity, 2012), 93. Another helpful book by Dr. Giles that feeds into this debate is *The Trinity and Subordinationism: The Doctrine of God and*

generation of the *Logos*, Justin believes, is to be likened to the manner in which the rational mind (*logos*) expresses itself in a relational word (*logos*). So the begetting of the Word (*Logos*) occurs when God 'speaks' and 'sends him forth.'" He cautions us that "the *Logos* for him is eternally with the Father but not *eternally begotten or generated*. He thus speaks of the *Logos* 'in the beginning' with God yet also coming forth as the first of God's creative acts." [68] This is where he notes Justin's difference from the Nicean perspective: "Fourth-century Nicene theologians, in distinction to Justin, would begin with the premise that God is triune for all eternity," but Giles also notes that the Nicene party "would all follow him in speaking of the self-differentiation of the Father and the Son in terms of begetting, but for them this was unambiguously an eternal begetting."[69]

The distinction is an important one. If Justin is claiming in the quotation we cited from the *Dialogue with Trypho* what he appears to be claiming, that the Son first appears as God's first act of creation and the subsequent creator through whom God works, then Arius can lay a certain claim to be aligned with his view. Giles distinguishes his own and the later Nicene Creed's (aka the Niceno-Constantinopolitan Creed, formulated c. AD 374–381) view as recognizing an "eternal begetting." A distinguishing took place eternally and does not have a beginning at creation, and it was not an act of creation of the Son, as Arius posited.[70] This is the distinction from Arius that Metropolitan Zizioulas rightly maintains.

J. N. D. Kelly seems to take a different reading of what is going on in the theology of the early church, however, when he explains, "For all of them the description 'God the Father' connoted, not the first Person of the Holy Trinity, but the one Godhead considered as author of whatever exists."[71] He also rejects "two stock criticisms" of current scholars levied at the early theologians: a failure to "distinguish the Logos from the Father until He was required for the work of creation" and that the early apologists "were guilty of subordinating the Son to the Father." Kelly's take on what is actually happening in early thought is that "long before creation, from all eternity, God had His Word or Logos, for God is essentially rational; and if what later theology

 the Contemporary Gender Debate (Downers Grove, IL: InterVarsity, 2002).

68. Giles, *Eternal Generation*, 93–94.
69. Giles, *Eternal Generation*, 95.
70. Giles, *Eternal Generation*, 95. See the Niceno-Constantinopolitan/Nicene Creed in Bettenson and Maunder, *Documents of the Christian Church*, 27–28.
71. Kelly, *Early Christian Doctrines*, 100.

recognized as the personality of the Word seems ill defined in their eyes, it is plain that they regarded Him as one with Whom the Father could commune and take counsel." In his view, "Later orthodoxy was to describe His eternal relation to the Father as generation; the fact that the Apologists restricted this term to His emission should not lead one to conclude that they had no awareness of His existence prior to that."[72]

Regarding subordination, Kelly does observe, "Justin spoke of [the Logos] as a 'second God' worshipped 'in a secondary rank,'" but he does not think Justin's intention was "so much to subordinate Him as to safeguard the monotheism which they considered indispensable." This does not mean solely the monotheism of the Father, but "the Logos as manifested must necessarily be limited as compared with the Godhead Itself." Now, this is a refined reading that puts more emphasis on the Trinity as a whole than simply all on the Father as the "one God of the Bible by being the ground of unity of the three persons," as Zizioulas stated. But each reader coming to this early church material must grapple with these claims, taking to heart Kelly's caution that "it is true that they lacked a technical vocabulary adequate for describing eternal distinctions within the Deity; but that they apprehended such distinctions admits of no doubt."[73]

If we depict the theology of God as a communion or community, incorporating the idea that God the Father was originally a Monad and the Trinity is a "later" development, then we have to ask and answer several serious questions and raise several serious issues.

What is the basis of this doctrine? The Bible nowhere clearly states what is now called the Son's eternal generation. The usual place to turn is Proverbs 8:22, with the Hebrew Bible's use of the word *qānāh* and the Septuagint's *ktizō* to describe the advent of the quality Wisdom. The BDB lexicon provides a range of meanings for *qānāh*, including "get, acquire," "gain," and "possess," among others, but it lists "of God as originating, creating" as its choice for the correct rendering of Proverbs 8:22: "The Lord created me."[74] This translation as the preferred meaning is also reflected in The Jewish Publication Society of America's rendering of Proverbs 8:22: "The Lord made me as the beginning of His way."[75]

72. Kelly, *Early Christian Doctrines*, 100–101.
73. Kelly, *Early Christian Doctrines*, 101.
74. See BDB, 888–89.
75. *The Holy Scriptures According to the Masoretic Text* (Philadelphia: The Jewish Publication Society of America, 1955), 994.

Kevin Giles, however, citing Bruce Waltke, disagrees with the Jewish translators: "In the Hebrew, the word in contention is *qānānî*, which is best translated as 'brought me forth.' It does not mean 'create.'"[76] Such a translation would, of course, automatically raise several related questions. What, then, does being "brought forth" mean? Where was the Son before "God brought me forth"? If the persons of the Godhead are already omnipresent (including the preincarnate person identified in John 1:1 as "the Word"), what would it mean for an omnipresent person of the Godhead to be "brought forth"? The language might be figurative, of course, as Giles notes, "Bruce Waltke says on this word, 'The metaphor "brought me forth" signifies that Solomon's inspired wisdom comes from God's essential being; it is a revelation that has an organic connection with God's very nature and being, unlike the rest of creation that comes into existence outside of him and independent from his being.'"[77]

Perhaps "brought me forth" might mean the person of the Trinity known as the Christ, the Word or the Son, became more prominent in the creation, being the Word spoken at creation that created all. But the Son is not clearly revealed until the incarnation, when, as Jesus Christ, this person of the Trinity is literally brought forth into our world as a baby. To determine which meaning of *qānāh*, "brought me forth" or "created," is more likely, a word study of the rest of this word's uses in the Hebrew Bible would be the best way forward. I notice that consistently, where the term is translated "brought forth" in the Old Testament, it is used interchangeably with "created," meaning creation of a human being or the earth.[78] In the Septuagint, *ktizō* is used: "The Lord made me the beginning of his ways for his works." According to BDAG, the term means "to bring someth[ing] into existence, create."[79] LSJ emphasizes it as a

76. Giles, *Eternal Generation*, 67–68.
77. Giles, *Eternal Generation*, 68.
78. The six instances are: a birth in Genesis 4:1, when Eve uses the term at the birth of Cain, "I have *brought forth* a man." This is the creation of a child. After that, the term is used to identify God as "*Creator* of heaven and earth" in Genesis 14:19, 22; and Deuteronomy 32:6. In Psalm 139:13, David employs it to describe God creating him, "You *created* my inmost being, you knit me together in my mother's womb," and the final entry is our passage under scrutiny, Proverbs 8:22. These NIV translations, under the entry "*qānâ*" (7865), are listed in John R. Kohlenberger III and James A. Swanson, *The Hebrew-English Concordance to the Old Testament with the New International Version* (Grand Rapids: Zondervan, 1998), 1411. All the other instances of the term (the primary usage) are for buying land, e.g., "the field Abraham had *bought* from the Hittites" (Gen. 25:10). Seventy-eight of these are listed. The bold print is in the book. Also worth noting is the second part of the verse, where wisdom is called "Front (*qêdêm*, BDB, 869) of his things made (*mip'āl*, BDB, 821, specifying, "Pr 8²²") [in] past time" (*āz*, BDB, 23).
79. BDAG, 572.

term of bringing about beginnings, as in "build houses and cities," "of a city, found, build," "plant a grove," "set up an altar," "produce, create, bring into being," "bring about," or "make."[80]

Further, Proverbs 8:22 is not a verse in isolation. It is in a context. Wisdom is feminine. It appears personified in Proverbs as a wise woman calling out in the streets and public squares (1:20–21), raising the consciousness of all who will take heed to avoid sin and follow the righteous laws of the Lord. Chapter 8 emphasizes this imagery, with verses 1–3 reiterating her calling of everyone to be guided by her to live righteous lives, ensuring that leaders will be just (8:15), and assuring her hearers the righteous ruler will be rewarded (vv. 20–21). In this context, she explains her advent as a creation of God. Thus, while the eternal generation of the Son is a doctrine promoted with the best intentions, to show the eternal equality of substance between the Father and the Son, it cannot rest securely on a verse that clearly presents a "daughter," not a son, who is the personification of a quality that is created.

In addition, the Bible data does not consistently match the claims made from Justin Martyr through to some today that Christ Jesus is the emitted Word, and the Holy Spirit is the emitted Wisdom, as exclusive names. For example, Christ in John 1:1, 14 is certainly identified as "the Word" who is with God and in God, and who "became flesh." But in 1 Corinthians 1:24 Christ is also called "the Power of God and the Wisdom of God." Again in verse 30 this incarnated person of the Trinity is referred to as "wisdom to us from God." Christ is called by both names, Word and Wisdom.[81] Thus, since

80. LSJ, 1002–3.
81. Meanwhile, the Holy Spirit is certainly associated with wisdom in such passages as Exodus 31:3; Nehemiah 9:20; Isaiah 11:2; as well as in 1 Corinthians 2:10 and in Acts 6:3, when the deacons are chosen from those with "the Spirit and wisdom." But at the same time the Spirit is characterized by power, and the Spirit's power is what is contrasted by Paul with human wisdom in 1 Corinthians 2:1–4, emphasizing the Spirit's demonstration of power against mere human wisdom, a power in verse 5 identified as God's power. Certainly, the Spirit's advent in Acts 2:1–4 is characterized by a "violent, forcible" sound (*biaios*, BDAG, 176). So the power is highlighted while the response is a gift of multilingual capability. Power and learning are linked together. In Luke 1:35, however, the angel tells Mary, "The Holy Spirit will come upon you, and the Power of the Most High will cover you." So here only the power is in play. That is certainly what the sorcerer Simon is counterfeiting and desiring in Acts 8:10. He is parading himself as "the Power of God" and attempting to buy the real power of the Holy Spirit in verses 18 and 19. Further, in John 14:16, Jesus calls the Holy Spirit the *paraklētos*, i.e., "one who appears in another's behalf, *mediator, intercessor, helper*" (BDAG, 766), and, in v. 17, "the Spirit of Truth." The Scripture does not depict the Holy Spirit as primarily the quality of wisdom in the Father now operating externally. The Spirit, as is the Word, is omnisciently and omnipotently varied in divine qualities and capabilities, as befits one of the persons of the Trinity.

the first appearance of the eternal generation theory seems to be in Justin Martyr's thought, this doctrine appears more to be the child of apologetics than of biblical revelation.[82]

Looking closer at the biblical data, we see in Genesis 1 evidence of the entire Godhead involved in creation. The logical question to ask is, Why was God not always triune? Why not posit a triune God forever in eternity—what I might call an eternal trinity position, simply affirming God as monotheistic in three persons forever—instead of attempting to conjecture how a monad becomes triune? Why would it be necessary to prove something about God that has not been revealed (i.e., that God was not always triune)? Why does it make sense to ask such a question and spend centuries puzzling over it if the biblical writers were not asking it?

Do we really believe God is an absolute, infinite, eternal being, as The Scot's Confession (1560), among other creeds, assures us? "We confess and acknowledge one God alone, to whom alone we must cleave, whom alone we must serve, whom only we must worship, and in whom alone we put our trust. Who is eternal, infinite, immeasurable, incomprehensible, omnipotent, invisible, one in substance and yet distinct in three persons, the Father, the Son, and the Holy Ghost."[83] If this creed is correct, how would God change in composition (from one to three) in eternity? Would not that mean that God is not consistently infinite but changeable in nature? After all, the incarnation where a person of the triune Godhead takes on human flesh—becoming human while remaining divine—takes place in time, not in eternity.

Further, why is any of this speculation necessary, and how is it helpful? What does it accomplish? The answer is that it underscores the divinity of Jesus, its main goal in the early church. But, if God were simply accepted as triune from eternity, then that piece would already be in place. One may also preserve

Further on the question of this doctrine's consistency, Theophilus of Antioch, who, after Justin Martyr, helped formulate this theory, believed "the Word" "always exists, residing within the heart of God. For before anything came into being He had Him as a counsellor, being His own mind and thought" (Theophilus, *Theophilus to Autolycus* 2.22). So, if God the Father's assistants—the Word and, presumably, the Wisdom that were to be distinguished as the Son and the Holy Spirit—had always been communing, counseling, and advising the Father from within, why could they not be queried on whether or not they would prefer to be distinguished or remain ensconced within the Father?

82. Those interested in my more thorough critique of this doctrine may see William David Spencer, "The Need for Caution in the Use of Eternal Birth Language for Jesus Christ in the Early Church and Today," *Africanus Journal* 10, no. 1 (2018): 5–22.

83. The Scot's Confession, in *The Constitution of the Presbyterian Church (U.S.A.): Part I, Book of Confessions* (Louisville: The Office of the General Assembly, 1999), 3.01.

monotheism if one regards the Father as the one God, but even that histori-cally has not assured that what God emits is considered equal to God, as the Gnostics argued. But an eternal one God in three persons, wholly other than anything else we experience or can conceive, who is forever in three divine persons, coeternal and coequal, would be simply a given fact: the immutable God is always triune in an eternal love relationship of mutual deference of fully equal persons in rank and glory, progressively revealed through history, accord-ing to God's great redemptive plan for humanity and our world.

When we are positing God as basically the Father (and the Son and Spirit as attributes within the Father that have been differentiated into persons), what type of community are we envisioning? Are we positing a set of rela-tionships of fully equal persons of the one God, or a lopsided relationship in tandem, that is to say, one God in substance but three persons in descending order of rank and glory? In fact, the idea that the Son was birthed (or even created) in order to himself create would fit awkwardly into John 1:3, which never suggests such an understanding. This type of thinking appears rather to be filtered through Plato's thought, particularly in the *Timaeus*, where God is identified as "Maker and Father of this universe" (*poiētēs* and *patēr*).[84] With humans, Plato writes, "He delivered over to the young gods the task of mould-ing moral bodies, and of framing and controlling all the rest of the human soul." Freighted along with this comes a whole Platonic doctrine of subordi-nation: "He, then, having given all these commands, was abiding in His own proper and wonted state. And as He thus abode, His children [the younger gods] gave heed to their Father's command and obeyed it."[85]

As a ramification, this subordination of one-way command/obedience spills over to humanity, wherein "since human nature is two-fold, the supe-rior sex is that which hereafter should be designated 'man.'"[86] And what about the inferior sex? Men who live justly have a celestial destination, but men who live unjustly "shall be changed into woman's nature at the second birth; and, if, in that shape, he still refraineth not from wickedness he shall be changed every time, according to the nature of his wickedness, into some bestial form after the similitude of his own nature."[87] These two ideas of a God who dele-gates the task of completing the creation of humans, and a resultant human-ity in whom being a woman is a form of punishment for wicked living, are a

84. Plato, *Timaeus* 28C.
85. Plato, *Timaeus* 42D–E.
86. Plato, *Timaeus* 42A.
87. Plato, *Timaeus* 42B–C.

pollutant to Christianity. We see neither of these ideas in the Bible, where God is approachable by anyone's prayer, and woman is a gifted and an empowered equal co-ruler with man right in Genesis 1:26–28.[88]

In short, such speculation is apologetic rather than biblical. The doctrine of the eternal generation of the Son's sheer flexibility has been helpful over the years in demonstrating the divinity of Christ for the orthodox apologists, but at the same time it has been unhelpful, serving those like Arius in undermining the divinity of Christ. To describe this doctrine in an image, it seems to me to have revealed itself to be like the two-faced Roman idol Janus, each face looking in the opposite direction.

CONCLUSION

The benefit of seeing God as a family or as a community is the interconnectedness of love among the three persons of the Trinity, a wondrous love that extends to bless humans. In fact, the incarnational imagery of the heavenly Father having an only Son born to Mary, a woman of the earth, is a beautiful affirmation of the unity of divine and human love. By the Holy Spirit being the actual conveyor to earth of the person of the Trinity who is the Son, biblical revelation avoids presenting a cosmic mating where heaven literally becomes a "home" to a divine family.

So used wisely, this image of the communion or community of God eternally in loving union within the Trinity, and through sheer graciousness the triune God extending that love relationship to humanity, can be seen as a beautiful model for reciprocally loving earthly relationships. As John, the beloved disciple, counseled: "Beloved ones, love one another, because love is from God" (1 John 4:7).

88. See further William David Spencer, "Equal Leadership: God's Intention at Creation," *Christian Egalitarian Leadership: Empowering the Whole Church according to the Scriptures* (Eugene, OR: Wipf & Stock, 2020), ch. 4.

CHAPTER 10

CONCLUSION

John, the friend that Jesus loved like a brother, tells us God is loving (1 John 4:8). The nature of love is to be shared, so God created a world to love and enjoy and populated it with people God would love. These people and this world God created are material and temporary, ever changing, beginning and ending. But God is an eternal spirit, never changing, having no beginning or ending. Therefore, there is no point of reference in our world by which we can understand God. Instead, we need revelation from God to tell us who God is.

God provided that revelation directly to our first parents. Then, when they became disobedient, offending and shutting God out, God still continued to communicate the divine wishes for what humans should believe and how they should act through human emissaries, the prophets. Finally, in God's chosen time, Jesus Christ, as divine representative of the triune Godhead, took on flesh, was born on earth, and became God-Among-Us. He explained through parables and healing actions the great, triune loving Spirit who is God to humanity once again and for all time. Christ's explanation culminated in redeeming God's chosen humans through word and deed, providing the necessary sacrifice to reunite us with the God who loves us. How did God-Among-Us convey that truth? Through many illustrations we would be able to understand, for example, adoption analogies from Roman law in Paul's letter to the Christ followers at Rome (8:22–25): individuals and entire families transfer from their birth homes and identities to

a new, rich, heavenly family to become heirs in God's reign. The Bible uses picture images like this one, forms with which humans can relate. Some of these illustrations are obvious, others subtle, but all are analogous to some truth about God's nature.

Such imagery also tells us about our responsibility as God's adopted heirs: to find appropriate ways to share this wonderful news with others. In this task, we face a dilemma. Our contingent world in its constant flux has shifted many times since the first revelation was given. In each successive era, God's friends are challenged with how best to convey the revelation of exactly who this God is who loves humanity to the people who presently populate this world.

Today, we live in a time that honors scientific and technological communication. All around the earth, many of us are connected in a postmodern, multinational supra-culture with shifting language and definitions. But lately an increasing number of Christians have shied away from using metaphorical language to describe God, retreating to the declarative words we find in the doctrinal passages in the Bible. Their concern is like that of any good scientist: desiring accuracy and verifiable, empirical truth. What can we know for certain? We are observing a widening communication gap between thinking Christians and those around us who do not share our faith in the one, great, living God. Our neighbors are speaking in the languages of virus payloads and anti-virus software, networking, databases, apps, downloads, memes, and emojis. We are anchoring in the language of sin, repentance, justification, and reconciliation, and even expiation, propitiation, supralapsarianism, and infralapsarianism. In other words, we are speaking alien languages. They are engaged in techspeak, and we are reasoning in Bible-ese.

Images and illustrations as analogies are a major way believers have spanned the communication gap throughout time. The intention is by no means to replace the language of technical theological terminology but to ease the demand that children, seekers, and secular hearers learn a new language in order to meet our loving Creator for themselves. Many of us, however, already know their language—we have to know it to be able to keep our jobs today—but loud voices from our Christian community challenge the appropriateness of us using their propensity for metaphorical language when describing the God who loves us, is still involved in human lives, and is guiding human destiny. This increasingly sizable group of God's friends is saying, "No!" It contends that we must stay with declarative, nonmetaphorical language or fall inevitably into the abyss of error, taking those with whom we speak hurtling down into the pit with us.

The present book, a primer in theologizing, has taken seriously the reasons for these objections and offers a way forward to reconcile them with those who extend metaphorical language and imagery to the discussion of God's nature. To accomplish this task, after identifying our intent, audience, and topic focus, we centered on language and its capabilities and limitations, and introduced the reason for not dispensing with all theological terms. We also detailed the context of our discussion. In addition, we introduced the intriguing presence of "types" (symbols of the messiah Jesus Christ in the Old Testament). We also addressed the preliminary foundational question: Is God really a Trinity?

Next, we looked at problems with describing the eternal Creator of such an infinitely vast, contingent universe armed only with a limited set of illustrative temporal words. We heard both a philosopher's and a theologian's qualified defense of doing so and a satirist's unqualified condemnation of those who try. By the end of chapter 2, it was time to do what any good follower of Jesus would do: look at the example of Jesus for guidance.

What we discovered was that Jesus used imagery. And we explored his means of delivery, his content, and the variety of illustrations he employed in his dramatic spoken-word presentations. We noted among other insights that contextualization is what Jesus did with his parables, and, if we follow his example, we will do the same with our analogies.

Jesus' example raised for us a question of whether such use of artistic means for communication was intended to be unique to him, or whether it was transferable to his followers. Continuing with his disciples and the New Testament writers, we discovered the practice branched out into the early church and continued down the centuries. Some of these presentations were accurate to the revelation once given to the saints, and some of them were perverted by theological error. Taking as our test case the endemic image of light that pervades the Bible's records, and basing on the model of its correct use and interpretation in Hebrews 1:3, we surveyed some examples. We saw first how early theologians erred in their speculations of what this passage meant, feeding into erroneous beliefs about the Godhead still being promulgated today. Second, we centered on corrections that returned us to the intentions of Hebrews 1:3 by the great defender of the Nicean creed, Athanasius, to clarify the correct beliefs of the early church. Once we laid down this interpretive groundwork, we invested the rest of our study in examining imagery used to depict the triune God sampled from the history of the Christian faith as well as examples in use today.

Our goal was to review what was beneficial and what could become detri-
mental to a correct interpretation of our faith in various sets of images and
illustrations. We warned at the outset that this book could not be exhaustive,
so we had to be selective, ignoring many other examples. The wise observa-
tion of John when speaking about the inability to record all Jesus did in John
21:25 might apply here also: more books than anyone could ever read might
be needed to contain every image ever used for the Trinity.

As an end result, we had to adapt and apply Ockham's Razor, even if
awkwardly, to our task: we had to curtail our goals and cut our discussion
down to representative illustrations. But, as a result, we did analyze a sizable
amount of images, beginning with those that move and change. These included
topographical images like the wind, including breath, wind, and spirit; water,
as in liquid, gas, solid; and others. We also considered the example of humans
with multiple roles, and we revisited the sun and its rays. As we considered
these, we were reminded that we need to avoid the error of modalism when
we emphasize the dynamic nature of God that the Bible reveals in its insights
on shared equality in the Trinity (e.g., Phil. 2:6).

Next, we looked at nonhuman images that are static and have parts. This
exploration took us back to topography, considering water, land, and sky
as three components of one landscape. We also saw types in yet one more
setting, then went from the complex to the simple with age-old favorites
such as the egg and the shamrock. We also traveled to Mount Rushmore and
examined the imagery of the boulder, the rock, and the dust. Parts imagery,
we noticed, underscores the diversity within the Godhead. And when the
unity in the one God counterbalances these distinctions, it offers a helpful
orthodox image to employ.

A major concern that emerged from the chapter we have been discussing
is our need to keep emphasizing we are talking about a personal God. Our
next exploration took us into human images that show cooperation, encour-
aging intentional diversity cooperating in unity. We began with our mate-
rial being and its components of body, mind, and soul, or body, soul, and
spirit. Then we looked at the illustrations of a club or society with members;
a government composed of three governing components, legislative, judicial,
executive; and a business with three officers. The strength we saw was in the
connections that were internal to the group, but a danger was in the possibil-
ity of stressing inequality among participants.

Our final examination was to consider God in a most intimate grouping:
as a family. This raised several issues, such as whether God has gender, how the

true God contrasts with false pretenders to God's rule, and what the implications of God as a community might be. This last topic asked whether some persons of the Trinity were subordinated to others, whether all were equal, and whether two of the persons were somehow emitted from the third in eternity.

What have we learned from the representative images we did explore? An image is not necessarily an allegory. When we take any of these images as point-by-point representations, then we can run into trouble. An image is a figurative type of analogy or comparison, which has one or more points of similarity and its meaning is limited to those points. Its goal is modest, simply providing one or more points of reference to illustrate some dimension(s) of the multidimensional God we worship.

Caution is essential when using images in order to avoid heresy, but contextualization is what Jesus did with his parables. If we follow his example, we will do the same with our analogical illustrations. As one of my students reminds us, "I want an image that tells a story when you look upon it. An image can be worth a *thousand words.*" If it's a good orthodox one, it can indeed.

APPENDIX: THE MEANINGS OF *TAXIS* IN THE EXTANT WRITINGS OF ATHANASIUS[1]

1. THE ORDER OF CREATION		
Writing	**Reference**	**Meaning**
Contra gentes (C. Gent.)	1. sec. 34, line 30	Orderliness (*taxis*) shows an Orderer
C. Gent.	2. 35, line 12	Though God is not seen, the order lets God be perceived
C. Gent.	3. 35, line 33	Celestial order shows ordering
C. Gent.	4. 36, line 21	Seasons and births show Orderer and Maker
C. Gent.	5. 37, line 19	Chaos if no Orderer that creation serves
C. Gent.	6. 38, line 1	Order not disorder, proportion not disproportion everywhere prove God is one not many
C. Gent.	7. 38, line 6	Harmony as well as order prove God is one not many
C. Gent.	8. 38, line 17	Order and harmony show God's unity
C. Gent.	9. 38, line 22	Universe's order shows God is the single ruler

1. The numbers in the Reference column follow the order of presentation and printing out in TLG, the sections or chapters or pages, the references in each book, and the line specified is where the term *taxis* appears.

1. THE ORDER OF CREATION		
Writing	**Reference**	**Meaning**
C. Gent.	10. 38, line 24	Arrangement shows the Word (*logos*) is one not many. Maintaining of universal order, Athanasius posits, shows one Ruler. (If more than one Ruler of creation, universal order would not be maintained)
C. Gent.	11. 38, line 27	Universal order would not be maintained without one Ruler
C. Gent.	12. 38, line 34	Order of diversity shows one Ruler (*archon*)
C. Gent.	13. 38, line 43	Order of whole universe is harmonious and shows one Ruler
C. Gent.	14. 38, line 45	All things make up one order, thus it is consistent to think of one Ruler
C. Gent.	15. 39, line 34	Creation is one, universe is one, the Artificer must be one
C. Gent.	16. 42, line 28	One universe being ordered shows the Word moving all things, but remaining unmoved with the Father
C. Gent.	17. 43, line 31	The Word nods, all things simultaneously fall into order
Epistula ad episcopos Aegypti et Libyae (Ep. Aeg. Lib.)	47. 25, p. 573, line 3	The works manifest the Word, as creation shows order not disorder
Orationes contra Arianos (C. Ar.)	48. 26, p. 36, line 31	The harmony and order of creation reveal the Son
C. Ar.	50. 26, p. 216, line 35	The same order and harmony in creation show us the Son is Lord (*despotas*) and God, showing his deity in his superiority, therefore he is out of the substance of the Father
Synopsis Scripturae Sacrae (Syn. script.)	86. 28, p. 349, line 33	The order of nature tells about the one who created it
Vita Sanctae Syncleticae (vita sanct. Synclet.)	110. 108. 28, p. 1532, line 17	The Lord, fabricating this world, put the inhabitants in twofold order (some to an honorable life for the sake of childbearing through appointed marriage)

1. THE ORDER OF CREATION

Writing	Reference	Meaning
De incarnatione verbi (Inc.)	18., ch. 43, sec. 3, line 4	Sun, moon, heaven, stars, water, air, stayed in their order, but not humanity
De fallacia diaboli (Fall. diab.)	43. sec. 1, line 18	The devil turns the order into disorder and the world order into world disorder
Fall. diab.	42. 1, line 21	The devil's lie had humans worshiping the stars and the order of heaven (please see XVI below for the devil's own subversive order [taxis])
In illud Qui dixerit verbum in filium (Hom. Luc. 12:10)	54. vol. 26, p. 661, line 1	Athanasius' refutation against those who, having seen the order of the world, claim it was created by Beelzebul
Epistula ad Marcellinum de interpretatione Psalmorum (Ep. Marcell.)	59. vol. 27, p. 29, line 34	Athanasius relates to the order of the universe these thoughts: advice to sing Psalms 18 and 23 when one is admiring the creation
Quaestiones Aliae	99. p. 789, line 16	Order of nature is overcome (or overturned) when God desires to do something unique
Sermo in Nativitatem Christi (Sermo Nat.)	106. vol. 28, p. 960, line 38	God conquers the natural order to accomplish the incarnation (neither displacing deity in becoming human or by human progression becoming God)
Sermo Nat.	107. vol. 28, p. 961, line 31	God conquers the order of nature to seal Mary's virginity for the Incarnation.

2. DOCTRINE AND PRACTICE OF CORRECT DOCTRINE

Writing	Reference	Meaning
De decretis Nicenae Synodi (Decr.)	19. ch. 41, sec. 12, line 5	Athanasius protests that Eusebius (of Nicomedia) mutilates the correct order of doctrine and practice
De Azymis	58., vol. 26, p. 1328, line 15	Order of the Jewish law
Expositiones in Psalmos (Expos. Psalmos)	65. vol. 27, p. 212, line 5:	Fragrance rising in the order of incense

2. DOCTRINE AND PRACTICE OF CORRECT DOCTRINE

Writing	Reference	Meaning
Expos. Psalmos	67. vol. 27, p. 289, line 24	Order of offerings to God
Syn. script.	88. vol. 28, p. 412, line 41	God did not spare the angels who did not keep the order of faith
Sermo in Annuntiationem Deiparae	104. vol. 28, p. 917, line 36	The order of the matters of the Incarnation and the arrangement of Christ's teaching in holy days
Vita sanct. Synclet.	109. vol. 28, p. 1540, line 25	Some properly follow the order of doctrine for illumination, some miss the mark

3. FILE OF SOLDIERS

Writing	Reference	Meaning
Apologia secunda (= Apologia contra Arianos Sive)(Apol. Sec.)	20. ch. 14, sec. 4, line 4	The commanding officer (prefect) of Egypt employs a file (*taxis*) of soldiers to terrify the church
Apol. sec.	22. ch. 31, sec. 1, line 5	Concerning the prefect and his soldiers who imprisoned Macarius and presided over the inquiry about the cup and table
Apologia ad Constantium Imperatorem (Apol. Const.)	30. sec. 24, line 23	Soldiers of the Duke
Apol. Const.	31. sec. 24, line 24	Soldiers of the Prefect of Egypt
Vita Antonii (Vit. Ant.)	57. vol. 26, p. 912, line 10	Soldiers of the governor
Expos. Psalmos	61. vol. 27, p. 68, line 52	Citizens [subjects] standing in military ranks (*taxis*) to resist attack

4. APPOINTMENT TO A PLACE OF AUTHORITY AND RANK IN THE CHURCH

Writing	Reference	Meaning
Apol. sec.	21. ch. 30, sec. 3, line 4	Athanasius discusses Gregory's conduct, as it reflects on his appointment to his rank (*taxis*)
Apol. Const.	32. sec. 31, line 20	Constantius summons Frumentius, who Athanasius appointed to his rank

5. ONE'S SOCIAL RANK OR POSITION IN SOCIETY

Writing	Reference	Meaning
Historia Arianorum (H. Ar.)	28. ch. 81, sec. 10, line 4	Position of commander (*taxis*) of the city police
Testimonia E Scripture (Test. Scrip.)	75. vol. 28, p. 60, line 91	Addressed to those in the position of the slave (advice to rely on the Son)

6. ANGELIC RANK OR POSITION

Writing	Reference	Meaning
In Illud Omnia Mihi Tradita Sunt (Hom. Matt 11:27)	46. vol. 25, p. 217, line 44	The disrespectful desire a superior rank (*taxis*) to angels
Orationes Tres Contra Arianos (C. Ar.)	51. vol. 26, p. 249, line 44	The Apostle discusses angels according to their order—whether an angel, whether a throne, whether a dominion, or an authority
Espistulae Quattuor Ad Serapionem (Ep. Serap.)	53. vol. 26, p. 612, line 41	None of the fallen kept their own order
Expos. Psalmos	68., vol. 27, p. 305, line 16	Imitating the order of the above spirits in praising God
Test. Script.	82. vol. 28, p. 77, line 27	Distinction within the angelic order
Quaestiones ad Antiochum Ducem (Quaest. Antioc. duc.)	98. vol. 28, p. 616, line 33 (also see lines 30–32 in Ibid., #91-#97 in TLG)	Differences in the angelic ranks (as humans have different orders of service, e.g., encouragement, service, succoring, giving freely of self)

7. ORDERS (COMMANDS FROM A SUPERIOR)

Writing	Reference	Meaning
Apol. sec.	23. ch. 56, sec. 1, line 2	Orders (*taxis*) of the Duke and the Prefect of Egypt
Apol. sec.	24. ch. 56, sec. 1, line 4	Orders in a letter from Constantius that he wants obeyed
Expos. Psalmos	66., vol. 27, p. 265, line 26	Much is in the command of the word

8. ORDER BOOK IN WHICH ORDERS ARE RECORDED

Writing	Reference	Meaning
Apol. sec.	25. ch. 85, sec. 7, line 7	Flavius Hermeius, the Receiver-General commands a tax collector, when he receives imperial orders (*taxis*), to make an abstract for the Order Book
H. Ar.	26. ch. 23, sec. 3, line 10	Constantius writes to Nestorius asking for letters among his "Orders"
H. Ar.	27. ch. 23, sec. 3, line 12 (continues #26 above)	Constantius specifies these letters are in his "Order Book"

9. ORDER AND ARRANGEMENT OF THE BOOKS OF THE BIBLE

Writing	Reference	Meaning
Epistula Festalis Xxxix (*Ep. fest.*)	33. p. 73, line 4	Order (*taxis*) of the Old Testament books
Ep. fest.	34. p. 74, line 15	Paul's letters in the order they were written
Argumentum in Psalmos	60., vol. 27, p. 56, line 37	Noting order of the psalms not set by chronology
Syn. script.	84. vol. 28, p. 296, line 11	Order of composition of each Bible book
Sermo de Descriptione Deiparae	105. vol. 28, p. 944, line 36	The order of events in the Incarnation recorded by Luke

10. A TASK

Writing	Reference	Meaning
De Virginitate (*Virg.*)	36. sec. 7. line 20	One with a task (*taxis*) makes use of messengers
Expos. Psalmos	62. vol. 27, p. 77, line 27	Task of accomplishment

11. A VOW

Writing	Reference	Meaning
Syn. Scrip.	87. vol. 28, p. 356, line 29	Vowing love (*taxis*) to someone (Athanasius reflects on Song of Solomon, using *taxate* from *tassō*, the verb form)

12. A MONASTIC ORDER		
Writing	**Reference**	**Meaning**
Virg.	37. sec. 10, line 12	Refers to women and men taking the order (*taxis*) of virginity in the kingdom of heaven
Vit. Ant.	56. vol. 26, p. 908, line 25	Order of monks

13. THE METHODOLOGY BY WHICH LIVES ARE ARRANGED (*ESPECIALLY IN REGARD TO SPIRITUAL DISCIPLINES*)		
Writing	**Reference**	**Meaning**
Virg.	38. sec. 19, line 1	Refers to the different order (*taxis*) that the righteous and the sinful follow in what motivates each to labor and what tasks they select
Expos. Psalmos	64. vol. 27, p. 189, line 20	God allows punishment for our training in the order of grace
Expos. Psalmos	69. vol. 27, 424, line 26	The illogical order of sheep
Expos. Psalmos	71. vol. 27, 556, line 18	We are given the order and way of those created before us to attain greater blessings
Expos. Psalmos	72. vol. 27, 585, line 52	Apostles offered up intellect in an order of sacrifice
Test. Scrip.	76. vol. 28, p. 77, line 23	Soldiers teaching discipline (as a metaphor for scholarly disciplines)
Test. Scrip.	77. vol. 28, p. 77, line 24	The order of doctrine (as a discipline to be learned in a soldierly manner)
Test. Scrip.	78. vol. 28, p. 77, line 25	Order of encouragement (as a discipline in a military metaphor)
Test. Scrip.	79. vol. 28, p. 77, line 25	Order of succoring (or retribution) (in a military training metaphor)
Test. Scrip.	80. vol. 28, p. 77, line 26	Order of giving freely of selves

13. THE METHODOLOGY BY WHICH LIVES ARE ARRANGED *(ESPECIALLY IN REGARD TO SPIRITUAL DISCIPLINES)*		
Writing	**Reference**	**Meaning**
Test. Scrip.	81. vol. 28, p. 77, line 26	Order of endurance (constancy) in serving people
Quaest. Antioc., duc.	90. vol. 28, p. 616, line 29	Soldiers are teaching these disciplines (similar to #76–81 above—metaphor for training in spiritual discipline)
Quaest. Antioc., duc.	91. vol. 28, p. 616, line 30	The order of doctrine (as a discipline to be learned in a soldierly manner)
Quaest. Antioc., duc.	92. vol. 28, p. 616, line 30	The order of encouragement
Quaest. Antioc., duc.	93. vol. 28, p. 616, line 30	The order of providence (a variation from the list in *Test. Scrip.*)
Quaest. Antioc., duc.	94. vol. 28, p. 616, line 31	The order of ministry of service (also a variation on the list in *Test. Scrip,* #76–81 above)
Quaest. Antioc., duc.	95. vol. 28, p. 616, line 31	The order of succoring or retribution
Quaest. Antioc., duc.	96. vol. 28, p. 616, line 32	The order of giving freely of self
Quaest. Antioc., duc.	97. vol. 28, p. 616, line 32	The order in [of] constantly serving others
Epistulae ad Castorem (Ep. Cast.)	101. vol. 28, p. 868, line 46	Do not follow the lazy in example, rise to the order of the good
Ep. Cast.	102. vol. 28, p. 872, line 23	The order of spiritual discipline by which one may reach perfection (fear of the Lord, good obedience, dependency on God, contempt of the world, killing the will and roots of pleasure), all of which promotes virtue.

14. ORDER BY WHICH THINGS ARE ARRANGED		
Writing	**Reference**	**Meaning**
Syn. Scrip.	85. vol. 28, p. 332, line 41	Order (*taxis*) of a song's melody
Ep. Cast.	103. vol. 28, p. 884, line 41	Order of inheritance (proper succession)

15. ORDER OF MELCHIZEDEK		
Writing	**Reference**	**Meaning**
Dialogus Athanasii et Zacchaei (Dial. Ath. Zac.)	39. sec. 81, line 8	Athanasius quotes Ps. 110:1–4 (LXX 109:1–4), "The Lord said to my Lord…'You are a priest forever according to the Order (*taxis*) of Melchizedek'"
Expos. Psalmos	70. vol. 27, p. 464, line 8	God gives an oath of promise, Athanasius alluding to Ps. 110:4, "You are a priest forever, according to the order of Melchizedek"
Homilia de Passione et Cruce Domini	83. vol. 28, p. 193, lines 1–4	"In the hymns it is written, '…you are a priest forever according to the order of Melchizedek"
Dial. Ath. Zac.	40. sec. 82, line 2	Zacchaeus notes concerning Solomon that it is said he is a priest according to the Order of Melchizedek (however, Athanasius disagrees that Solomon was a priest or pleased God all his life)
Dial. Ath. Zac.	41. sec. 82, line 4	Zacchaeus discusses the eternal quality of the Order of Melchizedek, Jesus Christ as a priest forever (alluding to Heb. 7:21).
Dial. Ath. Zac.	42. sec. 86, line 5	Athanasius explains Jesus is God by nature, but took flesh by Mary and became a priest by the anointing of the Holy Spirit forever in the Order of Melchizedek[2]

2. Interesting to note, in sec. 85, lines 1 and 2, Athanasius' defense of Christ has been so high that Zacchaeus asks if he is suggesting that Christ is greater than the "Blessed" (*eulogoumeou*, a substantive participle, i.e., gerund, which makes a noun out of a verb, in this case adapted out of the verb *eulogeō*, "to bless or praise," meaning the one who is being blessed or praised, i.e., the Father). Athanasius exclaims, "May it not be!" (*mē* = "not"; *genoito*, from *ginomai* = "become, be, or happen"). Athanasius, for emphasis, is using a rare form for his time, the aorist optative, which H. E. Dana and Julius R. Mantey (*A Manual Grammar of the Greek New Testament* [Toronto: Macmillan, 1955], 172) describe as "the mood of *possibility*," or "strong contingency," so we might render it, "Not possible to be!" In other words, Christ and the Father are equal.

15. ORDER OF MELCHIZEDEK		
Writing	**Reference**	**Meaning**
Test. Scrip.	73. vol. 28, p. 45, line 20	The order of Melchizedek[3]
Historia De Melchisedech	89. vol. 28, p. 529, line 45	Discusses Melchizedek as a type of Christ

16. THE DEVIL'S ORDER OR OPERATING PRINCIPLE		
Writing	**Reference**	**Meaning**
De Fallacia Diaboli	43. sec. 1, p. 881, line 14	The operating principle of the one working terror (the devil) was to be completely armed against us, upsetting the order (*taxis*) God sets for us so it becomes an order (*taxis*) of terror [cf. Sec. 1, line 18, also on the effect on heavenly order]
Vit. Ant.	55. vol. 26, p. 881, line 38	Not heeding the devil's order of discipline

17. ORDERLY CONDITION OF ONE'S PHYSICAL BODY		
Writing	**Reference**	**Meaning**
Expos. Psalmos	63. vol. 27, p. 133, line 40	Order (*taxis*) of the body's bones were dispersed

18. RANK IN THE INCARNATION		
Writing	**Reference**	**Meaning**
C.Ar.	49. vol. 26, p.188, line 35	Argues that the Son has the same order (*taxis*) as created beings, but he also has a different order than the others (being of the same substance as the Father)
De Sancta Trinitate (Dialogi 2 and 4)	35. vol. M28, p. 1197, line 5	This passage refers to the Word and Son's "nature" (*phuseōs*) before the incarnation being of first rank (*taxis*), unbegotten, now being secondary in birth, begotten, but still surpassing all nature on earth.[4]

3. Athanasius follows the LXX numbering, identifying this passage as from Ps. 109, which shows that Athanasius uses the LXX.

4. This passage echoes an argument Athanasius himself has made elsewhere, following Ignatius, that Jesus Christ could be said to be both generate and ingenerate. Eusebius of Nicomedia raised this issue in his well-publicized letter to Euphration, asking how

19. RANK OR ORDER IN THE TRINITY		
Writing	**Reference**	**Meaning**
De Syno-dis Arimini in Italia et Selecuiae in Isauria	29. ch. 23, sec. 6, line 4[5]	Athanasius points out the Semi-Arian Dedication Creed, which he quotes, distinguishes between the Father and Son in rank (*taxis*) or order, and, thus, is not the orthodox position
Epistulae Quattuor ad Serapionem (Ep. Serap.)	52. vol. 26, p. 580, line 24	"But as of such rank [*taxis*] and nature the Spirit has to the Son [as the Spirit has such rank and nature toward the Son[6]], so the Son has to the Father [such as the Son has toward the Father], how does one saying this one is a created being not the same also out of necessity they think concerning the Son? [how will the one saying this one (the Spirit) is a creation/creature and not think about the Son?]. For if the Spirit is a created being of the Son, it would follow for them to call (the Spirit) and the Word of the Father to be a created being. [For if the Spirit is the creation of the Son, would it not follow them to say that (the Spirit) and the Word of the Father are creatures?] For such the Arians are imagining, having fallen into Judaism according to Caiaphas. [This Arian imagining of such things has fallen under the Judaism of Caiaphas.]"

the Father could be Father and the Son, Son, if the Son were not "second," the Father ingenerate, the Son generate (quoted in *De Synodis* 2.4.17). Athanasius answers, "He who calls the Father ingenerate and almighty, perceives in the Ingenerate and the Almighty, His Word and His Wisdom, which is the Son" (*Defense of the Nicean Definition* 7.4.30), so he is explaining the Son is ingenerate, being eternal, but also generate when incarnated. Our present document, *De Sancta Trinitate*, clarifies the Son always being coeternal with the Father and of the same substance (*ousios*, line 11). (However, A. Gunthor thinks this particular document is spurious, crediting it to Didymus the Blind, not to Athanasius. See Johannes Quasten, *Patrology, Vol. 3* [Utrecht: Spectrum, 1975], 31; see also Berthold Altaner, *Patrology, Vol. 1*, trans. Hilda C. Graef [Edinburgh: Nelson, 1960], 315–16 for a list of such works.)

5. In the edition of the *De Synodis* we are using, the Dedication Creed is at 2.10.23. Also see it in Bettenson and Maunder, *Documents of Christian Church*, 43–45.

6. My literal translation. Classicist Dr. Catherine Kroeger's dynamic equivalent translation smoothed out the English in this final entry, included here in brackets. I also asked Anastasios Markoulidakis to give me his take on this same final passage, and here is his literal translation: "Moreover, the Spirit (is) having by the Son this sort of order and nature, which the Son has by the Father. How is this creature not saying the same? And how will (the creature) understand concerning the Son out of necessity? For if the Spirit

19. RANK OR ORDER IN THE TRINITY		
Writing	**Reference**	**Meaning**
Test. Scrip.	74. vol. 28, p. 52, line 4	Concerning the Spirit, "Do not grieve the Holy Spirit, in whom you are sealed. The heretics say that the deity has been established by rank (*taxis*) and numbering"
Sermo contra Latinos	100. vol. 28, p. 829, line 47	"With the Son, it is said, [the Spirit is] conjoined (or in unity) and together and not being inferior according to the emergence after the Son. But, the Son coming immediately out of the first, do not suppose also the same Spirit not to be immediately directly out of the first. For just as the Son immediately (or recently) and closely is out of the first, which implies the Father, so also the Spirit is immediately (or recently) out of the Father, with reference to the eternal (before the ages) emergence. But the Father is first (prior to) rather according to time, not according to rank—surely not!"[7]

of the Son is acolyte created to exist, he is saying to them that the Word of the Father is created as well. For fantasizing these (things,) the followers of Arius have fallen to the Judaism according to Kaiaphas." Anastasios also adds the next line, which I include here because it shows Athanasius' disdain for those holding this position of subordinating the Holy Spirit: "But if the ones concerning the Spirit are saying these things, they make believe not to follow Arius[;] they flew away from his words and did not [respect] the Spirit." Dr. Aída Besançon Spencer was also consulted for key readings and recast my dense original chart, which I presented to the Evangelical Theological Society, with this wonderful example of clarity.

7. So many sermons along with other works listed in this chart have been challenged as spurious, it is sometimes difficult to discover if a work is by Athanasius or by a follower, attempting to reflect his thinking, but, whatever the origin of these writings, none of them use *taxis* to support an eternal subordination of the Son.

BIBLIOGRAPHY

ANCIENT

The Apostolic Fathers. Vol. 1, *1 Clement, 2 Clement, Ignatius, Polycarp, Didache.* Edited and translated by Bart D. Ehrman. LCL. Cambridge, MA: Harvard University Press, 2003.

The Apostolic Fathers: Greek Texts and English Translation. Edited and translated by Michael W. Holmes. 3rd ed. Grand Rapids: Baker, 2007.

Arius. *Thalia.* In *Select Treatises of S. Athanasius, Archbishop of Alexandria, in Controversy with the Arians.* Vol. 8.1. Translated by Members of the English Church (John Henry Newman). Oxford: Parker, 1842.

The Athanasian Creed. In *The Book of Concord: The Confessions of the Lutheran Church.* 2020. http://bookofconcord.org/creeds.

Athanasius. *De Synodis.* In *Select Treatises of S. Athanasius, Archbishop of Alexandria, in Controversy with the Arians.* Translated by Members of the English Church (John Henry Newman). Oxford: Parker, 1842.

―――. *In Defence of the Nicene Definition.* In *Select Treatises of S. Athanasius, Archbishop of Alexandria, in Controversy with the Arians.* Translated by Members of the English Church (John Henry Newman). Oxford: Parker, 1842.

―――. *On the Incarnation.* Translated by a Religious of C.S.M.V. Yonkers, NY: St. Vladimir's Seminary Press, 2011.

Athenagoras. *Embassy for the Christians; The Resurrection of the Dead.* Translated by Joseph Hugh Crehan, SJ. Westminster, MD: Newman, 1956.

Augustine. *The City of God.* Translated by Marcus Dodds. New York: Modern Library, 1994.

Bhagavad-Gita. Translated by Swami Prabhavananda and Christopher Isherwood. New York: New American Library, 1951.

Clement of Alexandria. *The Miscellanies.* In *Ante-Nicene Christian Library* 12. Edited by Alexander Roberts and James Donaldson. Edinburgh: T&T Clark, 1869.

Clement of Rome. "First Letter of Clement to the Corinthians." In *The Apostolic Fathers, Vol. 1.* Edited and translated by Bart D. Ehrman. LCL. Cambridge, MA: Harvard University Press, 2003.

Eusebius: The Church History. Translated by Paul L. Maier. Grand Rapids: Kregel, 1999.

Gregory of Nazianzus. "Gregory of Nazianzus' Third Theological Oration concerning the Son." In *The Trinitarian Controversy*, edited and translated by William G. Rusch. Sources of Early Christian Thought. Philadelphia: Fortress, 1980.

————. *Gregory of Nazianzus*. Translated and edited by Brian E. Daley, SJ. The Early Church Fathers. New York: Routledge, 2006.

————. "To Cledonius the Priest against Apollinarius." In *Select Letters of Saint Gregory Nazianzen-St. Cyril of Jerusalem*. https://biblehub.com/library/cyril/select_letters_of_saint_gregory_nazianzen/to_cledonius_the_priest_against.htm.

————. "To Nectarius, Bishop of Constantinople." http://www.newadvent.org/father/3103a.htm.

Gregory of Nyssa. "An Answer to Ablabius: That We Should Not Think of Saying There Are Three Gods." "On Not Three Gods." In *Christology of the Later Fathers*. Edited by Edward Rochie Hardy and Cyril C. Richardson. LCL. Philadelphia: Westminster, 1950.

Hippolytus. *Against the Heresy of One Noetus*. In *The Writings of Hippolytus, Bishop of Portus, vol. 2, Fragments of Writings of Third Century*. Translated by S. D. F. Salmond. In *Ante-Nicene Christian Library* 9. Edited by Alexander Roberts and James Donaldson. Edinburgh: T&T Clark, 1869.

The Holy Scriptures According to the Masoretic Text. Philadelphia: The Jewish Publication Society of America, 1955.

Ignatius. "To the Ephesians." In *The Apostolic Fathers*. Vol. 1. Edited and translated by Bart D. Ehrman. LCL. Cambridge, MA: Harvard University Press, 2003.

————. "To the Philadelphians." In *The Apostolic Fathers*. Vol. 1. Edited and translated by Bart D. Ehrman. LCL. Cambridge, MA: Harvard University Press, 2003.

Irenaeus. *St. Irenaeus of Lyons: Against the Heresies, Book 1*. Translated by Dominic J. Unger. Ancient Christian Writers. New York: Paulist, 1992.

————. *St. Irenaeus of Lyons: Against the Heresies, Books 2–3*. Translated by Dominic J. Unger. Ancient Christian Writers. New York: Newman, 2012.

Jerome. *Lives of Illustrious Men*. In *Nicene and Post-Nicene Fathers*. Vol. 3, *Theodoret, Jerome, Gennadius, Rufinus: Historical Writings, etc.* Second series. Edited by Philip Schaff and Henry Wace. Peabody: Hendrickson, 1892.

Justin Martyr. *Saint Justin Martyr: The First Apology; The Second Apology; Dialogue with Trypho, Exhortation to the Greeks; Discourse to the Greeks; The Monarchy or The Rule of God*. FC 6. Edited and translated by Thomas B. Falls. Washington, DC: Catholic University of America, 1948.

The Koran. Translated by N. J. Dawood. New York: Penguin, 1997.

Marcion of Smyrna. "Martyrdom of Saint Polycarp, Bishop of Smyrna." In *The Apostolic Fathers*. Vol. 1. Edited and translated by Bart D. Ehrman. LCL. Cambridge, MA: Harvard University Press, 2003.

Methodius. *The Writings of Methodius, Alexander of Lycopolis, Peter of Alexandria and Several Fragments*. Edited by Alexander Roberts and James Donaldson. Ante-Nicene Christian Library 14. Edinburgh: T&T Clark, 1869.

The Mishnah. Translated by Herbert Danby. New York: Oxford University Press, 1977.

Origen. *Commentary on the Gospel According to John, Books 1–10.* Translated by Ronald E. Heine. Washington, DC: The Catholic University of America Press, 1984.

————. *On First Principles.* Translated by G. W. Butterworth. New York: Harper & Row, 1966.

————. *On Prayer.* In *Alexandrian Christianity.* LCC. Translated by John Ernest Leonard Oulton and Henry Chadwick. Philadelphia: Westminster, 1954.

Philo. *Allegorical Interpretations of Genesis II, III.* Vol. 1. Translated by F. H. Colson and G. H. Whitaker. Cambridge, MA: Harvard University Press, 1929.

Plato. *Timaeus, Critias, Cleitophon, Menexenus, Epistles.* Translated by R. G. Bury. Cambridge, MA: Harvard University Press, 1929.

Plotinus. "Ennead VI." In *Plotinus.* Vol. 7. Translated by A. H. Armstrong. Cambridge, MA: Harvard University Press, 1988.

Socrates Scholasticus. *The Ecclesiastical History.* In *Nicene and Post-Nicene Fathers 2.* Edited by Philip Schaff and Henry Wace. A Select Library of the Christian Church. Peabody, MA: Hendrickson, 1890.

Tatian. "Address of Tatian to the Greeks." In *Fathers of the Second Century: Hermas, Tatian, Athenagoras, Theophilus, and Clement of Alexandria.* In *ANF 2.* Translated by J. E. Ryland. Edited by Alexander Roberts, James Donaldson, and A. Cleveland Coxe. Grand Rapids: Eerdmans, 1979.

Tertullian. *Q. Septimii Florentis Tertullianiani Adversus Praxean Liber.* Tertullian's Treatise Against Praxeas. Edited by Ernest Evans. London: SPCK, 1948.

————. *Against Praxeas. On the Flesh of Christ.* In *The Christological Controversy.* Translated and edited by Richard A. Norris Jr. Sources of Early Christian Thought. Philadelphia: Fortress, 1980.

Theophilus. "Theophilus to Autolycus." In *Fathers of the Second Century: Hermas, Tatian, Athenagoras, Theophilus, and Clement of Alexandria.* ANF 2. Translated by Marcus Dods. Edited by Alexander Roberts, James Donaldson, and A. Cleveland Coxe. Grand Rapids: Eerdmans, 1979.

The Tibetan Book of the Dead. Edited by W. Y. Evans-Wentz. 3rd ed. New York: Oxford University Press, 1960.

Contemporary

Adams, John H. "Trinity Paper: Mother, Child and Womb?" *The Layman* 39, no. 3 (July 2006): 1, 20.

Adeyemo, Tokunboh et al., eds. *Africa Bible Commentary.* Nairobi, Kenya: Word Alive, 2006.

Altaner, Berthold. *Patrology.* Translated by Hilda C. Graef. Edinburgh: Nelson, 1960.

Assyrian Church of the East. "Nestorian Theology." Nestorian.org. 2002. http://www.nestorian.org/is_the_theology_of_the_church_of_the_east_nestorian-.html.

Barth, Karl. *The Doctrine of the Word of God: Prolegomena to Church Dogmatics.* Vol. 1., part 1. 2nd ed. Translated by G. W. Bromiley. Edinburgh: T&T Clark, 1975.

Bettenson, Henry, and Chris Maunder, eds. *Documents of the Christian Church*. 4th ed. Oxford: Oxford University Press, 2011.

Bloesch, Donald G. *The Battle for the Trinity: The Debate over Inclusive God-Language*. Ann Arbor, MI: Servant, 1985.

Boettner, Loraine. *The Person of Christ*. Eugene, OR: Wipf and Stock, 2009.

The Book of Mormon: Another Testament of Jesus Christ. Salt Lake City, UT: The Church of Jesus Christ of Latter-Day Saints, 1968.

Brown, A. Philip II, and Bryan W. Smith, eds. *A Reader's Hebrew Bible*. Grand Rapids: Zondervan, 2008.

Brown, Brad. "The Trinity and States of Matter, A Bad Analogy." 2015. https://www.bradbrownmagic.com/2015/01/29/the-trinity-and-states-of-matter-a-bad-analogy.

Burer, Michael H., and Jeffrey E. Miller. *A New Reader's Lexicon of the Greek New Testament*. Grand Rapids: Kregel, 2008.

Calvin, John. *Calvin's Commentaries: Ephesians–Jude*. Wilmington, DE: Associated Publishers and Authors, n.d.

_____. *Institutes of the Christian Religion*. 2 vols. LCL 20. Edited by John T. McNeill. Translated by Ford Lewis Battles. Philadelphia: Westminster, 1960.

Cassidy, James J., Jr. et al., eds. *Through Indian Eyes: The Untold Story of Native American Peoples*. Pleasantville, NY: Reader's Digest, 1995.

Champion, John B. *Personality and the Trinity*. New York: Revell, 1935.

The Constitution of the Presbyterian Church (U.S.A.): Part I, Book of Confessions. Louisville: The Office of the General Assembly, 1999.

Cooper, John W. *Our Father in Heaven: Christian Faith and Inclusive Language for God*. Grand Rapids: Baker, 1998.

Creamer, Jennifer Marie. *God as Creator in Acts 17:24: An Historical-Exegetical Study*. Africanus Monograph Series 2. Eugene, OR: Wipf and Stock, 2017.

Crossley, John. *Explaining the Gospel to Muslims*. Rev. ed. Key Books 5. London: United Society for Christian Literature, 1967.

Dana, H. E., and Julius R. Mantey. *A Manual Grammar of the Greek New Testament*. Toronto: Macmillan, 1955.

Dāsa, Ravīndra-Svarūpa. "The Descent of God." *Back to Godhead* 20, no. 5 (May 1985): 7–10, 29, 35.

Davis, John Jefferson. "A New Metaphysical Model for the Social Trinity: Father, Son, and Holy Spirit as *Reciprocally Nested Hypostases*." Paper presented at Gordon-Conwell Theological Seminary, Hamilton, Massachusetts, October 2018.

DeFazio, Jeanne C., and William David Spencer, eds. *Empowering English Language Learners: Successful Strategies of Christian Educators*. Eugene, OR: Wipf and Stock, 2018.

_____. *Redeeming the Screens: Living Stories of Media "Ministers" Bringing the Message of Jesus Christ to the Entertainment Industry*. Eugene, OR: Wipf and Stock, 2016.

Diario Libre. "Las abejas son muy diferentes." February 4, 2020, 30.

Eddy, Mary Baker. *Science and Health with Key to the Scriptures*. Boston: The First Church of Christ, Scientist, 1875.

Erickson, Millard. *Christian Theology*. 3rd ed. Grand Rapids: Baker, 2013.

————. *Who's Tampering with the Trinity? An Assessment of the Subordination Debate*. Grand Rapids: Kregel, 2009.

Fairbairn, Donald, and Ryan M. Reeves. *The Story of Creeds and Confessions: Tracing the Development of the Christian Faith*. Grand Rapids: Baker, 2019.

Farley, Andrew. *Twisted Scripture: Untangling 45 Lies Christians Have Been Told*. Washington, DC: Salem, 2019.

Ferguson, George. *Signs and Symbols in Christian Art*. Oxford: Oxford University Press, 1954.

Feyerabend, Karl. *Langenscheidt Pocket Hebrew Dictionary to the Old Testament: Hebrew-English*. New York: McGraw-Hill, 1969.

Fiene, Hans. "St. Patrick's Bad Analogies." March 14, 2013. https://lutheransatire.org/media/st-patricks-bad-analogies.

Ford, David, and Rachel Muers, eds. *The Modern Theologians: An Introduction to Christian Theology Since 1918*. 3rd ed. Malden, MA: Blackwell, 2005.

Frame, John M. "Men and Women in the Image of God." In *Recovering Biblical Manhood and Womanhood: A Response to Evangelical Feminism*, edited by John Piper and Wayne Grudem, 225–32. Wheaton, IL: Crossway, 1991.

Gesenius, W., E. Kautzsch, and A. E. Cowley. *Gesenius' Hebrew Grammar*. 2nd ed. Oxford: Oxford University Press, 1976.

Gesenius, William, E. Rödiger, Francis Brown, S. R. Driver, and Charles A. Briggs. *A Hebrew and English Lexicon of the Old Testament*. Oxford: Oxford University Press, 1907.

Giles, Kevin. *The Eternal Generation of the Son: Maintaining Orthodoxy in Trinitarian Theology*. Downers Grove, IL: InterVarsity, 2012.

————. *The Trinity and Subordinationism: The Doctrine of God and the Contemporary Gender Debate*. Downers Grove, IL: InterVarsity, 2002.

González, Justo L. *Essential Theological Terms*. Louisville: Westminster John Knox, 2005.

Gruenler, Royce Gordon. *The Trinity in the Gospel of John: A Thematic Commentary on the Fourth Gospel*. Grand Rapids: Baker, 1986.

Habershon, Ada R. *Study of the Types*. Grand Rapids: Kregel, 1997.

Halsey, William D., and Bernard Johnston, eds. *Collier's Encyclopedia*. 24 vols. New York: Macmillan, 1987.

Hamilton, Edith. *Mythology*. Boston: Little, Brown, 1942.

Hamilton, Edmond. "The Avenger from Atlantis." *Weird Tales* 26, no. 1 (July 1935): 2.

Hamilton, Victor P. *The Book of Genesis, Chapters 1–17*. Grand Rapids: Eerdmans, 1990.

Hanson, R. P. C. *The Search for the Christian Doctrine of God: The Arian Controversy, 318–381*. Grand Rapids: Baker, 1988.

Harris, Murray J. *Jesus as God: The New Testament Use of Theos in Reference to Jesus*. Grand Rapids: Baker, 1992.

Harrison, Everett F., Geoffrey W. Bromiley, and Carl F. H. Henry, eds. *Baker's Dictionary of Theology*. Grand Rapids: Baker, 1960.

Harvey, Van A. *A Handbook of Theological Terms.* New York: Macmillan, 1964.

Hengstenberg, E. W. *Christology of the Old Testament.* Grand Rapids: Kregel, 1970.

Henry, Matthew. *Commentary on the Whole Bible: Genesis to Revelation.* Edited by Leslie F. Church. Grand Rapids: Zondervan, 1961.

Hodge, Charles. *Systematic Theology.* 3 vols. Grand Rapids: Eerdmans, 1968.

Hoyt, Thomas Jr. "Interpreting Biblical Scholarship for the Black Church Tradition." In *Stony the Road We Trod: African American Biblical Interpretation,* edited by Cain Hope Felder, 17–39. Minneapolis: Fortress, 1991.

Hultkrantz, Åke. *The Religions of the American Indians.* Translated by Monica Setterwall. Berkeley, CA: University of California Press, 1979.

Jamieson, Robert, A. R. Fausset, and David Brown. *Commentary Practical and Explanatory on the Whole Bible.* Grand Rapids: Zondervan, 1961.

Jenson, Robert W. "God." In *The Blackwell Encyclopedia of Modern Christian Thought,* edited by Alister E. McGrath. Cambridge, MA: Blackwell, 1993.

————. *The Triune Identity: God According to the Gospel.* Philadelphia: Fortress, 1982.

Jowers, Dennis W., and H. Wayne House, eds. *The New Evangelical Subordinationism? Perspectives on the Equality of God the Father and God the Son.* Eugene, OR: Pickwick, 2012.

Kaiser, Walter C., Jr. et al., eds. *NIV Archaeological Study Bible.* Grand Rapids: Zondervan, 2005.

Kärkkäinen, Veli-Matti. *The Trinity: Global Perspectives.* Louisville: Westminster John Knox, 2007.

Kaufman, Gordon D. *Systematic Theology: A Historicist Perspective.* New York: Scribner's, 1968.

Keil, Carl Friedrich. *The Twelve Minor Prophets.* Vol. 2, *Biblical Commentary on the Old Testament.* Edited by C. F. Keil and F. Delitzsch. Grand Rapids: Eerdmans, 1949.

Kelly, J. N. D. *Early Christian Doctrines.* 2nd ed. New York: Harper, 1960.

Kimble, Gregory A., and Norman Garmezy. *Principles of General Psychology.* 2nd ed. New York: Ronald, 1963.

Kohlenberger, John R. III, and James A. Swanson. *The Hebrew-English Concordance to the Old Testament with the New International Version.* Grand Rapids: Zondervan, 1998.

Kopper, Philip et al., eds. *The Smithsonian Book of North American Indians Before the Coming of the Europeans.* Washington, DC: Smithsonian, 1986.

Kroeger, Catherine Clark. "Toward an Understanding of Ancient Conceptions of 'Head.'" *Priscilla Papers* 20, no. 3 (2006): 4–8.

LaCugna, Catherine Mowry. *God for Us: The Trinity and Christian Life.* New York: HarperCollins, 1973.

Leupp, Roderick T. *The Renewal of Christian Theology: Themes, Patterns and Explorations.* Downers Grove, IL: InterVarsity, 2008.

Ligonier Ministries and Lifeway Research. "The State of Theology 2020." Lifeway Research. www.lifewayresearch.com/wp-content/uploads/2020/09/Ligonier-State-of-Theology.

Long, Charles H. *Alpha: The Myths of Creation*. New York: George Braziller, 1963.

Lozzi, Roma S. A. S. *Rome from Its Origins to the Present Time and the Vatican*. Rome: Edizioni Lozzi Roma, n.d.

Maclaren, Alexander. *The Epistles of St. Paul to the Colossians and Philemon*. New York: Armstrong, 1897.

Martell-Otero, Loida I., Zaida Maldonado Pérez, and Elizabeth Conde-Frazier. *Latina Evangélicas: A Theological Survey from the Margins*. Eugene, OR: Cascade, 2013.

Mavromataki, Maria. *Greek Mythology and Religion*. Athens: Haïtali, 1997.

McBirnie, William Steuart. *The Search for the Twelve Apostles*. Wheaton, IL: Tyndale, 1973.

McGrath, Alister E., ed. *The Blackwell Encyclopedia of Modern Christian Thought*. Cambridge, MA: Blackwell, 1993.

Metzger, Bruce M. *A Textual Commentary on the Greek New Testament*. 2nd ed. Stuttgart: Deutsche Bibelgesellschaft, 2002.

Metzger, Bruce M., and Bart D. Ehrman. *The Text of the New Testament: Its Transmission, Corruption, and Restoration*. 4th ed. New York: Oxford University Press, 2005.

Mitchell, Basil, ed. *Faith and Logic: Oxford Essays in Philosophical Theology*. London: Allen & Unwin, 1957.

Moffat, James. *A Critical and Exegetical Commentary on the Epistle to the Hebrews*. ICC. Edinburgh: T&T Clark, 1924.

Mora, Michael. "10 Key Things to Consider When Designing Surveys." *Surveygizmo*. May 11, 2006. https://www.surveygizmo.com/resources/blog/designing-surveys.

Morris, Leon. *The Gospel According to John*. NICNT. Grand Rapids: Eerdmans, 1971.

Muhammad, Elijah. *Message to the Blackman in America*. Philadelphia: House of Knowledge, 1965.

Murphy, Nancey. *Beyond Liberalism and Fundamentalism: How Modern and Postmodern Philosophy Set the Theological Agenda*. Harrisburg, PA: Trinity, 1996.

Murrell, Nathaniel Samuel, William David Spencer, and Adrian Anthony McFarlane, eds. *Chanting Down Babylon: The Rastafari Reader*. Philadelphia: Temple University Press, 1998.

Ngewa, Samuel. "John." In *Africa Bible Commentary*, edited by Tokunboh Adeyemo et al., 1251–96. Nairobi, Kenya: Word Alive/Zondervan, 2006.

Nolland, John. *The Gospel of Matthew: A Commentary on the Greek Text*. NIGTC. Grand Rapids: Eerdmans, 2005.

Norris, Richard A. Jr., ed. *The Christological Controversy*. Philadelphia: Fortress, 1980.

Park, Seong Hyun, Aída Besançon Spencer, and William David Spencer, eds. *Reaching for the New Jerusalem: A Biblical and Theological Framework for the City*. Urban Voice Series. Eugene, OR: Wipf and Stock, 2013.

Presbyterian Church (USA). "The Trinity: God's Love Overflowing." 216 General Assembly Council Minutes. 2004. https://www.presbyterian.org.nz/sites/default/files/for_ministers/worship_resources/Inclusive_language_paper_PCUSA.pdf.

Phan, Peter., ed. *The Cambridge Companion to the Trinity*. Cambridge: Cambridge University Press, 2011.

Piper, John, and Wayne Grudem. *Recovering Biblical Manhood and Womanhood: A Response to Evangelical Feminism.* Wheaton, IL: Crossway, 1991.

Quasten, Johannes. *Patrology.* 4 vols. Westminster, MD: Christian Classics, 1986.

Rahner, Karl. *The Trinity.* Translated by Joseph Donceel. New York: Herder and Herder, 1970.

Peterson, Tracie. *A Sensible Arrangement.* Minneapolis: Bethany, 2014.

Random House Webster's Unabridged Dictionary. New York: Random House, 2001.

Richardson, Cyril C., ed. *Early Christian Fathers.* New York: Collier, 1970.

Ro, Bong Rin, ed. *Christian Alternatives to Ancestor Practices.* Seoul, Korea: Word of Life & Asia Theological Association, 1985.

Robertson, Archibald Thomas. *A Grammar of the Greek New Testament in the Light of Historical Research.* Nashville: Broadman, 1934.

_____. *Word Pictures in the New Testament.* Vol. 1, *The Gospel According to Matthew, The Gospel According to Mark.* Nashville: Broadman, 1930.

_____. *Word Pictures in the New Testament.* Vol. 4, *The Epistles of Paul.* Nashville: Broadman, 1931.

_____. *Word Pictures in the New Testament.* Vol. 5, *The Fourth Gospel, The Epistle to the Hebrews.* Nashville: Broadman, 1932.

Ruse, Michael. "Earth's Holy Fool." Aeon.com. January 14, 2013. https://aeon.co/essays/gaia-why-some-scientists-think-its-a-nonsensical-fantasy.

Ryken, Leland, James C. Wilhoit, and Tremper Longman III, eds. *Dictionary of Biblical Imagery.* Downers Grove, IL: InterVarsity, 1998.

Sanders, Fred, and Klaus Issler, eds. *Jesus in Trinitarian Perspective: An Intermediate Christology.* Nashville: B&H, 2007.

Shideler, Mary McDermott. *The Theology of Romantic Love: A Study in the Writings of Charles Williams.* Grand Rapids: Eerdmans, 1962.

Singleton, "Aakhun" George W. *Esoteric Atannuology, Egyptology and Rastafariology.* Vol. 1. Indianapolis: Enlightenment, 1997.

Spencer, Aída Besançon. *Beyond the Curse: Women Called to Ministry.* Grand Rapids: Baker, 1985.

_____. *A Commentary on James.* Kregel Exegetical Library. Grand Rapids: Kregel Academic, 2020.

_____. "The God of the Bible." In *The Global God: Multicultural Evangelical Views of God,* edited by Aída Besançon Spencer and William David Spencer, 21–36. Grand Rapids: Baker, 1998.

_____. *Paul's Literary Style: A Stylistic and Historical Comparison of 2 Corinthians 11:16–12:13, Romans 8:9–39, and Philippians 3:2–4:13.* New York: University Press of America, 1998.

_____. *2 Corinthians.* The People's Bible Commentary. Abingdon: The Bible Reading Fellowship, 2001.

Spencer, Aída Besançon, and William David Spencer, eds. *Christian Egalitarian Leadership: Empowering the Whole Church according to the Scriptures.* Eugene, OR: Wipf and Stock, 2020.

_____. *The Global God: Multicultural Evangelical Views of God.* Grand Rapids: Baker, 1998.

_____. *God through the Looking Glass: Glimpses from the Arts.* Grand Rapids: Baker, 1998.

_____. *The Prayer Life of Jesus: Shout of Agony, Revelation of Love, A Commentary.* Lanham, MD: University Press of America, 1990.

Spencer, Aída Besançon, Donna F. G. Hailson, Catherine Clark Kroeger, and William David Spencer. *The Goddess Revival: A Biblical Response to God(dess) Spirituality.* Grand Rapids: Baker, 1995.

Spencer, Aída Besançon, William David Spencer, and Mimi Haddad. *Global Voices on Biblical Equality: Women and Men Serving Together in the Church.* Eugene, OR: Wipf and Stock, 2008.

Spencer, William David. "An Evangelical Statement on the Trinity." *Priscilla Papers* 25, no. 4 (2011): 15–19.

_____. *Dread Jesus.* London: SPCK, 1999.

_____. "How to Address God in Prayer." In *Giving Ourselves to Prayer*, edited by Dan R. Crawford, 200–205. Terre Haute, IN: Prayershop, 2008.

_____. "Is He Risen Indeed? Challenges to Jesus' Resurrection from the Sanhedrin to the *Jesus Family Tomb*." *Africanus Journal* 3, no. 1 (April 2011): 27–54.

_____. "The Need for Caution in the Use of Eternal Birth Language for Jesus Christ in the Early Church and Today." *Africanus Journal* 10, no. 1 (April 2018): 5–22.

_____. "Rebuilding the City of Enoch with the Blueprints of Christ." In *Reaching for the New Jerusalem: A Biblical and Theological Framework for the City*, edited by Seong Hyun Park, Aída Besançon Spencer, and William David Spencer. Eugene, OR: Wipf and Stock, 2013.

Steffler, Alva William. *Symbols of the Christian Faith.* Grand Rapids: Eerdmans, 2002.

Steuart, William. *The Search for the Twelve Apostles.* Wheaton, IL: Tyndale, 1973.

Stevenson, Herbert F. *Titles of the Triune God: Studies in Divine Self-Revelation.* Westwood, NJ: Revell, 1956.

Stevenson, J., and W. H. C. Frend. *A New Eusebius: Documents Illustrating the History of the Church to AD 337.* Grand Rapids: Baker, 2013.

Stobbe, Les. "Earning the Right to Be Published." *Africanus Journal* 10, no. 2 (Nov. 2018): 4–11.

Swain, Scott R. *The God of the Gospel: Robert Jenson's Trinitarian Theology.* Downers Grove, IL: InterVarsity, 2013.

Thayer, Joseph Henry. *Thayer's Greek-English Lexicon of the New Testament.* Rev. ed. Marshallton, DE: The National Foundation for Christian Education,1889.

Thomas, Robert L., and Stanley N. Gundry. *A Harmony of the Gospels.* Chicago: Moody, 1978.

_____. *The NIV Harmony of the Gospels: With Explanations and Essays.* New York, HarperCollins, 1988.

Traupman, John C. *The New College Latin and English Dictionary.* New York: Bantam, 1966.

Turcescu, Lucian. *Gregory of Nyssa and the Concept of Divine Persons*. New York: Oxford University Press, 2005.

Twiss, Robert. *One Church Many Tribes*. Ventura, CA: Regal, 2000.

Van Brunt, Jessie. *California Missions: Painted and Described*. Los Angeles: Wetzel, 1932.

Vos Levitz, Louis B. *Monotheism and the Messiah in the Light of Messianic Apologetics*. Dover: Vos Levitz, 1999.

Ware, Bruce A. *Father, Son, and Holy Spirit: Relationships, Roles, and Relevance*. Wheaton, IL: Crossway, 2005.

Warfield, Benjamin Breckinridge. *The Person and Work of Christ*. Edited by Samuel G. Craig. Philadelphia: Presbyterian and Reformed, 1950.

Watchtower Bible and Tract Society of Pennsylvania and International Bible Students Association. *The Kingdom Interlinear Translation of the Greek Scriptures*. Brooklyn, NY: Watchtower Bible and Tract Society of New York and International Bible Students Association, 1985.

————. *New World Translation of the Holy Scriptures*. Brooklyn, NY: Watchtower Bible and Tract Society of New York and International Bible Students Association, 1984.

Watchtower Bible and Tract Society of Pennsylvania. *Reasoning from the Scriptures*. Brooklyn: Watchtower Bible and Tract Society of New York, 1989.

Webber, F. R. *Church Symbolism: An Explanation of the More Important Symbols of the Old and New Testament. The Primitive, the Mediaeval and the Modern Church*. 2nd ed. Cleveland, OH: J. H. Jansen, 1938.

Webster's Dictionary of Word Origins. New York: Smithmark, 1991.

Wiersbe, Warren W. *Index of Biblical Images: Similes, Metaphors, and Symbols in Scripture*. Grand Rapids: Baker, 2000.

World Council of Churches. "Re-Imagining . . . God , Community, and the Church." November 4–7, 1993.

Wright, R. K. McGregor. "God, Metaphor and Gender: Is the God of the Bible a Male Deity?" In *Discovering Biblical Equality: Complementarity without Hierarchy*, edited by Ronald W. Pierce and Rebecca Merrill Groothuis, 287–300. 2nd ed. Downers Grove, IL: InterVarsity, 2005.

Zerwick, Max, and Mary Grosvenor. *A Grammatical Analysis of the Greek New Testament*. 5th ed. Rome: Editrice Pontificio Istituto Biblico, 1996.

Zirker, J. B. "Sun." In *Collier's Encyclopedia*. New York: MacMillan, 1987.

Zizioulas, John D. *Communion and Otherness: Further Studies in Personhood and the Church*. Edited by Paul McPartlan. New York: T&T Clark, 2006.

————. *Being as Communion: Studies in Personhood and the Church*. London: Darton, Longman, and Todd, 2004.

SCRIPTURE INDEX

Mark

John

SUBJECT INDEX